The Shock of the New

Ian Dunlop

Seven Historic Exhibitions of Modern Art

American Heritage Press *A Division of McGraw-Hill Book Company*
New York St Louis San Francisco

This book is dedicated to DMF, JBF, FF and EE

Library of Congress Catalog Card Number: 77–39481
07–018267–1

Printed in Great Britain

Contents

7306455

INTRODUCTION

The idea for this book arose out of a conversation in an oyster bar in Shepherd's Market, London. My companion, Tristram Powell, suggested that there ought to be a book on famous exhibitions like the first Post-Impressionist exhibition at the Grafton Gallery. The idea appealed to me immediately. Like most people I had heard of the Grafton Gallery shows, the Armory Show, the first Impressionist exhibition and other similar events, without really knowing very much about them. So often the details of these exhibitions are glossed over because they are too well-known to be worth repeating. In many accounts the author confines himself to observing that such and such a picture created a scandal, or that the critics were particularly severe on such and such an artist, and the crowd found the whole thing quite incomprehensible and laughable. But what kind of scandal? What degree of severity? How much laughter? These details are frequently lost in generalities.

But they are worth considering. If one visits the Jeu de Paume and sees Manet's *Déjeuner sur l'herbe* or his *Olympia*, or goes to Philadelphia to see Duchamp's *Nude Descending a Staircase*, or to California to examine Millet's *Man with a Hoe*, it does require a great deal of imagination to understand why any of these pictures ever caused a scandal. The Manet looks like an Ingres (and that was said fifty years ago), the Duchamp seems no more remarkable than many Cubist paintings, and the Millet might easily be dismissed as a typical exercise in nineteenth-century sentimentalism. Why did they make people angry when they first saw them? Why did our grandfathers and fathers go purple in the face even at the mention of the artists' names? Is it subject-matter, technique, colour, or something less specific like newness? One reason why these questions are not easy to answer is that the paintings themselves have been separated from their historical context. If they could be seen alongside Bouguereaus, Meissoniers, Sargents and other popular favourites of the nineteenth and twentieth centuries their full originality might be easier to grasp. One aim of this book is to recreate the historical conditions under which new art was first exhibited.

Lack of knowledge was one reason why I wanted to undertake this book. But there was also a more personal reason. I used to be an art critic for a London newspaper and I have a natural sympathy for the way other critics shape up to the challenge of writing about new work. When I started I had to weigh up the merits of Rauschenberg's *Monogram*, the goat with a tyre round its middle, and when I ended I had to consider a loose pile of rubble in an exhibition called 'When Attitudes Become Form'. I cannot say either experience appealed to me, but at the same time I cannot say that either really undermined my understanding of the nature and purpose of art. In that period I made many mistakes. I have been bewildered by exhibitions; misled, frequently; astonished, occasionally; but never really shocked or angry. But would I have behaved like this in the 1860s or in the 1900s? Clearly when people saw Manets, Cézannes and Van Goghs for the first time their confidence in what they believed a picture should look like really was shaken. Many

felt that their way of life was threatened; and it was with good reason that a great critic, Théophile Thoré, said: 'Art changes only through strong convictions, convictions strong enough to change society at the same time.' Even technical matters, like the dispute over finish, and the question of painting out of doors, aroused a great deal of heat. Are we more tolerant, more receptive to new ideas and techniques? Or are we less concerned about art? Do we really care if an artist sprinkles paint straight from the can or draws up a scheme to drill a hole in the sea? Are we interested in what artists are doing? These questions are not easily answered, but I hope this book will make them seem worth asking.

I hope also that this book will draw attention to the merits as well as the defects of art criticism in the nineteenth century and the first part of the twentieth. Manet, Monet, Cézanne and Matisse suffered from vicious and bigoted criticism. But think of some of the good things that were said about them. Are there writers or critics today to compare with Baudelaire, Thoré, Zola, Maurice Denis, Roger Fry, Julius Meier-Graefe and Apollinaire? If the quality of criticism today does not equal that of a century ago neither does the quantity. Artists may dislike criticism and despise critics, but nowadays they are lucky to read any considered judgement of their work, good or bad. At best a one-man show will receive a paragraph in one of the surviving quality news-papers or with luck a longer article in a low-circulation art magazine, and that is about all. Books do better from reviews.

One noticeable difference between today's exhibitions and those covered by this book is that on the whole the initiative to put them on now comes from outside, from dealers, critics and museum directors. In the past they were staged as a result of pressures from artists acting either individually or as a group. One forgets how difficult it was a hundred years ago to show new work. The official and semi-official exhibitions held annually in most capital cities of the West came to be dominated by self-perpetuating cliques of artists only too content to benefit from the burst of collecting that followed the Industrial Revolution. In almost every country these exhibitions failed to meet the needs of a new generation of artists. Either the annual shows created their own splinter groups, as was the case in America, for example, or artists formed their own counter-exhibitions, as the Impressionists did in France, the New English Art Club did in Britain and Viennese artists did in Austria. Entwined in this book is the story of how artists set about evolving new methods for showing their work to their contem-poraries.

The selection of these exhibitions is my own. It is arbitrary and I am only too aware of its defects. I have limited myself to exhibitions where the work of living artists was shown to their contemporaries, often for the first time. I have excluded one-man shows and retrospectives. I have concentrated on exhibitions of painting and sculpture. I have confined myself to Western art from roughly the middle of the nineteenth cen-tury to the outbreak of the Second World War.

A glance at the notes will show some of the books I have consulted but I should like to thank the following for their help: Alan Bowness, Duncan Grant, Michael Holroyd, Benedict Nicolson, Sir Roland Penrose and Denys Sutton. I also owe a special debt to John Curtis for his encouragement and to Vivienne Menkes for her tireless efforts at checking the manuscript and correcting my spelling. I would also like to thank Enid Gordon for being a patient editor; Frederica Lord and Susan Kritz for their invaluable assistance on the Entartete Kunst chapter; Davina Lloyd, Lucy Lindsay-Hogg and Mary MacDougall for typing and checking parts of the manuscript.

I am grateful to the following publishers for permission to quote from their works: Paul Elek Ltd to quote from Thomas Walton's translation of Zola's *L'Oeuvre*; Bruno Cassirer for Marguerite Kay's translation of Degas' letters; The Hogarth Press for extracts from *Roger Fry* by Virginia Woolf; Fackeltrager Verlag for permission to quote from *Entartete Kunst* by Franz Roh; the Regents of the University of California for extracts from *Theories of Modern Art*, edited by Herschel B. Chipp, published by the University of California Press.

Lettre sur le salon de 1866 p. R. Martial

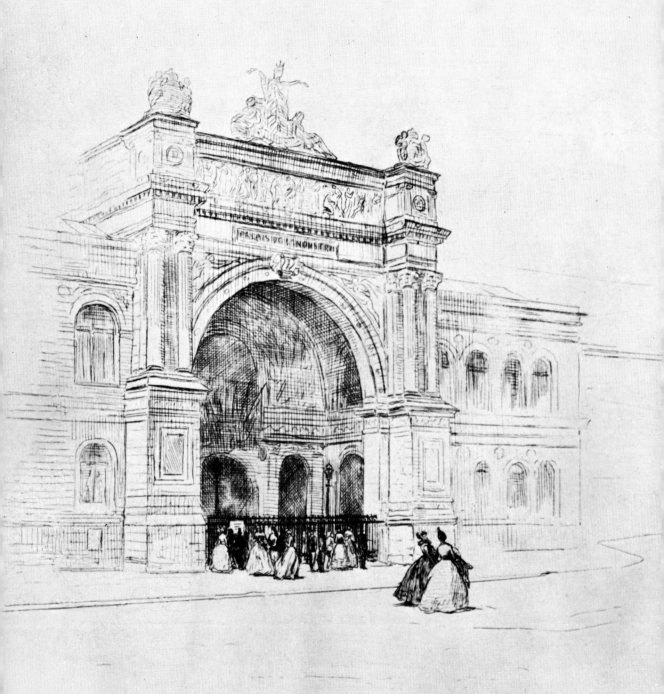

A Monsieur Gustave Henry a Commercy

Paris, 25 avri

1 The Salon des Refusés

In the nineteenth century people were passionately interested in the art of their contemporaries. New paintings and sculpture could arouse strong feelings. The most successful artists could expect to make sizeable fortunes and be rewarded with honours and distinctions normally reserved for generals and politicians. Prices for works by living artists were high and the annual or biennial exhibitions held in most capitals of Europe created a great deal of excitement.

Feelings about art were at their highest in Paris, which had come to occupy a pre-eminent position in the world of art. A number of factors had combined to bring this about. There was the political and geographical position of Paris itself, which neither the defeat of Napoleon I nor the upheavals of 1830 and 1848 had altered; there was a tradition of governmental patronage of the arts which successive regimes from the monarchs of the eighteenth century to the dictatorships of the nineteenth had maintained; and there was the existence of a highly developed educational system for training artists which survived the Revolution and continued unabated in the nineteenth century, a system that stemmed on the one hand from the École des Beaux-Arts, under the supervision of the Institute of France, and on the other from the private instruction offered by the eminent artists of the day in their studios. But all of this would have meant very little but for the presence of two artists of genius, Ingres and Delacroix. They were opposites in every way: one a Classicist, the other a Romantic; one a conservative, an upholder of tradition, the other a natural rebel; one a public servant and teacher, the other an outsider; one a believer in line, the other a proponent of colour. The sharpness of their debate undoubtedly added fire to the artistic climate of Paris; the emergence of a third voice in the 1850s, the loud plebeian voice of Courbet preaching realism, brought matters to a boil. Throw in writers of the genius of Baudelaire, add critics like Théophile Thoré and the Goncourt brothers, garnish with a propagandist of the talent of Zola, and you have the recipe that kept Paris at the centre of artistic creation.

The time to have been there was the decade from 1855 to 1865. These were the years when, as a historian has noted,[1] French painting lay between the past and the present, when one tradition, a distinguished one going back to the eighteenth century, gave way to something new. These were the years when people began to enjoy being modern and when certain concepts like that of the *avant-garde* became part of the fabric of artistic life, concepts that we are heirs to today.[2] If there is one year and one event that marks the turning-point it is 1863 and the Salon des Refusés; and if there is one artist and one painting that marks the birth of this new spirit it is Édouard Manet and the *Déjeuner sur l'herbe*.

The exterior of the Palais de l'Industrie; drawing by A.P. Martial in a letter on the Salon of 1866. The Palais was built for the International Exhibition of 1855.

Manet painted the *Déjeuner sur l'herbe* to show at the Salon of 1863. Like most artists of his day he hoped he might achieve one of those sweeping successes that was possible at the Salon and nowhere else. His teacher, Thomas Couture, had enjoyed just that success in 1847, when he exhibited his enormous and energetic masterpiece, *Romans of the Decadence*. On the strength of that one work he was declared the saviour of French painting, the only artist to find a solution to the rival demands of the Classicists and the Romantics.

The Salon was the place to win fame, recognition, prizes and commissions. When Cézanne arrived in Paris for the first time he wrote to a friend in Aix: 'I have seen the Salon. For a young heart, for a child born for art who says what he thinks, I believe that this is what is really best, because there all tastes, all styles meet and clash.'[3] The Salon, he told Zola, was a battlefield, 'the only battlefield on which an artist could reveal himself at one stroke.'[4]

The Salon attracted enormous numbers of visitors. On Sundays, when there was no entry charge, between thirty and forty thousand people went to it – that, anyway, is the figure announced by the Director of Imperial Museums, the Comte de Nieuwerkerke, in his speech at the end of the 1863 Salon. It contained between two and three thousand works of art and provided an ideal opportunity for collectors, critics and amateurs to survey the whole range of French art from history painting to the humble etching. Because the exhibition took place in alternate years, because there were no rival exhibitions and because the whole system of dealers was still in its infancy, the Salon was of immense importance in the artistic life of Paris in the nineteenth century. Some artists thought that it was too important. Ingres felt that his work had never been given its true recognition at the Salon and refused to take part in it:

> The Salon stifles and corrupts the feeling for the great, the beautiful [he said]. Artists are driven to exhibit there by the attraction of profit, the desire to get themselves noticed at any price, by the supposed good fortune of an eccentric subject that is capable of producing an effect and leading to an advantageous sale.[5]

He might have mentioned the prizes which were distributed at the Salon and which were substantial. The medal of honour was worth 4,000 francs and the next category 1,500 francs.

The Salon took place in the Palais de l'Industrie, a large building on the Champs-Élysées which had been built for the Universal Exhibition of 1855. It served a variety of purposes – mainly horse shows and exhibitions of industrial machinery – and on the whole it was a poor place to show works of art. Even a successful artist, Eugène Fromentin, complained of its lack of suitability:

> We send seven or eight thousand pictures every year to the entrance of a palace which has not been prepared for us, but which is lent us. Three thousand, at the outside, are received. This vast culling out is performed by a tri-

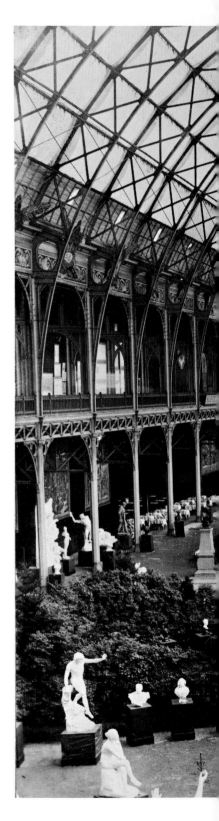

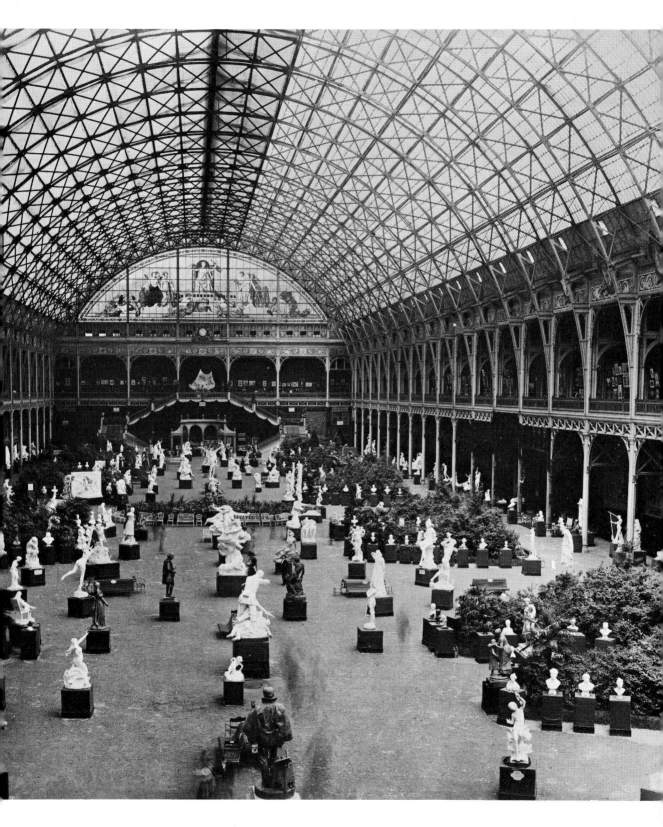

Interior of the Palais de l'Industrie. The paintings can be seen in the alcoves on the first floor of the building.

bunal we do not know, that we did not elect, which does not belong to our age; which has forgotten the ambitions, the ignorance, the intemperance, the manners and miseries of youth; which rules taste without understanding that taste may change, and which cheats the future by forgetting that it speaks in the name of the past. We are packed arbitrarily in the very poor places. The light is bad, the space too small, the surrounding odious. Bad works extinguish good ones, till the general level is lowered, and the mediocre equality of this confused conglomeration of pictures gives an impression which is enough to disgust one with painting.[6]

Some form of jury or tribunal was necessary. In 1848, when the jury had been abolished, over 5,180 artists took part in the Salon and the result, it was generally agreed, was pretty chaotic. A jury system was reintroduced in the next few years that consisted of fourteen members, the majority being drawn from the exhibiting artists and the remainder being made up of government appointees. Various methods of improving the selection of the jury were tried, none with any success. Inevitably there were complaints of unfairness and corruption, which the government, who retained responsibility for the Salon right up to 1890, could do little to put right. The difficulty was that whatever the system, power came to rest with a small perpetuating clique.

The artists who won the prizes sat on the jury that awarded the prizes.[7] Artists like Paul Baudry, William Bouguereau, Alexandre Cabanel, Jean-Léon Gérome, Jean-Jacques Henner and Ernest Meissonier retained control of the jury for Salon after Salon and were therefore able to exclude potential troublemakers like Manet. Few independents ever got a seat on the jury. Those who did, notably Corot and Charles-François Daubigny, did their best to create a more equable climate, but they were largely powerless. The regulars on the jury tended to be conservative, and at times complacent. Ernest Chesneau, for example, complained that at some sessions to select the 1863 Salon only four or five members were present.[8] But although the jury tended to support academic tradition, success at the Salon and success at the École des Beaux-Arts was not synonymous. It was possible for an artist to win acclaim at the Salon and reproof from his academic colleagues. Couture, for example, was regarded with suspicion at the École, and so were his pupils.

Popular success at the Salon was made possible by the influence of the critics. Every Salon was subject to an immense amount of publicity and criticism. All the principal newspapers – *Le Moniteur Universel*, *Le Figaro*, *Le Temps* and *Le Constitutionnel* – devoted space to it, sometimes as much as half a page. Generally the newspaper critic wrote one long introductory piece shortly after the opening of the exhibition, giving his first impression of the works on view and a broad comment on the state of French painting. Then he turned to consider the individual artists taking part, either alphabetically, which was then the order of the exhibition, or by subject matter. Ernest Chesneau, for example, writing in *Le Constitutionnel*, devoted twelve long articles to the Salon

Un tour au Salon

EXPOSITION

DES

BEAUX-ARTS DE 1863

ALBUM COMIQUE

PAR BARIC

—Je trouve, mossieu, que l'on fait trop de
nudités : qu'on en fasse, je le veux bien, mais
qu'on les habille ! ! !

PARIS

E. DENTU, LIBRAIRE-ÉDITEUR

PALAIS-ROYAL, 17 ET 19, GALERIE D'ORLÉANS.

1863

The Salon received a vast coverage in the newspapers and journals of the period. Special booklets and pamphlets were produced to amuse or instruct visitors, like the *Album Comique* by Baric.

in 1863; Théophile Gautier, who hated to leave anyone out and was one of the most conscientious critics of the day, wrote thirteen articles in *Le Moniteur Universel*; Paul de Saint-Victor, in *La Presse*, wrote eleven pieces; and Louis Leroy, writing reviews and humorous sketches in *Charivari*, had something to say about the Salon in eighteen issues. This was only a small proportion of the total output of criticism. There were reviews in the provincial and foreign newspapers, long notices in the art magazines, notably the *Gazette des Beaux-Arts*, edited by Charles Blanc, and *L'Artiste*, edited by Arsène Houssaye, literary magazines like *La Revue des Deux Mondes*, illustrated papers like *Le Monde Illustré* and the humorous journals, notably *Charivari*. Finally there were guide books, pamphlets and illustrated booklets specially produced to help the spectators on their way round the exhibition.

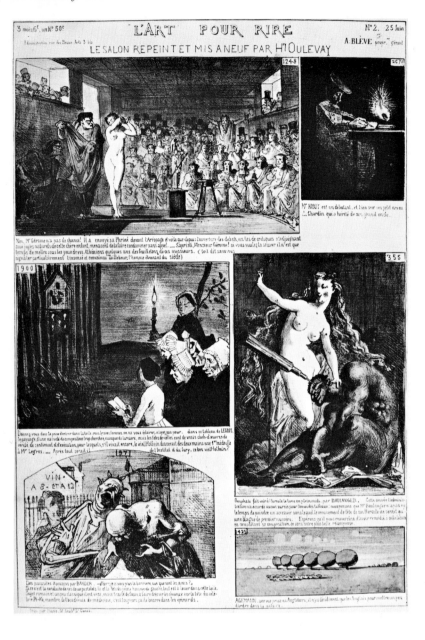

Left Another example of the illustrated journals devoted to the Salon.

Opposite, top Alexandre Cabanel, *The Birth of Venus*, Salon of 1863. The figure of the goddess was much appreciated but the Cupids were considered an unnecessary interference.
Bottom Édouard Manet, *Le Déjeuner sur l'herbe*, 1863.

Above Théophile Gautier, poet, author and the most influential art critic of the 1860s.

The leading critics were men of considerable influence. Few of them were professional art critics or art historians as we now know them. Most of them came from the world of letters and they were capable of writing about politics, literature, theatre and music. The doyen of them all was Théophile Gautier, a prolific writer, once a bohemian, who had earned his spurs in the '*Bataille d'Hernani*' wearing a red velvet doublet, a Romantic poet who in his old age had become increasingly conservative in his artistic tastes. He was a protégé of the Princesse Mathilde, cousin of Napoleon III, and his association with the Emperor's court

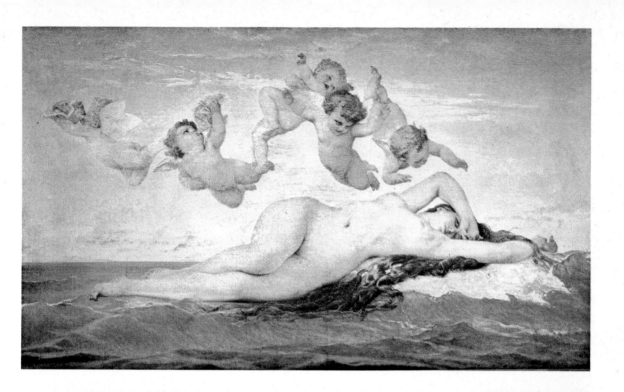

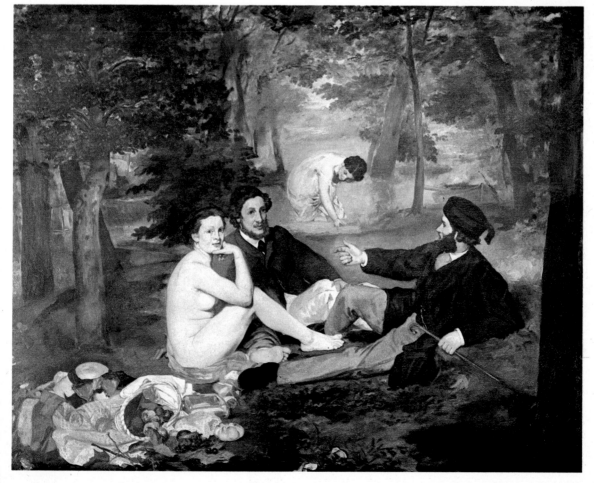

probably prevented him from winning a seat in the Institute in the elections of 1869. Next to him in influence was Paul Bins, Comte de Saint-Victor, also a conservative critic and man of letters, and also a luminary in the salons of the Second Empire. Saint-Victor became an Inspector-General of the Fine Arts and was often the government representative on the Salon jury. From the same world there was also Maxime Du Camp, Flaubert's friend and travelling companion, founder, with Gautier, of the *Revue de Paris* and author of a multi-volume history of Paris.

The other leading conservative critics were Hector de Callias, who wrote for *L'Artiste* and *Le Figaro*; Paul Mantz, critic for the *Gazette des Beaux-Arts*, a conscientious and thoughtful man who also wrote studies on Holbein and Boucher; Ernest Chesneau, who wrote for a variety of papers and took a special interest in the social background to the arts; and Arsène Houssaye. Mantz and Chesneau, like Saint-Victor, became associated with the government and held posts in the ministry responsible for the museums and art schools.

The more progressive critics of the period embraced an equally wide range of interests. Théophile Thoré started life as a lawyer and liberal politician. He took part in the revolutionary politics of the first half of the nineteenth century and in 1848 was offered the post of director of the École des Beaux-Arts. With the failure of the 1848 uprising he was forced into exile and during his travels in Belgium, Holland and England he came to have a wide knowledge of Dutch and Flemish art. He was largely responsible for the rediscovery of Vermeer. Like Baudelaire he believed that artists should draw their subjects from the world around them, and writing under the name William Bürger he supported the Realists and the Barbizon school of landscape painting. Jules-Antoine Castagnary was one of Courbet's supporters and like Thoré started life as a liberal-minded lawyer. He retained his interest in politics and eventually became President of the Municipal Council of Paris. Another supporter of the Realists was Champfleury (Jules Husson), who in his youth was a Romantic, a Socialist and a follower of the anarchist philosopher Pierre-Joseph Proudhon. He became a popular novelist and wrote a lengthy history of caricature. He later disowned the artistic enthusiasms of his youth.[9]

From these brief sketches it is possible to see the close link between art and politics that developed under Napoleon III. The government was not only in a position to reward artists it admired with commissions and prizes, it was also able to offer appointments and pensions to those critics who supported it. Inevitably there was a good deal of mutual back-scratching. The Goncourts noted that Arsène Houssaye once arranged for the Emperor to open a small art gallery at Blois so that he could sleep with an actress from the Théâtre-Français. Houssaye was rewarded with a tiepin, bearing the monogram N, which the Goncourts say he liked to wear on great occasions.[10]

The importance attached to the arts by Napoleon III is shown by his

choice of ministers to watch over the museums, art schools and Salons. The Director-General of Imperial Museums was the Comte de Nieuwerkerke – a man of magisterial bearing, as is confirmed by the drawing of him by Ingres – who helped consolidate the Louvre as a museum and who was even prepared to defend it from the attempted raids by members of the imperial household.[11] He was the former lover of Princesse Mathilde, cousin of the Emperor, and he continued to attend her salon in the 1860s. Above him was the Comte Walewski, who bore the title Minister of State, and was the natural son of Napoleon I and the Comtesse Walewska. In charge of the Musée du Luxembourg and of the Salon was the Marquis de Chennevières. Napoleon III did not necessarily support the policy of his ministers, as we shall see later, but those who questioned the way the arts were administered or who attacked the artists approved by the government were indirectly attacking the Emperor and the whole imperial system of government.

The Comte de Nieuwerkerke, Director-General of Imperial Museums.

The artists supported by dissident critics like Thoré were assumed to be of the same political outlook. In the case of Courbet the assumption was correct, but it was not always so. Millet, for example, was surprised that his work was tied with a Socialist label. In reply to the criticism raised against his *Man with a Hoe*, exhibited at the Salon of 1863, he wrote: 'All this gossip about my *Man with a Hoe* seems to me very strange, and I am grateful to you for reporting it to me. Certainly I am surprised at the ideas which people are so good as to impute to me! I wonder in what Club my critics have ever seen me?'[12] Manet's work was also thought to be subversive, although the subjects of his early Salon paintings carry no obvious political overtones. Any artist who set out to shock people – and both Millet and Manet expected to do just that at the Salon of 1863 – was bound to arouse suspicion. But they set out to shock the Salon public for very different reasons. Millet wished to draw attention to a Christian message. Manet wished merely to draw attention to himself.

Manet's thirtieth birthday was on 23 January 1862. In September his father died, leaving him moderately well off and free to do what he liked without fear of parental disapproval. He had had four years on his own, and since leaving the studio of Couture he had achieved a certain amount of success. Both his entries had been accepted for the Salon of 1861 and one of them, *The Spanish Guitar-Player*, had been mentioned by Théophile Gautier, who admired its boldness and colour. At the beginning of the exhibition the painting had been hung near the ceiling, or 'skied', but because of its popularity it was moved to a more prominent position. At the close of the Salon Manet was awarded an honourable mention.

He was an ambitious artist and he naturally looked forward to making an even greater success at the next Salon, due to take place in the spring of 1863. He was not the sort to be content to build up a reputation slowly, nor was he the sort to despise the popularity of the crowds.

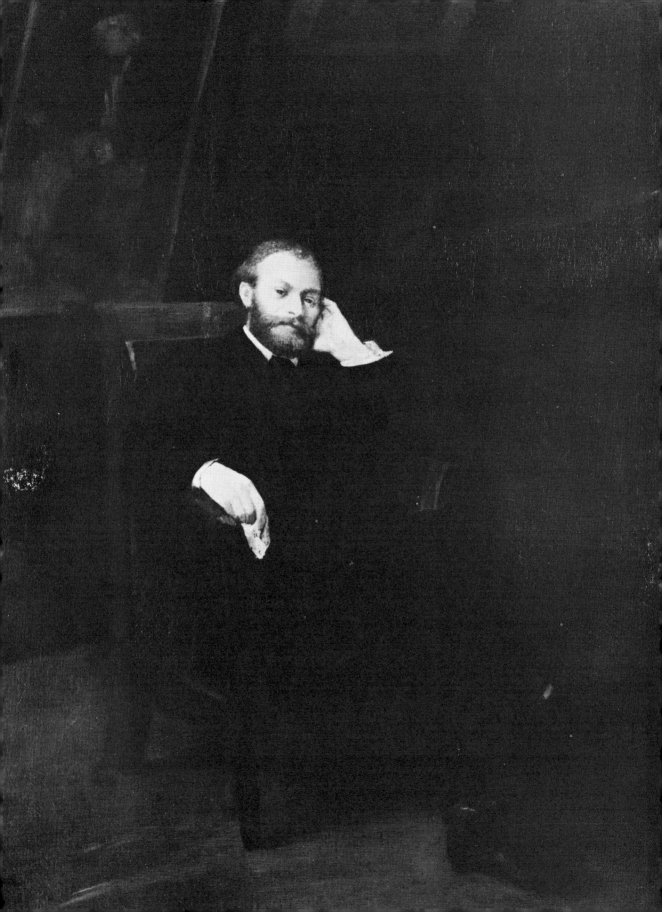

Alphonse Legros, *Portrait of Édouard Manet*. Manet's *The Spanish Guitar-Player* can be seen on the wall behind him.
Legros was one of the Realists to exhibit alongside Manet in the Salon des Refusés. He showed a *Portrait of E. M.* (Édouard Manet?).

In Paris he cut quite a dash. He dressed well and looked old for his age. He was known as a *flâneur*, one who confidently saunters down the boulevards appearing to know everybody. Manet enjoyed café life and was a regular at the Café de Bade and at Tortoni's. There he could be seen talking to like-minded men from the world of literature, music and the arts. The Brasserie des Martyrs, where Courbet ruled over a motley crowd of radicals and bohemians, was not to his taste.

In these years Manet must have seemed to his contemporaries to possess all that was necessary for success. He was young, confident and energetic. But he must also have seemed just a bit arrogant and just a bit too sure of his beliefs. He had one defect: he lacked self-criticism. He was so sure of his approach to painting that he could not understand why people should oppose it. When he came to select a subject for the Salon of 1863 he knew he would upset a few academic diehards as he had when he had been a student; he also knew he would startle the bourgeois public at the Salon; but he seems to have had no idea of the furore his work would create or that it would rebound against him.

If his friend Antonin Proust is correct, the idea for the *Déjeuner sur l'herbe* came to him while strolling along the banks of the Seine at Argenteuil. He spotted some people bathing and said to Proust: 'It seems I must do a nude. All right, I'll do one for them.'[13] The scene reminded him of Giorgione's *Concert Champêtre*, which he had copied as a student. 'It's too black, that picture,' he reflected. 'The priming's too strong. I should like to redo it and make it translucent, using models like those we see out here. I know I will be slated, but they can say what they like.'

Although these remarks were recorded with hindsight they do indicate that Manet's main concern was not with his subject but with the technique for realizing it. He conveyed his thoughts to Zola, who later wrote: 'Undoubtedly, the nude woman in the *Déjeuner sur l'herbe* is there only to provide the artist with an opportunity to paint a bit of flesh.'[14]

The academics of Manet's day needed no such excuse. They had merely to select some god or goddess, some fable or myth, and they could be sure of a favourable reception. Manet, echoing Baudelaire's views on subject matter, needed to find his subject in contemporary life and he thought he had found something like it in the scene at Argenteuil – though it is unlikely that he actually saw a naked lady and two clothed male companions. The trouble was that he pictured the scene in his mind's eye as an Old Master figure composition. He reassembled the figures to fit a previous mental image. At first it was Giorgione's painting in the Louvre, later the right half of an engraving after Raphael's drawing of the *Judgement of Paris*. Critics, from Thoré to Christian Zervos,[15] have often assumed that Manet's borrowings were a sign of weakness, of his 'compositional difficulties', but a more reasonable explanation is that they were a product of his training, which he was trying to develop along new lines.[16] In any event the 'borrowings' did contribute to the misunderstanding of his work. His large Salon

paintings of the 1860s looked like Old Masters, but not quite. They raised false hopes, and when they failed to live up to the standards of conventional figure painting they came to be regarded as jokes, elaborate *blagues*.[17]

Manet was probably too involved with the realization of his idea to be aware of any contradiction between his modern subject and traditional composition. He set about his painting in the manner taught to him in Couture's studio. For models he chose his brother Gustave, Ferdinand Leenhoff, a Dutch sculptor and brother of his mistress, Suzanne, and an unknown woman, at one time thought to be Suzanne herself. He probably worked on each figure separately, and the idea of painting his figures out of doors, so as to link the figures with the landscapes, would not have occurred to him.

Once satisfied with his sketches he turned to the large canvas.[18] He made two alterations: he enlarged the figure in the background and he asked his favourite model, Victorine Meurent, to pose for the naked bather in the foreground. Victorine was unusual-looking. She had a pale, almost sickly complexion, an expressive face, and a rather boyish slender figure, quite unlike the curvacious fleshy models then in fashion. Manet painted her in many guises, as a street singer, a matador, a courtesan.

Her virtues as a model are seen very clearly in the *Déjeuner sur l'herbe*. Her expression is lively and coquettish. She looks straight at the spectator and seems almost amused by the interest she has aroused. She certainly shows no sign of embarrassment and appears to be unaware of her nakedness or the presence of two fully dressed companions. Her skin is white, and because she is seen in profile her figure makes a sharp silhouette against the darker tones of the grass and trees on one side and the man's black coat on the other.

The sharp contrast between white and black and between one colour and another was a device that Manet had pioneered himself and that had been the subject of much discussion in Couture's studio. Academic practice, using drawing as a model, tended to play down this contrast by the use of half-tones to link the highlights and shadows and blend the edge between one colour and another. Couture recommended his students to rough out the light and dark patches of their paintings and then in the finishing stage to use over-paint to produce half-tones between the highlights and the shadows. The point of this technique was to achieve modelling, particularly in figures, but it had the disadvantage of reducing shadows to a uniform, murky brown.[19]

As a student Manet began to eliminate 'shade' from his pictures, or, in other words, to form his shadows out of colours. He avoided half-tones because, according to his fellow-student Proust, he felt that 'light appeared to the human eye with a unity such that a single tone was sufficient to render it. . . . It was preferable, crude though it may seem, to pass suddenly from light to darkness rather than accumulate features the eye does not see and which not only weaken the force of light but

attenuate the colouring of shadows, which it is important to empha-size.'[20] The unusualness of Manet's technique perplexed his teachers and other artists. Even Courbet, the arch-radical of Manet's student days, could not accept it and he compared Manet's paintings to playing cards. But the suppression of half-tones and the use of flat colour patches does to some extent explain the feeling of oddness generated by Manet's early Salon paintings. It can be felt today and must have been more noticeable in the 1860s.

Manet seems to have been an instinctive painter, able to work rapidly and decisively. George Moore and Jacques-Émile Blanche, both pain-ters by training, were deeply impressed by his facility with paint. When he started a canvas he would use the colours he saw before him. He avoided using the red-brown colour that the Academy and Couture used for under-painting, or *ébauche*. 'Although he took a lot of trouble over the pictures he sent to the Salon,' wrote Blanche, 'you would think they were sketches, so little has subsequent working since the first stage of blocking-out impaired the freshness of tone.'[21]

The week before the opening, cartoon by Honoré Daumier for *Charivari*, 1 April 1864.

Today the *Déjeuner sur l'herbe* looks as finished as an Old Master. But in the 1860s Manet's work was continually criticized for its 'sketchiness'.

For young artists like Manet with their hopes set on the forthcoming Salon the year 1863 opened ominously. On 15 January M. de Nieuwerkerke announced a number of changes in the conditions of entry to the Salon. Artists who had won first-class or second-class medals in previous Salons need no longer submit their work to the jury, but the number of entries was limited to three works each. Millet, who had won a medal in 1855, was delighted. He wrote to Alfred Sensier, his friend and biographer, that but for this measure his *Man with a Hoe* would almost certainly have been refused. Manet, who had merely won an honourable mention, felt that his chances of acceptance had been reduced. He had accumulated a number of suitable Salon paintings – mostly of Spanish subjects inspired by a recent visit of dancers from the Theatre Royal, Madrid – from which he could reasonably expect the jury to pick one or two. Other artists, besides Manet, felt that the new measures tended to favour already established artists at the expense of newcomers. A petition was started which Manet and the illustrator Gustave Doré presented to the Comte Walewski. They were received politely enough but their suggestions were ignored.

Unlike many of his colleagues, Manet had an alternative means of showing his recent work. He had been taken up by one of the few dealers of the period, Louis Martinet, and on 1 March he had his first one-man show. It contained fourteen paintings, including *Concert in the Tuileries Gardens, The Street Singer, Boy with a Sword, The Old Musician* and *Lola de Valence*, a portrait of the star of the Spanish troupe of dancers. The timing of the exhibition was such that favourable reviews might reach the Salon jury and help Manet's chances of acceptance.

If this was the plan it did not go as expected. Ernest Chesneau was guarded but he welcomed Manet's originality: 'I do not despair of seeing him triumph over ignorance to become a fine painter,' he wrote.[22] But Paul Mantz, writing in the *Gazette des Beaux-Arts*, found Manet's innovations in technique totally unacceptable and he concluded his attack by saying, 'To sum up, this art may be strong and straightforward but it is not healthy, and we feel in no way obliged to plead M. Manet's cause before the jury of the Salon.'[23] Paul de Saint-Victor was even more outspoken and declared that Manet's work reminded him of 'Goya in Mexico gone native in the heart of the pampas and smearing his canvases with crushed cochineal'.[24]

The sending-in dates for the Salon were from 20 March to 1 April. On 5 April the first news of the jury's harshness began to seep out, and on 12 April the results were known. Out of 5,000 works submitted to the jury only 2,217 had been accepted. The number of exhibitors had been cut from 1,289 in the previous Salon to 988. Manet had sent in

three canvases, the *Déjeuner, Mlle V. in the Costume of an Espada* and *Young Man in the Costume of a Majo*; all were rejected.

Because of the death of Horace Vernet there were thirteen rather than the usual fourteen members of the jury. They were Ingres, François Heim, François Picot, Victor Schnetz, Auguste Couder, J.R. Brascassat, Léon Cogniet, Joseph Robert-Fleury, Jean Alaux, Hippolyte Flandrin, Delacroix, Émile Signol and Meissonier. Ingres and Delacroix never had anything to do with the jury and, according to the 1864 catalogue, neither did Cogniet, Flandrin or Schnetz. Thus the main responsibility for choosing the Salon of 1863 fell on Signol, who had won the Premier Grand Prix de Rome for history painting in 1830, who was a staunch and bigoted upholder of the academic tradition and whose main contributions to the Salon of 1863 consisted of a scene from Tacitus, *Rhadamanthus and Zenobia*, and *The Wise and Foolish Virgins*; Picot, another history painter who taught the most successful of all the

The last day for sending-in, drawing by Gustave Doré. Cézanne used to deliver his paintings on an old wheelbarrow.

Jean Perraud, *The Childhood of Bacchus*, winner of the medal of honour at the Salon of 1863. Called by Saint-Victor 'one of the masterpieces of the modern school'.

nineteenth-century *pompiers*, Bouguereau; and Meissonier, the master of minutely detailed battle-scenes, presented with impeccable finish. The prevailing taste is revealed by the main prizewinners for 1863. The medal of honour went to Jean Perraud, winner of the Grand Prix de Rome in 1847, for a marble group, *The Childhood of Bacchus*. First-class medals went to Eugène Hillemacher for *The Emperor Napoleon I with Goethe at Wieland*, 1808; Désiré Laugée, represented by *St Louis Washing the Feet of the Poor*, and François Bonheur, one of the Bonheur family,

for his 'souvenirs' of the Pyrenees and the Basse-Bretagne – in other words for history subjects, battle-scenes and pastoral landscapes.

If Manet and a few young artists like him had been rejected alone the ensuing uproar might never have started. But the jury made the tactical error of refusing work by many regular exhibitors, including a few prizewinners. Some of the jury's decisions could be put down to caution and a desire to win governmental favour. *The Battle of Waterloo* by Louis Paternostre, for example, was turned down because it represented a defeat for the empire. But nothing but blind prejudice could explain the unnecessary harshness shown by the jury to landscape painters in general and the Barbizon school in particular. 'To reject, or concur in rejecting, as unworthy of the Salon, landscapes like those of MM. Harpignies, Lavielle, Chintreuil, Jongkind, Lansyer, Saint-Marcel, Pissarro, is most foolishly to invite the hostility of the artists and the reprisals of the critics,' wrote Castagnary.[25]

Among the more prominent names to be rejected were Jean-Paul Laurens, Adolphe-Félix Cals, Alphonse Legros, Antoine Vollon, and two contemporaries of Manet, Fantin-Latour and Whistler. Fantin-Latour could consider himself luckier than most as the jury had accepted his major figure composition, *The Lesson*, but they had turned down a self-portrait and a picture called *Fairyland*. Whistler must have expected the rejection of his single contribution, *White Girl*, as the Royal Academy had already refused the painting for the summer show in 1862.

News of the jury's harshness began to circulate on 12 April and the next few days were active ones. The angry artists considered drawing up a second petition but, realizing the pointlessness of this action, some of them turned to Louis Martinet, the one person who seemed prepared to show new original work. But all Martinet could do was to announce in his *Courrier Artistique* that painters of talent knew that they could count on his gallery for justice.

This did little to stop the complaints, which over the next few days reached such a pitch that they came to the attention of the Emperor. On the morning of 20 April Napoleon III set off to see if they were justified.[26] Accompanied by his aide-de-camp, General Leboeuf, he took his usual walk down the Champs-Élysées and stopped at the Palais de l'Industrie. There he asked to see some of the refused canvases and as luck would have it the ones he saw seemed no worse than the accepted canvases. Philippe de Chennevières, who was responsible for hanging the Salon, recalled in his memoirs the sight of the Emperor, 'cane under his arm, his hands pressed against his knees, stopping from time to time to express surprise at the severity of the jury'.[27] No doubt he was not pleased to learn that four decorative panels by Paul César Gariot, commissioned for the Empress's salon in the Palais de l'Elysée, were among the refused.

On his return to the Tuileries he sent for M. de Nieuwerkerke. An unbending man, he might have stood up to the Emperor, but he could

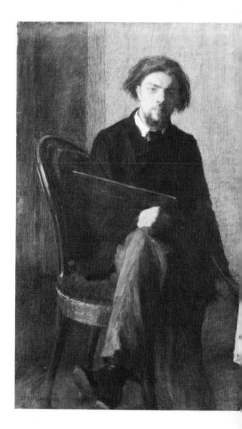

Henri Fantin-Latour,
Self-portrait, 1858.

not be found and a subordinate, M. Courmont, Chef de Division des Beaux-Arts, came instead. The Emperor informed the nervous official that the jury should meet again and reconsider the rejected canvases. The official pointed out that this would gravely injure the reputation and standing of the jury, and they might feel called upon to resign *en bloc*. The Emperor's solution was to make the public the jury. They could decide what should and what should not be exhibited. On 24 April an announcement appeared in *Le Moniteur Universel*:

> Numerous complaints have reached the Emperor on the subject of works of art which have been refused by the jury of the Exhibition. His Majesty, wishing to let the public judge the legitimacy of these complaints, has decided that the rejected works of art are to be exhibited in another part of the Palais de l'Industrie. This Exhibition will be voluntary, and artists who may not wish to participate will need only to inform the administration, which will hasten to return their works to them.[28]

On 28 April further details were given: 'An exhibition will open on 15 May.... Artists have until 7 May to withdraw their works. After this date works that have not been withdrawn will be placed on show.'[28]

The decision to set up the *Salon des Refusés* was characteristic of the man. Napoleon III was a dictator, but he liked to think of himself as a reformer and liberal. Indeed he seemed all things to all men. To the *ancien régime* he was an upstart and an impostor, to the Republicans a reactionary who ran an efficient police state, and to the Orléanists he was no better than a dangerous Socialist. In the first few years of his rule he had been forced to follow a severe and repressive policy, but by 1863, after more than ten years of peace, stability and economic improvement, there were growing pressures for reform of France's political and governmental institutions. In 1860, for example, the Emperor surprised even some of his closest ministers by his decision to allow greater freedom of debate in the Chamber of Deputies, a decision that marked the beginning of a series of parliamentary reforms. His decision to set up the Salon des Refusés must be seen as part of a general policy of liberation.

Napoleon III has often been underestimated by historians; contemporaries found him equally puzzling. Years of futile intrigues, followed by prison sentences and banishment, had the effect of making him unusually secretive and suspicious. In many respects he resembled de Gaulle. Both were soldiers who came to power in bloodless revolutions. Both were determined to restore France to stability and prosperity after years of political upheaval and democratic misrule. Both had a sense of national destiny coupled with a desire to spread French glory by whatever means seemed suitable. Both were prone to unexpected errors of judgement, which ultimately led to their downfall. But unlike de Gaulle, the Emperor was heartily disliked and never succeeded in gaining the confidence of his subjects.

The exhibition of rejected works of art was one of Napoleon's decisions that had almost the opposite of its desired effect. It put the art world into a quandary. Jules Castagnary summed up the situation:

When the Parisians first heard the news, it threw the studios into a state of frenzy. People laughed, cried and embraced each other. But the first rush of feeling gave way to doubt. In practice, what were the artists to do? To profit from the measure? To exhibit? That meant deciding, to one's detriment perhaps, the question that had been raised; it meant delivering oneself to the derision of the public, if the work is considered definitely bad; it meant testing the impartiality of the Commission and siding with the Institute not only for the present but in the future. Not to exhibit? That meant forcing oneself to admit one's lack of ability; it meant also, from another point of view, adding to the glory of the jury.[29]

Ernest Chesneau interpreted the Emperor's decision as a means of silencing the complaints of rejected artists:

We are familiar with the powerful lungs of a number of boasters without talent who are only too happy to pose as unrecognized geniuses and to shelter their well-known mediocrity behind the jealousy and the severity of the jury. These artists are in an awkward position. They are now free to exhibit. They can no longer complain that everyone is trying to stifle their immense talent. They have mocked us for too long with their insults and their ridiculous pretensions. They are now obliged to surrender themselves to the just mockery of the public. Those who withdraw are the feeble ones of the studios.[30]

It was provocative remarks like this that caused many artists to think again about exhibiting. They could hardly be blamed for wishing to avoid an inevitable confrontation, which was not of their own making, with the established order.

An English critic, Philip Hamerton, visiting Paris in order to compare French and British methods of showing contemporary art, was impressed by Napoleon III's innovation, but noted the practical disadvantages:

The Emperor's intention of allowing the rejected painters to appeal to the public has been in a great measure neutralized by the pride of the painters themselves. With a susceptibility much to be regretted, and even strongly condemned, the best of these have withdrawn their works, to the number of more than six hundred. . . . Of course the Emperor could not justly have compelled the artists to exhibit pictures *as refused*, which they had only offered for exhibition as accepted works; he therefore, with perfectly right feeling, allowed them to remove their pictures. But when it was known that artists might take away rejected pictures there was a general panic, the idea in every real artist's mind being just this, 'All other good men will take away their things, and if I don't fetch mine, I shall be left alone, surrounded by horrors.' The Emperor's delicacy, therefore, in some measure defeated its own object. But the main thought of exhibiting the refused works was full of wisdom.[31]

On the whole nearly everyone applauded the Emperor's decree, but for very different reasons. Whistler, for example, wrote to Fantin-Latour, 'It's marvellous for us, this business of the exhibition of Rejected Painters! Certainly my picture should be left there and yours too.'[32]

The Salon opened on 1 May. There were the usual number of carriages blocking the Champs-Élysées, and the usual crowds. Hamerton found much to admire in the arrangements. The French practice of combining artistic pleasures with physical comforts appealed to him, and he described the spectacle thus:

Entering there, the visitors find themselves at the foot of a magnificent staircase of white stone, on ascending which they arrive at the exhibition of pictures, which is on the upper floor, and extends the whole length of the building in an uninterrupted line of rooms with tent-like ceilings of white canvas to subdue the glare from the glass roof. There are three large halls, one in the middle, and one at each end of the building, with a double line of lower rooms between. The halls at the two ends open upon two other magnificent stone staircases, where the wearied spectator may refresh himself with brioches and babas, and Malaga or Xeres to his liking. A plan much to be recommended is to eat a baba and drink a glass of Malaga at one end, then to march steadily to the other, and repeat the dose. You then descend, at the eastern end of the building, into the garden, which occupies the whole of the immense nave, and there, under the broad glass roof, you see a great number of statues, each sufficiently isolated from the rest to admit of perfect examination. After looking at the statues, the majority of the spectators stop at the restaurant there established, and eat galantine, and drink wine and even hot coffee, and the gentlemen buy cigars, and so refresh themselves.[33]

On the whole he thought the French Salon of 1863 'presented to the world an almost ideal of all that an exhibition ought to be'. Only one detail upset him: 'The numbers are often pasted on the canvas itself instead of on the frames. Now to do this indicates absolute ignorance of the nature of a picture. The bit of colour, hidden by the label, is necessary to the effect of all the other colours, and the colour of the label itself is a hideous discord.'

Hippolyte Flandrin, *Portrait of Napoleon III*, Salon, 1863.

The central hall was as usual reserved for official pictures. It was dominated by two huge canvases by Pierre Puvis de Chavannes, *Work* and *Rest*, but the main emphasis was on portraits and battle-scenes. Hippolyte Flandrin, one of Ingres's star pupils, received widespread praise for his sober and impressive portrait of the Emperor in military uniform. Gautier, no doubt with an eye on a government pension, declared that the picture presented a perfect ideal of the modern sovereign. 'The eyes, deep and dreamy, look out beyond everyday matters and seem to distinguish the shape of the future, which is invisible to all of us.'[34] But it was not long before Gautier found himself agreeing with the Goncourt's description of Napoleon III as sinister. 'Yes, that's the word for him – sinister!' said Gautier. 'I always used to

Left The Salon Carré in 1863, *Le Monde Illustré*, 27 June 1863. A room reserved for official pictures, battle scenes and portraits. Two large paintings by Puvis de Chavannes can be seen on the far wall. Flandrin's portrait of Napoleon III is in the centre of the left-hand wall.

Above P. Puvis de Chavannes, *Work*, Salon, 1863.

Left Cham's cartoon reads: 'Cyclops afraid of showing their faces . . .'

Paul Protais, *The Morning Before the Attack*, Salon, 1863. One of a pair of paintings bought by the Emperor for twenty thousand francs.

think he looked like a circus artiste who'd been fired for drunkenness.'[35] Two imaginary battle scenes by Paul Protais, *The Morning Before the Attack* and *The Evening After the Battle*, both bought by the Emperor, were also singled out for praise.

The remaining rooms were hung in the alphabetical order invented by M. de Chennevières, which was intended to remove favouritism but added to the confused appearance of the Salon.

Soon after the opening the critics gave their first impressions of the new Salon. As might have been expected they were far from unanimous. On 5 May Ernest Chesneau wrote in *Le Constitutionnel*, 'This year's *Salon* is one of the best we have seen for a long time. The severity of the jury has provided us with a pleasant surprise. . . . Reduced numerically to three-quarters of what it was two years ago, it has gained in value what it has lost in extent. If the next Salon is reduced by a good third more, that is to say if we are shown no more than fifteen hundred or two thousand works, there is every reason to believe that it will be excellent.'[36]

M. Delécluze, the venerable critic for *Débats*, felt, however, that of the thirty-one Salons he had attended this was the worst, and Saint-Victor, in *La Presse*, thought the general impression created by the Salon was 'mediocre and confused, dominated as always by an average display of manual dexterity confined to paltry genre scenes'.[37] He particularly disliked the increasing number of narrative pictures, which

seemed to him to belittle the glorious history of Greece and Rome, or the century of Louis XIV.

Paul Mantz, writing in the *Gazette des Beaux-Arts*, was able to give a more measured summing-up:

The Salon presents nothing unforeseen, nothing lively, nothing excessive. . . . The time of adventure has passed. Our walk round the Salon was like a journey across great plains of beauty, which are dear to economists because they produce good corn but which tire the onlooker because there is scarcely a hillock or a valley to break up the eternal horizontality.[38]

However, if the critics disagreed in their generalizations they did show some unanimity in their admiration for two Venuses submitted by the Salon favourites, Baudry and Cabanel. They had a hard time deciding which was the better picture. 'We give the prize, as the public does, to that of M. Cabanel,' wrote Saint-Victor. 'It is a morsel from the gods and the first picture of the Salon. One cannot praise too highly the virgin purity of the neck, the simplicity of the stomach, the supply undulating turn of her hip, the pallor of her thighs, the delicate formation of her feet right down to her bent toe, to her curled fingers, as they are often done by Correggio. The canvas is spoilt by the cupids, and one wishes they could be sent back to the next-door café where they came from.'[39] Mantz followed much the same line of criticism, but Hamerton was almost overcome by the picture's scarcely concealed eroticism:

She lies in full light on a soft couch of clear sea-water, that heaves under her with gleams of tender azure and pale emerald, wherein her long hair half mingles, as if it were a little rippling stream of golden water losing itself in the azure deep. The form is wildly voluptuous, the utmost extremities participating in a kind of rhythmical, musical motion. The soft sleepy eyes just opened to the light are beaming with latent passion; and there is a half childish, half womanly waywardness in the playful tossing of the white arms.[40]

Hector de Callias showed himself no less apt at daydreaming in front of Paul Baudry's nude, which was called *The Pearl and the Wave, a Persian Fable*:

Nobody is taken in by this innocent artifice, nobody has opened Hafiz or Firdusi; and yet everybody has praised this Venus, who lying in the sand of the seashore, showing us her back, turns to give us a feminine wink. The mother-of-pearl sheen of the skin plays with the opal reflections of the scattered shells, but there is blood beneath this skin. Speak to her and she will reply, 'Keep quiet.'

We can sense the breath of her pink mouth, and if the frame were not made in such a way that it prevents her from rising, one would be afraid of seeing her run away. But she will not run away: she rolls voluptuously on her soft bed heated by the rays of the morning. She has slept all night long, and she is not annoyed to see you; you will be helping her to get up.

I know many people ask where the goddess is in this, but in the absence of a Phydias, I am pleased to come across a Praxiteles, who has made me see a beautiful woman. Indeed, is a beautiful woman not a goddess?[41]

Confronted by Baudry's vulgar and eye-catching nude, de Callias and other critics turn into caricature Frenchmen, and they might almost have added an '*oh-la-la!*' or a '*zut alors!*' to their reviews. Louis Leroy, in one of his sketches for *Charivari*, made fun of the critics' lascivious prose and to his credit Castagnary refrained from joining in the chorus of approval for these pictures. Baudry's goddess seemed to him no more than 'a bedroom Venus', and he added: 'How much more at ease that pretty women with the air of a Parisian milliner would be on a sofa! She, who lived so comfortably in her rich flat off the Chaussée-d'Antin, must feel rather ill at ease on the hard rock next to those scratchy pebbles and prickly shells.'[42]

Castagnary, the defender of Courbet and Realism, was well aware that the public would always prefer nudes that lulled the senses and provoked pleasant daydreams to the harsh reality depicted by the painters he admired. Pictures that threatened to disturb people's peace of mind were automatically the target of the critic's venom. Poor, sincere, hard-working Millet came in for a terrible lambasting for his

Jean-François Millet, *Man with the Hoe*, Salon, 1863. 'I see ... the stony place where a man has been toiling and panting since morning, and now tries to straighten up for a short breather. The action is shrouded in splendours.' (Millet).

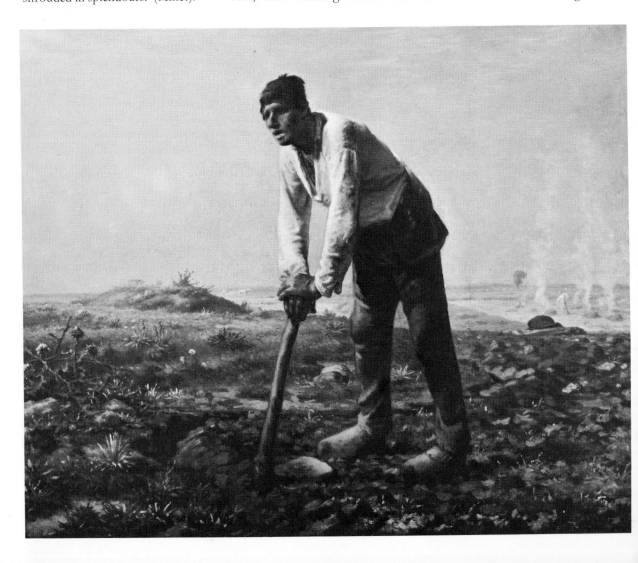

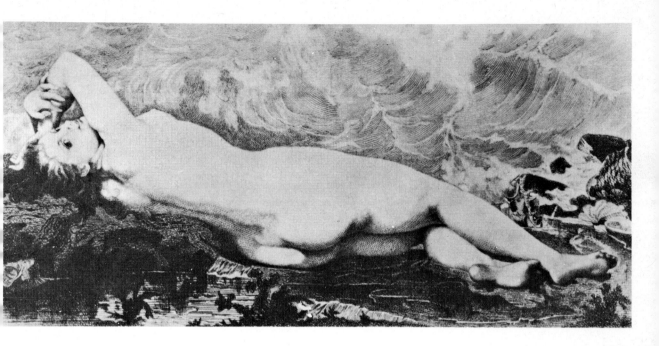

Above P. Baudry, *The Pearl and the Wave*, an engraving after the painting exhibited at the Salon of 1863.

Left Cham's version of the *Man with the Hoe* reads: 'A wretched peasant digs everywhere with his hoe, hoping to find the other half of his head which M. Millet has hidden somewhere.'

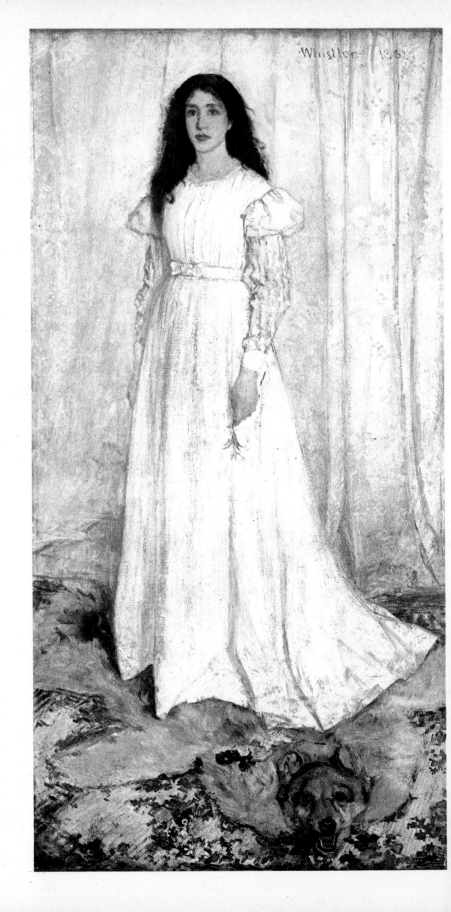

picture *Man with a Hoe*. The peasant was mockingly called Dumoulard after someone who had murdered his employer's family. Saint-Victor was at his most sarcastic when he came to consider the painting. He made the familiar accusation that artists like Millet copied ignoble models, and added:

M. Millet lights his lantern and sets out to look for an idiot; he has looked hard and for a long time before finding this peasant resting on his hoe. Similar types are not common, even at the Hôpital Bicêtre. Imagine a monster without a skull, with one blind eye, and an idiotic expression, planted in the middle of a field, like a scarecrow. . . . Has he just finished working or has he just killed someone? Is he sweating a living from the earth, or is he scooping out a grave?[43]

The interpretations of his painting surprised Millet and the tone of his letter to Sensier is one of injured innocence:

Is it then impossible simply to accept the ideas that come into one's mind at the sight of the man who 'eats bread by the sweat of his brow'? There are people who say that I see no charms in this country. I see much more than charms – infinite splendours. I see, as well as they do, the little flowers of which Christ said: 'I say unto you, that even Solomon in all his glory was not arrayed like one of these.'[44]

Courbet's name was enough to drive most critics into a state of apoplexy. His main contribution, *The Return from the Conference*, which showed a group of drunken clerics, was turned down on moral grounds, but he was represented by *The Fox Hunt*, a reprise of his previous Salon success, *Stags Fighting*; he also sent in a sculpture, which caused the cartoonist Cham to depict a bourgeois couple fleeing from the galleries crying, 'One is not safe, even among the sculptures. M. Courbet has insinuated himself even there.'

The Fox Hunt produced the usual chorus of complaints. 'It would be cruel to speak of paintings by M. Courbet,' wrote Saint-Victor. 'Artistic childishness disarms, like physical childishness. How can a painter whose technical ability to handle brush and palette even his most fierce adversaries cannot deny produce punishable caricatures signed with his name? It only goes to show that realism attacks the hand, after perverting taste and paralysing the imagination.'[45] 'What a downfall,' cried the painter Alfred Stevens, under the pseudonym of J. Graham in the *Figaro*.

Hamerton, accustomed to hunting scenes by Landseer, was at a loss to explain the picture. He wrote:

James Whistler, *The White Girl*, 1862. The picture became the success of the Salon des Refusés. The French critics reversed some of the harsh things said against the picture when it had been exhibited in London.

And the picture of fox-hunting! A stupid-looking gentleman on a wooden red horse, stock still, with a fox under its nose that two dogs are worrying, whilst a fellow on foot boldly approaches to finish the poor thing with a hay-fork – and all this cruelty for the amusement of that one idiot on the horse, who is contemplating it in a cool and satisfied manner! The picture is a disgusting one, but may have been intended for a satire.[46]

Cham's cartoon of Courbet's *The Fox Hunt*. The caption reads: 'An inconsolable fox dies after being run down by a bow-legged horse.'

To many critics Cabanel and Courbet represented the heights and depths of the Salon, but the most popular pictures were those that told a story. Jean-Léon Gérôme's painting of Louis XIV and Molière was much admired for its fine detail and psychological insight. It depicted the famous story of the King inviting the playwright to eat with him, much to the consternation and disapproval of his courtiers. Visitors to the Salon admired the King's face, which beamed with malicious pleasure at the sensation he had created, the look of expectation on the faces of his courtiers, and in the background the figure of a bishop in violet vestments, apparently trembling with anger and scorn. Cardinal pictures in general were popular and the three paintings by the German artist Ferdinand Heilbuth were widely admired. So too were Pierre-Charles Comte's pictures of Charles V at Fontainebleau presenting a diamond to the Duchesse d'Étampes and another work showing Louis XI amusing himself by watching rats. This last-mentioned picture showed the King 'eager for his amusement in a mean, timid, but interesting manner', surrounded by his courtiers, who appear either excited or disdainful, and the inevitable jolly monk who is much amused by the sport.

Eastern subjects were then much in fashion and there were several French artists who painted nothing else. Among the chief examples at the Salon were an Arab bivouac by Eugène Fromentin, three views of Cairo by Léon Belly and some Sahara scenes by Gustave Guillaumet.

The art of landscape painting was one of the issues that created the most controversy at the Salon of 1863, as it had in previous years. It was the landscape painters, for example, who had suffered the most from the severity of the jury. It is difficult to account for this severity without over-simplification. It is not true to say, for example, that the academics were opposed to landscape painting. They thought it inferior to history painting because it provided fewer opportunities for the artist to show his erudition and skill, but as early as 1791 there had been moves to include it in the curriculum,[47] and a Prix de Rome for historic landscape was established in 1817.[48] The respectability of this art stretched back to the founding of the Academy in the days of Poussin and Claude. But, while the academics tended to foster historic landscapes with figures and an edifying title drawn from classical authors, they did allow room for a less formal approach to the art, and the sketch from nature was recognized as part of the process of painting that culminated in the finished studio picture. At the same time they encouraged spontaneity and freshness and these qualities were allowed to be retained in the finished work. The main area of dispute between official teaching and current practice was one of degree: the degree of sketchiness, the degree of informality. Perversely, academic teaching encouraged 'imagination', though this did not mean spontaneity so much as the imaginative reassembling of nature in the studio. Too faithful a study of a particular landscape was regarded as a branch of topography rather than of art.

Eugène Fromentin, *Hunting with Falcons*, Salon of 1863. Eastern subjects were always popular at the Salon.

At the Salon landscape painting tended to divide the critics, in much the same way as Realism did. Conservatives like Saint-Victor preferred historic landscapes to rustic scenes, Italian subjects to northern ones, finish to sketchiness, contrasting tonality to over-all brightness. The more progressive critics took an opposite line. Several of them had the advantage of having studied the landscape schools of northern countries. Thoré and Fromentin, for example, were keen admirers of the Dutch masters of the seventeenth century, and there were still many advocates for the English school, particularly the work of Constable. Between 1830 and 1855 French artists led by Théodore Rousseau had adapted these outside influences to French subjects. The Barbizon school had been founded, and by the 1860s it was beginning to be enormously popular with collectors inside and beyond France. Rosa

Bonheur, for example, who combined Barbizon landscape with reassuring scenes of country life, had already become popular abroad. She had no work to show at the Salon of 1863 and Thoré remarked that Mlle Bonheur, 'like Joan of Arc, had been surrendered to the English'.[49]

By the 1860s Théodore Rousseau had won the recognition of the more enlightened critics. Fromentin came to regard him as the intermediary between the Dutch and the French schools[50] and Thoré called him in his review 'the greatest landscape painter of our day, whom posterity will rank on the level of the great landscape painters of the seventeenth century'.[51]

There were many who would have said the same of Corot. He too had survived the attacks of the academics and the critics to win a position of esteem. He was the only landscape painter to be elected to the jury of 1864, but for many he was still a controversial artist. The poetry of his Salon landscapes – so different from the small sketches admired today – appealed to people either enormously or not at all; he was also thought to be a bad influence on the young.

Charles François Daubigny had his admirers but he was not thought to be the chief French landscape painter, as Hamerton declared in his review. He had a popular following and was in some respects an innovator. He was, for instance, among the very few artists whose Salon

Charles-François Daubigny, *Grape Harvest in Burgundy*, 1863. Daubigny was among the first of the French landscape painters to exhibit work done in the open air. As early as 1865 one critic referred to him as chief of the school of the impression.

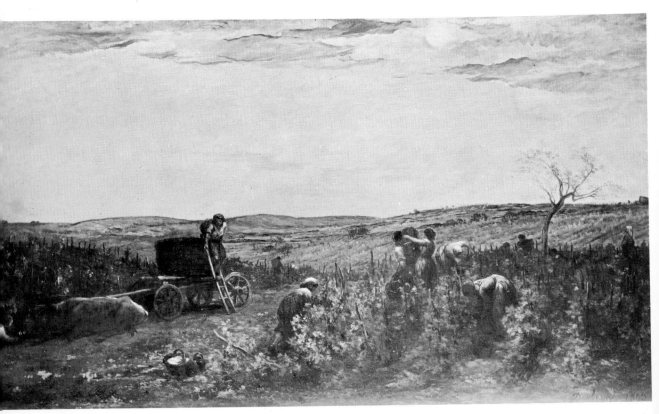

work was executed in the open. He often worked from a specially constructed boat with a small cabin which he kept on the river Oise. He was frequently attacked by the critics for his sketchiness and as far as the Salon was concerned he was only just on the border of acceptability. In 1863 several painters who worked in a similar vein, notably J.B. Jongkind and to a lesser extent Henri Harpignies, found themselves on the wrong side of the dividing line, among the refused. Harpignies, for example, had one work accepted and the rest refused. It was the jury's inconsistency as much as anything else that led to the Salon des Refusés.

Preparations for the Salon des Refusés continued during the first two weeks of the official Salon. The artists taking part formed a committee to look after their interests. It consisted of Antoine Chintreuil, the two Desbrosses, Félix Dupuis, Frédéric Juncker, Charles Lapostelet, Louis-Charles Levé and Jules Pelletier. The administration, headed by M. de Chennevières, would have little to do with them, but they were able to assemble a catalogue for what they called the 'counter-exhibition'. It was printed by Pillet Fils at the expense of the Marquis de Laqueville and it consisted of sixty-eight pages and a supplement, bringing the total number of pages to eighty.[52] It cost 75 centimes. The catalogue mentions 781 items but there must have been more entries than this in the final exhibition. The committee felt it necessary to add a note expressing its deep disappointment in the number of artists who had withdrawn their work from exhibition. 'Their abstention is all the more regrettable in that it deprives the public and the critics of many works that would have been of great value, both as a reply to the idea that inspired this counter-exhibition, and as a full explanation of this test, possibly a unique test, that is being offered to us.'[53]

When the catalogue appeared the printers of the official catalogue, MM. Charles de Morgues, hired bailiffs to prevent it from being sold inside the building.

Those in charge of hanging the exhibition were not in a position to treat the refused artists with such open hostility. The rooms were inferior to the official Salon but they were prepared in much the same way, with drapes, backcloths and curtains. Louis Leroy wrote in *Charivari*: 'The rooms are good, well lit, and the works of the pariahs of the Salon can be examined in the best possible conditions.' In arranging the rooms de Chennevières did not follow his normal alphabetical system, perhaps because he did not have a complete list of names to work with, but scrupulously followed the order in which the works had been left in the building. He made no attempt to sort the good from the bad, or the landscapes from the portraits, and as a result the exhibition looked even more of a jumble than it need have. Some really grotesque canvases ended up in the best positions, and some commentators naturally thought the administration had deliberately drawn attention to the worst work in order to embarrass the Emperor and vindicate the jury.

Catalogue of the Salon des Refusés.

A page of cartoons from *Charivari*, 1864. The Salon des Refusés was repeated in a modified form in 1864.

Hamerton thought this was the case:

It always happens, in every country, that there are many persons quite ignorant of the rudiments of drawing and painting, but who nevertheless boldly send things which have nothing to do with art, to public exhibitions of pictures. These curious objects are perfect god-sends to jurymen anxious to justify their proceedings in the public eye, and they naturally make the utmost use of them. On entering the present exhibition of refused pictures, every spectator is immediately compelled, whether he will or no, to abandon all hope of getting into that serious state of mind which is necessary to a fair comparison of works of art. That threshold once past, the gravest visitors burst into peals of laughter.[54]

Hamerton's solution to the problem was to suggest that the 'queer ones' should be 'united in a great hall of merry laughter, whither all persons of a lugubrious or melancholy temperament might resort for the benefit of their health'.

Among the paintings to cause the most laughter was a large picture of horses in a meadow. The horses were nearly lifesize and apparently

42

painted in bright blues, mauves and pinks. The picture may have been no. 57, *Studies of Horses; ten types* by Vincent Brivet.[55] If it was it made a lasting impression. Zola mentions it in *L'Oeuvre* and two critics writing about the first Impressionist exhibition over ten years later in 1874 mention it as an example of Impressionist colouring gone haywire (see page 78).

Unfortunately for the more serious artists in the Salon des Refusés the exhibition was full of such oddities. Many of the subjects belonged properly to the official Salon and must have been turned down simply because they were badly executed. The catalogue mentions battle scenes (*General Bonaparte Accompanied by his Escort on the Morning of the Battle* by Auguste Andrieux); scenes of domestic tenderness (*Care and Anxiety* by Mlle Amélie Léonie Fayolle); portraits (M. Dambry, 'inventor of the *"capsule dite tire-feu"* adopted by the artillery in 1847 and commissioned for the museum at Soissons'); religious pictures (*Sainte Juliette* by Mlle Clara Filleul); theatre scenes, mainly drawn from Shakespeare and Faust; history paintings (*Cincinnatus Being Called from the Fields to Become Consul*); numerous cow-and-sheep pictures; still-lifes and landscapes.

But although the standard was low there were artists of proven ability. There were several winners of Salon medals (third class) – Jongkind, for example, Paul-César Gariot and Charles Gratia – and pupils of famous teachers like Marc-Gabriel-Charles Gleyre, Corot, Daubigny and even a member of the jury, Léon Cogniet. In addition there were several really talented artists: landscape painters like Étienne-Prosper Berne-Bellecour, François Blin, Étienne Cartier, Jean-Charles Cazin, Antoine Chintreuil, Louis-Amable Crapelet, Léopold Desbrosses, Henri Harpignies, Lapostelet, Jongkind and Pissarro; flower-painters like Frédérick Juncker; painters of rural and domestic life like Cals, Gustave Collin, Jean Desbrosses, Paul-César Gariot, Armand Gautier; portraitists and realists like Fantin-Latour, the Ottin brothers, Antoine Vollon, and a future teacher at the Slade school in London, Alphonse Legros; engravers like Bracquemond and Gautier; sculptors like Henri-Edmond Cross.

With the works in place all was set for the opening on 15 May. There was immense curiosity to see what the exhibition was like and in the first few hours about seven thousand people passed through the turnstiles. The excitement of the opening is conveyed in the newspaper reports. The account in *La Presse* on 17 May read:

A compact crowd, moved by many diverse feelings, poured into the rooms of the rejected artists. In the last resort everybody is keen to judge for themselves the conduct of the jury. Groups of sympathizers and scoffers form in front of the canvases which are then declared good or in need of an irresistible dose of laughter. . . . The success of the exhibition seems to be a 'girl in white' by a young American, M. Whistler. It is a painting of distinction of an altogether mysterious character. It was immediately bought by a talented writer.[56]

Over the next few days the crowds visiting the exhibition increased and some observers thought that more people were going into the rooms marked '*Expositions des ouvrages non admis*' ('Exhibitions of rejected work') than into the official Salon. The Salon favourites were undoubtedly concerned and resented the attention given to the *refusés*. Louis Leroy in *Charivari* based one of his comic sketches on the attempts jury members, appropriately disguised, made to prevent people going to the rival exhibition, and the caricaturist Cham drew a cartoon with a dejected artist saying: 'My painting has been accepted, but nobody looks at it', to which his companion replies: 'Mine is with the refused and there is a crush to see it.'

Among those trying to see the exhibition were Cézanne and Zola. Cézanne was on his second visit to Paris, having at last won permission from his father to study art. Zola was still a struggling writer, and had not yet turned his atention to art criticism. It was probably Cézanne who encouraged him to go to the exhibition and in his notes he recorded the painter's enthusiasm: 'The Salon des Refusés. Great discussions with me.'[57] A full and vivid description of the exhibition appears in his novel *L'Oeuvre*, and although written in 1885 (the preliminary draft was probably drawn up in 1869), it nevertheless captures better than many contemporary accounts the excitement and atmosphere of the Salon des Refusés.[58] In chapter five Claude, who is based on Cézanne, is depicted arriving at the exhibition with his friend Sandoz, who is Zola:

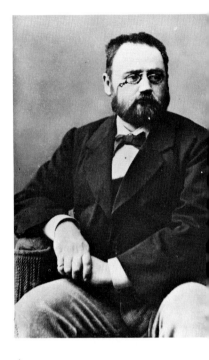

Émile Zola. Zola went to the Salon des Refusés with Cézanne. It made a significant impression on both of them.

> It looked very much like the official Salon, with the same gold frames, the same patches of colour for the pictures. But what was not immediately obvious was the predominant liveliness of the atmosphere, the feeling of youth and brightness. The crowd, already dense, was growing every minute, for visitors were flocking away from the official Salon, goaded by curiosity, eager to judge the judges, convinced from the outset that they were going to enjoy themselves and see some extremely amusing things.

The confused impression created by the exhibition, the jumble of styles and subjects, is conveyed in a later passage:

> On every side the walls were covered with a mixture of the excellent and the execrable, in every possible style; last-ditchers of the 'historical' school cheek by jowl with youthful fanatics of Realism, colourless mediocrity with blatant originality, a 'Jezebel Dead' that looked as if she had mouldered away in the cellars of the Beaux-Arts hung next to a 'Woman in White', a curious vision, but seen by the eye of a great artist; opposite an immense 'Shepherd contemplating the Sea (Fable)', a tiny picture of Spaniards playing *pelota*, a marvel of intensity in lighting. The execrable was very fully represented; nothing was left out, neither military subjects complete with toy soldiers, wishy-washy Classical subjects nor Medieval subjects heavily scored with bitumen. Superficially, it was an incoherent jumble, but there was truth and sincerity enough about the landscapes and sufficient points of technical interest in most of the portraits to give it a healthy atmosphere of youthful passion and vigour. There may have been fewer frankly bad pictures in the

official Salon, but the general level of interest and attainment was certainly lower. Here there was a scent of battle in the air, a spirited battle fought with zest at crack of dawn, when the bugles sound and you face the foe convinced you will defeat him by nightfall.

Zola was particularly struck by the laughter of the crowds. He noticed women trying to stifle their merriment behind handkerchiefs; he watched the men give way to great roars of laughter; and he observed the contagious hilarity of the crowd, 'gradually working itself up to the point where it would laugh loudly at nothing and just as convulsed by beautiful things as by ugly ones'. Zola was also struck by the silliness of people's remarks: everybody seemed to be trying to outdo each other with their comments and wisecracks. All his descriptive powers were brought to bear on the scene before Manet's *Déjeuner sur l'herbe*. With increasing anger Claude finally fights his way to the room in which it hangs:

As soon as they reached the doorway, he saw visitors' faces expand with anticipated mirth, their eyes narrow, their mouths broaden into a grin, and from every side came tempestuous puffings and blowings from fat men, rusty, grating whimperings from thin ones, and, dominating all the rest, high-pitched fluty giggles from the women. A group of young men on the opposite side of the room were writhing as if their ribs were being tickled. One woman had collapsed on to a bench, her knees pressed tightly together, gasping, struggling to regain her breath behind her handkerchief. The rumour that there was a funny picture to be seen must have spread rapidly, for people came stampeding from every other room in the exhibition and gangs of sightseers, afraid of missing something, came pushing their way in, shouting 'Where?' – 'Over there!' – 'Oh, I say! Did you ever?' And shafts of wit fell thicker here than anywhere else. It was the subject that was the main target for witticisms. Nobody understood it; everyone thought it 'mad' and 'killingly funny'. 'There, do you see, the lady's too hot, but the gentleman's wearing his jacket, afraid of catching a cold.' – 'No, that's not it! She's green, can't you see! Must have been in the water some time when he pulled her out. That's why he's holding his nose.' – 'Pity he painted the man back to front, makes him look so rude, somehow!'

Zola's description of the scene before Manet's *Déjeuner* was not exaggerated. He had the opportunity to observe the crowd's reactions for himself and later he had the advantage of talking to Manet about it. Why did this painting create such a commotion and why did it take so long for the public to accept it? Why, even after Manet's death, was it so difficult to get the French nation to buy it?

Manet's answer would probably have revolved round the technical innovations he had used in painting it. My own answer would be the element of parody in the picture. But undoubtedly the main reason at the time it was first shown was its subject matter: the doubtful morality conveyed by the scene of a naked woman and two fully dressed gentlemen. Napoleon III, who had a stream of mistresses himself, is said to have stared at it and turned away in disgust. Of course most people

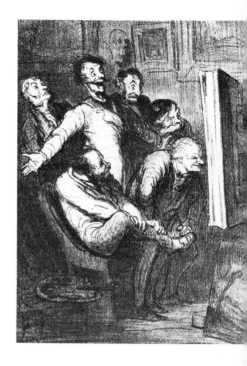

H. Daumier, *A Group Admiring a Painting*. Zola was struck by the reactions of the crowd to Manet's *Déjeuner*. 'There was always a grinning group in front of it', he wrote.

knew that such scenes took place, but in private, behind red velvet curtains, upstairs in the *salon privé* of certain restaurants, not in public and certainly not in the open air where anyone might see them. The picture exposed the sexual hypocrisy of the times and it proved, as Hamerton noted, that 'the nude, when painted by vulgar men, is inevitably indecent'.[59]

Louis Étienne in his pamphlet *Le Jury et les exposants* puts the charge bluntly:

A commonplace woman of the *demi-monde*, as naked as can be, shamelessly lolls between two dandies dressed to the nines. These latter look like school-boys on a holiday, perpetrating an outrage to play the man, and I search in vain for the meaning of this unbecoming riddle. . . . This is a young man's practical joke, a shameful open sore not worth exhibiting in this way.[60]

Hamerton agreed:

I ought not to omit a remarkable picture of the realist school, a translation of a thought of Giorgione into modern French. Giorgione had conceived the happy idea of a *fête champêtre*, in which, although the gentlemen were dressed, the ladies were not, but the doubtful morality of the picture is pardoned for the sake of its fine colour. . . . Now some wretched Frenchman has translated this into modern French realism, on a much larger scale, and with the horrible modern French costume instead of the graceful old Venetian one. Yes, there they are, under the trees, the principal lady, entirely undressed, sitting calmly in the well-known attitude of Giorgione's Venetian woman, another female in a chemise coming out of a little stream that runs hard by, and two Frenchmen in wide-awakes sitting on the very green grass with a stupid look of bliss. . . . Cabanel's Venus, though wanton and lascivious, is not in the least indecent; neither is Paul Baudry's beautiful girl on the seabeach – but these pictures *are*.[61]

'*The Bath* is very daring,' admitted Thoré. 'Unfortunately, the nude hasn't a good figure and one can't think of anything uglier than the man stretched out next to her, who hasn't even thought of taking off, out of doors, his horrid padded cap. It is the contrast of a creature so inappropriate in a pastoral scene with this undraped bather that is so shocking.'[62]

Castagnary, however, was one of the few to attack the picture on the grounds of Manet's technique:

There has been a lot of excitement about this young man. Let us be serious. The *Bath*, the *Majo*, the *Espada* are good sketches, I will grant you. There is a certain verve in the colours, a certain freedom of touch which is in no way commonplace. But then what? Is this drawing? Is this painting? Manet thinks himself resolute and powerful. He is only hard. And the amazing thing is that he is as soft as he is hard. That's because he is uncertain about some things and leaves them to chance. Not one detail has attained its exact and final form. I see garments without feeling the anatomical structure that supports them and explains their movements. I see boneless fingers and heads without skulls. I see side-whiskers made of two strips of black cloth that could have been glued to the cheeks. What else do I see? The artist's lack of conviction and sincerity.[63]

Édouard Manet, *Mlle V. in the Costume of an Espada*, 1862.

46

Many writers, whether for or against Manet, believed he had deliberately set out to shock people. Thoré, for example, wrote that his three paintings in the Salon des Refusés were 'a provocation to the public, which is dazzled by the too vivid colour'. Zacharie Astruc, a friend and supporter of Manet, recognized this quality when he wrote, 'He pleases or displeases at once; he quickly charms, attracts or repels. His individuality is so powerful that it eludes technical considerations. Technique is effaced in favour of the full metaphysical and tangible value of the work.'[64] And a *Bourgeois de Paris*, believed by some to be none other than Delacroix himself, wrote to the *Gazette de France*: 'M. Manet has those *qualities* that would make him be rejected with unanimity by all the juries of the world. His harsh colouring hits one in the eye like a steel saw; his figures stand out as if punched out by a cutting-machine, with a crudity which no compromise softens. He has the sharpness of green fruit that will never ripen.'[65]

Harsh words. By contrast, Whistler emerged almost triumphant from the Salon des Refusés, reversing some of the severe things said about his work in London. His *White Girl* was generally considered the success of the exhibition.

The painting was executed in Paris, in a studio on the Boulevard des Batignolles, just before Whistler left to take up residence in London. The model for the picture was Joanna Heffernan, a young Irish girl whom Whistler had picked up in Paris. She had striking looks, a white face, big eyes and a mass of red hair, and Courbet was later to use her as the model in *La Belle Irlandaise*. In Whistler's painting she stands in a white room dressed in white and stares out at the spectator as if she were in a trance. She is painted in that rather loose, thin style that led the critic of the *Daily Telegraph* to write in 1861, 'If Mr. Whistler would leave off using mud and clay on his palette and paint cleanly, like a gentleman, we should be happy to bestow any amount of praise on him.'[66]

The *White Girl* was first shown in London in 1862 in a mixed exhibition at the Berners Street Gallery, having been refused by the Royal Academy. The critic of the *Athenaeum* agreed that it was the most prominent picture in the exhibition but, '... able as this bizarre production shows Mr. Whistler to be, we are certain that in a very few years he will recognize the reasonableness of its rejection. It is one of the most incomplete paintings we have ever met with.'[67]

The critic mistakenly thought the painting was inspired by a recent novel by Wilkie Collins and Whistler wrote the first of many letters to the press: 'I had no intention of illustrating Mr. Wilkie Collins' novel; it so happens, indeed, that I have never read it. My painting simply represents a girl dressed in white, standing in front of a white curtain.'[68]

The French critics, discounting Whistler's matter-of-fact interpretation of his picture, were impressed by its mysteriousness and some, like Castagnary, did not hesitate to give their solution:

Édouard Manet, *Young Man in the Costume of a Majo*, 1862. This, and the portrait on the previous page, were two of Manet's contributions to the Salon des Refusés. Castagnary disliked Manet's work and wrote: 'I see whiskers made of two strips of black cloth that could have been glued to the cheeks'.

I have proposed an interpretation of the *White Woman* which has had no success except with me, so true is it that one is loath to grant painters ideas. 'What have you wanted to do?' I asked the strange painter whose fantastic etchings I alone had previously admired. 'A *tour de force* of your craft as a painter, consisting of dashing off whites on whites? Permit me not to believe it. Let me see in your work something loftier, *The Bride's Tomorrow*, the troubling moment when the young woman questions herself and is so astonished at no longer recognizing in herself the virginity of the night before.'[69]

Paul Mantz, who had scarcely a good word to say for any other work in the Salon des Refusés, wrote: 'Whence comes this white apparition? What does she want of us, with her unravelled hair, her enormous eyes drowned in ecstasy, her languid attitude, and this flower without petals

in the fingers of her fallen hand? Nobody is able to say: the truth would detract from the strange charm of M. Whistler's work: for us the *White Woman* is the most important piece of the Salon of heretics.'[70]

Mantz argued that the faults of the picture – he mentions the head and the blue in the carpet – were mitigated by the strong personal quality of the work seen as a whole, and he found nothing disturbing in the basic white tone of the picture. Oudry, he pointed out, had done something very similar in one of his still-lifes. Interestingly, Mantz is the first to use the word 'symphony' in connection with Whistler's pictures, a term which the artist was to use constantly in the titles of his subsequent work.

Although the crowds pouring into the Salon des Refusés hardly gave the landscapes in the exhibition a second glance, nevertheless one or two painters could feel that their work had been vindicated. Jongkind, for example, a gloomy nervous man, wrote on 6 June to his new friend Eugène Boudin, whose work was in the official Salon:

I work all the time. My canvases are among the refused and I am having some success. I have seen your canvas and it is well enough placed and is very good.

For the rest I suffer all the time, and it is necessary to find some time and rest in order to recuperate; I hope for the best.[71]

Louis Leroy, in one of his rare serious moments in *Charivari*, wrote:

The rejection of the three landscapes by M. Jongkind is a gross blunder by the jury, patently obvious to everyone.

These gentlemen are the only ones who are unaware of the fact that this artist, a colourist from the family of Bonington, is much appreciated by enlightened art-lovers; and the three rejected canvases, above all the study of the moon with a windmill in the background, cannot but add to the painter's reputation.[72]

Harpignies, Chintreuil and Blin all had favourable reviews, and Castagnary wrote about Pissarro, 'I take it that he is a young man. Corot seems to be a favourite with him. A good master, *monsieur*, but one on no account to be imitated.'[73]

Johann Barthold Jongkind, *The Ruins of the Château de Rosemont*, 1861. Jongkind was one of the few artists to benefit from the publicity given to the Salon des Refusés.

In terms of attendance the Salon des Refusés was an enormous success; it also led to temporary reforms in the selection of the jury and the running of the Salon; it was followed by further reforms in the administration of the École des Beaux-Arts; and it helped draw attention to the work of some artists who might otherwise have been overlooked. But in terms of justifying Manet's work and of creating a new atmosphere for the appreciation of new painting it was a disaster. Manet was never again able to exhibit at the Salon without causing controversy. The prejudices he aroused with the *Déjeuner sur l'herbe*, prejudices that were reinforced by *Olympia* and his other Salon contributions of the 1860s, were paraded with monotonous and heart-rending regularity every time he showed his work in public.

Antoine Chintreuil, *Landscape*.

New art in general was done a disservice by the exhibition. The experiment made the administration all the more determined not to repeat their mistakes. Their view is expressed in Nieuwerkerke's reply to Cézanne's request for a new Salon des Refusés in 1866; 'What he asks is impossible; it has been recognized how unsuitable the exhibition of the rejected was for the dignity of art, and it will not be re-established.'[74]

Critics close to the administration had shown a similar attitude in 1863. Gautier and Saint-Victor were too conscious of their own dignity to write about it. Less contemptuous critics had to admit that the standard of the exhibition was low. 'Before the Salon des Refusés,' wrote Castagnary, 'we could not imagine what a bad painting was. Today, we know. We have seen it, witnessed and confirmed.' Maxime Du Camp wrote, 'The exhibition is at times sad and grotesque. It proves superabundantly what one knew already, that the jury shows an incontestable indulgence.' Even Édouard Lockroy in Martinet's jour-

nal, *Le Courrier Artistique*, a magazine that might have supported the *avant-garde*, confessed, 'The Salon des Refusés will certainly be a triumph for the jury.' The overwhelming laughter of the public seemed only to prove the jury's point. But one or two critics stopped to think. Charles Monsolet wrote to the *Figaro*, under the name Monsieur de Cupidon, that one went to the exhibition in order to laugh but one left, 'serious, anxious and troubled'. Thoré was one of the few critics to try and analyze the cause of the laughter and to weigh up its significance. With almost uncanny prescience he wrote:

A naive foreigner who visited the Salon of the Reproved, thinking himself in the official exhibition, would doubtless believe that the French school is moving, with apparent unity, toward the reproduction of men and nature, such as they are seen, without a preconceived idea, without a fixed style, without tradition, and also without personal inspiration. . . . The people who are starting out have, in their barbarity, a certain touch of sincerity, and, at the same time, a bit of burlesque and imperfection. Novelty and singularity.[75]

Thoré noted two tendencies: a new subject-matter based on present-day life, avoiding mythology and the history painting found in the official galleries, and a new style of painting that seemed to him less concerned with line and finish but more and more directed at rendering the 'effect in its striking unity'. He approved of both innovations.

It is obvious that the sketches of Corot are worth more than the highly finished miniatures of M. Gérôme, the portrait of a worker in his smock is certainly worth as much a the portrait of a prince in his golden costume. The customs of those who act and produce, who think, who love, who fight, and who suffer in the humble station are as interesting as the customs of use-less, wicked people, whose lustre is merely the result of a borrowed station in life.

But the young artists in the Salon des Refusés are not in Thoré's opinion ready for the task they have taken on:

These precursors of the possible transfiguration of an old, exhausted art are, up to this point, for the most part, only inept or even grotesque. Thus they arouse the hearty laughter of the gentlemen who are well trained in sound principles. But should a few artists of genius, endowed with love of beauty and distinction, come to the same subjects with the same methods, then the revolution would be prompt. The public would be astonished at the confident admiration accorded to the nonsense that today triumphs in the official Salon, in the boudoirs, and even in the wealthy galleries.

Even while these words were being written, a few artists of genius – Monet, Renoir, Bazille, Degas and Cézanne – were gathering in Paris and preparing the next assault against tradition. Manet had failed in his attempt to win popular approval through the Salon, and the Salon des Refusés had failed to provide a new climate for the appreciation of *avant-garde* art. But, as Thoré and others were dimly aware, the exhibition was the first crack in the academic wall. The year 1863 marks a turning-point in the history of French art.

2 The First Impressionist Exhibition

Claude Monet, *Impression –
Sunrise*, 1872.

Claude Monet, *Wild Poppies*, 1873.
'Daub three-quarters of a canvas
with black and white, rub the
remaining space with red and
yellow, sprinkle a few red and blue
spots, and you have an *impression*
of spring which will send the
fans into ecstasy.'
(Cardon in *La Presse*)

Around 1866 Manet began to use the Café Guerbois at 11 grande rue
des Batignolles, now the avenue de Clichy. His studio was nearby and
the café was large, comfortable and a convenient place to meet his
friends. There he held court, as Courbet had done ten years before at
the Brasserie des Martyrs. Round him collected some of the most
brilliant, certainly the most argumentative, young writers and painters
in Paris. The writers included Zacharie Astruc, poet, sculptor and
Manet's defender at the Salon des Refusés, Zola, who took up Manet's
cause in 1866, Duranty, a former companion of Courbet, a novelist of
the Realist school and now a firm Manet supporter, and Théodore
Duret, his future biographer and historian of the Impressionists. The
other regulars included Commandant Lejosne, owner of the oil sketch
for the *Déjeuner sur l'herbe*, Degas, Frédéric Bazille and two engravers,
Marcellin Desboutin and Félix Bracquemond; the latter had been a
fellow exhibitor with Manet at the Salon des Refusés.

According to Duret, 'Manet was the dominating figure; with his
animation, his flashing wit, his sound judgment on matters of art, he
gave the tone to the discussions.'[1] But as far as wit was concerned
Degas was more than a match for him, though his judgements on art
were quirky and idiosyncratic. 'They were on good terms,' Renoir
told Vollard. 'Beneath Manet's somewhat "boulevard" manners, Degas
found a man of good education and of good middle-class principles
like his own. But as with all great friendships, theirs was not without
frequent quarrels and reconciliations.'[2] One such dispute resulted in
Degas returning a Manet still-life with a curt note: 'Sir, I'm sending
back your plums.'[3]

From 1868 onwards artists of a very different social background to
Manet's and Degas's, and with very different artistic interests, began
to drop in at the Café Guerbois. They were Monet, Renoir and Sisley,
all friends of Bazille since their student days at Gleyre's studio. Camille
Pissarro, who was ten years older than any of them but shared many of
their views on landscape painting, also became a visitor. Cézanne, an
old friend of Zola and a recent one of Pissarro, made occasional forays
into the café, where he would sit sullenly listening to the ceaseless
conversation. Sometimes the talk would irritate him to such an extent
that he would utter a loud '*merde*!' and leave.

The conversation was always animated, often too animated. A row
between Manet and Duranty led to a duel in which the two inexperi-
enced swordsmen attacked each other with such ferocity that when
they were separated their swords were found to have turned into a pair
of corkscrews.[4] But despite these events Monet looked back on his
days at the Café Guerbois with affection. 'Nothing could be more

Right Edgar Degas, *Portrait of Manet*. Degas and Manet had much in common but their relationship was often troubled by fierce quarrels and frequent reconciliations.

Below Degas, drypoint by Marcellin Desboutin.

Paul Cézanne, *Self-portrait*, 1873–6. The first 'wild man' of modern art.

interesting than these animated *causeries* with their perpetual clash of opinions,' he told an interviewer. 'They kept our wits sharpened, they encouraged us with stores of enthusiasm that for weeks and weeks kept us up, until the final shaping of the idea was accomplished. From them we emerged tempered more keenly, with a firmer will, with our thoughts clearer and more distinct.'[5]

A brilliant reconstruction of the Café Guerbois and its personalities has been provided by John Rewald in his history of Impressionism and there is very little to add.[6] But in summary, the *dramatis personae* can be described as follows: Manet, the leader, bruised but not battered by the attacks on his work, still possessing the courteous manners and distinctive appearance of a man of the world, still searching for popular recognition; Degas, a brilliant technician, now engaged on an ambitious programme to depict the contemporary world around him, a mordant wit and rather patrician in his political views; Pissarro, kindly, always prepared to help his friends, a socialist in the anarchist tradition of Proudhon, his saintliness reinforced by a beard of biblical proportions; Monet, determined, independent, plagued by financial worries but resolute in his convictions; Bazille, tall, generous, thoughtful; Renoir, nervous and good-natured; Sisley, silent; Cézanne, a smouldering volcano, reserved, broody, terrified of women and all forms of physical contact.

A stranger observing them from a distance might well not have realized they were painters. On the whole they looked respectable and well-dressed, Manet exceptionally so. Even the poorer artists among them managed to keep up appearances. Renoir, for example, might

Henri Fantin-Latour, *A Studio in the Batignolles Quarter*, 1870. From left to right: Scholderer, Manet, Renoir (wearing his favourite hat), Astruc, Zola, Maître, Bazille (hands behind his back), Monet. The picture was dubbed *Jesus Painting among the Disciples* or the *Divine School of Manet*.

pass for a well-off undergraduate in Bazille's portrait of 1867. In Fantin-Latour's *A Studio in the Batignolles Quarter* he wears a neat Inverness cape and a smart-looking hat; a similar hat can be seen in his self-portrait of 1876, a sign perhaps of his frugality and his sartorial taste. Sisley, who was often as badly off as Renoir, also owned some decent-looking clothes, and in Renoir's portrait of him and his wife, dated 1868, he wears an elegant morning coat and holds a top hat and white gloves in his right hand. The Impressionists seem to have been conscious of their appearance even in their student days and avoided the colourful attire of the bohemians. In Renoir's painting of 1866, *At the Inn of Mother Anthony, Marlotte*, his friends have a neat, well-scrubbed look, in marked contrast to the caricature of a scruffy individual on the wall behind, the figure being Henri Murger, author of *La Vie de Bohème*.[7] Fantin-Latour's portrait of Manet and his group in his studio is the picture of respectability. Even allowing for the formal character of the painting the group could be mistaken for doctors attending an anatomy lesson.

However, they were not all well-dressed. Pissarro seems to have preferred loose peasant-type wear and Cézanne almost deliberately cultivated an unkempt appearance. Cézanne was out to shock people and seems to have used his filthy dress, matched by equally foul language, as a way of avoiding contact with people. One evening at the Café Guerbois he followed the usual French practice of shaking hands with his friends, but when he came to Manet he said, 'I'm not offering you my hand, Monsieur Manet. I haven't washed for eight days.'[8] Interestingly Cézanne and Pissarro were the only two at that time who consistently preferred living in the country to living in the town, and peasant clothes to town ones. Also, neither of them appear in Fantin-Latour's painting or in Bazille's painting of his studio and friends.

If their clothes did not proclaim their calling, the conversation at the Café Guerbois certainly did. According to Duret it nearly always revolved round painting: in part theoretical – the rights and wrongs of painting in the open air – and in part technical – the advantages of broken colour, the right way to paint shadows, the use of drawing and such matters.[9] Hardly one of the group agreed with another; all had their own ideas about painting and how it should be done, and they were apt to cling to them dogmatically. No two painters could be more unalike than Degas and Monet, for example; one worked from memory in his studio, the other worked directly from nature; one was deeply versed in the Old Masters, the other largely ignored them; one an upholder of tradition, the other a natural socialist; one a master of line and drawing, the other a master of colour. They were as far apart as Ingres and Delacroix had been twenty years before. The others at the Café Guerbois expressed equally divergent views. Manet, for example, had little respect for landscape painting in general, and *pleinairisme* in particular. He was eventually won round to Impressionist practices by Monet. Even so he thought very little of Renoir's ability and in

Pierre-Auguste Renoir, *Alfred Sisley and his Wife*, 1868. The clothes worn by the Impressionists give little indication of their calling or their financial difficulties and hardships.

1874 said to Monet: 'That poor boy has no talent at all. Do tell your friend to please give up painting.'[10] Manet did not escape criticism himself. Degas thought he lacked originality and was unable to paint a picture without thinking of someone else's work. Cézanne had started as an admirer and had been deeply affected by the *Déjeuner sur l'herbe* and *Olympia*, but in his conversations with Vollard he implies that Manet lacked the true temperament of a great artist.[11] With the exception of Pissarro and to some extent Renoir, none of the group liked Cézanne's work. Pissarro, in fact, was the only one who consistently supported the work of his colleague.

With so much to drive them apart, with so many differences in art, politics and social background, it is a wonder that they ever met, or that they managed to stay in contact with each other for so long. But they did have interests in common. They all shared a common dislike of authority and the way the Salon was selected and run; they had a common dislike of the *pompiers*, notably Bouguereau, a common dislike of history painting and all forms of artiness and pretension; they also had a common respect for subjects drawn from contemporary life, and from nature as it is rather than as it ought to be; they all believed that freshness and spontaneity were qualities to be kept in the finished work even at the risk of its looking sketchy; they all believed in natural colour unmodified by half-tones. But perhaps the topic that found them at their most united was the desirability of showing work and attracting collectors and critics. 'One must be able . . . to exhibit what one has done,' declared Manet. 'Without that, the artist would be all too easily shut up in a circle from which there is no exit. He would be forced either to stack his canvases or to roll them up in a hayloft.'[12]

These words were part of a statement issued by Manet to accompany the one-man show he had arranged and financed for himself in 1867. The show was his solution to the problem of exhibiting his work. Manet felt he was being victimized for the scandal created by his *Olympia* in 1865. The jury seemed determined to exclude his work; all three of his entries to the Salon of 1866 had been rejected and to forestall the same thing happening in 1867, the year of the World Fair in Paris, he had decided to follow the example of Courbet, who had faced a similar problem at the World Fair of 1855 and who had staged his own one-man show.

Monet hoped that by bypassing the jury and appealing straight to the public his work would win acceptance. 'It happens,' he wrote, 'that after looking at something you become used to what was surprising or, if you wish, shocking. Little by little you understand and accept it.'[13] He was at pains to point out that his exhibition was not meant to be a political gesture, simply a means for showing his work. Unfortunately for Manet his exhibition was poorly attended and received very little attention. Disappointed, he decided that there was no alternative to the Salon and that the only answer was to go on sending in.

Younger artists who had not been through his trials thought the

answer might lie in the new Salon des Refusés. Cézanne, egged on by Zola, tried to get the idea accepted in 1866. Nieuwerkerke's reply has been given in the previous chapter. In 1867 there were further attempts but most of the artists realized that it was a forlorn hope. In May 1867 Bazille wrote to his parents about his own disappointments and the feeling of his fellow-artists. It is worth quoting at length as it reveals the first mention of a group exhibition:

I have bad news to tell you: my paintings were refused for the exhibition. Don't be too upset about this; there is nothing discouraging about it; on the contrary, my works share this fate with everything that was good in the Salon this year. A petition is being signed at this moment demanding an exhibition of the *Refusés*. This petition is being supported by all the painters of Paris who are of any value. However, it won't get anywhere. In any case, the annoyance I experienced this year won't happen again, for I will no longer send anything to the jury. It's much too ridiculous, when one knows one isn't a fool, to be exposed to these administrative whims, above all, when one doesn't care at all about medals and distributions of prizes. As for what I am telling you, a dozen talented young people think the same way as I do about it. We have therefore resolved to rent a big studio each year where we will show as many of our works as we want. We will invite the painters whom we like to send paintings. Courbet, Corot, Diaz, Daubigny, and many others with whom perhaps you aren't familiar have promised to send up paintings and highly approve of our idea. With the latter, and Monet who is stronger than all of us, we are sure to succeed.[14]

Bazille's plan foundered for lack of financial support.[15] Once again the artists were driven back to the Salon. In 1868 they were nearly all successful. Manet showed his portrait of Zola; Renoir showed his large figure composition, *Lise*; Pissarro had two views of Pontoise accepted; Monet and Sisley had landscapes accepted; Bazille showed a second version of *The Artist's Family on a Terrace* and Degas a portrait. In the following year Monet and Sisley were the only ones to have their work completely rejected; and in 1870, the last Salon of the Second Empire, Monet alone was rejected.

In these years Cézanne was the one person never to have shown anything at the Salon. He regularly sent work in, often delivering it on an old cart. He seems to have given up all hope of being accepted and went through the process of rejection almost as a form of ritual. Once, when asked what he was going to show at the Salon he replied: 'A pot of shit.' His friends realized that his cause was hopeless. In 1868 his friend Marion reported on his progress to a mutual acquaintance:

Cézanne has no chance of showing his work in officially sanctioned exhibitions for a long time to come. His name is already too well known, too many revolutionary ideas in art are connected with it; the painters on the jury will not weaken for an instant. I admire Paul's persistence and nerve. He writes: 'Well! They'll be blasted in eternity with even greater persistence.' Nevertheless he ought to think up some different and still more effective method of publicity.[16]

The outbreak of the Franco-Prussian War on 18 July 1870 put an end to the discussions. Cézanne left for Provence and to escape the draft took residence in L'Estaque; Zola also fled. Manet stayed in Paris, joined the National Guard and found himself serving under Meissonier. Degas, Renoir and Bazille enlisted; Bazille was killed on 28 November. Pissarro, Monet, and later Sisley, went to England. The defeat of the French forces and the fall of Napoleon III were followed by a much worse human tragedy, the Commune of 1871 and the appalling loss of life that resulted from its collapse on 28 May.

During these turbulent months the group were able to see little of each other. Only Manet went on going to the Café Guerbois. It was his only resource, he told his wife, 'and that is getting pretty monotonous'.[17] By the end of 1871 things had begun to get back to normal and most of the group had returned to Paris. But in 1872 they seem to

Claude Monet, *The Bridge at Argenteuil*, 1874. At Argenteuil Monet rented a little house close to the river. Renoir was a frequent visitor and the two artists often painted the same views. Their work there marks the beginning of a new direction in Impressionist painting.

have tired of the city and again they went off in separate directions. Manet went to Holland; Degas left France to visit his brother in New Orleans; Monet made a second visit to Holland and then settled at Argenteuil, a small town on the Seine on the outskirts of Paris. This became a great Impressionist centre and Monet's move there marks the beginning of a new direction in Impressionist painting. The group's work became freer, their colour more vibrant, and their brush-strokes were broken into smaller dots and dashes. Monet and Renoir often painted side by side. Sisley was also a frequent visitor. Nearby, Pissarro and Cézanne had taken up residence at Pontoise, and they too worked closely together, sharing the same motif; Cézanne went so far as to make a copy of a Pissarro landscape.[18]

For a brief period the fortunes of the Impressionists improved. During their time in London Monet and Pissarro had met the dealer Paul Durand-Ruel. He specialized mainly in the Barbizon painters but he now turned his attention to the new generation of landscape painters and began to buy Monet's and Pissarro's work, and later that of Sisley and Renoir. The average price of a landscape at that time was between two and three hundred francs, but in the next few months Pissarro's prices began to rise and at an auction in 1873 one of his works fetched 950 francs. Pissarro felt confident enough to write to Duret on 2 February: 'You are right, my friend, we are beginning to find a niche for ourselves; we are still strongly opposed by certain masters, but we must expect differences of opinion when intruders like ourselves have succeeded in hoisting our little banner in the midst of the crowd.'[19] Manet, too, began to benefit from the new climate. Durand-Ruel called at his studio and bought twenty-three canvases for thirty-five thousand francs, including the *Spanish Guitar-Player*, which Gautier had liked, and *Mlle V. in the Costume of an Espada* for three thousand francs each; he later resold them to the singer Jean-Baptiste Faure for four thousand francs each.[20]

With Durand-Ruel in the market the Café Guerbois group had less need to show their work at the Salon. In 1872, for example, Degas, Pissarro, Monet and Sisley seem not to have sent in any recent work. The Salon of 1873 does not seem to have attracted their attention either. Manet, however, went on regularly sending in, and Renoir continued out of force of habit. In 1873 Manet at last gained the success he had been looking for. His *Bon Bock*, a portrait of the engraver Belot sitting at the Café Guerbois, was widely acclaimed. It was with some justice that the critic Armand Silvestre, who often went to the Café Guerbois, wrote: 'Manet still belongs in the field of discussion, but no longer of bewilderment.'[21] He was no longer the *enfant terrible* of French painting, and from then on the initiative to reform the institutions for showing art passed to the younger painters in his circle. It was Monet, for example, who in the second half of 1873 proposed the idea of a group exhibition, paid for by the artists taking part and held as an alternative to the official Salon. The idea had first been suggested by Bazille in the

Alfred Sisley, *Landscape at Louveciennes*, 1872.

Édouard Manet, *Portrait of Théodore Duret*, 1868. Duret pleaded with Pissarro not to take part in any independent group exhibition.

letter quoted above. It had failed then because of lack of funds. Now, with prices for their work improving, Monet and his friends felt that they were at last in a position to act on their own. Pissarro, true to his syndicalist views, welcomed the idea of a group exhibition and told his friend Théodore Duret about the plan. Duret was horrified. He was already rather suspicious of Monet and had once advised Pissarro, 'Don't think of Monet and Sisley, don't pay any attention to what they are doing. Go your own way, on your path of rural nature.'[22] Now he thought Pissarro was making a tactical error. On 15 February 1874 he wrote to explain his views. The letter has been quoted elsewhere, but it is too important to be left out. It went:

There still remains one step for you to take, that is to begin to be known by the public and to be accepted by all the dealers and art lovers. For this there are only the auctions at the Hôtel Drouot and the big exhibition at the Palais de l'Industrie. You now possess a group of admirers and collectors with whom you are established and by whom you are supported. Your name is known by artists, critics and by a special public. But you must take one more step and become widely known. You won't get anywhere with exhibitions put on by special groups. The public does not go to these exhibitions. There will only be the same nucleus of artists and admirers that know you already.

The Hoschedé sale did you more good and advanced you further than all the special exhibitions imaginable. It brought you before a large mixed public. I strongly urge you to follow that up by exhibiting this year at the Salon. Your name is now known and they won't refuse you. Besides you can send in three canvases, and of the three they are bound to accept one or two.

At the exhibition you will be seen – among the forty thousand people who, I imagine, visit the show – by fifty dealers, art lovers, critics who would never look for you and find you anywhere else. If you only achieve that, that would be sufficient. But you'll achieve more, because you are now in the limelight among a group which are talked about and which, despite some reservations, are beginning to be accepted.

I urge you to choose some canvases where there is a subject, something resembling a composition, pictures which are not too freshly painted. . . .

I urge you to exhibit; you must succeed in making a noise, in defying and attracting criticism, coming face to face with the public at large. You can begin to do all that only at the Palais de l'Industrie.[23]

Duret was not the only one to advise against the exhibition. Manet spoke vehemently against it, and according to Monet treated those in favour as 'faint-hearts'.[24] The doors of the Salon were still there to be broken down. With the help of his *Bon Bock* he had succeeded in getting a wedge in, and he turned to Monet, Renoir and his protégée and future sister-in-law, Berthe Morisot, and entreated them to remain loyal. 'Why don't you remain with me?' he said. 'You can see very well I am on the right track.'[25]

The idea had gone too far for it to be abandoned. Monet, Renoir and Pissarro stuck to their plan. Besides there was an additional reason to hold the exhibition. The boom that had allowed Durand-Ruel to buy their work came to an end in 1873. It had been helped by the rapid

inflation that followed the Franco-Prussian War. Early in 1874 the French economy crashed and remained depressed for the next six years. Monet and his friends were largely unaware of the effect that this would have on the market for their paintings, but they felt the first signs of it when Durand-Ruel, in 1874, gave up buying their work.[26] They needed other alternatives and a group exhibition seemed one solution to their problems.

Rather surprisingly the idea of an exhibition appealed to Degas. Since he never experienced the difficulty of the others in getting work accepted by the Salon, and since he was against most collective enterprises he might have been expected to oppose the idea. But instead he supported it and he thought Manet silly not to join in. From his letters to Bracquemond and James Tissot it is clear that his motives were artistic ones. 'The realist movement ... must show itself as something distinct,' he wrote to Tissot, 'there must be a salon of realists.'[27] The official Salon did not appeal to him, and unlike Manet he cared little for either official or popular success. Like his hero, Ingres, he looked down on the Salon as a vulgar arena which encouraged artists to show off, and since he knew he possessed all the skills of the Salon favourites, and a good deal more besides, he had no reason to envy their company.

Berthe Morisot is another artist who might have been expected to be against an independent exhibition. Like Degas she had little difficulty in gaining admission to the official Salon and had been a regular exhibitor since 1864. Her career as an artist had brought her into contact with almost the complete range of art in the Second Empire. She had started as a pupil of Joseph Guichard, who in turn was a pupil of Ingres. As a student she had been attracted to the work of Millet and the Barbizon school. Then she came under the influence of Corot, who had a lasting effect on her style. Corot, a confirmed bachelor, broke his monastic routine and used to dine with her family every Monday. Later she got to know Daubigny and Honoré Daumier. The history painter Puvis de Chavannes fell in love with her and pursued her endlessly. Degas made up to her, while at the same time venting his misogynist views. Fantin-Latour introduced her to the Realists and later to Manet. Manet painted her portrait on several occasions and asked her to sit for his large Salon painting of 1869, *The Balcony*. Manet impressed her enormously and she did her best to encourage him through his Salon disappointments. But although he, ungallantly, took up another young painter, Éva Gonzalès, she remained loyal to him and finally married his brother, Eugène.

Berthe's mother was deeply suspicious of her artist friends and seems to have had little confidence in her talents as a painter. 'When a few artists compliment her, it goes to her head,' she once wrote to Berthe's sister, Edma. 'Are they really sincere? Puvis has told her that her work has such subtlety and distinction that it makes others miserable, and that he was returning home disgusted with himself. Frankly, is it as

Édouard Manet, *Berthe Morisot with a Muff*, 1868–9.

good as all that? Would anyone give even twenty francs for these ravishing things?'[28] When Berthe's mother got to hear that her daughter had given up the Salon in order to take part in an exhibition of Salon failures she was naturally alarmed and sent for Berthe's old teacher, Guichard. Guichard's report is given later (see page 80).

Degas was particularly keen to see artists like Berthe Morisot take part in the exhibition. It was important, he felt, to include successful Salon artists. Otherwise the exhibition would look like a new Salon des Refusés. Also he was frightened that an exhibition limited to a small dissident group would seem like a political act of defiance. After the Commune, and Courbet's activities, such acts were liable to be misconstrued in the new, more reactionary political climate. Some of the group seemed to be proposing dangerous socialist ideas. Pissarro, for example, was a staunch syndicalist and, according to Renoir's friend and biographer, Georges Rivière, he suggested that the artists taking part

in the independent exhibition should adopt the rule book of a society
of bakery workers he had once met at a union meeting.[29] Renoir, who
hated all rules and regulations, objected and persuaded the others to
reject Pissarro's plan. He was also in favour of taking up Degas's sug-
gestion that the group should invite outsiders to take part. His reason
was simple: it would reduce the amount each artist would have to
contribute to the general pool. Some of the others thought that such
a plan would destroy the character of the exhibition, but Degas won
the day and they all set about inviting their friends. Monet, for example,
persuaded his old friend and teacher Eugène Boudin to take part;
Pissarro invited the friends he had worked with at Pontoise, Armand
Guillaumin, Édouard Béliard and Cézanne, the latter being accepted
by the others with great reluctance; and Degas invited his friends
Tissot, then a resident in London, Stanislas-Henri Rouart, who had
been at school with him and had served in the same regiment during the
Franco-Prussian War, Joseph de Nittis, a success at the Salon, and two
long-standing acquaintances, Ludovic-Napoléon Lepic and Stanislas
Lépine. For a man who is generally supposed to have been cantanker-
ous and aloof, Degas behaved with remarkable diplomacy throughout
the negotiations to get them to join the exhibition. He also did his best
to calm the engraver Bracquemond, who had been invited by the writer
Philippe Burty. His letters show that the project filled him with en-
thusiasm and he worked as hard as anyone to make the exhibition a
success. To Bracquemond he wrote:

To begin with we are opening on the 15th. So we must hurry. The things
have to be handed in by the 6th or 7th or even a little later but in time to
have the catalogue ready for the opening. . . . We are getting an excellent re-
cruit in you. Be assured of the pleasure you give and the good you are doing
us. (Manet, egged on by Fantin and crazy himself, continues to refuse, but
nothing seems definite yet from this side.)[30]

Later in the same week Degas dashed off a letter to Tissot:

Look here, my dear Tissot, no hesitations, no escape. You positively must
exhibit at the Boulevard. It will do you good, you (for it is a means of show-
ing yourself in Paris from which people said you were running away) and
us too. Manet seems determined to keep aloof, he may well regret it. Yester-
day I saw the arrangement of the premises, the hangings and the effect in
daylight. It is as good as anywhere. And now Henner (elected to the second
rank of the jury) wants to exhibit with us. I am getting really worked up and
am running the thing with energy and, I think, a certain success. The news-
papers are beginning to allow more than just a bare advertisement and
though not yet daring to devote a whole column to it, seem anxious to be a
little more expansive.

The realist movement no longer needs to fight with the others; it already
is, it *exists*, it must show itself as *something distinct*, there must be a *salon of
realists*.

Manet does not understand that. I definitely think he is more vain than
intelligent.

So exhibit anything you like. The 6th or 7th is a date but unless I am very much mistaken you will be accepted after then.

So forget the money side for a moment. Exhibit. Be of your country and with your friends. . . .

Degas added a postscript:

I have not yet written to Legros. Try and see him and stir up his enthusiasm for the matter. We are counting firmly on him. He has only another sixty francs to deposit. The bulk of the money is all but collected.

The general feeling is that it is a good, fair thing, done simply, almost boldly.

It is quite possible that we will wipe the floor with it, as they say. But the beauty of it will be ours.

Hurry up and send.[31]

Degas failed to persuade Tissot or Legros to exhibit and both Bracquemond and de Nittis were distressed by the arrangements. Shortly after the exhibition he was forced to write a calming letter to the engraver, but de Nittis was never mollified. In his *Notes et Souvenirs* he gave his account of the exhibition:

For the first exhibition of the Impressionists Degas asked me to send something important. He added: 'Because you exhibit at the Salon, people who are not conversant with these things will not be able to say we are an exhibition of *refusés*.'

I sent a painting. With pleasure; as I would do on every occasion when someone has the courtesy to ask me. It doesn't matter where. It doesn't matter what the company. It is the work that counts. When it is hung in a good light it can be seen anywhere.

But my entry was not hung during the first few days. Even when this was put right my painting was hung in the worst possible position, in poor light, and when the press and the first visitors had gone. . . .

I said to myself, laughing: 'It's a lesson. I will not do it again.'[32]

Renoir was probably responsible for ruffling de Nittis's feelings. He was one of the committee to whom the delicate task of hanging the exhibition was delegated, but after a few days his fellow-members dropped out and he more or less hung the exhibition on his own. At Pissarro's insistence there was a system of votes to determine the position of each painting. But how far Renoir went by this system it is hard to say. Certainly there were some odd arrangements. A delicate Berthe Morisot appears to have been hung next to a particularly rough, emotional work by Cézanne. In his review of the exhibition Castagnary gave an account of the hanging procedure:

All the associates have equal rights, for the preservation of which it is proposed that there should be a council of administration of fifteen members, nominated by election and renewed by vote from year to year. The works are placed according to size; the smallest on the dado-rail and the rest above; everything in alphabetical order. . . . It is a sensible arrangement, which guarantees every member exactly the same advantages.[33]

Paul Cézanne, *A Modern Olympia*, 1872–3. The critics were united in deploring this painting. This and Monet's *Impression – Sunrise* were largely responsible for the adverse reception given to the exhibition as a whole.

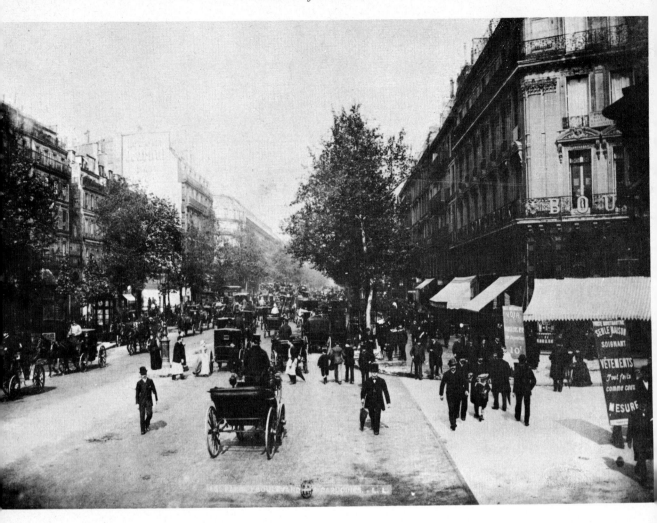

The boulevard des Capucines, photograph taken around 1880. The boulevard was, and is, one of the busiest in Paris.

The premises chosen for the exhibition belonged to the photographer Nadar. They were on the first floor of 35 boulevard des Capucines, a corner site facing the rue Daunou. There was a large staircase that gave direct access to the studio from the busy street outside. The studio was a good place for an exhibition. Philippe Burty wrote: 'The rooms, hung with red-brown cloth, are extremely favourable for paintings. They receive daylight from the side, as in a flat. They are quite isolated, so as to show the paintings to their full advantage.'[34]

The organizers were extremely fortunate to have the use of Nadar's studio. Nadar was a famous figure in Paris and his studio was a well-known landmark on what was, and still is, one of the busiest boulevards in Paris. The façade was marked by a gigantic sign bearing Nadar's signature, executed by Antoine Lumière, at that time a sign painter. In his youth Nadar had been a prominent bohemian and he retained a taste for flamboyant dress throughout his life. He seems to have had a particular taste for red. According to one description:

Nadar's studio, 35 boulevard des Capucines. The studio was extremely favourable for paintings. A staircase gave direct access from the street.

The whole of the exterior and interior was painted red. . . . Nadar himself greeted visitors in a garment of red wool which, coupled with his tall figure, his red hair, his walrus moustache and pale complexion, gave him the appearance of an imposing devil. The prints that he delivered were bordered in red, and the signature and address were printed in red. Indeed it was altogether an orgy of red.[35]

Although he is best known as a photographer he had many other talents. He was a gifted cartoonist in the Daumier tradition and he was a passionate ballooner. He was also one of those people who seem to know everybody. He photographed all the leading writers, painters and musicians of the Second Empire; his name crops up in the correspondence of two such disparate characters as Baudelaire and Jongkind. He probably got to know the Batignolles artists at the Café Guerbois and although he was prepared to make fun of their work in his caricatures he was basically in sympathy with their aims. 'No more juries! Free exhibitions!' was one of his slogans.[36]

Nadar at a costume ball in 1852. In his youth Nadar was a prominent bohemian. He enjoyed wearing exotic clothes and he had a passion for everything red.

There still remained two important details to decide – the title of the exhibition and the date of opening. The title caused some discussion. Degas suggested that they call the group *Les Capucines*, after the nasturtium (*capucine* in French), and also after the boulevard. Renoir proposed an even more neutral-sounding title, the Anonymous Society of Artists, Painters, Sculptors and Engravers, and was successful. He explained to Vollard later:

I was the one who objected to using a title with a more precise meaning. I was afraid that if it were called the 'somebodies' or 'the so-and-sos' or even 'The Twenty-Nine', the critics would immediately start talking of a 'new school', when all that we were really after, within the limits of our abilities, was to try to induce painters in general to get in line and follow the masters, if they did not wish to see painting definitely go by the board.[37]

Next, the opening date was fixed for 15 April, two weeks before the opening of the Salon. By this device the exhibitors hoped to emphasize that their show was not a new Salon des Refusés. Also they hoped to attract the attention of the critics before they turned to their saturation coverage of the Salon.

Finally a catalogue was printed. It cost fifty centimes and it gave the dates of the exhibition – 15 April to 15 May 1874; the hours of opening – ten in the morning to six in the evening, and again eight to ten at night; and the price of entry – one franc. The catalogue mentions thirty exhibitors: Zacharie Astruc, Antoine-Ferdinand Attendu, E. Béliard, Eugène Boudin, Félix Bracquemond, Édouard Brandon, Pierre-Isidore Bureau, Adolphe-Félix Cals, Paul Cézanne, Gustave Colin, Louis Desbras, Edgar Degas, Armand Guillaumin, Louis Latouche, Ludovic-Napoléon Lepic, Stanislas Lépine, Jean-Baptiste-Léopold Levert, Alfred Mayer, Auguste de Molins, Claude Monet, Berthe Morisot, Mulot-Durivage, Joseph (Giuseppe) de Nittis, Auguste-Louis-Marie Ottin, Léon-Auguste Ottin, Camille Pissarro, Pierre-Auguste Renoir, Léopold Robert, Stanislas-Henri Rouart, and Alfred Sisley.

There were 165 works in the exhibition, including a number of drawings, watercolours and pastels. The principal organizers were well represented: Degas had eleven works, covering his most typical subjects – ballet dancers, horse-racing, washerwomen and *toilettes*; Monet had nine works, including a painting of the boulevard des Capucines and the *cause célèbre* of the exhibition, no. 98, *Impression – Soleil Levant*; Berthe Morisot also had nine, among them the charming *Cache-Cache*, or *Hide-and-Seek*; Pissarro had five, mainly landscapes at Pontoise; Renoir was represented by seven paintings, the most notable being *La Loge* and *The Dancer*; Sisley sent five landscapes, including two belonging to his dealer Durand-Ruel. Cézanne chose to show both sides of his warring temperament: he sent the dramatic, hallucinatory canvas belonging to his friend Dr Gachet, *A Modern Olympia*, and two landscapes executed under Pissarro's influence, the most famous being *The House of the Hanged Man at Auvers-sur-Oise*.

The general effect of the exhibition must have been one of happiness,

liveliness and optimism. Simple domestic pleasures provide the theme for many of the pictures. Several paintings are of pastimes and sports, and in so far as landscape can express a mood, those by Pissarro, Sisley, Renoir and Monet, for example, suggest pleasure and confidence. The Romantic approach to landscape, with the emphasis on bad weather, stormy skies, wind, rain, fire and lightning, is outside their range. Instead they depict peaceful rural scenes, well-cultivated fields, sunny days and settled weather. Renoir's *La Loge*, for example, shows an attractive woman, richly and fashionably dressed, with a flower pinned to her bodice, roses in her hair and several rows of pearls garlanded round her neck. She smiles gently and sweetly out at the spectator, while her escort, in white tie and tails, inspects the upper balconies of the theatre through his opera-glasses. The models for this beautiful painting were Renoir's brother Edmond and the Montmartre model Nini, neither of whom can at that stage have had much experience of this fashionable world.

Pierre-Auguste Renoir, *La Loge*, 1874.

Renoir's other contributions to the exhibition betray a similarly hedonistic note. His *Harvesters* is a delightfully informal mosaic of colours, similar in spirit to Monet's *Wild Poppies*, which is believed to have been included in the exhibition, and which shows a woman and a young child apparently drowning in a sea of green, dotted here and there with splashes of red.

Monet was also represented in the exhibition by a large early canvas, *Le Déjeuner*, which shows a happy domestic scene of a mother looking tenderly at her child, who is on the point of tapping a boiled egg. The table is covered with a freshly laundered white tablecloth, fruit, wine and *pâtisseries*. In the background is a maid in a white cap. Another woman leans with her back to the window. The sunlight pours in, and in the foreground is a child's cap and a broken doll. Every detail in this picture speaks of domestic comfort, financial security and, for want of a

Above Pierre-Auguste Renoir, *Meadow*, 1873.

Opposite Claude Monet, *Le Déjeuner*, 1868. The critic for *L'Artiste*, thought this painting was one of the triumphs of the exhibition, superior to a Manet. At the table are Monet's first wife, Camille, and their son, Jean.

76

better expression, decent middle-class values. Berthe Morisot's *Hide-and-Seek* also has a mother and child as its central theme. It is a charmingly fresh study of feminine ways, the mother full of innocent playfulness and the child apparently finding the whole game quite incomprehensible. Degas's *Carriage at the Races* has a holiday atmosphere. It shows Paul Valpinçon with his family. A top-hatted driver of a coach-and-pair looks back at his passengers. The dog beside him looks in the same direction and seems to be parodying his master. In the back of the coach two women are anxiously looking after a child-in-arms and they hold up a parasol to protect themselves and the child against the sun. In the background a horse-race is in progress. The whole scene is rendered with the matter-of-factness of a snap-shot, and seem hardly the stuff from which controversies are made.

Yet many visitors to the exhibition seem to have found it not only controversial but even pernicious. The pleasant, optimistic note struck by so many of the pictures in the exhibition appears to have been largely overlooked. According to Durand-Ruel, 'the public flocked to the exhibition in crowds, but with the fixed intention of seeing in these great artists only presumptuous ignoramuses, out to gain attention by their eccentricities.'[38]

Allowances have to be made for the peculiar temper of Parisian crowds. Then, as now, the boulevards were full of people whose sole aim in life was to jeer and mock the things they did not immediately understand. The same people who went, according to Durand-Ruel, to Nadar's studio, 'with the express intention of laughing and not to give the smallest look at the pictures',[39] could be found baying for the blood of authors at first-nights, or howling at Wagner when his music was first performed in Paris. The Parisian is quick-witted, but if there are things that he does not understand he feels he is being made a fool of. Several observers writing about the exhibition mention the possibility of its being a hoax. *La Patrie* of 21 April comments:

> But the rest of the canvases. . .! Those who have not seen them cannot imagine how puzzled the visitor is. Do you recall the Salon des Refusés, the first one, that is: the one where you could see naked women the colour of a sickly Bismarck, jonquil-coloured horses, trees of Marie-Louise blue? Well, that was the Louvre, the Pitti, the Uffizi compared to the exhibition at the boulevard des Capucines.
>
> Looking at the first rough drawings – and rough is the right word – you simply shrug your shoulders; seeing the next lot, you burst out laughing; but with the last ones you finally get angry. And you are sorry you did not give the franc you paid to get in to some poor beggar.[40]

The general run of visitors to the exhibition, like the writer in *La Patrie*, scented incompetence. They clung to their set views on what a picture should look like with even greater firmness than the painters on the Salon jury so distrusted by Manet and Bazille. They simply mistook the sketchiness of many of the works, the lack of drawing and

Opposite, top Edgar Degas, *Carriages at the Races*, 1870–3. The sitters were Degas' friend Paul Valpinçon and his family.

Opposite, bottom Berthe Morisot, *Hide-and-Seek*, 1872–3. Berthe Morisot's teacher was horrified to find his pupil exhibiting with the Impressionists. He advised her to give up oils and make a complete break with 'this so-called school of the future'.

the unfinished look for clumsiness, and, in proper fat-man-on-a-banana-skin fashion, they laughed.

The painters who went to the exhibition suspected folly or contrariness. Typical of these was Guichard, whose report must have alarmed Madame Morisot. He wrote:

I have seen the rooms of Nadar, and wish to tell you my frank opinion at once. When I entered, dear Madam, and saw your daughter's works in this pernicious milieu, my heart sank. I said to myself: 'One does not associate with madmen except at some peril; Manet was right in trying to dissuade her from exhibiting.'

To be sure, contemplating and conscientiously analysing these paintings, one finds here and there some excellent thing, but all of these people are more or less touched in the head. If Mlle Berthe must do something violent, she should, rather than burn everything she has done so far, pour some petrol on the new tendencies. How could she exhibit a work of art as exquisitely delicate as hers side by side with *Le Rêve du Célibataire* [Cézanne's *A Modern Olympia*]? The two canvases actually touch each other!

That a young girl should destroy letters reminding her of a painful disappointment, I can understand; such ashes are justifiable. But to negate all the efforts, all the aspirations, all the past dreams that have filled one's life, is madness. Worse, it is almost a sacrilege. . . . [41]

Guichard's only explanation for some of the paintings on view at Nadar's studio is 'madness', and he means that almost literally. The same line of attack appears in the reviews of the exhibition. Louis Leroy, for example, in his satirical article in *Charivari*, builds his sketch round the progressive madness of an imaginary academic painter called Joseph Vincent. Monsieur Vincent is at first shocked; later incomprehension leads to incredulity; and, finally, at the sight of Cézanne's *A Modern Olympia*, he is reduced to raving lunacy. The narrator, who shepherds him round the exhibition, seems to take a malicious pleasure in Vincent's discomposure:

Let us go and look at the Cézanne again. What do we see? A woman bent double, while a Negress is taking off the last of her veils and exposing her in all her ugliness to the fascinated gaze of a dark-skinned puppet. Do you remember M. Manet's *Olympia*? Well, that was a masterpiece of draughtsmanship compared with the one by M. Cézanne.

Finally the dam burst. Old Vincent's brain, attacked from too many sides at once, became completely unhinged. He stopped in front of a municipal guard, who had been posted there to keep an eye on all these treasures, and, mistaking him for a portrait, delivered himself of a stinging criticism. . . .

'Easy now,' said the 'portrait'. 'You'd better be moving on.'

'Did you hear that? The picture's got a voice! The pedantic fool who put all that finish to his work must have spent a lot of time on it!'

And, to show how serious he was about his aesthetics, old Vincent started doing an Indian scalp-dance in front of the guard, chanting in a choked voice:

'Wah! I am an impression on the march. I've got my palette-knife ready to avenge Monet's *Boulevard des Capucines*, Cézanne's *Maison du Pendu* and *The Modern Olympia*. Wah! Wah! Wah!'[42]

The charge of madness was taken up and repeated at subsequent exhibitions. Albert Wolff, the influential critic for *Le Figaro*, ended his sarcastic review of the second Impressionist exhibition with the arrest of a poor man because 'he began biting everyone in sight'. Émile Cardon, in *La Presse*, published on 29 April, also singles out the two Cézannes and Monet's *Boulevard des Capucines* for attention, and says: 'One asks oneself if there has not been a deliberate attempt to mystify the public, or it might be the effect of mental alienation, which one certainly should deplore. If the second case is correct, the exhibition calls for the opinion of Dr Blanche and not a critic.'[43]

The accusation of madness levelled at the Impressionists seems among the most unfair and most tasteless of all the many insults they had to put up with. But madness was then regarded with less compassion than it is today. It was associated, for example, with the last stages of venereal disease, and also with artistic and intellectual life. The Goncourt journals are full of lurid accounts of their friends' bouts of insanity. The bohemians lived with the threat of madness always hanging over them, and the newspapers were full of stories of suicides committed in sudden fits of depression.[44] Manet had the misfortune to discover the suicide of one of his models. Monet is thought to have attempted suicide in 1868. Claude commits suicide in *L'Oeuvre*.

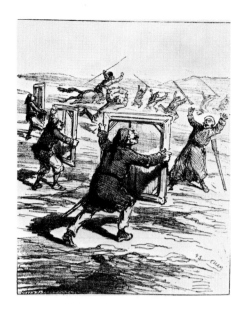

Cartoon by Cham, *Charivari*, 1877. Jokes against the Impressionists emphasized their dangerousness.

In Cézanne's case the charge of madness had some justification. He was the most eccentric of the exhibitors and was a mass of complexes, fears and uncertainties. The enormous concentration he devoted to painting seems to have been accompanied by acute hypertension. While painting he became extremely sensitive to the slightest noise and was liable to fly into terrifying rages. He would suddenly hack a canvas to pieces with his palette-knife and sitters found the strain of posing for him almost unbearable.[45] In Cézanne 'temperament' – one of his favourite subjects – was liable to mean both artistic originality and an uncontrolled state of mind. With good reason Roger Fry referred to him as 'the first wild man of modern art'.[46]

A Modern Olympia is an expression of that wildness. It is supposed to have been inspired by a conversation with his friend and early supporter, Dr Paul Gachet, who had a house at Auvers-sur-Oise, near Pontoise, often visited by Cézanne and Pissarro. Dr Gachet was an amateur painter and enjoyed talking with artists about art. In one conversation with Cézanne he raised the topic of Manet and mentioned the unique qualities of his *Olympia*. 'What? *The Olympia*!' said Cézanne. 'I could do that sort of thing.' 'Well, do it then,' Gachet replied.[47] The result was partly a parody of Manet, partly a tribute to Delacroix, and partly an essay in wish-fulfilment. The balding figure of the painter himself reclines on a sofa with what appears to be a riding stick in his hand and his black top hat beside him. On the floor is a woolly black animal, a reference to Manet's black cat. Before him, floating on what might be clouds, but is presumably a bed, is the squatting, bleary, distorted figure of the goddess herself. An attendant Negress, with a

dramatic flourish, has just removed the last veil, and the naked goddess seems to crouch in order to hide herself, but at the same time the gesture of her outstretched arms seems to be inviting the painter to embrace her. On his right is an enormous bowl of flowers which shoot out of their stand like bursting fireworks.

One hundred years later this work still seems astonishing for its time. It anticipates the Expressionism of Kirchner and others by forty years and the distortion of the goddess has hardly been equalled by a modern painter like Francis Bacon. The fact that the most enlightened critics of Cézanne's day found it impossible to accept is hardly surprising, and one wonders why Cézanne chose it for the exhibition. He must have known it would cause trouble. Needless to say many critics used it to damn the exhibition as a whole. Its sketchiness, its lack of drawing, the squiggles with which the paint has been applied to the canvas, the pale green wall behind the Negress contrasting with the bright orangy-red of the table in the foreground, all combined to make the picture the scapegoat of the exhibition. 'Marc de Montifaud', the lady critic for *L'Artiste*, provided a charitable explanation:

> On Sunday the public saw fit to laugh at the fantastic figure who exhibits herself, surrounded by an opium-laden sky, to an opium smoker. This apparition made of a little bit of naked pink flesh, which is being thrust into the hazy Empyrean by a kind of demon, where, like a voluptuous vision, this corner of an artificial paradise is incubating, has suffocated even the best of men. M. Cézanne merely gives the impression of being a sort of madman who paints in a fit of *delirium tremens*. People have refused to see in this creation inspired by Baudelaire a dream, an impression brought about by oriental vapours and which had to be rendered by means of a strange sketch drawn from the imagination. Isn't the incoherence part of the very nature, the special quality of praiseworthy sleep? Why look for a dirty joke or a scandalous theme in the Olympia? In reality it is only one of the weird shapes generated by hashish, borrowed from a swarm of amusing dreams that must still hide away in the corners of the Hôtel Pimodan. . . .[48]

Jean Prouvaire, in his review of the exhibition for *Le Rappel* on 20 April, does not look for any explanation of Cézanne's disturbing work. 'All the juries, even in a dream, would never entertain the possibility of accepting his work,' he wrote. Cézanne is the only out-and-out revolutionary in the exhibition. He remembers him arriving at the Salon, 'carrying his canvases on his back, like Jesus Christ his cross'.[49]

Castagnary, in a thoughtful review published in *Le Siècle* on 29 April, wrote:

> The case of M. Cézanne (*A Modern Olympia*) can serve as a warning of the fate in store for [the Impressionists]. They will go from one idealization to another, until they reach such a pitch of unrestrained romanticism that Nature is no more than a pretext for dreaming; and the imagination becomes incapable of formulating anything except personal and subjective fantasies without a trace of general rationality, because they are uncontrolled and cannot possibly be verified in reality.[50]

In Jean Renoir's biography of his father the painter comments on this article in later life, saying:

Now I am inclined to agree with Castagnary, so far as Impressionism is concerned. But it still makes me angry to think he didn't understand that Cézanne's *Modern Olympia* was a classic masterpiece, closer to Giorgione than to Claude Monet: a perfect example of a painter who had already gone beyond Impressionism. What is to be done about these literary people, who will never understand that painting is a craft, and that the material side of it comes first? The ideas come afterwards when the picture is finished.[51]

Cézanne's *A Modern Olympia* seems to have been attacked more on the grounds of its lack of drawing than its lack of decency. Castagnary felt that the artist carried to extremes a tendency that seemed common to many of the exhibitors, a tendency to prefer the first sketch to the more laborious finished work. The other chief culprit was Monet, with his *Impression – Sunrise*. The subject of this picture is air and water, the most insubstantial of things, making a 'composition' in the academic sense virtually impossible. The canvas is a mass of pale blue brush-strokes, scrubbed onto the canvas in a multitude of directions. The pink glow in the sky is applied with equal spontaneity. There is hardly one definite form or shape in the painting. The background is blurred and the outline of the masts of ships, jetties and cranes can be made out only with difficulty. The only recognizable elements in the picture are the glowing red disc of the sun, its reflections on the water and the dark blobby outlines of two boats with oarsmen. The signature in the bottom left-hand corner is almost the most definite mark on the canvas.

Monet's *Wild Poppies* is also made up of dashes of colour, requiring the spectator to take that small but important pause for thought as he gathers together the visual information presented to him and translates it into a recognizable subject. Today we make the translation with ease, but in 1874 that pause for thought must have seemed to last for eternity. People were used to having all the detailed work done for them, and faced with some of the paintings they were quite literally mystified. The figures in Renoir's *Harvesters*, like the faceless promenaders in Pissarro's *Public Garden, Pontoise* and, above all, the crowds in Monet's *Boulevard des Capucines*, are all rendered in a summary fashion by a few strokes of paint. They have small round blobs for heads and larger blobs for bodies. Many visitors to the exhibition saw the blobs but not the image behind them. Leroy makes fun of this perplexity. He draws attention to Renoir's use of 'three strips of colour, which is supposed to represent a man in the midst of wheat!'.[52] Vincent, the academic painter, cannot make out the figures in Monet's *Boulevard des Capucines*. 'Only be so good as to tell me what those innumerable black tongue-lickings in the lower part of the picture represent?'

Throughout his piece, which has been quoted at length in Rewald's *History of Impressionism* and need not be repeated here, Leroy plays on the word 'impressionism' and as a result he has largely been credited with the distinction of being the first to call the exhibitors 'impres-

sionists'. However, the term was in fairly common use and had been applied to other landscape painters, notably Daubigny and Jongkind, before Monet. Both Cardon in *La Presse* and Castagnary in *Le Siècle* describe the group as 'impressionists', though admittedly their articles appeared a few days after Leroy's. Castagnary strips the word of its satirical edge and uses it as a term of description. He writes:

> The common view which unites this group and which makes them a collective force in the midst of our divided age is the deliberate intention of not looking for completion, but to stop when a general aspect has been reached. Once the impression has been seized and fixed they declare that their role is finished. The label '*Japonais*', which was given to them at first, was meaningless. If we must define them by a word which explains them it will be necessary to forge a new term, *impressionists*. They are *impressionists* in the sense that they render not landscape as such, but the sensation produced by a landscape. The word has passed into their language: M. Monet's *Sunrise* is not labelled *landscape* in the catalogue, but *impression*. In this way they leave reality behind and enter the world of idealism.
>
> Thus what separates them essentially from their predecessors is the question of the degree of finish.[53]

Having defined what he means by the term, Castagnary goes on to question its value as a style: questions which, while missing the point, were asked by the Impressionists themselves a few years later. With remarkable foresight he predicts the eventual break-up of the group:

> Now, what are we to think of this innovation? Does it constitute a revolution? . . . No, because a school lives on ideas and not on concrete methods; it is characterized by its doctrines and not by its methods of execution. If it is not a revolution and if it does not contain the germ of any school, what is it then? A manner and nothing more. After what Courbet, Daubigny and Corot have produced, one cannot say that the *impressionists* invented the unfinished manner of painting. But they pride themselves on it, they exalt it, they make it into a system, they make it the keystone of their art, they put it on a pedestal and they worship it; that's all. This exaggeration is a mannerism. And what is the fate of mannerisms in art? It is to remain the trademark of the man who invented them or else of the little band of worshippers who adopt them; it involves limiting understanding instead of developing it; it makes one static, unable to reproduce, and soon condemns one to extinction.
>
> In a few years' time the artists who have joined forces on the boulevard des Capucines will have split up. The strongest among them, those who are thoroughbreds, will have recognized that, while some subjects lend themselves to the impressionist manner, are content with a sketched outline, others, and indeed the great majority, cry out for a clear expression, for precise execution; that the superiority of the painter consists precisely in treating each subject in the manner that suits it, and thus in not following a system but in boldly choosing the form that must give full shape to his concept of it. The latter, who in the course of their career have succeeded in perfecting their drawing, will leave impressionism behind, as something that has become really too superficial for them.[54]

Castagnary, who almost seems to understand what the painters are up

Jules Castagnary; he almost understood Impressionism.

to, stumbles at the last hurdle. As in his review ten years earlier of Manet's *Déjeuner sur l'herbe*, he cannot quite adjust to the lack of drawing in many of the works on view. He confuses the shadows for the substance. He mistakes the Impressionist lack of finish for style. He believes that sketchiness *is* Impressionism. But his article does show his appreciation of the situation facing the Impressionists, their difficulties with the jury and their right to exhibit their work. And furthermore it is the most intelligent piece of criticism the exhibition received, a far cry from Émile Cardon's rather silly article in *La Presse*. Cardon, like Castagnary, felt the Impressionists were obsessed with a far-fetched theory.

> ... this school has abolished two things: line, without which it is impossible to reproduce the form of a living being or an object; and colour, which gives form the appearance of reality.
>
> Daub three-quarters of a canvas with black and white, rub the remaining space with yellow, scatter some red and blue dots at random, and you will have an impression of spring which will send the initiated into ecstasy.
>
> Smear a panel with grey, slap on a few black or yellow lines at random, and those in the know will say to you: Well! well! what a good impression that gives of the woods at Meudon!
>
> But when it comes to the human figure, it is quite another matter; the artist's aim is no longer to render the form, the modelling or the expression; it is sufficient to render the *impression* without a definite line, without colour, without shadow or light; in order to put such a far-fetched theory into execution, the practitioners fall into a senseless, mad, grotesque mess, fortunately without precedent in the history of art, for it is quite simply the negation of the most elementary rules of drawing and painting. A child's scrawls have a naiveté and a sincerity that make you smile, but the excesses of this school are nauseating or revolting.[55]

Cardon's analysis of Impressionist technique, for all its implied criticism, is a fairly accurate description. But it is a line of attack that basically appealed to painters, and Cardon evidently felt it necessary to throw in some purely *ad hominem* arguments. He believed that the exhibition represented a dangerous tendency whereby artists could bypass juries. Like the author of the article in *La Patrie* he compared the exhibition to the Salon des Refusés and argued similarly that the standard of the Impressionist exhibition was even lower. His main objection was on personal grounds. He disliked the artists' presumptuous manner, their belief in themselves, their refusal to respect authority. Finally he accused those dealers and collectors who supported their work, notably the singer Faure, of putting on airs and seeking publicity.

The writer of the art column in *La Patrie* also disliked the exhibitors for their effrontery, their superiority in the face of criticism, all qualities that earned them the description of '*Intransigeants*'. This term, as much as 'Impressionist', was used to refer to the group.

However, it would be a mistake to think that the exhibition was a complete critical flop. The number of sympathetic reviews does in fact outweigh the purely hostile ones.[56] Léon de Lora in *Le Gaulois* felt that

the efforts of the exhibitors ought to be encouraged, and among the landscapes singled out for praise in his article are works by Pissarro, Sisley and even Cézanne's *House of the Hanged Man*. Jean Prouvaire in *Le Rappel* also showed sympathy for the exhibitors, whom he found in practice less revolutionary than their theories. He particularly admired the three portraits by Renoir. *L'Artiste*, next to the *Gazette des Beaux-Arts* the most influential art review in Paris, carried a seven-page notice by 'Marc de Montifaud' which, while failing to say anything very penetrating about the exhibition, does have many favourable descriptions of Monet's work:

> The largest contribution in numerical terms comes from M. Monet, with his vast canvas called *Le Déjeuner*. The fact that his type of painting is almost identical to that of Manet need not concern us again. But M. Monet asserts himself, whereas his quasi-namesake remains stationary. His talent is more flexible, even if he doesn't have the brutal force of genius, and he comes close to the Old Masters with his bold . . . colour-range, with his constant striving for local colour and his firm strokes. . . .

But the writer had reservations:

> Whereas, in *Le Déjeuner*, the facial features of the small child sitting at the table are reminiscent – albeit distantly – of the clear, bold tones of Velazquez in his portrait of the Infanta Margaret, the impression created by *Sunrise* is treated by the childish hand of a schoolboy daubing colours for the first time on some surface or other.[57]

Philippe Burty, who was to become one of the leading apologists for the Impressionists, contributed an enthusiastic review of the exhibition in *La République Française*. In it he defended the Impressionists against the charge of haughtiness and of an inability to finish their work. Transcribed sensations, he pointed out, are often as fleeting as the sensations themselves. The public should be grateful that these young artists had attempted to pin down something as unpaintable as the gust of heat from a field of stubble, the languor of an autumn evening, the touch of rouge on a young cheek. He recognizes that Impressionist technique will seem mystifying at first. 'The public does not understand it easily,' he wrote, 'for example, when one looks at a flight of poplars on the banks of a river, the branches don't prevent one seeing through them.'[58]

Reviews like this no doubt helped to sustain the morale of the exhibitors. Also attendances were good, even if the majority of the visitors were there only out of curiosity. Pissarro was sufficiently satisfied with the way things were going to write to Duret: 'Our exhibition is going well. It is a success. The critics are devouring us and accuse us of not studying. I am returning to my studies; that is more worthwhile than reading the critics. One learns nothing from them.'[59]

A sense of disappointment began to dawn later. At the close of the exhibition the organizers must have realized how little they had achieved. The public had not been won over; new collectors for their work had failed to materialize; they had not made any important con

Camille Pissarro, *The Chestnut-Trees at Osny, c.* 1873, one of five works by this artist in the exhibition.

...erts among the critics. As Duret had predicted, the special exhibition had attracted the same nucleus of artists and admirers as the Impressionists knew already. It would have been a help if a supposed admirer like Zola had spoken out on their behalf. He could have turned their exhibition into a great rallying-point for progressive opinion. But he chose to remain silent.

The failure of the exhibition to help the Impressionists' cause was demonstrated a year later at a sale at the Hôtel Drouot on 24 March 1875. There the average price for their canvases was about 150 francs. Most of Renoir's paintings failed even to reach the 100-franc mark. Monet's prices varied between 165 and 325 francs, way below the price levels that his work had reached the year before. The auction was conducted in an atmosphere of bitterness and hostility and at one stage the police had to be summoned to keep order in the saleroom.

But despite this the need to exhibit continued. The idea of an independent exhibition organized by the artists themselves had taken root. And although the first Impressionist exhibition was not a turning-point, it was a beginning. Twelve of those taking part decided to exhibit again in the second Impressionist exhibition in 1876. There were further group shows in 1877, 1879, 1880, 1881, 1882 and 1886. Although the Impressionists as a group had begun to split up by the middle of the 1880s they left as a legacy the idea of an independent exhibition. Out of the debris of their shows grew the Salon des Indépendants, which abolished all restrictions on entry, and which played such an important role in the development of progressive art from 1886 to 1914.

3 The Salon d'Automne

Why does the period known as the Edwardian Era in Britain and *La Belle Époque* in France evoke a feeling of pleasure? Why does life there seem so attractive and why do the participants seem so young, so innocent and optimistic? We know that this carefree life was enjoyed by a privileged few; we know that most people sweated under conditions that were much the same as in the nineteenth century; and we know that it all ended in the most destructive war in history. Yet the era still seems charmed. Close the eyes and images come to mind of fat rulers and women with thin waists, of music-halls and racecourses, of people riding bicycles and others walking along the promenades of seaside resorts and spas against a backdrop of wedding-cake hotels. The photographs of Henri Lartigue capture the excitement with which people greeted the new machines, the motorcars and the aeroplanes. No one seems to have been aware of the dangers they posed. The heroes of the day are those daredevil young men in goggles and leather flying helmets. Everything seemed new. The Eiffel Tower was new, electric light was new, the century was new. The mood of the era seems confident, optimistic and opulent. And if there is one image that conveys the spirit of those times it is the Edwardian hat. Its voluminous proportions required yards of tulle, muslin and lace, complete with elaborate decorations of fruit and flowers. Its popularity was world-wide. It dazzled artists. Fashionable portrait painters like John Singer Sargent, Giovanni Boldini and Joseph Helleu depicted it with great skill and flourish; it became the subject of jokes in *Punch*, *Charivari* and *Harper's Weekly*; and it appears in the most advanced painting of the new century, Matisse's *Woman with a Hat*.

This chapter is about that painting and about the exhibition where it was first shown, the Salon d'Automne of 1905. Both the painting and the exhibition mark the emergence of a new artistic spirit – a new feeling for colour, a new roughness that seemed primitive, and a new emotionalism.

By 1905 the problem of exhibiting new work had been more or less solved. There were now four recognized annual exhibitions that accepted new work with varying degrees of strictness and there were dealers who put on exhibitions of their own. The old Salon was a shadow of its former self. In 1890 it had split into two, the Salon des Artistes Français, or 'Bouguereau's Salon', as Cézanne used to call it, and the Salon de la Nationale, founded by Meissonier. The latter, under the presidency of Puvis de Chavannes, had been a fairly liberal organization. Matisse made a successful début there in 1896. But it was best known for displaying the work of the fashionable portrait painters of the day, Sargent, Boldini, Jacques-Émile Blanche and Émile-Auguste

Henri Matisse, *Woman with a Hat*, 1905.

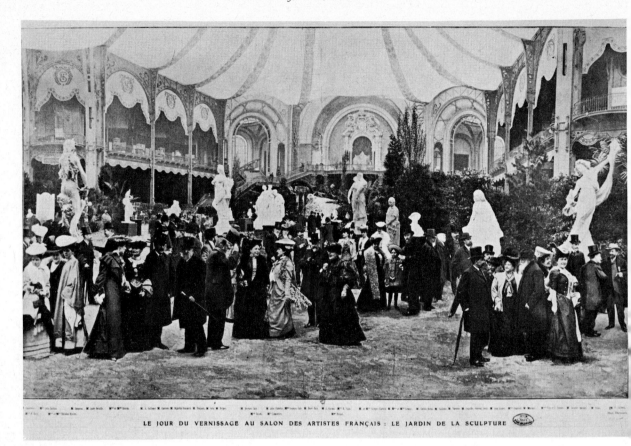

LE JOUR DU VERNISSAGE AU SALON DES ARTISTES FRANÇAIS : LE JARDIN DE LA SCULPTURE

The opening of the Salon des Artistes Français, 1905.

Carolus-Duran. The real showcase for progressive art was the Salon des Indépendants, founded in 1884 by Georges Seurat and Odilon Redon. It was the easiest of all the exhibitions to get into; it had no jury, merely a hanging committee drawn from the exhibiting artists. The results were often confused and ragged, and the standards were not always of the highest, but nearly all the most *avant-garde* art from 1890 to 1914 was shown there at one time or another. In 1903 a rival exhibition was founded, the Salon d'Automne. It was intended to fill the gap between the anarchistic Indépendants and the increasingly strict Nationale, which, under a new president, Carolus-Duran, had become no more tolerant than the Salon des Artistes Français.

The Salon d'Automne was never exclusively a platform for the *avant-garde*. It presented a wide cross-section of artistic activity and the majority of the exhibits were safe, respectable exercises in Edwardian sentimentality. But it did present new developments in a coherent way and as a result the Fauves of 1905 and the Cubists of 1910 made a bigger impression than they would have in the loosely organized Independants. The Salon d'Automne provided a yardstick. People were able to compare Matisse's use of bright colours with Eugène Carrière's impressionistic greyness. They were also able to compare both with the

work of their immediate forbears. In 1903 the Salon showed a group of paintings by Gauguin, who had died that year. In 1904 there were special exhibitions devoted to Puvis de Chavannes and Cézanne, and in 1905 it was the turn of Ingres and Manet. The Salon became a forum for all the arts. Concerts were arranged during the months it was open and there were special sections devoted to posters, illustrations, designs, music-covers and architectural plans and models.

It is difficult to say who started the Salon d'Automne. The idea seems to have occurred to a number of people in the Paris art world at roughly the same time. Among the initiators was a poet, Yvanhoé Rambosson, who worked as a curator at the Petit Palais and who managed to persuade the municipal council to allow the basement of the Palais to be used for an exhibition. The first president of the new Salon was Frantz Jourdain, an architect and writer, known to most of the leading artists of the day.[1] Among his achievements was the design for the pedestal for Rodin's monument to Balzac, and he was also the president of a syndicate of art critics. He was a strong-willed man, a little pompous, and one gets the impression that he was often disliked. Apollinaire says that he was called 'the president of façades' and 'the good Samaritan', after the department store La Samaritaine, which he helped to design.[2] The dealer Ambroise Vollard clearly regarded him as a humbug. In his memoirs he repeats the remark of a colleague: 'The extraordinary thing is that for an architect, Jourdain has never touched a pencil.'[3] Still, Jourdain had other qualities to recommend him. He stood up to Carolus-Duran and behaved well when the Salon came under fire for showing the Cubists.

Jourdain made a good figurehead and he was to build up a strong team of founding members. Among the first to join the new Salon were Georges Rouault, Edouard Vuillard, Félix Vallotton and the portraitist Antonio de la Gandara; the writers Arsène Alexandre, Gustave Geffroy and Gustave Kahn (a pioneer of free verse); and the collector Count Camondo. Eugène Carrière, one of the most popular artists of the day, became an honorary president of the new Salon in 1903 and Renoir held the same post in 1905.

The first Salon d'Automne opened in the Petit Palais and caused a good deal of excitement. Not only was it unusual to have a Salon in the autumn months, it was the first time an exhibition had opened at night and the first time electric light had been used to illuminate the works of art. The exhibition was a success, but the rooms at the Petit Palais were cramped and musky. Henri Marcel, director of the Beaux-Arts, came to the rescue and offered the use of the Grand Palais opposite. Carolus-Duran, whose Salon de la Nationale used the same building, was furious and attempted to ban the members of his Salon from taking part in the new exhibition. A fierce struggle with Jourdain took place, with Jourdain emerging victorious. By 1905 the Salon d'Automne was an established feature on the artistic calendar and a natural opportunity for Matisse and the other artists to show their work.

Frantz Jourdain, architect and mainstay of the Salon d'Automne.

The opening of the Salon d'Automne, 1903.

As it happened, the work of Matisse and his friends caught people by surprise, but the more observant would have seen the explosion coming. Taste was changing. To mention one instance: in June 1905 a Whistler memorial exhibition was attacked by the critics. Marcel Proust, a long-standing admirer, wrote to a friend: 'You know that at present the artistic élite of France are having a frightful reaction against Whistler. He is regarded as a man with exquisite taste who, because of it, was able to pass himself off as a great painter when he was nothing of the kind.'[4] Proust mentions Blanche as one of the detractors, but he could have named Maurice Denis, who wrote: 'The influence of Whistler is finished. His exhibition has above all had a bad press. The flock of imitators has ceased to follow him; and the public, more insatiable than ever for novelty ... has already forgotten that twenty or thirty years ago he was the painter of the *avant-garde*.'[5]

Advanced opinion had begun to react against the whole Impressionist school. Charles Morice noted this view when he interviewed a

number of young painters for the *Mercure de France*, and Maurice Denis, in an essay assessing the general scene, declared: 'The opinion which is most widely held is that Impressionism is finished; one has even come to doubt that it ever existed.'[6]

Two new heroes had emerged – Cézanne and Van Gogh. Both were linked to the Impressionist school, but both seemed to have taken the movement a stage further. Both artists were to a large extent discoveries of the twentieth century. Buried in Provence, Cézanne was almost further from the limelight than Gauguin in Tahiti. 'Cézanne seems to be a fantastic figure,' wrote a critic, 'although still living he is spoken of as though he were dead. A few examples of his work are owned by a small number of collectors.'[7] In 1895 Vollard mounted an exhibition of his work which came as a surprise even to old friends like Pissarro and Renoir.[8] Over the next few years his works came to be talked about by a group of young painters including Charles Camoin, Émile Bernard and Maurice Denis. Denis later payed a tribute to his

influence in his *Hommage à Cézanne* of 1901, which shows a group of Nabis admiring a small Cézanne still-life. But the public at large had little opportunity to see his work in depth until the large retrospective exhibition at the Salon d'Automne of 1904.

Van Gogh suffered from a similar neglect, managing to sell only one painting in his exhibiting career.[9] He too remained a painter's painter, and although there were two commemorative exhibitions following his death, one a group of ten works at the Indépendants in 1891 and the other a show of sixteen works organized by Émile Bernard at the Galerie Le Barc de Bouteville in 1892, there was no full-scale exhibition of his work in Paris until 1901.[10] This consisted of seventy-one works and took place at the Galerie Bernheim Jeune. It proved an eye-opener for several young painters and marks the beginning of the Fauves.

Below André Derain, *Portrait of Vlaminck*, 1905.

Bottom André Derain, *Self-portrait*, 1905.

Among the visitors to the exhibition was Maurice de Vlaminck. He was twenty-five, a boisterous, larger-than-life character, with a strapping physique and energies to match. The Van Goghs made an immediate impression on him. Their energy rivalled his own and he felt that he had found the spiritual master he had been looking for. 'Up to that date I had not known of Van Gogh,' he explained later. 'His work impressed me as final. . . . I was glad of the certainties that he brought me, but I had received a heavy blow! I found in him some of my own aspirations. The same Nordic affinities, perhaps. And with that a revolutionary feeling, an almost religious feeling for the interpretation of nature. My soul was in a turmoil when I left that retrospective exhibition.'[11]

Vlaminck made several visits to the exhibition, bringing with him another young painter, André Derain. The two had met at Chatou, a small town on the Seine on the outskirts of Paris. Derain was twenty-one and a very different character from his companion. He came from a respectable middle-class home and had benefited from a good education. He was intelligent and highly-strung and, as Matisse later observed, just a bit in awe of his elder companion. Back at Chatou both artists attempted to put their new-found enthusiasm for Van Gogh into practice. Vlaminck found it relatively easy. As his name suggests, he had Dutch ancestors and felt a natural sympathy for Van Gogh's art. He was particularly struck by his use of pure, unmixed colour and in his autobiography he wrote:

I heightened all my tone values and transposed into an orchestration of pure colour every single thing I felt. I was a tender barbarian, filled with violence. I translated what I saw instinctively, without any method, and conveyed truth, not so much artistically as humanely. I squeezed and ruined tubes of aquamarine and vermilion, which, incidentally, cost quite a lot of money at the paint shop at the Pont de Chatou where I used to be given credit.[12]

On a return visit to the Van Gogh exhibition Vlaminck and Derain met Matisse. Derain had known Matisse when he was a student in a

studio run by Eugène Carrière. Matisse was much older and in 1901 he would have been thirty-two. He was already a rather commanding figure, very serious, very self-possessed, a bit of a pedagogue, in fact just the right person, Derain thought, to persuade his parents that art was a respectable calling. Derain asked Matisse to visit him and Vlaminck in Chatou. Matisse's account of that visit, which took place some time after the Bernheim Jeune show, is given in his son-in-law's book on the Fauve movement:

I saw Derain in the company of an enormous young fellow who proclaimed his enthusiasm in a voice of authority. He said: 'You see, you've got to paint with pure cobalts, pure vermilions, pure Veronese.' I still think Derain was a bit afraid of him. But he admired him for his enthusiasm and his passion. He came up to me and introduced Vlaminck. Derain asked me to go to see his parents to persuade them that painting was a respectable trade, contrary to what they thought. And to give more weight to my visit, I took my wife with me. To tell the truth, the paintings of Derain and Vlaminck did not surprise me, for it was close to the researches I myself was pursuing. But I was moved to see that these very young men had certain convictions similar to my own.[13]

Vlaminck's version is rather different. 'This visit was decisive for him [Matisse]!' he maintained. 'Impelled by a kind of anxiety and, at the same time, by a desire to assert himself, Matisse came back the same day. "I haven't slept a wink all night," he told us. "Let me have another look at all this."'[14]

Vlaminck was loud, unruly, bohemian and defiantly uncultured – he used to scoff at the Old Masters in the Louvre – while Matisse was quiet, disciplined and had a deep respect for the art of the past. Jean Puy, another student of Carrière's, said, 'The whole character of Matisse, what I might even call his "pride", this is in no censorious sense, but merely for the sake of definition, explains the sometimes disconcerting effect of certain paintings and the fault which can generally be ascribed to him: a certain lack of humanity.'[15] Interestingly, Gertrude Stein noted the same characteristic. Matisse baffled her: he seemed both bohemian and middle-class, virile and sexless, intelligent and ponderous. She came to dislike what she called his 'brutal egotism', the ruthless concentration on his work to the exclusion of those small touches of concern for the feelings of others.[16]

Matisse, in his own quiet way, was more than a match for Vlaminck. The story of their musical duet is characteristic. Both were violinists, Matisse an amateur, Vlaminck a semi-professional, having made use of his talents to support himself as a painter. At a studio party they were encouraged to play a duet, but it was not a success: Vlaminck insisted on playing everything *fortissimo*, 'and the same is true of his paintings,' added Matisse.

Vlaminck was also unaware that Matisse's interest in Van Gogh had developed at least two years before the Van Gogh exhibition. In 1898 he had been tempted by Van Gogh's *L'Arlésienne*, which he saw in

Vollard's shop. Vollard was asking five hundred francs and Matisse decided to think about it. After an appropriate interval he returned, but by then Vollard had raised the price to nine hundred francs. Looking round the shop he caught sight of a small oil sketch by Cézanne, *Three Bathers*, now in the Petit Palais. The little picture seemed to eclipse everything else and Matisse was determined to buy it, even though it was much more expensive than the Van Gogh and was priced at thirteen hundred francs. Matisse kept the picture for nearly forty years and when he gave it to the City of Paris he wrote: 'It has sustained me spiritually in the critical moments of my career as an artist.'[17]

Matisse, like so many artists at the turn of the century, was deeply affected by Cézanne's art. In the reaction against Impressionism Cézanne seemed to offer an alternative. While Impressionist colour had apparently dissolved the illusion of depth by creating a veil of hazy, amorphous spots of paint, Cézanne seemed to have used colour to restore a sense of solidity and durability to objects and landscapes. Pissarro explained the difference between Cézanne and Impressionism to the young Matisse: 'Cézanne is not an Impressionist because all his life he has been painting the same picture. He has never painted sunlight; he always paints grey weather.' 'What is an Impressionist?' asked Matisse, to which Pissarro replied, 'An Impressionist is a painter who never paints the same picture, who always paints a new picture.'[18] As far as Matisse's art was concerned the influence of Cézanne can be seen in the modelling of the early figure studies of the late 1890s and it persisted through to the early summer of 1904, in the landscapes he did at Saint-Tropez.

Then a new influence came into his life: Neo-Impressionism. Until 1904 the Pointillist method had had little to offer Matisse. Perhaps he had listened to Pissarro's comment on Seurat: 'It's like print.' But around this time the Neo-Impressionists had begun to be the subject of a late burst of interest. There were several exhibitions of their work which helped bring their names to the fore again. Druet organized one-man shows of Maximilien Luce and Paul Signac in 1904 and the following year it was the turn of Henri-Edmond Cross. There was also an impressive retrospective exhibition devoted to Seurat at the Indépendants in 1905. During the summer at Saint-Tropez Matisse met Signac, who lived there. Cross was staying nearby at Le Lavandou. Signac was the most forceful of the surviving Neo-Impressionists, and a powerful figure in the Salon des Indépendants. His example awakened in Matisse an interest in pure colour which had been suppressed in his rather sombre, restrained pictures of the last two years. Matisse began to use a Pointillist method of applying colour, but in a cruder fashion than that employed by Signac or Cross. He also began preliminary studies for a large composition, *Luxe, calme et volupté*.

The finished picture, which was shown at the Indépendants of 1905, reveals a variety of influences. The theme is one dear to Cézanne and reminiscent of the *Three Bathers*, the composition owes something to

Cézanne's *Three Bathers* was bought by Matisse in 1898.

Puvis de Chavannes, and the technique to Signac and Cross. It is in many ways an unsatisfctory work, yet it was acclaimed by Signac, president of the Indépendants, who bought it and arranged for it to be given a place of honour in the exhibition. There it was seen by Raoul Dufy, a young man of twenty-eight, who later acknowledged its significance in his own development as a painter. 'I understood all the new principles of painting,' he declared, 'and Impressionist realism lost its charm for me as I contemplated this miracle of the imagination introduced into design and colour. I immediately understood the new pictorial mechanics.'[19] Othon Friesz, a friend of Dufy from their schooldays at the Le Havre Beaux-Arts, also began to take note of Matisse's work and like Dufy began to be dissatisfied with Impressionism. He later explained: 'Impressionism, the only living expression of the late nineteenth century, had led us in the right direction, we were indebted to it; however, it seemed to me that its pictures were not constructed, but amounted only to an active documentation of nature: they were arrangement and not composition. Colour appeared as our saviour.'[20] But a future patron of Matisse, Leo Stein, then searching for something new and interesting, was unhappy with Matisse's style. 'Matisse made perhaps the strongest impression,' he remembered, 'though not the most agreeable. He was at this moment trying pointillism, the ugliest technique – to my thinking – ever invented. His pointillism was splotchy and messy, and though both his drawings and his colour had a decisive quality of energy, his pictures were not satisfying.'[21]

A lesser personality might have remained content with the success of *Luxe, calme et volupté*, but after the six months or so that separated the Indépendants from the Salon d'Automne Matisse carried his researches into colour, half-realized in this large work, a stage further. The change took place at Collioure, a small harbour on the south-western coast of France beyond Perpignan and a few miles from the Spanish border; it was as important to the Fauves as Argenteuil had been to the Impressionists. Derain joined Matisse at Collioure, keeping Vlaminck informed of their progress. Derain was impressed by Matisse's seriousness and his painstaking manner. 'I've been slogging away with Matisse,' he wrote, 'and I don't think he realized I possessed a knowledge of colour like the one contained in the manuscript I read you. He's going through a crisis right now, in connection with painting. But on the other hand he's a much more extraordinary fellow than I would have thought, where logic and psychological speculations are concerned.'[22] As a young man Derain was full of self-doubt, with moments of exhilaration quickly followed by despair. Matisse acted as a calming influence, but judging by Derain's letters to Vlaminck his restlessness partly stemmed from sexual frustration. 'The "cunts" are like fierce wild beasts,' he complained. 'When they're tamed you go into their cage; you flatter them; you stroke their backs, but keeping a watchful eye on them. Then, they gobble you up in a single mouthful.'[23] He concludes his letter with a request for a copy of Jarry's *Ubu roi*.

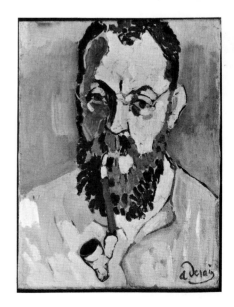

André Derain, *Portrait of Matisse*, 1905. Derain was impressed by Matisse's seriousness and sense of dedication.

André Derain, *Collioure*, 1905. The brush-strokes are broad and separated from each other. Derain's technique was partly derived from Van Gogh.

During these summer months at Collioure Matisse began to be dissatisfied with the programmed method of applying colour as practised and taught by Signac. He adopted a freer approach, choosing his colours instictively and applying his paint in large flat areas alternating with smaller blobs of colour. He worked quickly, dashing off a number of small canvases. One of these was *The Open Window*, which became the most famous of the paintings done at Collioure that summer. It shows the boats in the harbour floating on pink water and framed by the bright green leaves of the balustrade, which is itself framed by the window and walls of a room, painted green on one side and mauve and orange on the other. It is a riot of colour and the note of spontaneity is

Henri Matisse, *The Open Window*, 1905. One of the key works in the development of Fauve painting. It still shows traces of pointillist influence.

Overleaf Henri Rousseau, *Le Lion, ayant faim ...* 1905. This huge work (nearly seven foot by ten) dominated Room Seven.

underscored by the variety of ways the paint has been applied. In places the canvas shows through; in other parts the colour has been applied in thick blobs or scrubbed on to the canvas in a few swift movements.

Derain at that time was working with equal freedom, but there is something more consistent about his technique, and his attitude to colour is more immediately pleasing, less challenging. In these paintings he adopted a modified Divisionist approach, banishing all sense of shade and modelling. The paint is applied in longish dabs, placed rhythmically on the canvas like some of Van Gogh's Arles landscapes, but the dabs are often not joined up and the raw canvas is allowed to show through, which gives an extra luminosity to the paint. Derain's

Henri Rousseau

colours are more varied and subtler than Matisse's and he refrains from Matisse's habit of playing with complimentaries.

Derain worked hard, producing many paintings, but he was tiring of his monastic routine. On 28 July he wrote to Vlaminck: 'I'm thirsty for Paris, for *femmes galantes*, for witty conversation and for funny jokes. It's silly! I used to hate all that once. I am very much alone and it's beginning to get on my nerves. I am becoming coarser and coarser in this painting. . . . I want to put in too much of myself. I crowd it, I suffocate it.'24 On 5 August he again let off steam and announced his return to Paris with thirty finished canvases, twenty drawings and fifty sketches. He announced his intention of showing his work at the Salon d'Automne.

Matisse probably returned to Paris before Derain. The change of locality did not affect the course of his painting and, with the lessons learnt in Collioure still fresh in his mind, he embarked on a portrait of his wife, selecting a larger canvas than he had used during the summer. The pose was a conventional one: Madame Matisse sat sideways, resting her arm on the back of the chair and looking over her shoulder at her husband. She wore a fashionable and voluminous hat which she had probably made herself. Matisse worked quickly and instinctively and probably finished the painting in a few days. It is difficult to be sure of his working methods at that time. The painting looks like a work which was successful first time, but the more one looks at it the more planned and organized it seems to be. In his 'Notes d'un Peintre', published in December 1908, when the first Fauve fervour was behind him, Matisse speaks of his dissatisfaction with unrevised work: 'Perhaps I might be satisfied momentarily with a work finished at one sitting,' he wrote, 'but I would soon get bored looking at it; therefore, I prefer to continue working on it so that later I may recognize it as a work of my mind.'25 Matisse's views on colour, recorded in the same notes, fit in with his working methods of 1905. He wrote: 'I put down my colours without a preconceived plan. If at the first step and perhaps without being conscious of it one tone has particularly pleased me, more often than not when the picture is finished I will notice that I have respected this tone while I have progressively altered and transformed the others. I discover the quality of colours in a purely instinctive way.'

The colours of the *Woman with a Hat* are certainly instinctive. It is probably the most intensely expressionistic painting ever done by Matisse; but at the same time it is a work that shows great control and self-discipline. The colour patches are firmly rooted to the picture plane, and there is something about the portrait which is as solid as a Cézanne.

The *Woman with a Hat* is one of those works – Manet's *Déjeuner sur l'herbe* is another – that seems to excite controversy almost as soon as it leaves the easel. Once finished they seem to take on a life of their own and the artist is powerless to do anything about it. Matisse must have

sensed the first sign of trouble long before the Salon d'Automne opened. According to Vollard, Frantz Jourdain attempted to have the painting refused:

He wished to appear friendly to the new trend in painting, but as a prudent leader he practised a certain opportunism, taking care not to break too openly with academic art, which still enjoyed the favour of public opinion. So in the constant apprehension lest one of his 'colts', taking the bit between the teeth, should compromise him in his official capacity, he decided that Matisse, with his *Portrait of a Woman*, was 'playing the modern' to excess. He begged the jury to refuse the painting 'in their friend's interest'. It was accepted nevertheless. 'Poor Matisse!' moaned M. Jourdain. 'I thought we were all friends here!'[26]

The Salon d'Automne of 1905 would have been a remarkable exhibition even without Matisse's *Woman with a Hat*. An idea of its quality can be gained from the famous two-page spread in *L'Illustration*, published on 4 November. Ironically the editor chose his pictures with the intention of ridiculing the *avant-garde* element in the exhibition and, to underline the credulity of its supporters, he used excerpts from the more favourable reviews as captions. Nevertheless he seems to have had an unerring eye for quality. The Cézanne, the Vuillard, the Rousseau, the Rouault and the Matisses are all works of the first rank, all revered today, while the pictures chosen by the rival editor of *Le Monde Illustré*, chosen to represent the best of the Salon d'Automne of 1905, have been, with the exception of a Manet, forgotten.

The purpose of the exhibition, however, was to link advanced art with more traditional forms, not to divide them, as the illustrated papers tended to do, and the choice of the two special retrospective exhibitions that year, Manet and Ingres, struck the note of compromise that the organizers wished to impart. During his long and distinguished career Ingres had been the staunch upholder of the Academy and a tradition of painting that stemmed from Raphael; Manet became, against his will, the arch-rebel. Ingres had been an immensely successful artist; Manet, by his own standards, a failure; but since their deaths, Ingres's in 1867 and Manet's in 1883, there had been a reversal of positions. Ingres's perfectionism had come to be regarded as cold and lacking in life. A cartoon in *Charivari* on 29 October 1905 sums up the general view. A spectator wrapped up in an overcoat and wearing his top hat talks to an artist: 'You find you are not sufficiently frozen at your salon so you have to make matters worse by showing the work of Ingres, the coldest of the masters of the French school.' Manet, on the other hand, was beginning to acquire the status of an Old Master. He was still looked on with suspicion by the diehards in the Academy and the museums, but in society more modern-minded people now acknowledged his stature. Marcel Proust puts it perfectly in *Remembrance of Things Past*, when the aristocratic Oriane, Duchesse de Guermantes, says: 'But really, the other day I was with the Grand Duchess in the Louvre and we happened to pass before Manet's *Olympia*. Nowa-

Georges Rouault, *At the Salon*. Rouault was one of the founders of the Salon d'Automne. Louis Vauxcelles, in a thoughtful review, felt that Rouault possessed 'the soul of a Catholic dreamer and misogynist'.

Overleaf L'Illustration, 4 November 1905. This famous two-page spread reproduced the more controversial works in the Salon d'Automne of 1905 together with comments by the more progressive critics, notably Louis Vauxcelles and Gustave Geffroy. The intention was to ridicule the critics rather than to lend support to their views. 'All we can say,' says the editorial, 'if the critics once kept their praise for established reputations and all his sarcasm for newcomers, things are very different today.'

LE SALON D'AUTOMNE

On nous a dit : « Pourquoi L'Illustration, qui consacre chaque année aux traditionnels Salons du printemps tout un numéro, affecte-t-elle d'ignorer le jeune Salon d'automne ? Vos lecteurs de province et de l'étranger, exilés loin du Grand Palais, seraient heureux d'avoir au moins une idée de ces œuvres de maîtres peu connus, que les journaux les plus sérieux (le Temps lui-même) leur ont si chaleureusement vantées. »

Nous rendant à ces raisons, nous consacrons ici deux pages à reproduire de notre mieux une douzaine de toiles marquantes du Salon d'automne. Il y manque malheureusement la couleur ; mais on pourra du moins juger le dessin et la composition. Si quelques lecteurs s'étonnent de certains de nos choix, qu'ils veuillent bien lire les lignes imprimées sous chaque tableau : ce sont les appréciations des écrivains d'art les plus notables, et nous nous retranchons derrière leur autorité. Nous remarquerons seulement que, si la critique, autrefois, réservait tout son encens aux gloires consacrées et tous ses sarcasmes aux débutants et aux chercheurs, les choses ont vraiment bien changé aujourd'hui.

PAUL CÉZANNE. — Les Baigneurs.

Pau Cézanne donne une sensation d'harmonie, de gravité. La nature est, chez Cézanne, solennelle et éternelle... Je ne puis m'empê ce singulier et si simple artiste une des plus belles incarnations de l'art de peindre... J'ai devant ces œuvres si pures la sensation devant des aspects à jamais fixés... Je crois que cette peinture traversera le temps. Sa beauté est profonde et sereine...

GUSTAVE GEFFROY, le Jo

Cézanne : le public va-t-il comprendre enfin ce langage rude et haut qu'on ne parle guère à ses oreilles ?... Il est temps que s grandeur de cette œuvre inégale, mais toujours émouvante... Les Baigneurs michelangesques, sous un ciel obscur d'été orageux...

LOUIS VAUXCELLES, Gi

CHARLES GUÉRIN. — Baigneuses.

Dans le clan des jeunes, Guérin est un des premiers qui se soient frayé une voie neuve... Les transcriptions de la forme féminine qui constituent son envoi principal ont ceci de très particulier qu'elles sont à la fois familières, extrêmement réalistes, et pourtant sans vulgarité. Elles se relèvent d'une ingénuité de sentiment qui, dans une très forte mesure, les stylise...

THIÉBAULT-SISSON, le Temps.

J.-E. VUILLARD. — Panneau décoratif.

Un des plus beaux peintres que ces dernières années nous aient révélés ; ses harmonies sont une perpétuelle fête pour le regard.

ARSÈNE ALEXANDRE, le Figaro.

Ces pa ysages sont reposants, ces intérieurs silencieux et quiets, propices infiniment à l'étude, aux douces

HENRI ROUSSEAU. — Le lion, ayant faim, se jette sur l'antilop

Ancien douanier en retraite, M. Henri Rousseau, auquel les Salons des Indépendants firen pour sa naïveté miraculeuse et sa gaucherie non apprise, a été accueilli avec un pieux respect au S où la toile reproduite ici occupe une place d'honneur.

C'est une miniature persane agrandie, transformée en un énorme décor, non dépourvu d'ailleu

THIÉBAULT-SISSON,

M. Rousseau a la mentalité rigide des mosaïstes byzantins, des tapissiers de Bayeux : il es sa technique ne soit pas égale à sa candeur. Sa fresque n'est pas du tout indifférente : je con lope du premier plan s'adorne à tort d'un museau de brochet ; mais le soleil rouge et l'oisea les feuillages témoignent d'une rare ingéniosité décorative.

LOUIS VAUXCELLES,

ALCIDE LE BEAU. — Le long du lac (Bois de Boulogne).

Il est tout un groupe qui continue le mouvement impressionniste avec talent, mais sans forme générale et l'aspect particulier des choses déjà vus par des peintres tels que Mone MM. Maufra,... Alcide Le Beau (qui, lui, voisine, cette fois, avec Van Gogh). Ils savent peindre e belles toiles : on ne peut que leur demander de découvrir la nature pour leur compte.

GUSTAVE GEFFROY, le

Il a élargi puissamment sa manière, rejette les détails superflus ; sa vision du Bois de Bou

HENRI MANGUIN. — La Sieste.

Manguin : progrès énorme ; indépendant sorti des pochades et qui marche réso-
vers le grand tableau. Trop de relents de Cézanne encore, mais la griffe d'une
te personnalité, toutefois. De quelle lumière est baignée cette femme à demi
sommeille sur un canapé d'osier !

LOUIS VAUXCELLES, *Gil Blas.*

GEORGES ROUAULT. — Forains, Cabotins, Pitres.

Il est représenté ici par une série d'études de forains dont l'énergie d'accent et la robustesse de dessin sont extrêmes. Rouault a
l'étoffe d'un maître, et je serais tenté de voir là le prélude d'une période d'affranchissement que des créations originales et
des travaux définitifs marqueront.
THIÉBAULT-SISSON, *le Temps.*

M. Rouault éclaire, mieux que l'an passé, sa lanterne de caricaturiste à la recherche des filles, forains, cabotins, pitres, etc.
GUSTAVE GEFFROY, *le Journal.*

M. Rouault... âme de rêveur catholique et misogyne.
LOUIS VAUXCELLES, *Gil Blas.*

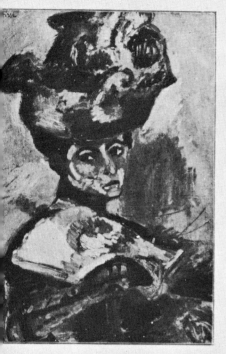

HENRI MATISSE. — Femme au chapeau.

ANDRÉ DERAIN. — Le séchage des voiles.

M. Derain effarouchera... Je le crois plus affichiste que
peintre. Le parti pris de son imagerie virulente, la juxta-
position facile des complémentaires sembleront à certains
d'un art volontiers puéril. Reconnaissons cependant que
ses bateaux décoreraient heureusement le mur d'une cham-
bre d'enfant.
LOUIS VAUXCELLES, *Gil Blas.*

LOUIS VALTAT. — Marine.

A noter encore : ... Valtat et ses puissants bords de mer
aux abruptes falaises. THIÉBAULT-SISSON, *le Temps.*

M. Louis Valtat montre une vraie puissance pour évoquer
les rochers rouges ou violacés, selon les heures, et la mer
bleue, claire ou assombrie.
GUSTAVE GEFFROY, *le Journal.*

ENRI MATISSE. — Fenêtre ouverte.

tisse est l'un des plus robustement doués des
aujourd'hui. Il aurait pu obtenir de faciles bravos:
s'enfoncer, errer en des recherches passionnées,
au pointillisme plus de vibrations, de luminosité
ouci de la forme souffre.
LOUIS VAUXCELLES, *Gil Blas.*

ri Matisse, si bien doué, s'est égaré comme d'autres
ricités coloriées, dont il reviendra de lui-même, sans

JEAN PUY. — Flânerie sous les pins.

Le Monde Illustré, 1905. The choice
of pictures indicates the
prevailing tastes of visitors to the
Salon d'Automne.

days nobody is in the least surprised by it. It looks just like an Ingres!
And yet, heaven only knows how many spears I've had to break for that
picture, which I don't altogether like but which is unquestionably the
work of *somebody*.'[27]

In his address to Eugène Carrière, printed in the 1905 catalogue,
Élie Faure gives the reasons for choosing two such different artists:
'The Salon d'Automne has undertaken to demonstrate, by its retrospec-
tive exhibitions, the permanent right of revolutionary endeavour to
rejoin tradition. . . . Like Puvis last year, Ingres and Manet make us
aware that the revolutionary of today is the classic of tomorrow.'[28]

The two exhibitions contained some remarkable works. Ingres was
represented by sixty-nine paintings and drawings. The central feature
was *The Turkish Bath*, lent by Prince Amadée de Broglie, and ten pre-
liminary studies from the Musée de Montauban. The Manet exhibition

contained thirty-one works and was arranged and selected by his friend, the critic Théodore Duret. Many of the pictures had not been seen since the retrospective exhibition of 1884. They came from all periods of his career and among them were *The Boy with Cherries, Concert in the Tuileries Gardens, Portrait of the Artist's Parents*, portraits of Zola, Berthe Morisot and Éva Gonzalès, *The Execution of the Emperor Maximilian*, and under a special heading of works done in the 'open air' was *The Roadmenders, rue de Berne*.

The pattern of exhibitions within an exhibition seems to have been encouraged by the Salon organizers. In addition to the two retrospectives there was a special room devoted to Rodin, a display of art and illustrated books – Théodore Duret's monographs on Manet and Whistler were on view alongside William Morris's *The Wood Beyond the World*, and Walter Crane's illustrations to Spenser's *The Faerie Queene* – and music-covers with lithographs by Bonnard, Chéret and Steinlen.

Several countries seem to have arranged special delegations to the exhibition. There was a strong Russian contingent with Kandinsky and Jawlensky prominent among them. There were also at least a dozen Americans, including four future exhibitors at the Armory Show, Putnam Brinley, Patrick Bruce, Theo Butler and Mahonri Young.[29]

Jean-Auguste Dominique Ingres, *The Turkish Bath*. By 1905 Ingres had fallen from grace and one critic went so far as to call this picture, 'nothing more than a timid and almost decent repetition of gestures from yesterday and poses from time gone by' (Cordonnier).

Right Jean-François Raffaelli, *Portrait of M. Clemenceau*. The portrait was much admired and was subsequently acquired by the Musée du Luxembourg.

Below View of the interior of the Salon d'Automne, 1905.

The British team was a very mixed group. It included Maxwell Arm-field, who can best be described as a post-Pre-Raphaelite, Roderick O'Conor, an associate of Gauguin at Pont-Aven, Gerald Kelly, future president of the Royal Academy, John Lavery, one of the most successful portrait painters in Edwardian England, and Sickert.

The *avant-garde* of several generations of French artists were grouped together. Cézanne, who had been given a special showing the previous year, again played a prominent part in the exhibition. He sent ten works, mainly landscapes of Provence, but also a large *Bathers* and a portrait of his wife. Renoir, now honorary president, sent several figure paintings. Guillaumin, president of the painting committee, Jean-François Raffaelli, represented by his much-admired *Portrait of M. Clemenceau*, and Odilon Redon, doyen of the Symbolists, were all grouped alongside each other in the room opening onto the central staircase, Room One in the Salon de la Nationale held in the spring, where they made a 'showpiece' for the whole exhibition.

The *avant-garde* of the 1890s was represented by Bonnard, who exhibited some of his finest and most sensual work – *Sleep*, *Dans le Cabinet de toilette*, *The Tub*, for example – Vuillard, who sent in some large decorative panels, Félix Vallotton, and Xavier Roussel with his typical nymphs and Bacchanales.

The sculpture, which, apart from Rodin's, was integrated with the paintings, was dominated by Émile-Antoine Bourdelle, a former pupil of Rodin and an important figure in the development of sculpture in the twentieth century; Rembrandt Bugatti, represented by his animal bronzes; Aristide Maillol; and Albert Marque, whose small bronze sculpture of a young boy is alleged to have been placed in the room with the Matisses, which inspired the art critic Louis Vauxcelles to remark: 'Ah – Donatello amidst the Wild Beasts [*Fauves*].'[30]

The 'Fauves', as they later came to be known, and other disruptive elements were all grouped together in Room Seven. Matisse was represented by ten works, including *Young Woman in a Japanese Robe*, *The Open Window* and the *Woman with a Hat*. In the catalogue these were listed under Henri-Matisse, the name adopted by Matisse to distinguish himself from the successful academic, Auguste Matisse.[31] Derain sent nine works, mainly landscapes done at Collioure. Vlaminck sent five oils, mostly early work, including riverscapes done at Chatou, and nudes in prostitute scenes *à la Rouault*; although all of them were characterized by vigorous brushwork and colouring they were not the most 'Fauve' of his career. The work of colleagues and acquaintances of Matisse hung nearby. Albert Marquet, Camoin, Friesz and Louis Valtat showed landscapes done in the South of France that summer. Jean Puy was represented by work he had done, isolated from the others, in Brittany. Kees van Dongen showed his brightly coloured figure paintings of the Parisian *demi-monde*.

The *avant-garde* section of the Salon d'Automne that year also included the work of two very individual artists, whose work cannot be

The Salon d'Automne, 1905. Cover of catalogue.

tied down to any one movement: Georges Rouault and Henri Rous
seau. Rouault, like Matisse a former student of Gustave Moreau, had
played a prominent part in the founding of the Salon d'Automne. He
was represented by a triptych entitled *Prostitutes*, with one panel being
inspired by M. and Mme Poulot, two characters from the novel by
Rouault's friend, Léon Bloy, *La Femme pauvre*. Bloy had no real eye for
painting and after a visit to the Salon d'Automne he wrote in his diary
on 31 October:

> This artist, whom one thought capable of painting seraphim, no longer
> seems to be able to conceive anything but atrocious, vengeful caricatures.
> The meanness of the bourgeois arouses such a violent reaction of horror in
> him that his art has apparently been fatally wounded by it. He thought he
> was doing my Poulots. For nothing on earth would I accept such 'illustra
> ·tion' as this.[32]

The more enlightened critics, however, were more generous to
Rouault. Thiébault-Sisson was complimentary and Louis Vauxcelles
observed: 'It is with the soul of a misogynist Catholic dreamer that
Rouault observes the hapless inmates of brothels and, with none of the
caustic bitterness of a Degas or a Lautrec, records the disfigurement of
their prematurely worn bodies.'[33]

Rousseau, a regular exhibitor at the Indépendants, and already acquir
ing a near-legendary reputation, was given a place of honour for one
of his largest and most beautiful works.[34] The title alone is famous for its
length and for its curious poetry. It reads: '*Le Lion, ayant faim, se jette
sur l'antilope, la dévore, la panthère attend avec anxiété le moment où, elle
aussi, pourra en avoir sa part. Des oiseaux carnivores ont déchiqueté chacun un
morceau de chair de dessus le pauvre animal versant un pleur! Soleil couchant.*'
('The lion, famished, leaps onto the antelope, devours it, while the
panther waits anxiously for the moment when it, too, can have its
share. Some carnivorous birds have each torn a piece of flesh from the
wretched animal, who is in tears. Sunset.')

The remaining exhibitors are hardly remembered today. But it is
worth noting the presence of Eugène Carrière, Simon Bussy, Marie
Laurencin, the famous poster artist Jules Chéret, Laure Hayman,
Proust's friend and model for Odette in *Remembrance of Things Past*, the
Canadian James Morrice, the Australian Impressionist, John Russell
and a future figure in the *avant-garde*, Francis Picabia, then a painter of
Impressionist landscapes.

Reviews of the exhibition began to appear on 17 October, the day
before it was open to the public. In the main they were friendly. *Le
Figaro*, which in the days of Albert Wolff had used every opportunity
to denigrate the work of the Impressionists, was now in the more
tolerant hands of Arsène Alexandre, and as a founder-member of the
Salon d'Automne he remained basically in favour of its policies. *Le
Temps*, *La République Française*, and *Gil Blas* carried favourable notices.
L'Intransigeant was one of the few newspapers to criticize the Salon for
its leniency. The intellectual reviews, which appeared later, in general

Above Kees van Dongen, *La
Chemise noire*, 1905–6.

Opposite Édouard Vuillard: *La
Lecture*, 1896. 'He is the most
personal, the most intimate of
storytellers. I know of few pictures
which bring the observer so
directly into conversation with the
artist. I think it must be because his
brush never breaks free of the
emotion which guides it ...'
(André Gide, *La Gazette
des Beaux-Arts*).

André Derain, *Collioure*, 1905.

supported the exhibition even if they disagreed with some of its activities.

By the standards of Manet's day the level of criticism seems rather bland. What it makes up in tolerance it loses in bite. The invective of Saint-Victor, the enthusiasm of Gautier, the independence of Thoré and Castagnary and the pugnaciousness of Zola in his early days are missing. And with one or two notable exceptions there is the feeling that critics were not fully aware of the significance of the occasion. Surprisingly few of the critics mention Matisse by name and the references to the new paintings of Matisse and his friends are veiled in generalities. Arsène Alexandre, for example, goes out of his way to mention everyone he can in his review of up-and-coming young painters to watch, without describing Matisse's work or seeing any connection between it and the other exhibitors in Room Seven. R. de Bettex in *La République Française*, Thiébault-Sisson in *Le Temps*, and Charles Morice in *Mercure de France* fail to mention Matisse at all. Only André Gide in the *Gazette des Beaux-Arts*, Maurice Denis in *L'Ermitage* and Louis Vauxcelles in *Gil Blas* were really aware of a new development, and although they were not entirely in favour of it, they were all aware that Matisse was a powerful new force in painting.

The views of the correspondent of *The Times* agree with the majority of his French colleagues. His report, published on 19 October, states:

The battle waged by the courageous enthusiasts who felt the time was ripe to secure official recognition for the revolution that has taken place in the art of painting in this country has been a long one. They have won it splendidly. The visitors to the Grand Palace of the Champs Elysées during the next five weeks will find themselves in the presence of a demonstration of art sufficiently characteristic and original to justify the founders in their initiative. . . . Mannerism, mercantilism have not yet invaded this association, which is composed of searchers whose daring stops short of audacity, and whose sincerity has none of that spirit of paradoxical opposition which characterised the disquieting energies of the youths of the Salon des Indépendants.

The Salon d'Automne is made up, it is true, of revolutionary painters, but not of anarchists. There is no sensationalism here, but a quiet harmony of effort to record frankly and honestly sensations that neither the tyranny of a 'school' nor the direct suggestion of a master have imposed.[35]

The sentiments of *The Times*'s man in Paris are proper enough, but it seems possible that he never went to Room Seven, and if he looked at the Matisses, the Rouaults, the Derains, the Rousseau, he must have thought that the safest course was to ignore them. Indeed his taste was for Vuillard, Simon Bussy, M. Maufra, 'one of the best of Marine painters in France', and for a host of Edwardian nonentities. He, like many of his Paris colleagues, seems to have regarded the triumph of Manet and 'the famous revolutionaries of 1874', after years of hostile opposition from their critics, and their new association with 'tradition', here visibly expressed in the form of Ingres, as an excuse for avoiding a

confrontation with the young revolutionaries of the twentieth century.

Arsène Alexandre, like *The Times*'s correspondent, is only too aware of the danger of ridiculing that which is not at first understandable. 'How many times lately have great artists been taken for daubers?' he asks. 'The presence of twenty to thirty fine works by Manet in the retrospective section of the Salon serves as a warning to look carefully at those who show daring, and to have sympathy, even compassion, for those who in all sincerity deceive themselves, while mumbling their profession of faith.'[36]

But Arsène Alexandre's warning was ignored by two short-sighted critics who still felt on safe ground in attacking Cézanne. 'Let others admire the Cézanne-style scarecrows,' wrote R. de Bettex in *La République Française*, 'painted with mud, or something even worse, and let us stop instead in front of this *Eileen* by John Lavery, where we find again all the touch of the colourist of the *Young Woman in White* of 1903.'[37] Félix d'Anner in *L'Intransigeant* is equally blunt: 'Of M. Cézanne, I will say nothing; his art – since it seems that it is art – is on a level that is beyond my humble comprehension. But each must judge for himself.'[38]

On a more serious level there was some disagreement between the critics on the merits and significance of Ingres. Alexandre saw in Ingres a 'fighting artist' and a 'great revolutionary':

His conception of form, which he believed in good faith he had inherited from the Greeks and from Raphael . . . was in reality the most audacious and most modern of all. The proof of this assertion can be seen again in the most admirable *Turkish Bath*; the art of our time has not produced anything freer, less classic and more passionate. The shape, the proportions, the character all reveal Ingres to be the ancestor of these young 'deformers' who perhaps make you smile today.[39]

Émile Cordonnier in *La Grande Revue* took a diametrically opposite line:

. . . his women lack conviction. One gains the impression of a preface to a book which does not exist, a prologue to a play of which the first act has not been written, of a stage before the curtain rises, of a church service with no priest officiating. There is no orgy. It is nothing more than a timid and almost decent rehearsal of tomorrow's gestures and poses.[40]

Cordonnier, like many of his colleagues, believed that there was more sincerity and more passion in a Carrière than in an Ingres:

None knew better than him how to draw out the infinite tenderness of a mother's kiss and the confident response of the child. This time, it is the evening kiss, the soft farewell before the sleep of night. The child offers his lips to his mother who presses them greedily, holding him in a long caress, in a gesture of regal possession, of egotistical passion, as if she wished to recapture her child, to have him all for herself alone, in the same way as once, before his birth, they had mingled their souls and their flesh.[41]

Rousseau threw the critics into a quandary. They seemed unsure whether to smile at his *gaucherie* or marvel at his innocence, to admire his sincerity or to criticize his childishness. He seemed to play a deeply ambiguous role within the *avant-garde*. His simplicity of character was both an impenetrable mask and the real thing. One critic, Thiébault-Sisson, noted his influence on the young:

The ideal to which a section in the battalion of young artists recently aspired involved recapturing the soul of a small child – that of a small child who has never seen any images – to look at nature and life with sincerity, and to interpret both with greater naïveté. But unless one is a savage or an invalid, it is difficult to keep the soul of a small child when one reaches maturity; it is even more difficult to recapture it once one has lost it. Therefore all these would-be *naïfs* marvelled at a newcomer called Rousseau.[42]

Thiébault-Sisson recognizes the sincerity of Rousseau's endeavour:

. . . in his retirement he satisfies an inner compulsion by daubing on canvases. . . . Being free of any academic training or any long study of the masters in the Louvre *le douanier* Rousseau was free to interpret nature and life exactly as his eye saw them; the hand of this man who came to painting late in life translated his vision into paint with a child-like application that was the wonder of all these young painters who sought their models among the primitives and made painstaking efforts in which freshness and spontaneity were sadly lacking. . . . Rousseau, with prodigious intensity, realized the ideal to which they aspired: he was a fetish for them, a mascot. But the mascot is no more.

Rousseau's visual innocence, he believed, had been overwhelmed by the recent exhibition of Persian miniatures (an exhibition which, incidentally, had impressed Matisse too), and *Le Lion, ayant faim . . .* was a miniature blown-up into a huge decorative mural. According to Vollard, who may have invented the story, the comparison caused the president of the Salon d'Automne to shudder. 'Persian, in my place!' M. Jourdain is alleged to have remarked. 'I shall be blamed for not being up to date.'[43]

Thiébault-Sisson seems to link the Fauves, though he does not mention their names, or identify them as a group, with Rousseau. In fact Matisse never thought very much of *le Douanier*'s paintings and it was Picasso who really admired his work and played host at the legendary banquet in Rousseau's honour in 1908. But Thiébault-Sisson was not alone in sensing a new interest in primitive art – the critic for *Le Monde Illustré* felt that the 'terrible revolutionaries' of Room Seven, who had become the pontiffs of an '*art sauvage*', had borrowed their motifs from the 'multicoloured carts painted by Sicilian peasants and the prows of the fishing-boats of Chioggia'. Felix d'Anner noted 'the legendary Douanier Rousseau, to whom a special place of honour has been granted' and the proximity of a whole heap of 'excentricities, extrava-

ganzas and bluffs which are deliberately meant to astound the bour
geoisie and the critics'. But d'Anner seems to regard it as all a bit ol
hat:

Today the bourgeoisie and the critics are less 'shocked' [*épatés*] than the
used to be – they have seen so much! – and if it were still possible for some
thing to amaze them, then it would be the extraordinary candour with whic
certain people, despite everything, persevere in their identical little dis
plays. . . . It would be regrettable to see [the worthwhile] drowned in a wav
of productions whose proper place is at the Incoherents or elsewhere, bu
not at a Salon which has become an accepted survey of French art.[44]

The more serious critics realized that it was too easy to dismis
Matisse's work as irrational. They also realized that Matisse's new
style did not stem from any outside source but from an inner compu
sion to examine the very nature of painting itself. Louis Vauxcelles i
Gil Blas felt that Matisse was 'one of the most richly endowed c
today's painters', who, instead of remaining content with past succes
had chosen to 'drive himself on, to undertake passionate experiment:
and to force Pointillism into greater vibrations'. Vauxcelles had reserv:
tions about Matisse's new work because he believed that his sens
of form had suffered as a result of his preoccupation with colour.

André Gide was no less convinced of Matisse's natural gifts, but

. . . the canvases that he paints today seem to be demonstrations c
theorems. I stayed quite a while in this gallery. I listened to the visitors an
when I heard them exclaim in front of a Matisse: 'This is madness!' I fe
like retorting: 'No, sir, quite the contrary. It is the result of theories.' Ever
thing can be deduced, explained; the intention has nothing to do with th
matter. Without doubt, when M. Matisse paints the forehead of this woma
apple colour and the trunk of this tree an outright red he can say to us, 'It
because – .' Yes, this painting is reasonable, or rather it is reasoning. How f:
removed from the lyrical excesses of a Van Gogh. . . .[45]

Gide felt that Matisse had been motivated by the principle c
exaggeration for its own sake, as did Gustave Geffroy in *Le Journa*
But Maurice Denis, in *L'Ermitage*, which had Rémy de Gourmont an
André Gide on its editorial board, felt that he was driven by the desir
to discover the principles of pure painting:

Of course, as in the most extreme departures of Van Gogh, something st:
remains of the original feeling for nature. But here one finds, above all in th
work of Matisse, the sense of the artificial; not the literary artificial, like th
search for idealistic expression; nor that of decorative artificiality, such as on
sees in Turkish and Persian carpet weavers; no, it is something even mo
abstract; it is painting above every contingency, painting in itself, the pu
act of painting. All the qualities of the picture other than the contrasts of li:
and colour, everything which the rational mind of the painter has not co
trolled, everything which comes from instinct and from nature, finally all th
factors of representation and of feeling are excluded from the work of a:
Yet, strange contradiction, this absolute is limited by the one thing in th
world that is most relative: individual emotion.[46]

Denis concludes: 'The recourse to tradition is our best safeguard against the infatuation with reason, against an excess of theories.' He could not really accept the idea of pure painting and he mistakenly felt that Matisse was motivated by an idea rather than by instinct. Yet he correctly recognized Matisse as a new force in painting and was aware that 'the school of Matisse is the most alive, the newest and the most disputed'.

Denis and others like him were, however, far ahead of public opinion. The crowds going to the exhibition were, as one might have expected, more vigorous and more vocal in their dislike of the paintings of Matisse and his friends. As at the Salon des Refusés their reaction was a mixture of laughter and anger, and there is an echo of Zola's description in *L'Oeuvre* of the crowd's behaviour before the *Déjeuner sur l'herbe* in some of the eye-witness accounts. A friend of Sarah and Michael Stein, Thérèse Jelenko, recalled the atmosphere of the crowds before Matisse's *Woman with a Hat*: 'I still can see Frenchmen doubled up with laughter before it, and Sarah saying, "it's superb" and Mike couldn't tear himself away.'[47]

The Stein family, Michael, Leo and Gertrude, and Michael's wife Sarah, had, after many travels, recently gravitated to Paris. Leo, who

ve Maurice Denis, *Self-portrait*,
8. The founder and principal
orist of the Nabis, he came to
t a considerable influence
writer and champion
ézanne.

t Leo, Gertrude, and Michael
n in the courtyard of 27 rue de
rus, Paris, *c.* 1906. The Stein
ily temporarily united.

had a naturally inquiring turn of mind and was an amateur painter, was on the look-out for new work. Only a year before the art historian Berenson, in response to Leo's request to see more challenging new work, had suggested that he should look at the Cézannes at Vollard's. Leo had been converted, and in the spring of 1905 he and Gertrude acquired the *Portrait of Madame Cézanne* (now in the Bührle Collection, Zürich). Leo had gone to the Indépendants and, as has already been noted, failed to respond to Matisse's Pointillism, but the sight of the *Woman with a Hat* astonished him. He later wrote:

It was a tremendous effort on his [Matisse's] part, a thing brilliant and powerful, but the nastiest smear of paint I had ever seen. It was what I was unknowingly waiting for, and I would have snatched it at once if I had not needed a few days to get over the unpleasantness of the putting on of paint. One was not yet accustomed to the smears that since then are commonplaces of technique. It was almost worse than had been the splashy points.[48]

Gertrude Stein went with her brother to the exhibition and in *The Autobiography of Alice B. Toklas* she describes the reaction to Matisse's *Woman with a Hat*, and compares it to the Cézanne portrait she and her brother had bought:

People were roaring with laughter at the picture and scratching at it. Gertrude Stein could not understand why, the picture seemed to her perfectly natural. The Cézanne portrait had not seemed natural, it had taken her some time to feel that it was natural, but this picture by Matisse seemed perfectly natural and she could not understand why it infuriated everybody. Her brother was less attracted but all the same he agreed and they bought it. She then went back to look at it again and it upset her to see them all mocking it. It bothered her and angered her because she did not understand why because to her it was so all right. . . .[49]

Gertrude Stein's muddled account – she confuses both the time and the place of the exhibition – infuriated Leo. She seemed to imply that he would have preferred to buy something else. In a letter to Dr Albert Barnes dated 20 October 1934 Leo wrote to thank the collector for sending him his monograph, *The Art of Matisse*, and having congratulated the author on his work, he turned quickly to the subject that nagged him: Gertrude's autobiography, published the previous year. He asks:

I suppose you have read her autobiography, that farrago of rather clever anecdote, stupid brag and general bosh.

Her yarn about the *Femme au Chapeau* is a wonder. The picture which she says I bought as a compensation is one I had bought several years earlier, before I'd even heard of Cézanne, while Gertrude was still in America, and which she had seen on the walls of the studio every day that she was in Paris for two years preceding. . . .

Until Gertrude bought a Cubist Picasso, she was never responsible for a single picture that was bought, and always said so. She was proud of her slow reaction time, and always said she couldn't tell whether she liked a picture or not until she had lived with it, and so on. . . .[50]

Whichever of the Steins was behind the purchase of the *Woman with a Hat*, and Leo seems the most likely, the purchase itself made a great difference to the artist and helped restore his morale.[51] Matisse made only one visit to the Salon and was so shocked by the reception of his paintings that he never returned. Even his friends, including the Socialist politician Semblat, were against him. His wife kept clear of the exhibition altogether. The offer to purchase the *Woman with a Hat* must have been as unexpected as it was welcome. The Matisses were short of money, but with iron will they turned down Leo's first offer of four hundred francs for the picture, which was one hundred less than the asking price. According to Gertrude Stein it was Matisse's wife who had persuaded her husband to hold out for more. Leo raised the offer and the *Woman with a Hat* entered the flat of Leo and Gertrude Stein in the rue de Fleurus.

Thus ended an eventful chapter in the story of modern art. A decisive break with the past had been made. Matisse soon overcame the initial sense of discouragement and embarked on a major composition, the *Joy of Life*. Signac, his former champion, wrote in January 1906, 'Our young painters, a little ravenous, manage to exhibit all the time and bowl over the collectors. Matisse, whose attempts I have liked up to now, seems to have gone to the dogs.'[52] Matisse paid no attention – though according to Duthuit there was a row between the two painters – and the next spring, after a visit to North Africa, he was back once again in Collioure. Derain, at Vollard's suggestion, followed Monet's example and went to London, where he painted some of the finest pictures of his career and some of the purest examples of Fauvism. Vlaminck remained true to the Seine and, encouraged by a windfall from Vollard, who bought his entire studio, allowed his natural exuberance full throttle. Braque joined the movement, though in fact it was never a movement as such, and there was never a common doctrine or ideal agreed by all the members. Fauvism amounts to no more than the sum of its individual parts.

However, certain points held in common by the Fauves, notably their belief in the primacy of colour, began to have an effect throughout Europe. In 1905 four art students at the Technical Institute in Dresden, Ernst Ludwig Kirchner, Erich Heckel, F. Bleyl and Karl Schmidt-Rottluff, joined together to form *Die Brücke* ('The Bridge'). Emil Nolde was invited to join the group in the following year and in 1907 Kandinsky, on his way back to Munich from Paris, took part in the second *Die Brücke* exhibition. No doubt he informed his German colleagues of the Fauves and their experiments. In any case Matisse's work was beginning to be well known in Germany due to the efforts of Hans Purrmann, a devoted admirer of Matisse, who had come to Paris in 1905 to see the Manet retrospective but had been overwhelmed by the Matisses instead. Five years later two English critics, Roger Fry and Clive Bell, made the same discovery, and the effect of that discovery is the subject of the next chapter.

4 The Post-Impressionists

The fifth of November is, as all English children know, reserved for the memory of Guy Fawkes and his attempt to blow up the Houses of Parliament with all inside it, including King James I. In the course of time the date has become an excuse for a party, and Guy Fawkes has emerged, if not as a hero, as a kind of patron saint for all those wishing to destroy tradition at one stroke. The fifth of November was an appropriate day, as one art critic, Robert Ross, has noted, for 'revealing the existence of a widespread plot to destroy the whole fabric of European painting'. On that day in 1910 'the Press were invited to the Grafton Gallery – an admirable substitute for the vaults of Westminster – where the new Guido Fawkes, his colleagues, and alleged predecessors are exhibiting their gunpowder. . . . Today, which is the private view, it will be decided if the anticipated explosion is going to take place.'[1]

He was referring to an exhibition called 'Manet and the Post-Impressionists', Guido Fawkes was Roger Fry and, as he feared, an explosion did take place which, if it failed to destroy the whole fabric of European painting, did fundamentally affect the course of British painting in the twentieth century.

The Monday newspapers in Britain were full of reports on the exhibition, mostly critical, and these were followed by letters from eminent leaders in the art world denouncing the paintings. There developed what Sickert described as a 'rumpus', and the rumpus collected a crowd. Soon everyone was involved, not just those interested in art, but politicians, writers, passers-by and what the *Illustrated London News* admitted to be all fashionable London. The rooms of the Grafton Gallery were full of excited, gesticulating people. The painter Duncan Grant remembers visitors expressing their anger by shaking their umbrellas at the paintings. Others merely laughed and, according to the secretary of the exhibition, Desmond MacCarthy, there was 'a stout elderly man of a good appearance, led in by a young woman, who went into such convulsions of laughter on catching sight of Cézanne's portrait of his wife in the first little room that his companion had to take him out and walk him up and down in the fresh air'.[2] Oliver Brown, a director of the Leicester Gallery, remembered an old Academician saying to him, 'Don't go in, young man, it will do you harm. The pictures are evil.'[3] Wilfrid Scawen Blunt, the poet and statesman, who was old enough to recall the fuss generated by the Pre-Raphaelites noted in his *Diary* that the paintings at the Grafton Gallery were 'works of idleness and impotent stupidity, a pornographic show'.[4]

Considering that the principal exhibitors in the exhibition were safely dead, and considering that the organizers had been careful to exclude any nudes of questionable propriety, Blunt's words seem all the more

The Illustrated London News, 3 December 1910. 'I found among the cultured who had hitherto been my most eager listeners the most inveterate and exasperated enemies of the new movement.' (Fry).

There are
some who smile;

Some who
are ecstatic;

Some who seek
the why;

Some who
look for the
wherefore;

Some who peer
in a desire to
praise;

Some who
would imitate;

Some who point the
finger of scorn;

Some who explain what to
them is unexplainable;

Some who are in blank
amazement, or stifle
the loud guffaw;

Some who
are angry;

Some who sleep.

F. R.

startling. What was there about the paintings that seemed so offensive and so dangerous? Why did people regard some of the works as obscene? What was the reason for such violent language?

Today the rumpus seems almost inconceivable. The main exhibitors Cézanne, Van Gogh and Gauguin, are among the most widely popular artists of all time, better known through reproductions than many masters of the Renaissance. But to understand why such a large number of adult men and women went astray it is helpful to know something about the art world in Edwardian London.

In 1904 Sir Edward Poynter, president of the Royal Academy, told a Select Committee of the House of Lords: 'The best artists come into the Academy ultimately. I do not say that there have been no exceptions but as a general rule all the best artists ultimately become Academicians.' These were remarkable words. The Academy had been under constant attack for the best part of fifty years. From the emergence of the Pre-Raphaelites onwards it had shown itself to be a reactionary institution, reluctant to recognize new talent. Some of the most distinguished artists of the nineteenth century – Holman Hunt, Rossetti, Burne-Jones, Watts and Whistler – had either been refused admittance or had refused to join even when invited. The Academy's administration of the Chantrey Bequest – the only fund available for the purchase of works by living artists for the nation – was shown to be incompetent if not corrupt, and it was as a result of this scandal that Sir Edward found himself before a House of Lords inquiry.[5] Yet despite these attacks the Academy remained the unofficial arbiter on all artistic questions and its exhibitions remained the main artistic event in Britain well into the twentieth century.[6]

From 1870 to 1914 was a glorious period for living artists, particularly Academicians. Fortunes were made and one painter, Frederic Leighton, became the first artist in Britain to be raised to the peerage. He died in 1896, having lived to see his neo-classical works triple in value. His contemporaries, Sir Lawrence Alma-Tadema, and Sir Edward Poynter, remained respected and revered figures right up to their deaths in 1913 and 1919 respectively. The British were devoted collectors of their work and other leading nineteenth-century artists. At the famous sale of modern pictures formed by the mining millionaire George MacCulloch in 1913 a Millais was sold for £8,190, a Burne-Jones for £5,040, an Alma-Tadema for £2,730 and two conversation pieces by the genre painter William Orchardson for £4,620 each. The collection, which fetched a total of £136,859, would, as Gerald Reitlinger has pointed out, have brought a new destroyer for the navy or a small passenger liner, but 'if it were sold today, it might buy a small motor launch'.[7]

Since Whistler's arrival in London in the 1860s there had been a series of attempts to break the hegemony of the Academy, but, like the Catholic Church, the Academy succeeded eventually in forgiving and em-

bracing most of the rebels. From 1880 to 1910 the main centre of rebellion was the New English Art Club, which consisted mainly of artists who had trained in France and whose work showed the influence of the French Impressionists, if only at second or third hand. It was founded in 1886 and one of the original members was the portrait painter John Singer Sargent, who had studied under Carolus-Duran in France and had associated with Monet and Pissarro. Another leading member was Walter Sickert, who had had the benefit of a close friendship with Degas. The New English contained many factions – there was the Newlyn group consisting of George Clausen, Henry Tuke and H. La Thangue, a Glasgow contingent led by John Lavery and Crawhall, and a London group with Sickert, Philip Wilson Steer, Frederick Brown, Sydney Starr and Théodore Roussel – but it was united by its opposition to the Academy and its respect for recent developments in French painting. According to Alfred Thornton there had at the start been the idea of calling the club the Society of Anglo-French Painters. He and his friends were, he says, 'in utter revolt against the prettiness and anecdotal nature of the work at home, and enthusiastic for the impressionism of Monet, as well as for Manet, whose *Olympia* was still a cause of fierce controversy.'[8] The opposition to the Academy had an anti-Ruskin and anti-William Morris flavour and much of the debate stemmed from two sources – Whistler's famous 'Ten O'Clock' lecture, delivered for the first time in 1885, which said in effect that a work of art did not need Ruskin's sense of morality for it to give pleasure, and R.A.M. Stevenson's book on Velazquez, first published in 1895, particularly the chapter entitled 'The Dignity of Technique', which again minimized the importance of subject-matter in art and stressed the artist's chosen means of expression or technique.[9]

In their day the New English Art Club, and their views on art, aroused heated argument. They were vehemently attacked by the Academy and its supporters and defended with equal vigour by critics like Robert Ross, who was a director of the Carfax Gallery and wrote for the *Morning Post*, D.S. MacColl, a future director of the Tate Gallery and a tireless opponent of the Academy over the Chantrey Bequest, and later Frank Rutter, art critic for the *Sunday Times*. Gradually the New English won acceptance and their works began to sell – Steer never seems to have had much difficulty in that respect – and with that English ability to forget differences of principle in the interest of a compromise over details, one by one the members of the Club began to drift over to the Academy: Sargent became an associate in 1894, Clausen in 1895, La Thangue in 1898, Tuke in 1900 and William Orpen in 1910. Soon people came to regard the New English as a stepping-stone to the Academy itself, and this was already noticeable in the years leading up to the Post-Impressionist exhibition. The final seal of approval for the club was given by the Establishment dealers, Agnew's, who in February 1906 put on an exhibition entitled 'Some Examples of the Independent Art of To-day'. 'What a glorious moment

it was!' wrote Frank Rutter. 'It was a great victory for the New English. Steer, Tonks, Sickert, Rothenstein, Orpen and the rest had "arrived". They were at Agnew's!'[10]

One artist among them, the most talented, Sickert, refused to be drawn in the direction of the Academy. As a friend of the Impressionists he still felt it necessary for artists to behave as they did in France and '*épater le bourgeois*'. He had spent the last six years, from 1899 to 1905, living abroad, mainly in Venice and Dieppe, and although he continued to send paintings to the New English exhibitions he had been unable to play much part in their affairs. On his return he found the members, with their new air of respectability, not as congenial as before and he began to see more of younger artists like Spencer Gore, Harold Gilman, Lucien Pissarro, Robert Bevan and Augustus John. His studio at 19 Fitzroy Street became a meeting-place. On Saturday afternoons cups of tea were handed out, pictures by Sickert's friends were placed in rotation on the easel for inspection and even bought by visiting collectors. Young artists like Wyndham Lewis, Henry Lamb and Albert Rutherston made their first mark in Fitzroy Street. A nucleus of *habitués* was formed that became the Camden Town Group and later the London Group. An off-shoot of their activities was the Allied Artists' Association, started by Frank Rutter, which held an exhibition at the Royal Albert Hall in July 1908, modelled on the jury-less Société des Indépendants. It was a confusing exhibition with over three thousand works on view, but it did bring to light a number of now prominent names, among them the Scottish artists J. D. Fergusson and S. J. Peploe. At the second exhibition in 1909 Kandinsky was represented by his first abstracts, which inevitably caused considerable discussion, but which, surprisingly, found a buyer in a young writer and don, Michael Sadler, one of the most adventurous collectors of his time.

The Fitzroy Street group were a loose association with no real artistic or social ties and from the beginning there was a certain amount of coming and going between them and the New English; Sickert and John, for example, exhibited at both. But in so far as they were a group, they were more 'advanced' than the New English and more up-to-date in their contacts with developments in France. Bevan had worked with Gauguin at Pont-Aven, and his colleagues Gore and Gilman all came under Gauguin's spell. Pissarro, through his father, was the best informed of them all about French painting, and at one stage had been associated with the Neo-Impressionists. John had made many visits to Paris from 1899 onwards and although he did not like what he saw he had at least been to see what was happening at the Indépendants and other exhibitions.

But if the members of the Fitzroy Street group were advanced by British standards they could hardly be called *avant-garde*. The spirit of revolt, of defiance of authority, of change for change's sake, of anarchy and restlessness that had affected every major city in Europe – Munich,

Dresden, Berlin, Brussels, Paris and Moscow, in particular – is almost totally absent from the London artistic world. There was an underworld in London, made up from immense poverty and lawlessness and spiced with petty villainy, but never a Bohemia; and although one or two writers had explored it, Dickens for example, it had never been glamorized into a place of escape. There is no equivalent to the Latin Quarter in London: Whistler's Chelsea was never an artistic *quartier* in the Parisian sense and it cannot be compared with Montparnasse and Montmartre. There was no Jarry, and therefore no tradition of outrageous, silly behaviour, no Apollinaire to preside over and support new art forms, no Fauves, no 'wild men'. Apart from the Café Royal there were no artistic cafés and certainly nothing to match the *chansonnier* establishments like the famous 'Chat Noir' and the 'Lapin Agile'. Instead of wild gatherings, like the celebrated banquet for Rousseau given by Picasso and others at the *Bateau Lavoir*, there were the endless dinner parties arranged by Rothenstein and his friends at the Chelsea Arts Club – usually ending with speeches. This lack of an *avant-garde* tradition explains the almost incredulous surprise that greeted some of the paintings in the Post-Impressionist exhibition. Parisians could say they had seen it all before; Londoners could not.

In these circumstances the excitement and sense of novelty provoked by Augustus John in the 1900s is perhaps less surprising than might at first be thought. His tall, well-built figure, beaky nose, careless dress, his travels with the gypsies and his sexual adventures combined to form a colourful figure. But although he was considered too 'advanced' for the Agnew's exhibition, his art remained closely linked with tradition. He did for a time toy with a more expressive palette but he never made the break with natural colour and he stops well short of what even an artist like Kees van Dongen achieved. But in the 1900s several people, including collectors like Michael Sadler and critics like Frank Rutter, regarded John's work as new and original.

Augustus John photographed by Beresford, 1902. Unconventional in his dress but traditional in his art.

We expect so much more in the way of novelty from our artists nowadays [explained Rutter in 1933]. We were more humble and easily contented then. John did not wring admiration from us because he was able to put into exhibition-frames things the like of which had never before been seen in frames – or anywhere else. John had not the inventive resourcefulness of M. Picasso. We admired John, not because he was doing new things, but because he was doing old things superbly well, better than they had been done for a long, long time.[11]

The ability to admire old things done well, and feel happy about it, is typical of the age and the Edwardian turn of mind. It affected artists as well as critics, and as a result the era is characterized by a host of minor painters like William Nicholson, Henry Tonks, William Rothenstein, Charles Conder and others with limited ambitions but showing high standards of skill. The painting has a peculiarly lazy English charm. Its lack of novelty is in a way its saving grace and although

much of the work rightly deserves the epithet 'genteel', and although few people outside Britain are ever likely to take it seriously, nevertheless there were one or two artists of real ability: Sickert, first and foremost, who stands out now as he did in his own time as the one major artist to emerge in Britain from the death of Turner to the birth of Francis Bacon; not far behind are Steer and Gore; Sargent's flashiness seems more and more forgivable – he was a dazzling painter – and his fellow portrait painters Lavery, Orpen and John were successful in what they attempted to do.

But there is a reverse side to this coin, a less happy picture. The leading Edwardian artists, critics and collectors were depressingly complacent and insufferably insular, almost provincial. It was as if Victorian jingoism had affected their artistic judgement and by admiring their own native produce they were lulled into a false sense of security with regard to invasion from abroad. From 1880 onwards wave after wave of British artists went to Paris to study and although they did not remain immune to developments in French painting it is remarkable how little their Parisian experiences meant to them. Few of them really bothered to seek out what was happening or to take part in *avant-garde* life. Lavery, for example, missed seeing the Impressionists when he was a student in Paris; Steer had apparently never heard of Manet before the memorial exhibition of 1884; and Roger Fry, as an art student in Paris in 1892, was remarkably unadventurous, and in his letters home merely comments on his disappointment with Whistler and Jules Bastien-Lepage.

This reluctance to get embroiled in the Parisian art world (and it also affected the many American artists studying in France) is not easily accounted for except in human terms. They remained apart, partly because the bohemian tradition was alien to them, partly because of shyness, and partly because of a language barrier. Both Lavery and Steer, for example, give their lack of command of French as an explanation for their failure to find out more about the Impressionists and Impressionism during their student days in Paris. But even when language offered no problem English artists seldom bothered to seek out their French or European colleagues for discussions, as Clive Bell has confirmed.[12]

The same reluctance to find out about the latest developments in French painting affected collectors and the public at home. 'The old story that the English were proverbially slow to discover the greatness of the French Impressionists is a tendentious half-truth,' maintains M Douglas Cooper in his invaluable study of the English response to French Impressionists. 'The truth is that the artists, the critics and the public interested in art in England were well acquainted with many of the developments of French art between 1860 and 1900 but that they were not enthusiastic about what they saw and looked down upon Impressionism as a passing craze.'[13]

Even the exhibition of Impressionist pictures organized by Durand

Ruel at the Grafton Gallery in 1905 had a mixed reception. The exhibition itself was an enormous draw and was seen by twelve thousand people. Rutter recalls meeting a young cousin of his, 'seated on a settee in the big gallery and the tears were streaming down her face. "What's the matter?" I asked. "The pictures are so beautiful", she sobbed in reply.'[14] But he adds that his cousin belonged to the minority. A large number of visitors were still commenting on the lack of finish of many of the paintings and wondering why even skilled painters should bother with such ugly subjects. He also tells of his difficulty in persuading the National Gallery to accept an Impressionist painting even as a gift. Mr Cooper records that less than ten of the three hundred pictures were sold. Collectors in Britain, if they were interested in nineteenth-century French paintings at all, preferred the work of the Barbizon school or the followers of Millet, and Dutch equivalents like the Maris brothers.

There are many explanations for the failure of the English to appreciate the greatness of the French Impressionists. Provincialism has something to do with it and a misplaced enthusiasm for the native school is also a factor. It is tempting to regard this failure as reprehensible, as writers from Rutter to Cooper seem to do, but although England had as many philistines, as many bone-headed Academicians and as many badly advised collectors as any nation, their numbers are not enough to explain the lateness of the English appreciation of Impressionism. There is a deeper reason, which is seldom mentioned because it is hard to pin down. It has to do with English visual habits which from the Pre-Raphaelites onwards found enjoyment in what Professor Quentin Bell has called 'hard-edge' painting.[15] It favoured bright enamel-like colour, sharp-focused images, and a curving, sinuous but definite outline, and this taste, adapted by William Morris to design and continued in painting by artists like Walter Crane and Burne-Jones, persisted alongside Whistler's soft, fuzzy colorations until well into the twentieth century. The 1890s, for example, saw not only the emergence of Steer, Sickert and Sargent, 'sloshers', to use the Pre-Raphaelite term, but also the linear, hard black-and-white inventions of Beardsley, which were immensely popular in Britain, and William Nicholson's equally successful posters with their flat, even colour and simplified designs. Thus the year that saw the first Post-Impressionist exhibition, 1910, also saw the death of the last Pre-Raphaelite, Holman Hunt. He still had a devoted following and his exhibition at the Leicester Gallery in 1906 was, according to Oliver Brown, a great crowd-puller.[16] The taste for hard-edge painting affected the appreciation of the Old Masters – Botticelli rose to prominence between 1890 and 1905 – and also the understanding of contemporary French painting. Degas, the artistic descendant of Ingres, for example, was the most liked of the Impressionists, and Gauguin, the least 'sloshy' of the Post-Impressionists, was also the least disliked.

Roger Fry was not immune to this attitude. The Pre-Raphaelite tradition undoubtedly played a part in the formation of his taste.[17] His first forays into painting and art criticism were conducted under its influence and as a result Fry was never really happy with Impressionism; he always felt there was something missing. As a student in Paris he says, in one of his letters, that he does not like undigested facts thrown at his head. Back in London he often found himself an outsider in New English Art Club discussions; 'cussedness', he said later, prevented him from appreciating the merits of Sickert and Steer; he never succumbed to Sargent's lush technique: 'Mr Sargent', he wrote, 'is simply a précis writer of appearances.'

In *Vision and Design* Fry puts his dissatisfaction with Impressionism down to the absence of 'structural design'.[18] But there is a feeling that at the time Fry found Impressionism, at least the English variant, slightly immoral and lacking in scientific precision. And to a man with his particular background these would have been important factors.

Short of reading Virginia Woolf's moving and successful biography of Roger Fry[19] there are one or two facts about his life that are relevant to the understanding of his taste. First he was brought up as a Quaker. He came from two of the oldest Quaker families in England, the Frys and the Hodgkins. Quaker morality, its puritanism, its scrupulousness, its disapproval of pleasure, was bound to leave a lasting mark on all brought up in its shadow. It was also bound to make a young man feel a sense of difference and isolation from the rest of the world. The Quakers of Fry's youth still tended to keep to themselves, to wear different clothes from the rest of the community, and frequent inter-marriages between the Howards, the Hodgkins, the Eliots and the Frys reinforced their separation. The denial of pleasure meant that art and works of art were inevitably suspect. Artists were thought of as idlers and pleasure-loving wastrels, and the thought of owning pictures would never have occurred to Fry's family. Flowers, Fry learnt as a child, were not to be enjoyed, but studied. But that is the negative side of the Quakers. On the positive side there is the Quaker respect for truth, their industry and their enlightened paternalism. All three characterisics are noticeable in Fry – truth, hard work and a feeling of social responsibility and an abiding interest in the social relevance of art, of which the Omega Workshops were but one example.

Secondly, Fry was trained as a scientist. He was a very able one and took a first in botany at Cambridge. When he gave up science for art, much to the horror of his parents, he did not give up his habits of thought. The scientist's liking for method, the practice of testing hypotheses by experiments before formulating a theory, stayed with him all his life.[20] Scientists are always prepared to abandon past theories, however successful, if they fail to account for new facts, and Fry liked to maintain an open-mindedness about his past pronouncements. He continuously readjusted and modified his judgements on art and painters, dead and living. To art historians and critics, brought up to

Opposite, top Paul Gauguin, *Christ in the Garden of Olives*, 1889. 'A strange grandeur has crept into Gauguin's figures, a grandeur that recalls Michelangelo.' (Sickert).

Bottom Paul Gauguin, *L'Esprit veille*, 1892, today called *Manao Tupapau – The Spirit of the Dead Keeps Watch*. It was bought after the exhibition by Michael Sadler.

Sir Max Beerbohm, *A Law Giver.*
Roger, first King of
Bloomsbury, 1931.

trust the dogmatic rightness of their own reactions to painting, such
open-mindedness was not just remarkable, but suspect. Fry was often
accused, even by an intelligent critic like D. S. MacColl, of inconsistency,
of suddenly changing his mind at the last moment. Sir William Rothen-
stein found fault in this side of Fry's character. Rothenstein turned down
his invitation to join in a second Post-Impressionist exhibition. 'As
Fry had from the first been my warmest supporter he expected that I
would now support him; but since I held aloof, the good Roger, who
can always convince himself as magically as he convinces others, dis-
covered that my work was no longer of any importance.'[21]

Fry's conversion to Post-Impressionism was, as he pointed out in a
letter to D.S. MacColl, certainly not sudden. It was a process that

started round about his fortieth year, at an age when most people's tastes are beginning to settle down for life. In 1906, in the International Society exhibition at the New Gallery, he caught sight of two early Cézannes and wrote an enthusiastic appreciation of their primitive qualities.[22] He had seen, or rather heard of, Cézanne before – anyone who went to Paris could hardly fail to, and there were Cézannes in the Durand-Ruel exhibition of 1905 – but he had understood Cézanne to be a 'kind of hidden oracle of ultra-impressionism',[23] and as a result he had not expected to like his work and did little about going to see it for himself. In 1906 he still regarded Cézanne as limited, but by 1908 he seems to have modified this opinion and in a letter to the *Burlington Magazine* he declared a Cézanne still-life to show 'a great advance in intellectual content' when compared to a Monet, and in general: 'Cézanne's art seems to me to betray a finer, more scrupulous artistic sense.'[24] Two years later, early in 1910, he published in the *Burlington Magazine* a translation of Maurice Denis's 1907 article on Cézanne in *L'Occident*, in which the painter is put forward as a great 'classic', and the 'Poussin of Impressionism'. By then his views had already begun to form into a coherent whole, for in 1909 he had published *An Essay in Aesthetics*, in which he drew attention to the 'emotional elements of design', as distinct, almost abstract entities, independent of their imitative function.[25]

His fellow critics and painters can be forgiven for not following the progress of his thoughts. He was, in the years leading up to the Post-Impressionist exhibition, a hard man to pin down. He was immensely energetic, always on the move, frequently engaged in several activities and projects at the same time. His wife's insanity, confirmed in 1910, was a tragic blow but it seems to have had the effect of making him work harder and harder. Fry led many lives. There was Fry the painter, not very successful but respected by his colleagues; Fry the lecturer, an extremely gifted and successful one, possessing a deep, mellifluous voice which Bernard Shaw said was one of two voices worth listening to for its own sake – Johnston Forbes-Robertson, the Shakespearean actor, possessed the other – and an extraordinary ability to extemporize about works of art in front of his audience as if he were conducting a new experiment each time he spoke; Fry the scholar and art historian who wrote about the Old Masters of the Renaissance – Bellini, for example – and helped found and edit the *Burlington Magazine*; Fry the art critic, contributing to the *Athenaeum* and other intellectual periodicals on whatever took his fancy; Fry the connoisseur and expert, the man brought in to authenticate or disprove the attribution of Old Master paintings; Fry the museum adviser, buying pictures for the Metropolitan Museum, New York, and coping as best he could with the demands of Pierpont Morgan; and Fry the activist, always prepared to take on some new project and persuade others to support and help him. This last man could be gullible to the point of naïveté. No insult, no rebuff, could deflect him once he had decided upon a course of action.

This then is a partial view of the man who returned to England in 1910, having just lost his job at the Metropolitan Museum. Virginia Woolf supplied further elements in the picture:

To a stranger meeting him then for the first time [1910] he looked much older than his age. He was only forty-four, but he gave the impression of a man with a great weight of experience behind him. He looked worn and seasoned, ascetic yet tough. And there was his reputation, of course, to confuse a first impression – his reputation as a lecturer and as an art critic. He did not live up to his reputation, if one expected a man who lectured upon the Old Masters at Leighton House to be pale, academic, aesthetic-looking. On the contrary, he was brown and animated.[26]

Virginia Woolf goes on to point out that 'it was easy to make him laugh. Yet he was grave – "alarming", to use his own word of his father. He too could be formidable. Behind his glasses, beneath bushy black eyebrows, he had very luminous eyes with a curious power of observation in them as if, while he talked, he looked, and considered what he saw.'

What kind of world had he returned to? Edward VII had died on 6 May 1910, and Britain was at last beginning to emerge from its Victorian complacency and face the realities of the twentieth century. Victorian morality and conduct were beginning to be challenged. Politically there were signs of upheaval. A constitutional crisis over the power of the House of Lords developed, and in the winter of 1910 Asquith dissolved Parliament and called for a general election. In November, a few days after the opening of the Post-Impressionist exhibition, the Home Secretary, Winston Churchill, ordered the troops in to break up the strike of Welsh miners at Tonypandy, an action that was to have a lasting effect on labour relations in Britain. Throughout that year the suffragette movement gained momentum.

In the world of art and letters there were signs of unrest. 'On or about December 1910 human character changed,' wrote Virginia Woolf.[27] The disappearance of Count Tolstoy and his subsequent death seemed to mark the end of an epoch. The question of a performance of Richard Strauss's *Salome* naturally caused a controversy. In June an exhibition of French paintings organized by Robert Dell, the Paris correspondent of the *Burlington Magazine*, opened at the Exhibition Galleries, Brighton, and attracted considerable publicity and attention. It included works by Bonnard, Vuillard, Signac, Cross, Vlaminck, Derain, Rouault, Marquet and Puy, the first time that many of these artists had shown in Britain.

And what was the state of the art world in London in 1910? To sum up: the Royal Academy was still powerful; the New English Art Club had become respectable; a rival grouping, with Sickert prominent, had emerged; a new generation was about to make its mark – the oldest were Matthew Smith and Vanessa Bell (born in 1879), a middle group in their twenties consisted of Wyndham Lewis (born 1882), Duncan

BEFORE THE FOOTLIGHTS OF ÆSTHETICISM

QUIZ

Roger Fry; a caricature by Powys Evans. Virginia Woolf said that in 1910 Fry was certainly not 'pale, academic, aesthetic-looking', the impression conveyed by this caricature.

Grant (1885), Frederick Etchells (1886), James Innes (1887), and Paul Nash and C.R. Nevinson (1889).

British collectors – with the exception of one or two Glasgow shipping millionaires and the Irishman Hugh Lane – were still mainly interested in nineteenth-century British art and disliked, though not actively, the French Impressionists. Post-Impressionism, as a concept, was as yet unformed and the art of Cézanne, Van Gogh and Gauguin had hardly been seen in Britain. It was, however, beginning to be writ-

ten about. Julius Meier-Graefe's enthusiastic assessment of these artists was included in his work *Modern Art*, which was published in translation in Britain in 1908. Comments on Cézanne were beginning to appear in books and journals, and on the eve of the Post-Impressionist exhibition in 1910 two articles on Van Gogh by Meÿer-Riefstahl appeared in the *Burlington Magazine*, with illustrations. Fry had over the last four years begun to form a new aesthetic philosophy that was to find practical realization in an exhibition of recent French art at the Grafton Gallery in the autumn and winter of 1910.

Accounts differ on how the exhibition came about. There was a gap in the exhibition programme at the Grafton Gallery, just off Bond Street. Some say Fry suggested an exhibition of French art as a stop-gap measure,[28] others say he was invited.[29] In any event the exhibition was not a long, premeditated affair, but one got together in a hurry without much thought for the consequences. The rush with which it was organized undoubtedly contributed to the confusion created by the exhibition. To help him, Fry chose not experienced people in the art world but two Cambridge acquaintances. One was Desmond MacCarthy, then beginning to make a name for himself as a book reviewer and critic; he became the secretary for the exhibition in charge of the financial details and the catalogue. The other was Clive Bell, whom Fry met on a train and, discovering a kindred spirit, seems to have asked there and then to help out.

MacCarthy has given an account of how he became involved in the exhibition. He was chosen, he says, not because he knew anything very much about painting – in fact he had never seen any of the work that came to be exhibited – but because he and Fry 'were happy together. My failings were not the sort which annoyed him, nor (equally important) were my virtues. Masterful men often prefer a rather incompetent colleague to an over-confident one. Fry was capable of making muddles himself; he would not have been quite comfortable with anyone implacably efficient. And here I must mention that he was also a most persuasive man.'[30]

The executive committee, while distinguished, were hardly very experienced in the art they were about to show. They consisted of Lionel Cust, Keeper of the King's Pictures and co-editor with Fry of the *Burlington Magazine*, Professor Holmes, Director of the National Portrait Gallery and member of the New English Art Club, Lord Henry Bentinck, a collector, Lady Ottoline Morrell, the Bloomsbury hostess, Dr Meÿer-Riefstahl and Robert Dell, part-organizer of the Brighton exhibition mentioned above.

The arrangements over the exhibition were settled in a hurry MacCarthy had not even agreed with the management of the Grafton Gallery the percentage they should take if any of the works were sold. 'Neither the committee of the Grafton Galleries nor Roger Fry thought for one moment that the show could be a financial success.'[31]

It soon became apparent that the success of the exhibition would depend on the co-operation of the Paris dealers. In the summer of 1910 Fry and MacCarthy set off to make the rounds. They were joined by Clive Bell. Lady Ottoline Morrell was also in Paris and Fry wrote to his friend Goldsworthy Dickinson: 'She is quite splendid.'[32] Lady Ottoline appears to have been almost one step ahead of Fry in getting to know the Paris art world. Through Leo and Gertrude Stein she met Matisse, who looked like 'a commercial businessman', and she recorded in her journal: 'He seems exceedingly competent, but it is difficult to imagine he has an inward vision of beauty. Obviously he has a great sense of design and form and ability of hand. He looks more Flemish than French with his fair beard and square face.'[33]

Fry does not appear to have sought out any artists on his visit to Paris – unlike the organizers of the Armory Show – but he was content to work through the dealers and here he showed his negotiating skill. Vollard provided Cézannes, Gauguins and Vlamincks; Druet lent Cézannes and Rouaults; Kahnweiler lent Vlamincks and Derains; and Bernheim Jeune lent Manets, Van Goghs, Signacs and Seurats. One or two private loans were negotiated. Leo Stein lent an early Picasso, *Nude Girl with a Basket of Flowers*, and the dealer Clovis Sagot lent his portrait by Picasso. Bernard Berenson lent a Matisse landscape.

Most of the Van Goghs in the exhibition came from Van Gogh's sister-in-law, Mme Gosschalk-Bonger, whom MacCarthy visited in Holland. In his account he says that she was asking only about £120 for an oil, but he must have been mistaken. Van Gogh's prices were rising and by 1913 a still-life had been sold at auction for £1,450.

Having concluded the arrangements Fry felt pleased with the collection. 'The show will be a great affair,' he told Goldsworthy Dickinson. 'I am preparing for a huge campaign of outraged British Philistinism.'[34] One of Fry's most endearing qualities was his enormous enthusiasm in front of pictures. 'I remember his raptures,' wrote MacCarthy. 'He would sit in front of them with his hands on his knees groaning repeatedly, "Wonderful, wonderful".' Virginia Woolf gives a beautiful vignette of the Cézannes, Gauguins and Van Goghs propped up on chairs at the Grafton Gallery beneath a portrait by Watts. She wrote:

And there was Roger Fry, gazing at them, plunging his eyes into them as if he were a humming-bird hawk-moth hanging over a flower, quivering yet still. And then drawing a deep breath of satisfaction, he would turn to who-ever it might be, eager for sympathy. Were you puzzled? But why? And he would explain that it was quite easy to make the transition from Watts to Picasso; there was no break, only a continuation. They were only pushing things a little further. He demonstrated; he persuaded; he argued. The argument rose and soared. It vanished into the clouds. Then back it swooped to the picture.[35]

The exhibition began to take shape. MacCarthy reported that several hundred pictures were available; the transport and insurance would

Paul Cézanne, *The Viaduct at L'Estaque*, 1882–5.

amount to about £150. Next came the question of what the exhibition should be called. MacCarthy's account is interesting and shows the almost casual atmosphere in which the exhibition was created:

> Roger and I and a young journalist who was to help us with publicity met to consider this; ... Roger first suggested various terms like 'expressionism', which aimed at distinguishing these artists from the impressionists; but the journalist wouldn't have that or any other of his alternatives. At last Roger, losing patience, said: 'Oh, let's just call them Post-Impressionists; at any rate, they came after the impressionists.'[36]

The hanging of the exhibition, like the other preliminaries, seems to have been done casually and in a rush. Fry's main concern was to find which picture looked best next to another; works by one artist were not kept grouped together and thus it was difficult for people seeing works by many of the artists for the first time to gain a clear view of the exhibitors. There was also a disproportionate number of Gauguins, and one critic complained that they had been used to 'salt' the exhibition.[37] MacCarthy seems to have had a hard time keeping track of the works and matching the numbers with the titles. He spent a sleepless night before the press day worrying at 'the prospect of public ridicule owing to having, say, catalogued a nude girl as "Station-master at Arles"'.[38]

It would be a mistake to make too much of Fry's choice of pictures as revealed by the catalogue – some things were forced on him, others were omitted because of the lack of time – but it does give an idea of the development of his views. The main emphasis of the exhibition fell on Cézanne, Van Gogh and Gauguin. The Neo-Impressionists Seurat, Signac and Cross were included, but more from historical necessity than from any belief in their merits. Fry was later to admit his failure to realize the true significance of Seurat.[39] Maurice Denis's canvases were given quite a lot of prominence and there were works by Sérusier and Vallotton. But the Intimists, Vuillard and Bonnard, were not included, an omission that drew comments from Sickert and others. Of the Fauves, Vlaminck, with nine oils, was the best represented, but these already showed his abandonment of Fauvism proper for a more formal art closer to Cubism. Cubism, as such, was not included and the Picassos were unrepresentative of the art he was doing at that time.

Interestingly, among the Cézannes in the exhibition were many early works; the later painter of 'spheres, cones and cylinders' and father of Cubism was, as Mr Benedict Nicolson has pointed out, not particularly noticeable in the first Post-Impressionist exhibition.[40] There were twenty-one works and these consisted of three early figure subjects of the mid-1870s, a still-life of a vase of petunias, dated 1875, a portrait, *The Woman with a Rosary*, and a portrait of his wife, landscapes at L'Estaque, a Montagne Sainte-Victoire and *The Great Pine*. Fry always seems to have appreciated Cézanne's early expressionistic works, believing that they showed that rich sense of colour that is revealed in his later work.

Paul Cézanne, *The Great Pine*,
1892–6. 'Cézanne is
neither coherent nor
architectural' (Ross).

Vincent van Gogh, *The Garden of
Daubigny*, 1890. 'Van Gogh is the
typical matoid and
degenerate of the modern
sociologist.' (Ross).

The choice of Van Goghs also points to Fry's appreciation of the expressionistic element in a work of art. There were over twenty works, giving a fairly complete picture of Van Gogh's principal interests after his Impressionist phase. The pre-Impressionist works were not included. The main paintings in the exhibition were a version of the *Sunflowers*, a painting of irises, a copy of a Delacroix *Pietà*, several Auvers landscapes, a view of Arles, *La Berceuse* (a portrait of Madame Augustine Roulin), *Dr Gachet*, *The Postman* and *Cornfield with Blackbirds* (or *Crows in the Wheatfields* as it is now called).[41]

There were thirty-seven Gauguins, including a large number of Tahitian pictures – the most notable being the haunting *L'Esprit veille* – and a lesser number of Breton pictures, dominated by the *Christ in the Garden of Olives*.

Vincent van Gogh, *Pietà* (after Delacroix), 1890.

A cross-section of the most discussed paintings in the exhibition, from the *Illustrated London News*, 26 November 1910.

The Manets, eight oils and one pastel, served as an introduction to the exhibition and as a rather remote ancestor to Cézanne's art and that of all revolutionaries.

All in all it was an astonishing collection of pictures. The insurance value today would be well over £10 million. Those who saw it really did have the experience of a lifetime. It was apparent almost immediately that the exhibition would cause a commotion – none of the organizers could have had any illusion about that – but Sir Charles Holroyd, director of the National Gallery, who was on the honorary committee for the exhibition and as such not responsible for the choice

THE ILLUSTRATED LONDON NEWS, Nov. 26, 1910.—825

ATTRACTORS OF ALL SOCIETY: WORKS BY POST-IMPRESSIONISTS.
THE MANET AND THE POST-IMPRESSIONISTS EXHIBITION, AT THE GRAFTON GALLERIES.

1. "COUP DE VENT D'EST," BY HENRI-EDMOND CROSS (1856–1910). 3. "L'AMAZONE," BY EDOUARD MANET (1832–1883). 5. "LE POSTIER," BY VINCENT VAN GOGH.
2. "DR. GACHET," BY VINCENT VAN GOGH (1853–1890.) 4. "LE GARAGE," BY MAURICE DE VLAMINCK. 6. "UN BAR AUX FOLIES BERGÈRES," BY EDOUARD MANET.

of works, was apparently thunderstruck by the exhibits and asked for his name to be removed from the catalogue. MacCarthy has provided a description of the atmosphere on press day:

As I walked about among the tittering newspaper critics busily taking notes (they saw at once that the whole thing was splendid copy) I kept overhearing such remarks as 'Pure pornography', 'Admirably indecent'. Not a word of truth, of course, in this. . . . I had been careful to exclude too frankly physiological nudes and, indeed, at the last moment, instead of hanging two of the pictures, I told Roger they had better be kept, for a time, in my sanctum downstairs.[42]

The reviews in the daily papers were critical. Both *The Times* and the *Morning Post* came out strongly against the exhibition. *The Times* felt that the paintings constituted an 'abandonment of what Goethe called "the cultural conquests" of the past' and called on Time, *'le seul classificateur impeccable'*, to put matters right.[43] The *Morning Post*, once Queen Victoria's favourite morning reading, allowed its critic, Robert Ross, a column and a half in which to dispose of the exhibition and display his celebrated wit. He obliged by lashing out at as many targets as he could and he seems to have regarded Post-Impressionism as a danger to public health. 'If the movement is spreading,' he argues, 'it should be treated like the rat plague in Suffolk. The source of the infection (e.g., the pictures) ought to be destroyed.'[44] His suggestion finds an echo in a letter to the *Saturday Review*, which pointed out, 'There is one hopeful sign about the whole thing – when putrescence has continued beyond a certain point sweetness supervenes, decay and corruption eventually result in a return of the corrupting substance to wholesome elements, invisible beneficent gases ready to reassume some cleanly form.'[45] The *Daily Telegraph*'s review, by Sir Claude Phillips, the stout, immaculately dressed and heavily scented curator of the Wallace Collection, put in a plea for tolerance:

Here is an exhibition which must be seen and faced. Those who come to scoff will perhaps remain, not to pray, but to wonder at this new art, and at the time of which it is in a sense the reflection. And yet though we may grieve, and feel saddened, bewildered, by the garishness and the horror of it all, we must not wholly avert our faces. For out of those things which have been done in absolute sincerity – mistaken sincerity it may be – out of the very few which are truly attributable to the desire to express 'the emotional significance that lies in things' may yet emerge the painting of the future. We wait and watch; declining to howl with the crowd, or to rhapsodise with the excessive eulogists. . . .[46]

The reviews in the Sunday newspapers make it clear that the exhibition was drawing the crowds and it had become the most hotly debated event since 'Ruskin libelled Whistler's nocturnes at the Grosvenor Galleries'.[47]

The pictures at the Grafton Gallery had reduced most of the critics and letter-writers if not to a loss of words at least to a loss of any accepted standards. They turned to the preface to the catalogue, which *The Times* admitted was 'cleverly-written', and which they assumed was the responsibility of Roger Fry, and made it their starting-point.[48] As a result a good deal of the criticism generated by the exhibition is about aesthetics: the paintings are treated as mere props to an argument.

Among the first questions to be asked was: what was an intelligent and learned man like Roger Fry doing in an exhibition like this? Here was a man who lectured so eloquently on tradition supporting an art which seemed to typify 'the latest and most violent of all the many violent reactions against tradition which modern art has seen'.[49] Even

Fry's most hostile critics were prepared to admit his ability as an art historian, and there is a note of despair, of bewilderment, behind Robert Morley's letter to the *Nation*. It went: 'To think of the great art of which France was so justly proud – the calm, true reflections of the lives of the peasantry, lovingly depicted by J. F. Millet, and to look at these! What does Mr Roger Fry mean? Where are the "emotional ideas" in these daubs? There are none, absolutely none, nothing but the base negation of all that was great in the past.'[50] *The Times* felt that Roger Fry, 'a distinguished scholar and critic, who had made his name by his writings on Bellini and the older art', was setting a bad example; less sincere men might swallow his views without thinking. Robert Ross thought that Fry's involvement in the exhibition was something to be pitied: 'It is only comparable to the no less deplorable credulity evinced by serious men of science in the chicanery of spiritualism, automatic writing and the narratives of the neuropath.'[51] Some people felt that Fry was quite literally mad, and went so far as to point to his wife's insanity as a contributing factor.

But how was it possible to reconcile admiration for the Old Masters with a liking for Post-Impressionism? Lewis Hind asked himself that question in the *English Review* and felt that the answer lay in a willingness to learn.[52] Fry was more definite. The Post-Impressionists were not in revolt against tradition:

I believe [he wrote in the *Nation*] that it is not difficult to show that the group of painters whose work is on view at the Grafton Gallery are in reality the most traditional of any recent group of artists. That they are in revolt against the photographic vision of the nineteenth century, and even against the tempered realism of the last four hundred years, I freely admit. They represent, indeed, the latest, and I believe, the most successful, attempt to go behind the too elaborate pictorial apparatus which the Renaissance established in painting. In short they are the true Pre-Raphaelites. But whereas previous attempts – notably our own Pre-Raphaelite movement – were made with a certain conscious archaism, these artists have, as it were, stumbled upon the principles of primitive design out of the perception of the sheer necessities of the actual situation.[53]

This argument was good enough, but the trouble was that Fry went on to argue that many of the artists in the exhibition 'had proved themselves accomplished masters in what is supposed to be the more difficult task of representation', but they had deliberately abandoned these skills. Michael Sadler, then a supporter of Augustus John and the New English Art Club, wrote to the *Nation*, saying: 'Definite abandonment of one technique for another is hardly "stumbling", and it is with this very consciousness of primitivism that I have to quarrel.'[54] He was not alone. Several critics made this point. 'There is nothing more tedious than affected naiveté,' proclaimed Laurence Binyon in the *Saturday Review*.[55]

The critics then asked themselves whether the paintings lived up to the qualities claimed for them; had Cézanne succeeded in finding a

design which matched 'the coherent architectural effect of the master-
pieces of primitive art'?[56] 'All I can say is that he failed,' stated Ross
bluntly. 'M. Denis in one room illustrates the impossibility of a French-
man assimilating the sentiment of the Primitives; Cézanne, in the other
the hopeless attempt to parody their objectivity. Cézanne is neither
coherent nor architectural.'[57] Michael Sadler asked: 'Did Van Gogh
burn with the same passion when he painted his boulevard as Cimabue
when he painted his Madonna?'[58] To which Arnold Bennett, who had
begun to take an interest in art during his long sojourn in Paris,
replied: 'The answer is most emphatically, Yes! Let Mr Sadler inquire
into the details of Van Gogh's career.'[59]

The biographical details of an artist's life, normally considered irrele-
vant to the merits or defects of his work, became in the course of the
exhibition one of the chief arguments for the defence. The myth of the
artist as an outsider, constantly struggling against poverty and the
insults of his fellow men, gained ground with the Post-Impressionist
exhibition and is one of its main legacies. Few people in Britain at that
time knew more than the bare outlines of the lives of Cézanne, Van
Gogh and Gauguin. Cézanne's 'struggle to realize his sensations', Van
Gogh's 'madness and suicide' and Gauguin's 'escape from civilization
to the primitive life of the South Seas' had yet to be embodied into
popular mythology and as a result they could be used by the critics to
their own advantage.

Rutter in the *Sunday Times* pointed to these facts as evidence of the
artists' sincerity and A. Clutton-Brock, in a thoughtful appreciation of
the exhibition in the *Burlington Magazine*, wrote:

If Cézanne, Gauguin, and Van Gogh were charlatans, they were like no
other charlatans that ever lived. If their aim was notoriety, it is strange that
they should have spent solitary lives of penury and toil. If they were incom-
petents, they were curiously intent upon the most difficult problems of their
art. The kind of simplification which they attempted is not easy, nor, if
accomplished, does it make a picture look better than it is. . . . They look just
as easy as the lyrical poems of Wordsworth or Blake.[60]

This argument eventually won the day, but at the time it did not prevent
people saying that their children could do better – Wilfrid Blunt typified
a common response when he says, 'The drawing is on the level of that
of an untaught child of seven or eight years old, the sense of colour
that of a tea-tray painter, the method that of a schoolboy who wipes
his fingers on a slate after spitting on them'[61] – nor did it prevent
Robert Morley from saying that the canvases 'reflect the debasement of
the lives of the painters living in the Gay City'.[62] Insanity was still no
excuse. Robert Ross wrote, 'Van Gogh is the typical matoid and
degenerate of the modern sociologist. *Jeune Fille au Bleuet* and the *Corn-
field with Blackbirds* are the visualized ravings of an adult maniac. If
that is art it must be ostracised, as the poets were banished from
Plato's republic.'[63]

TAKE YOUR CHOICE, READERS
An Adaptable Sample of Post-Impressionist Art.

PLAGUE-STRICKEN RATS UP A TREE

THROUGH A LATTICE WINDOW

THE "DAILY MAIL" GARAGE AT WORMWOOD SCRUBS.

HOUSE IN A GREEN FIELD (AFTER-DINNER EFFECT)

The above picture, by He bin, referred to in our article on the prev.cus page, is of that variety which may be catalogued under the " you-pay-your-money-and-takes-your-choice" style of picture. Merely seeing it the right way up as in the bottom picture of this page is a waste of good material. Turned sideways in both directions as in the two top pictures it makes just as clear an impression of two other subjects. Indeed, turn the bottom picture upside down and you get an impression of the "Daily Mail" garage at Wormwood Scrubs. O.din.ry artists such as Sargent, Herkomer, and Collier, who can only paint one thing at a time, will have to look to their laurels if the Post-Impressionists continue

229

The exhibition reduced the *Tatler*'s correspondent to outright silliness. Page from the *Tatler*, 23 November 1910.

Van Gogh's work, particularly the *Crows in the Wheatfields*, seems to have divided the opponents to the exhibition. It provided the *Tatler*'s correspondent with an excuse for a laugh, though there is a suggestion of nervousness behind the heavy humour as he describes how he nearly came to blows with his companion over it: 'I said it was a prairie fire. My companion insisted that it was a sandstorm. Someone beside us entered into the fray by deciding that it was the Great Fire of London, while yet another stranger came up and called it a ham omelette smoking. At that we both assumed our expression of artistic enlightenment

and moved severely away'.[64] D.S. MacColl, while finding Van Gogh limited in comparison to Blake, was prepared to admit that his madness gave 'a heightened, hallucinatory intensity' to his work.[65] Claude Phillips felt that despite the exaggeration in the execution of the *Crows in the Wheatfields*, 'there blows a tempestuous wind that carries with it the sound of music'.[66] Van Gogh's flower pictures began to cast their spell on the popular imagination. Fry, the former botanist, maintained: 'Modern European art has always maltreated flowers, dealing with them at best as aids to sentimentality until Van Gogh saw, with a vision that reminds one of Blake's, the arrogant spirit that inhabits the sunflower, or the proud and delicate soul of the iris.'[67] According to her biographer Lady Ottoline Morrell attempted to buy the *Sunflowers*, but found the price too high.[68]

Gauguin, says Spencer Gore, was the 'least disliked' of the Post-Impressionists. In fact he could have put it more positively, as Gauguin's work gained a number of converts in the course of the exhibition. Michael Sadler, for example, began collecting Gauguins and a year later lent four to a London exhibition, including *L'Esprit veille*. A painting by Gauguin was the only work in the exhibition to please Wilfrid Blunt's critical eye, because it showed 'a good general dark colouring, such as one sees in old pictures blackened by candle-soap smoke'.[69] Writing in the suffragette journal the *Englishwoman*, Mary Lowndes, a stained-glass worker, admitted that before the exhibition she, like the general English public, knew nothing about the so-called Post-Impressionists. Gauguin was a revelation to her, particularly as a colourist, and she felt obliged to rethink her artistic views. The critics (males) were partly to blame. 'To Gauguin we feel perhaps they might have introduced us before,' she wrote. 'He is dead – has been dead these seven years.'[70]

Surprisingly, defenders of the exhibition like Clutton-Brock and Fry felt obliged to apologize for the fact that Gauguin was relatively easy to appreciate. Fry thought there was an element of self-consciousness and rhetoric in Gauguin's work, 'a desire to impress and impose'. Ross, however, saw why Gauguin appealed to English taste: 'He has some of the pattern and invention of Beardsley,' he wrote.

Cézanne, as in France ten years before, proved to be the most difficult of the Post-Impressionists. The greater the claims made for his art by Fry, Bell, Clutton-Brock and others the greater the resistance it provoked in the opposition. Fry, on the whole, must take responsibility for the subsequent course of the argument and the confusion created by Cézanne's work. By making Post-Impressionism stand for anti-Impressionism he was forced to lift Cézanne out of his Impressionist context and make him into something else, a great classic, which, as Benedict Nicolson and others have pointed out, was a mixture of Maurice Denis's appreciation of Cézanne as a pattern-maker and Meier-Graefe's view of him as an Expressionist. The term 'classic' was stretched in the process. In one article Fry, in talking about a Cézanne

Cézanne, *Madame Cézanne in a Red Armchair*, 1877.

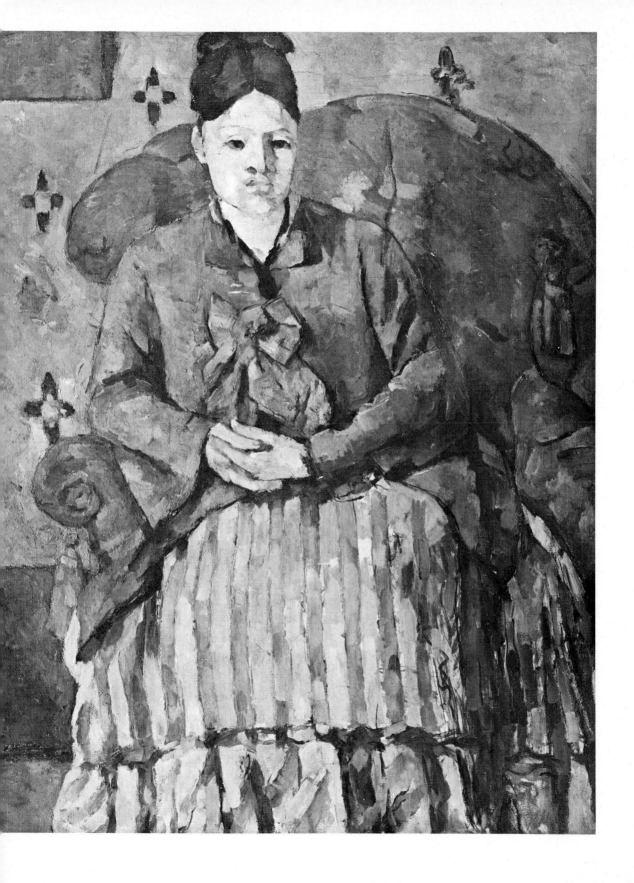

ortrait, uses classic to mean the ability to 'seize individual character in s broad, static outlines' and he compares a portrait of the artist's ife to 'the great monumental quality of Piero della Francesca or Mantegna';[71] in another he uses 'classic' to mean 'the power of finding a things themselves the actual material of poetry and the fullest ratification for the demands of the imagination'.[72]

The trouble was that Cézanne seemed to attempt one thing – the eproduction of his sensation of appearances – and ended by achieving omething else – 'the coherent architectural effect of the masterpieces f primitive art'. With Cézanne there is a gap between intention and chievement and this gap was seized on with alacrity. 'Cézanne was not great classic,' wrote D. S. MacColl, 'he was an artist, often clumsy, ways in difficulties, very limited in his range, absurdly so in his most umerous productions, but with "quite a little mood," and the haunt-g idea of an art built upon the early Manet, at which he could only nt.'[73] With dour Scottish logic MacColl was quick to point out that ry's use of the word 'classic' really meant 'romantic'. In the opinion the New English Art Club MacColl appeared to have answered ry's claims. MacColl himself never changed his views and even in his onograph on Wilson Steer, published in 1945, he pours scorn on Cézanne's toppling jugs, botched and bashed apples, bodiless clothes, uddled perspectives and the rest'.[74] He seems to have believed that ézanne suffered from some physical infirmity in his eyes and cites ézanne's own words as evidence.[75]

Some critics, like Claude Phillips, were prepared to admit that there ight be something in Cézanne, Van Gogh and Gauguin, but they felt at there was a danger that they would encourage less sincere artists try to imitate them. '*Fumisterie*' or practical joke seems to have been a onstant fear of the English critics[76] and they trembled at the thought anything like the Salon d'Automne or the Indépendants taking place London. Phillips felt that 'the crowd of *fumistes* who in France hang to every new movement and bring it into disrepute' had been dmitted to the exhibition and that they were responsible for 'some of e most detestable daubs that have ever disgraced a London Gallery'.[77] he chief *fumiste* was Matisse, who even though he was represented by ly one important oil, the *Girl with Green Eyes*, and a disproportionate umber of bronzes was soon recognized as a ringleader and arch-arlatan. The fact that a well-known art historian, Berenson, had lent ne of his paintings to the exhibition and believed in Matisse, a fact at Arnold Bennett endeavoured to point out to readers of the *Nation*, ly went to show the foolishness of art historians like Berenson and ry when they ventured outside their own territory.

Laurence Binyon in the *Saturday Review* felt that *fumisterie* was a ench disease, caused by the fact that 'French art cannot get on without ovements'. Returning to this theme in a second article, he wrote with ide: 'We in England don't have movements if we can help it. Perhaps is as well, in spite of the excitement we lose. It may be that we can

D. S. MacColl; a caricature by Powys Evans. A progressive critic until faced with the Post-Impressionists.

Opposite Vincent van Gogh, *Crows in the Wheatfields*, 1890 (detail). 'There blows a tempestuous wind that carries with it the sound of music.' (Phillips).

appreciate in a truer light the actual men and their works.'[78] Binyon pointed to the 'mild and secluded atmosphere of the New English Art Club' as providing the right climate for genuine artists. Michael Sadler agreed and singled out for attention the work of Augustus John, which, he argued, has 'revived the directness and simplicity of primitivism more than any Post-impressionist picture I have seen. And John has done this without a violent reaction from the art of his time. He is a development, whereas Post-impressionism is an open breach.'[79]

It is depressing to have to record that much of the hostility created by the exhibition stemmed from fear: fear of the unknown, fear of charlatanism, and xenophobia, fear of foreigners. The fact that the French seemed to countenance this art was bad enough but the fact that the Germans appeared to like it was very suspicious indeed. Several critics used the exhibition as an excuse for venting their anti-German feelings. P.G. Konody in the *Observer* wrote: 'It is not likely that English collectors will follow the lead of Germany and rush blindly into filling their houses with pictures that are highly interesting on the walls of an exhibition. . . . The majority of the pictures at the Grafton Gallery are not things to live with. Germany is welcome to them.'[80] Ross thought it to mention the dismissal of 'a high official from a Berlin Gallery' by order of the German emperor. He was referring to Hugo von Tschudi, a wealthy and enlightened collector and museum director, among the first in Germany to buy Cézannes and Matisses. MacColl chose the occasion to mock Meier-Graefe's enthusiasm for the new painting and added:

The Germans, so enviably endowed for music, for science, and for business, are eager for all the arts. Denied almost entirely an instinct for the art of painting, they study it, they 'encourage it', egg it on, adore, and even buy. . . . They dine, they sleep, they commit every act of life in 'Art Nouveau'. And to their serious bosoms they have taken each extravagance of Montmartre and added an 'ismus' to its name.[81]

After several years in Paris Arnold Bennett thought that

. . the attitude of the culture of London towards [the exhibition] is of course humiliating to any Englishman who has made any effort to cure himself of insularity. . . . The mild tragedy of the thing is that London is infinitely too self-complacent even to suspect that it is London and not the exhibition which is making itself ridiculous. . . . London may well be unaware that the value of the best work of this new school is permanently and definitely settled – outside London. So much the worse for London. For the movement has not only got past the guffawing stage; it has got past the arguing stage. Its authenticity is admitted by all those who have kept themselves fully awake. And in twenty years London will be signing an apology for its guffaw.[82]

In France it had been the painters who first discovered the merits of Cézanne, Van Gogh and to a lesser extent Gauguin. What was the reaction of the English painters to the exhibition as a whole, to the

Henri Matisse, *Girl with Green Eyes*, 1909. 'An intentionally childish daub.' (Konody). Matisse outraged the critics even more than Van Gogh and Cézanne.

work of Cézanne in particular, and what effect did it have on their work?

As might be expected the Establishment painters and the Royal Academicians hated the exhibition. Sir William Richmond and Sir Philip Burne-Jones, 'professional *scandalisables*' who could be counted on to enter any artistic dispute, were quick to denounce the exhibition in the *Morning Post*. It gave Richmond, a portrait painter and the artist responsible for some unfortunate mosaics in St Paul's, the opportunity to express his shame at bearing the designation of painter. 'That is perhaps even more than one had ventured to hope,' commented Fry.[8]

Sargent was provoked into expressing his opinion on the exhibition by a rather loosely worded article by Fry in the *Nation* of 24 December in which Sargent seemed to be referred to as one of the converts of the show. On 7 January he wrote:

> I had declined Mr. Fry's request to place my name on the initial list of promoters of the exhibition on the grounds of not knowing the work of the painters to whom the name of Post-Impressionists can be applied; it certainly does not apply to Manet or Cézanne. Mr. Fry may have been told – and have believed – that the sight of those paintings made me a convert to his faith in them.
>
> The fact is that I am absolutely sceptical as to their having any claim whatever to being works of art, with the exception of some of the pictures by Gauguin that strike me as admirable in color, and in color only.[84]

On 14 January Fry gave his explanation of the confusion: Sargent had once written to him of his admiration of Cézanne and he had meant to convey in his article that Sargent was a supporter 'at least as regards Cézanne', though not of the other exhibitors. In subsequent accounts of this disagreement Fry's reply has been lost sight of and as a result Sargent's letter achieved an unfortunate significance. It was used by the American critic Royal Cortissoz as a weapon in his attack on the Post-Impressionists in the Armory Show. It was also used by Fry's opponents in Britain as an example of his 'intellectual dishonesty'. It took a long time to be forgotten and even appears in a biography of Sargent by Charles Merrill Mount.[85]

Next it was the turn of the New English Art Club to express their views. The exhibition came as a greater shock to them than to any other sector of the community. Having been treated as 'advanced' by most of their public, they now found themselves treated as almost *passé*, and, as biographers of the leading members point out, this experience was not at all pleasant. If Cézanne had been allowed by Fry to remain an Impressionist they might have come round to a grudging respect for his art, but Cézanne was meant to prove the invalidity of Impressionism and their own version of it, and so he became the focus of their opposition. Steer, for example, had admired an early Cézanne of a black clock shell and other objects which he had seen in Paris in 1907,[86] but Post-Impressionism prevented him from finding anything else in Cézanne to admire. His close friend Henry Tonks thought that the claims put

John Sargent.

Henry Tonks; a caricature by
Powys Evans. Tonks came to
regard Fry as a dangerous dictator.

forward by Cézanne's supporters were not borne out by the work. When drawing was denied, the Slade professor felt, as his biographer points out, that he was in the presence of a 'dangerous enemy of all the beliefs which had governed and guided his own life as a teacher and artist'.[87] Fry and his god Cézanne appeared to be having a bad influence on the students at the Slade, and even on one or two members of the teaching staff. Frederick Brown, a Slade professor, was one of those to feel the force of Fry's arguments. Having begun as one of the scoffers he wrote to Fry a generous letter of retraction. 'He had been completely converted by these painters,' Fry proudly told his father.[88]

Tonks became the most fierce of the Slade New English Art Club group in his opposition to Fry, depicting him as a dangerous mesmerizer, but it is clear from a letter written in 1917 that he was by no means sure of his position and needed constant reassurance:

First of all I would like you to clear up a difficulty that I have in following the somewhat wordy articles that have been written about him [Cézanne]. Do these exponents of his art claim that before all others he was eminent in representing solidity and the third dimension; or what does plasticity mean? . . . I see in him and I would particularly like you to tell me if you agree, a genius of the French tradition, but one terribly confined by his difficulty of expression, a caged eagle, as one might say. You have probably had much more opportunity of seeing him than I have so you can speak with more authority. . . .[89]

Evidently the arguments over Cézanne and Post-Impressionism within the New English Art Club were so frequent that, according to MacColl, Tonks and Steer 'determined to by-pass the perpetual yapping of the patriarch's name by calling him "Mr. Harris"'. Steer's niece recalled the story of a lady who refused to marry a man because he was too dull to discuss Cézanne. 'Surely enough has already been said about Cézanne,' said Steer, wearily.[90] Some release from all this serious discussion was found in a parody of the Post-Impressionist exhibition put on at the Chelsea Arts Club in December 1910. It was called 'Septule and the Racinistes'. A mock catalogue was produced with an introduction which explained that the Racinistes 'go to the root of things' and that the leader of the school, Quinte Septule, born at Arles the son of a prosperous *charcutier*, 'evinced from his earliest years an almost abnormal talent for design'.[91]

William Rothenstein missed seeing the first Post-Impressionist exhibition because he was on a voyage to India. He might have injected some sense into the discussions, as he was among the few artists in Britain to know anything about Cézanne. He had first seen Cézannes in the 1890s at Vollard's, and he had come across further examples on visits to Florence at the homes of Berenson and Loeser in the early 1900s, at about the same time as Leo Stein.

I thought him a puzzling and provocative artist [he recorded]. His pictures seemed awkward, but yet had a strange and powerful honesty, so that despite his lack of skill, they had an intensity which was denied to the pictures of men of greater natural capacity. . . .[92]

Rothenstein was kept informed of developments by Eric Gill, whose summing-up of the effect of the exhibition is worth repeating:

You are missing an awful excitement just now being provided for us in London; to wit, the exhibition of 'post-impressionists' now on at the Grafton Gallery. All the critics are tearing one another's eyes out over it and the sheep and the goats are inextricably mixed up. John says 'it's a bloody show' and Lady Ottoline says 'oh, charming'. . . . The show quite obviously represents a reaction and transition and so if, like Fry, you are a factor in that reaction

and transition then you like the show. If, like MacColl and Robert Ross, you are too inseparably connected with the things reacted against and the generation from which it is a transition, then you don't like it. If, on the other hand, you are like me and John, McEvoy and Epstein, then, feeling yourself beyond the reaction and beyond the transition, you have a right to feel superior to Mr Henri Matisse (who is typical of the show – though Gauguin makes the biggest splash and Van Gogh the maddest) and can say you don't like it.[93]

In point of fact Augustus John appears to have changed his mind, at least about certain aspects of Post-Impressionism, during the course of the exhibition. In a letter to the American collector John Quinn in December he says that his opinion of the exhibition is 'by no means favourable'. But a letter to Quinn, dated 12 January, gives a different view:

I went to the post-impressionists again yesterday and was more powerfully impressed by them than I was at my first visit. There have been a good many additions made to the show in the meanwhile – and important ones. Several new paintings and drawings by Van Gogh served to convince me that this man was a great artist. My first view of his works disappointed and disagreed with me. I do not think however that one need expect to be at once charmed and captured by a personality so remarkable as his. Indeed 'charm' is the last thing to talk about in regard to Van Gogh. The drawings I saw of his were splendid and there is a stunning portrait of himself. . . . As for Matisse, I regard him with the utmost suspicion. He is what the French call a fumiste – a charlatan, but an ingenious one. He has a portrait here of a 'woman with green eyes' which to me is devoid of every genuine quality – a vulgar and spurious work.[94]

Walter Richard Sickert. The rumpus brought out the entertainer in him.

What would Sickert have to say? It is one of the engaging sides to Sickert's character that no one knew what he would do or say until he did it. Like the actor and *poseur* that Clive Bell and others have claimed him to be, Sickert knew the advantage of suspense, of keeping his audience guessing.[95] He enjoyed teasing his fellow artists and the critics. Fry became a natural target and Clive Bell recalls the story of a friend asking Sickert why he kept a peculiarly idiotic German picture on his mantelpiece: '*pour emmerder* Fry,' was the answer.[96] Still, Sickert is always worth reading; he can be stimulating and he is often very funny.

The Post-Impressionist exhibition, as might be expected, put him in an awkward predicament. The Cézannes, and to a greater degree the Matisses and Vlamincks, were not to his taste. As for Van Gogh, he was quick to admit his hearty dislike of the Dutchman's method of applying paint, 'but that implies a mere personal preference for which I claim no hearing,' he added.[97] To his later embarrassment Sickert had once advised Gauguin, or so he claims, to stick to stockbroking. But if he disliked some aspects of Post-Impressionism he disliked the more vocal opponents of Post-Impressionism – Richmond, Burne-Jones and others – even more. He was intelligent enough to see that

Henry Tonks, *The Unknown God*, exhibited 1923. Fry holds up a dead cat, a symbol of 'pure form', while Clive Bell rings a bell announcing the new creed: 'Cézannah Cézannah'. In the front row are some of Fry's staunchest opponents: Sickert, MacColl, George Moore and Steer.

the art of Cézanne, Gauguin and Van Gogh was far superior to the art maintained by these men. By nature he was European in his outlook and wished where possible to break down English reserve towards foreign discoveries. Also, he was inclined to be generous to his fellow artists, even if he did not agree with their work. Thus his assessment of Cézanne and Van Gogh, in his contribution to the *Fortnightly Review* of January 1911, is not unsympathetic. Of Cézanne he wrote, 'The moral weight of his single-hearted and unceasing effort, of his sublime love for his art, has made itself felt'; and of Van Gogh, 'He said what he had to say with fury and sincerity and he was a colourist. *Les Aliscamps* is undeniably a great picture. . . . Blond dashes of water at an angle of 45 from right to left, and suddenly, across these, a black squirt. The discomfort, the misery, the hopelessness of rain are there. Such intensity is perhaps madness, but the result is interesting and stimulating.' His praise for Gauguin is sweeping: 'A strange grandeur has crept into Gauguin's figures, a grandeur that recalls Michelangelo. . . . It will be a crime if *L'Esprit veille* . . . is not acquired for the nation. . . . Was ever painted figure more sculpturesque than the awe-stricken Vahina prone on the couch, not daring to move in the haunted room? Has paint ever expressed perfect form more surely and with more fullness?'[98]

Sickert's admiration for Gauguin, and for certain aspects of the work of Cézanne and Van Gogh, was no pose. But what irritated him, and in the end caused him to come out against the Post-Impressionists, was their elevation overnight into gods, or tribal deities, to use Fry's expression.[99] He, Sickert, had known about these artists for several years – though not as long as he claims – while Fry was still studying the Old Masters and trying to paint like them. He had been a friend of the Impressionists and had heard them discuss Cézanne long before Fry, and it was irritating to say the least to have this academic come along and say that not only was Cézanne not an Impressionist, which was absurd for a start, but that he was better than the Impressionists, and a much greater artist.

Sickert asked himself what lay behind this sudden deification of Cézanne. He detected signs of a dealer's operation, and in an article written three years later when the Cézanne cult had grown even more he repeated this charge, with greater vehemence.[100] Cézanne, he argued, had left hundreds of unfinished canvases that he would not have given a name to, but the dealers had got hold of them and were now trying to get rid of them at vast prices. Interestingly MacColl also thought that there was a 'dealer's ramp' behind Cézanne. The basis for this suspicion was the rise in Cézanne's prices following his memorial exhibition at the Salon d'Automne of 1907. A still-life fetched £760 in 1907 and £2,180 in 1913.[101] Vollard's Cézannes in 1910 would certainly not have been cheap. At the Post-Impressionist exhibition Clive Bell thought of buying one but found it too expensive.

Deep down, however, Sickert felt that Cézanne was what he called *'un grand raté'*, someone who had tried but failed. Cézanne lacked what

Sickert called 'a sense of aplomb'. Monet had it, and so had all great draughtsmen, but 'Cézanne was utterly incapable of getting two eyes to tally, or a figure to sit or stand without lurching. I admit he was looking for something else, for certain relations of colour. But the great painters get their objects *d'aplomb*. ...'[102] This failure was considered to be as unacceptable as amateur theatricals to the professional actor. Sickert was a professional.

The real impact of the exhibition was felt not so much by Sickert and his circle but by a younger group, in particular the Bloomsbury painters Duncan Grant and Vanessa Bell. 'We were wildly enthusiastic about the exhibition,' recalls Grant. Fry became, according to Rothenstein, 'the central figure round whom the more advanced young painters grouped themselves'.[103] But they were not just painters. A generation of writers, poets, musicians and composers found themselves suddenly living in a new world, with new possibilities, new forms, new ideas. Virginia Woolf was right: human nature did change. Katherine Mansfield, for example, then twenty-two, was at the turning point in her career as a writer. She saw the exhibition and years later told her friend, the painter Dorothy Brett, that two Van Goghs 'taught me something about writing, which was queer, a kind of freedom – or rather, a shaking free. When one has been working for a long stretch one begins to narrow one's vision a bit, to fine things down too much. And it's only when something else breaks through, a picture or something seen out of doors, that one realises it'.[104]

It is interesting to compare her reaction with that of E. M. Forster, then thirty-one, with several novels to his credit including *Howard's End*, which was published in 1910. He went to the opening and was shocked by what he saw. 'Gauguin and Van Gogh were too much for me,' he confessed to Edward Marsh.[105] Another of Fry's Bloomsbury friends, Lytton Strachey, then thirty, also failed to respond to the new aesthetic. Privately, as his biographer makes clear, he was capable of being quite rude about Fry and once referred to him as 'a most shifty and wormy character';[106] publicly he felt obliged to fight for Fry's right to express his beliefs. Most of Bloomsbury, from Lady Ottoline Morrell downwards, were eager to join the fight, and as Samuel Hynes has observed in a recent study, 'English Post-Impressionism was less a movement than a social group'.[107]

Who were Fry's enemies? In *Retrospect* he pointed to the educated upper classes:

I found among the cultured who had hitherto been my most eager listeners the most inveterate and exasperated enemies of the new movement. . . . I now see that my crime had been to strike at the vested emotional interests. These people felt instinctively that their special culture was one of their social assets. That to be able to speak glibly of Tang and Ming, of Amico di Sandro and Baldovinetti, gave them a social standing and a distinctive cachet. . . . It was felt that one could only appreciate Amico di Sandro when one had acquired a certain considerable mass of erudition and given a great deal of time and

A page from Claud Lovat Fraser's *Journal* recalling a visit to the Grafton Gallery on 10 November. The sketches are based on paintings by Vlaminck (*A Steamboat on a River*), Matisse (*A Young Lady*) and Gauguin (*Eve during the Fall*).

A steam boat on a River —

The Settlers Cottage —

A Young Lady —

Eve
after
the
Fall

A Study of a head —

attention, but to admire a Matisse required only a certain sensibility. One could feel fairly sure that one's maid could not rival one in the former case, but might by a mere haphazard gift of Providence surpass one in the second.[108]

Few people admit that they are wrong immediately. It took time, not as long as might be thought, for Fry's views to win acceptance. In the end he was very successful. As Kenneth Clark has pointed out:

A large, confused section of the public, dimly desiring to appreciate works of art, had begun [by the 1930s] to prefer coloured reproductions of Cézanne and Van Gogh to the meagre, respectable etchings which had furnished houses of a preceding generation; and many of Fry's theories had been assimilated by those who had never read a word of his writing. In so far as taste can be changed by one man, it was changed by Roger Fry.[109]

Indeed even today, reproductions of some of the paintings in the exhibition – Van Gogh's *Sunflowers* or *La Berceuse* – are among the most popular prints ever.

Was the exhibition a success? In Mr Cooper's view it was a failure. It was 'an unfortunate exhibition', which 'had the effect of frightening the English public away from rather than encouraging it to take an active interest in modern French art'.[110] Clive Bell's assessment is to the contrary:

The first Post-Impressionist exhibition was a prodigious success. It set all England talking about contemporary painting, and sent the more alert not only to Paris but to museums and collections where they could have a look at primitive, oriental and savage art. The attendance was a record for the gallery; the sales were more than satisfactory; the Yorkshire Penny Bank, which held the Grafton Galleries in mortgage, made a pretty penny.[111]

There is no denying the interest created by the exhibition. 'What scorn, what noble rages, what talk, what clouds of dust,' wrote Laurence Binyon in the *Saturday Review*. 'One would think that art had really got hold of the nation at last, so bitter and so heartfelt is the language used.'[112] Soon books on Post-Impressionism appeared.[113] Lewis Hind wrote in his account of the movement:

When the exhibition of Post-Impressionist pictures at the Grafton Gallery closed I sighed, supposing that the stimulus to thought, talk and writing of the pictures was ended – for the present. But no. . . . This whirl of argument had continued, week by week, ever since the opening of the exhibition. What does this mean? Why should a mere picture exhibition stir phlegmatic England? Moreover, it stirred people who are not particularly interested in art. Why should this be?[114]

No subsequent exhibition in Britain has created so much fuss. Fry's second Post-Impressionist exhibition in 1912 – in many respects a stronger and more coherent show, and also more up-to-date – failed to catch on to quite the same extent. By then many of the visitors had become familiar with the Post-Impressionists and the shock of Matisse,

Picasso and others had worn off. The international Surrealist exhibition at the New Burlington Galleries in 1936 and, nearer our time, the two London shows of American Abstract Expressionism, have created a stir, but on the whole the effect has been felt by artists and by those already sympathetic to new art. The first Post-Impressionist exhibition, however, affected the whole nation, whether they were interested in art or not. There is a strong case for saying that it marks the high-water mark of public concern for art in Britain.

A Room at the Second Post-Impressionist Exhibition, 1912. This work has been attributed to both Roger Fry and Vanessa Bell. It shows the room devoted to Matisse which the organisers of the Armory Show saw on their way back to America.

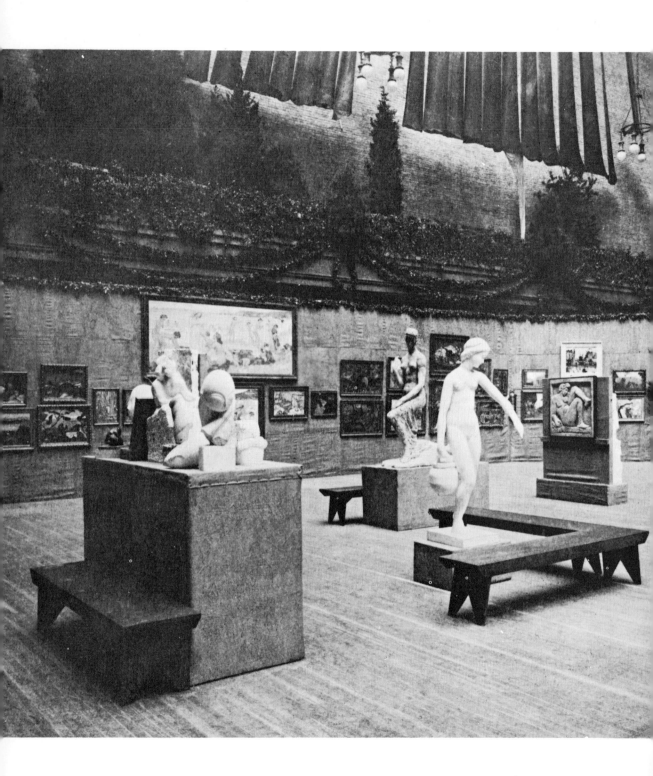

Interior of the Armory Show with sculpture by Brancusi and Lehmbruck.

5 The Armory Show

In November 1879 a French singer, Madame Ambre, went to America with her friend and manager, Count Gaston de Beauplan, for an engagement with the Italian Opera Company in New York and Boston. Among her luggage and effects was something rather unusual – Manet's large and spectacular painting, *The Execution of Emperor Maximilian*. On political grounds the painting had been banned from exhibition in Paris, but Madame Ambre, who had been painted by Manet, thought that by showing the picture in America she could both do the artist a favour and at the same time earn herself some useful publicity. Count Gaston helped with the arrangements and a number of handbills were printed showing a picture of Madame Ambre on one side and Manet's painting on the other. It read: 'Come in! Come in to see the famous picture of the famous painter Ed. Manet!'[1]

Unfortunately the poster did little good. The painting failed to attract the crowds Madame Ambre had hoped for and receipts did not cover expenses. Count Gaston sent the bill for the deficit to Manet.

Thirty-four years later the scene shifts to an armoury on Lexington Avenue between 25th and 26th Street. It is the training-ground and meeting-place of the 69th Regiment of the New York National Guard, called the 'Fighting Irish'. Inside – again rather unexpectedly – there is a large art exhibition. Madame Ambre's modest side-show has been replaced by a circus. The floor is divided into eighteen octagonal booths, the walls are covered with canvas, or burlap, and the decorations are made up of pine trees, festoons of greenery and flags. Yellow and grey streamers reach up to the ceiling to form a big top. The opening of the exhibition takes place on 17 February 1913, but unlike Madame Ambre, who invited 250 guests to a special showing of the Manet at the Clarendon Hotel, of whom only fifty turned up, the organizers of this show have invited four thousand guests and they are all there. A brass band is playing. Somebody calls for order. The president of the exhibition, a quiet, unassuming man, Arthur B. Davies, says a few words. He is followed by an Irish-American lawyer, well and truly accustomed to public speaking. He is John Quinn, a distinguished expert on financial law, a doughty political fighter and a patron of writers and artists. 'This exhibition will be epoch-making in the history of American art,' he shouts out. 'Tonight will be the red-letter night in the history not only of American, *but of all modern art.*' Nobody disagrees. 'Now that the exhibition is a fact,' he continues, and you can almost see him lean back, stick out his chest and place his thumbs between the arm and front of his waistcoat, 'we can say with pride that it is the most *complete* art exhibition that has been held in the world during the last quarter century. We do not except any country or any capital.'[2]

In Barnum and Bailey tradition Quinn reminded his audience that a show like this, with a *cast of thousands*, had been brought to the public *at considerable expense*. In fact ten thousand dollars had been raised by private subscription to put the show on. But the principal organizers were supremely confident that the exhibition would be a hit and would possibly make money.

It would be easy for the European to smile at this enthusiasm and even deplore the publicity-seeking methods of the organizers. Indeed it is hard to imagine Fry behaving in a similar fashion. But this was the American way of doing things and it paid off. In the number and variety of the exhibits the Armory Show did eclipse Fry's Grafton Gallery exhibitions and in attendances it surpassed a similar large-scale survey of modern art, the Cologne Sonderbund. It was a success and it did have its intended effect of waking the American public up to the latest developments in modern art. Collectors, critics and the art-minded public began to look on art in a new light. So did American artists, and rumblings of that first shock to their systems can be detected in American art fifty years later.

Given the importance of the occasion it is hardly surprising to note that a considerable literature on the Armory Show has built up over the years. A bibliography would fill two or three pages. In addition to the accounts provided by the participants there is one definitive study by Milton W. Brown[3] – without it this chapter could not have been written.

What was the art world like in America in the years leading up to the Armory Show?

First, there was an academy in New York that was called the National Academy, 'but,' said one dissatisfied artist, John Sloan, 'it is no more national than the National Biscuit Company.' Although there were rival academies and although it never reached the dominant position of the Royal Academy in London, for example, it did give its members prestige and its annual exhibition was a major event on the artistic calendar. Like all academies it became towards the end of the nineteenth century a more or less reactionary and moribund institution. There were the usual revolts. In 1877 William Chase, a contemporary of Sargent with a similar approach to painting, led a splinter group, the Society of American Artists, which eventually returned to the fold in 1905. In 1898 a group called The Ten, the American equivalent of the New English Art Club, was formed, not in opposition to the Academy but in order to gain greater attention for their work. A more serious revolt occurred in 1907, led by a forceful member of the Academy itself, Robert Henri, in his day one of the most influential teachers in America. It resulted in an exhibition at the Macbeth Galleries in 1908, which consisted of four of Henri's pupils from Philadelphia – William Glackens, John Sloan, George Luks and Everett Shinn – who shared a common dislike of conventional 'genteel' sub-

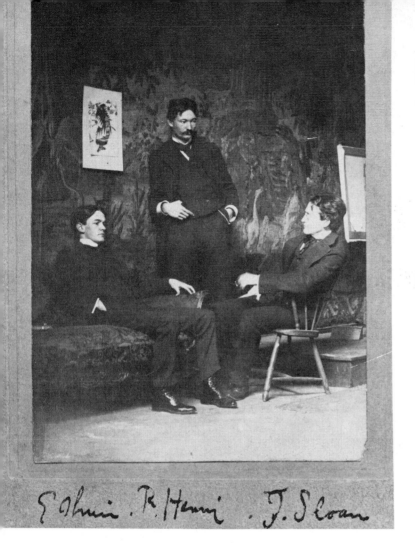

Robert Henri with his pupils,
Everett Shinn and John Sloan.

ect-matter and an interest in the working-class life of the metropolis,
nd, to add variety, three individualists – Arthur B. Davies, a Symbolist,
Maurice Prendergast and Ernest Lawson, a pupil of the two distin-
guished American Impressionists, J. Alden Weir and John H. Twatch-
man. Of the group only Prendergast had any great knowledge of recent
developments in Europe. He had been in Paris in the late 1890s and
became one of the first American artists to recognize Cézanne's impor-
tance, but although he often spoke of his enthusiasm to his com-
patriots his work showed little of Cézanne's influence. In his use of flat
colour and mosaic patterns he does, however, have similarities with
some of Cézanne's followers among the Nabis.

The Eight created a good deal of excitement, not on stylistic grounds
but because of their subject-matter. The socially conscious followers of
Henri were called the Black Gang and, several years later, the Ash Can
School. In retrospect it can be seen that their work was but one example
of a general cultural movement that had ramifications not just in art,
but in politics, literature and the world of ideas.[4] A common concern

for social conditions can be found in the photographs taken by Stieglitz, Lewis Hine and Jacob Riis. It can be felt in the writings of Upton Sinclair, Sherwood Anderson and Theodore Dreisser. It can be detected in Theodore Roosevelt's fight against the growing power of the trusts and monopolies, the evangelical socialism of Eugene Debs, a close friend of John Sloan, and the anarchism of Emma Goldman, the apostle of birth control. Among the foremost spokesmen of this movement was Hamlyn Garland who, in his influential book *Crumbling Idols*, preached not only veritism, the truthful, accurate recording of life, but also the need to find subject-matter in America and not in distant European models. Realism entailed closer contact with America. Thomas Eakins, the outstanding American Realist of his day, summed up the situation when he said: 'If America is to produce great painters and if young art students wish to assume a place in the history of art in this country, their first desire should be to remain in America, to peer deeper into the heart of American life, rather than to spend their time abroad obtaining a superficial view of the art of the old world.'[5]

To stay in America was easier said than done. Most artists were dissatisfied with their lot. They were isolated from the rest of society and their position was made worse by the age-old problem of exhibiting their work and selling it. The exhibitions with the greatest prestige were those held by the National Academy in New York and the Carnegie Institute in Pittsburg, and, like their European counterparts, each had become an annual occasion for mutual admiration between members and their friends. There was no alternative and nothing comparable to the Salon d'Automne or the Indépendants. In 1910 an attempt was made to start a jury-less exhibition. It was held in a hired loft at 29 West 35th Street. Twenty-seven artists took part, including Henri, but the experiment was not repeated. The commercial galleries were, well, commercial. 'They vied in coldness and aloofness with the museums,' recorded Guy Pène du Bois. 'They were hung in horrible red velvet and a pall of stuffy silence.'[6] But there were one or two small more progressive-minded galleries: the Madison Gallery, which was part of a decorating business started by Mrs Clara Davidge; the Haas Gallery, which was little more than a picture-framing shop; a gallery started by Gertrude Vanderbilt Whitney; and, most important of all, a gallery opened by Alfred Stieglitz at 291 Fifth Avenue. There, in what was called 'the largest small room in the world', the adventurous were able to see for the first time in America work by Matisse, Rousseau, Cézanne, Picasso, Francis Picabia, Constantin Brancusi and Gino Severini, and also by the more advanced American artists, notably Max Weber, Alfred Maurer, John Marin, Marsden Hartley, Arthur Dove and Stanton Macdonald-Wright. Stieglitz was an irrepressible character and not always easy to get on with. Inevitably there was a certain amount of rivalry between his circle and the Henri group. John Sloan, for example, said that Stieglitz acted as if he 'owned ultra-

Henri Matisse, *Nasturtiums and the Dance II*, 1912. 'No one suffered the lacerating critical assault that he did. ... It was angry, vicious, and almost psychotic in its ferocity.' (Milton Brown)

modern art'. 'I went to 291 once,' he remarked, 'and he talked off one ear. It has grown back pretty well, but I never returned to 291.'[7]

Stieglitz tended to preach to the converted. Collectors showed little interest in modern art; the energies of Pierpont Morgan, Frick and others were dedicated to the acquisition of Old Masters. Little of that superabundance of wealth found its way into patronizing contemporary art. The little that did went to established portraitists like William Chase and Sargent or into the commission of extravagant architectural follies. Thorstein Veblen called it 'conspicuous waste' and he attacked the patronage of the wealthy as 'an indefinitely extensible consumption of superfluities'.[8]

It is hardly surprising to find that art was regarded by the legislature as a luxury, and it was taxed as such by the United States customs in the same manner as imported French fashions or furnishings, much to the inconvenience of the Morgans, the Mrs Gardners and others. Despite pleas emphasizing the 'educational' value of art the tax remained in force until the Tariff Act of 1909, which allowed works of art more than twenty years old to come in duty-free. A tax of fifteen per cent remained on modern works right up to the Armory Show.

It is also hardly surprising to note that most American artists felt the materialism of their fellow countrymen to be uncongenial and destructive to their art. As the country prospered they came to feel more and more isolated. Some found refuge in an American brand of bohemianism that began to appear in small pockets in the big cities – 'hobohemia' it was sometimes called; others in retirement – Winslow Homer and Albert Ryder, two of the greatest American artists of the late nineteenth century, were both recluses; but the majority fled to Europe. The list of expatriates is remarkable. Among painters it includes Whistler, Sargent, and Mary Cassatt; among writers, Henry James, Edith Wharton, Gertrude Stein and T. S. Eliot; and among art historians, Bernard Berenson and Charles Loeser. These are only the tips of an iceberg. Wave after wave of American artists went to Europe in defiance of Eakins's cry to stay at home. The main attraction was Paris, and as a student there himself Somerset Maugham observed the invasion. The hero of Maugham's novel *Of Human Bondage* is startled by the sight of two men in brown velveteens, enormous baggy trousers and Basque caps. 'They're Americans,' explains his cynical companion. 'Frenchmen haven't worn things like that for thirty years, but the Americans from the Far West buy those clothes and have themselves photographed the day after they arrive in Paris. That's about as near to art as they ever get.'[9]

The speaker was both right and wrong. Like the English artists mentioned in the last chapter, most Americans had little contact with the Paris *avant-garde*. Even a future modernist like John Marin, for example, managed to come through his first visit to Paris unaffected by Fauvism or Cubism. But a small proportion of Americans did get involved with the new movements. Maurice Prendergast, as has been

noted, was affected by the growing interest in Cézanne in the late 1890s. Alfred Maurer, who arrived in Paris in 1900, was among the first to be interested in Fauvism. Max Weber, who arrived in 1905, became a friend of Rousseau and along with Patrick Bruce joined Matisse's classes, which started in 1908. Among the Americans in Paris to be affected by Cubism were Arthur Dove, Morgan Russell, Stanton MacDonald-Wright, Thomas Benton, Joseph Stella, Andrew Dasburg, Edward Steichen and Walter Pach. One source of contact was the Salon d'Automne, in which many took part. There were over twenty Americans in the first Salon d'Automne in 1903; in 1904 there were sixteen; among those to take part in subsequent years were Max Weber, Edward Steichen and Alfred Maurer. Most of these Americans returned home to play a leading part in the spread of modernism in America. Some, like Patrick Henry Bruce, stayed, never to be heard of again.

The better-connected American artists in Paris often acted as agents for collectors back home. In 1887 J. Alden Weir, encouraged by William Chase, bought two important Manets for the collector Erwin Davis, which were presented to the Metropolitan Museum two years later. Mary Cassatt bought the Impressionists for her relations, for the Havemeyers in New York and for Mrs Potter Palmer in Chicago. Edward Steichen was largely responsible for the first Matisse exhibition in America at Stieglitz's gallery in 1908.[10]

Matisse's name must have been quite well known in America before the Armory Show.[11] The Steins had told their friends about his work. The painter George F. Of and the two Cone sisters owned Matisses. The first exhibition of drawings at 291 attracted a good deal of critical attention, mainly hostile, but this was counteracted by favourable comments from Berenson (in a letter to the *Nation*), an article by Charles Caffin and a report on 'the wild men of Paris', by Gelett Burgess for the *Architectural Record*. Matisse's second exhibition, in 1910, won him a number of converts, including James Huneker of the *New York Sun* and the art historian Frank Jewett Mather. Guy Pène du Bois wrote that so much attention had been paid to Matisse that his master, Cézanne, had been overlooked and neglected.

Thus before the Armory Show many Americans had had the opportunity to read about and see the new art of Europe, but their knowledge was piecemeal, spasmodic and undirected. What was needed was a comprehensive exhibition that could reveal the development of modern art since the Impressionists. At the same time there was a need for something like the Salon d'Automne in which the leading American modernists could show their work in a serious context. The Armory Show was an attempt to meet both needs. One of the reasons for the disagreements between the organizers later was the fact that the show succeeded in its first aim and failed in its second.

The initiative for putting on such an exhibition came from the Association of American Painters and Sculptors, a group formed to-

Above Walt Kuhn. Always enthusiastic.

Below Arthur B. Davies. 'The isolationist strode out in the open ...' (Du Bois).

wards the end of 1911. Brown starts his account of the association with a meeting between four artists, Walt Kuhn, Elmer MacRae, Jerome Myers and Henry Fitch Taylor, at the Madison Gallery on 14 December 1911. The topic of conversation was the usual artistic grouses – the failure of the National Academy to do anything for younger artists, the lack of good galleries and the need for new exhibitions – but unlike many such discussions, which start with promising suggestions and end with nothing achieved, this time those present formed a plan to get together an association of like-minded artists – and set about fulfilling it. Within five days they had contacted about a dozen artists and arranged a meeting. It took place on 19 December at the Madison Gallery and among those present were Arthur B. Davies, Gutzon Borglum, Putnam Brinley, William Glackens, Ernest Lawson, George Luks, John Mowbray-Clarke and Leon Dabo. During the course of the evening it was decided to give the group a name – the Association of American Painters and Sculptors – and a purpose – that of 'developing a broad interest in American art activities, by holding exhibitions of the best contemporary work that can be secured, representative of American and foreign art'. Additional members were proposed and among those to join the new association were Robert Henri, John Sloan, Everett Shinn, George Bellows, Guy Pène du Bois, Maurice Prendergast, Jo Davidson, Sherry Fry and Mahonri Young. Looking at these names it becomes clear that the association derived from three principal groups – Henri and the Realists; the independents who took part in the exhibition at the Macbeth Galleries, Davies, Prendergast and Lawson; and a number of academic dissenters led by the sculptor Borglum. The artists close to Stieglitz are noticeably absent from this list. As Brown points out, 'the members of the association were largely American-orientated, perhaps radical in a local sense, but essentially insular in outlook'.[12]

The first president of the association was J. Alden Weir, who has been mentioned earlier. Weir was a long-standing member of the National Academy but he was liberal in his outlook and wished to help young artists. But he did not share the radical aims of some of the members and when he read what the association hoped to do he quickly resigned. A new president was needed. The obvious choice would have been Henri, but perhaps he was considered too obvious, too closely associated with a certain type of art and a certain type of artist, for the association chose a less assertive figure, Arthur B. Davies. According to du Bois:

Davies underwent an amazing metamorphosis. He had been a rather pervid dweller in the land of romance, an invention of his or of his Welsh blood, in which attenuated nudes walked in rhythmic strides borrowed from the languors of lovers. This was a moody and not too healthy world. Women adored it. Davies, keeping himself inviolate, lived a secret life from which he sometimes emerged, nervous, furtive, apparently incapable of making the

contacts of the real world. . . . His presidency produced a dictator, severe, arrogant, implacable. The isolationist strode out into the open, governed with something equivalent to the terrible Ivan's rod of iron.[13]

Du Bois wrote his description after his disagreement with Davies and it is in this respect not entirely reliable. If Davies had been too remote a figure he would never have been chosen as president. As it was he had a number of qualities that made him suitable for the post. He was respectable, well-connected, a good fund-raiser, intelligent, cultivated and open-minded. Before the Armory Show his knowledge of modern art was limited. In 1893, with help from his dealer and friend William Macbeth, he had visited Europe, where he studied the Old Masters and developed a taste for the Romantics. Of the moderns he was mainly interested in Moreau, Puvis de Chavannes and Böcklin. According to Walter Pach, Davies was reluctant to speak French, an inconvenience that must have limited his contacts with contemporary French artists.[14]

Although he was qualified for the role of president, it is hard to fathom his reasons for accepting. In many ways, as du Bois noticed, Davies was a mysterious and secretive figure. He left no published account of his role with the association or his motives in organizing the Armory Show. In his personal life he was of necessity secretive, for, as Brown discovered, he had two families and sometimes adopted the name David Owen.

Davies was elected president on 9 January 1912, and over the next few months he and the more active members of the association began to make plans for an exhibition. The scope and scale of the exhibition does not appear to have been properly thought out but evidently they were thinking big because by April Walt Kuhn had found an armoury that could be rented for an exhibition.[15] After months of negotiations a lease for the hire of the armoury was signed on 1 July. Even then there does not seem to have been any definite plan for the form of the exhibition. However, the association knew that it would have to put on something big to fill the floor space, and something spectacular to bring in the crowds. The solution to the problem came in the form of the catalogue of the Cologne Sonderbund show, which Davies received late in the summer of 1912.[16]

The show was organized by the Federation of West German Art-lovers and Artists. Its president was Karl Osthaus, one of the first men in Germany to buy and support the Post-Impressionists and possibly the only museum man to go to Aix-en-Provence to buy directly from Cézanne. The aim of the Cologne exhibition was to provide 'a con-spectus of the movement which has been termed Expressionism'. The core of the exhibition was devoted to Van Gogh, who was represented by a collection of over 120 works, but there were large collections of works by Cézanne, Gauguin and Munch. In the anteroom to the main exhibition halls there were works by El Greco, who seemed to estab-

Odilon Redon, *Andromeda*, 1913.
'We are going to feature Redon
big (BIG!).' (Kuhn).

lish a historical precedent for the work of the moderns. One of the most
important features of the show was its internationalism, and it managed
to impart a sense of unity to the work of many factions. Expressionism
was treated in its broadest sense and the show included the Fauves,
Munch, the Berlin New Secession and the Munich *Blaue Reiter*. It
included a wide-ranging view of Picasso's achievement; his work out-
numbered Matisse's, even though the latter was at that time better
known in Germany. It also encouraged the active participation of
leading German artists. Ernst Kirchner and Erich Heckel worked
furiously on decorating a chapel which was one of the successes of the
show.

Davies must have realized its scope from the catalogue. He scribbled
on his copy a note to Kuhn: 'I wish we could have a show like this.'

Kuhn was on a painting trip in Nova Scotia when he received the
catalogue. But, always a doer, he there and then decided to catch the
next boat to Europe and see the show for himself. He arrived just as
the exhibition was closing but he managed to wander round while it
was being dismantled and talk to one or two artists and dealers.

With hints picked up at the exhibition Kuhn set off on a trail that led
him to The Hague, Munich and Berlin. At The Hague he saw a batch
of Redons that he knew would appeal to Davies and he began plans to
make Redon one of the discoveries of the Armory Show. He then went
on to Paris, where following another tip from Davies he looked up
Walter Pach, who gave him an eye-opening tour of the galleries and

studios. Kuhn realized that it was all too much for one man to handle and he cabled Davies to join him.

Davies arrived in France on 6 November and the two men – Davies quiet, reflective, decisive, and Kuhn enthusiastic, adventurous and eager – set off to discover the Paris art world with Pach as their guide. Their itinerary naturally included the Steins, where they were able to see a cross-section of Matisses and Picassos, the dealers Vollard, Druet and Bernheim Jeune, but it also included a visit to Brancusi and to the three Duchamp brothers. The last two visits left their mark on Davies and as a result Brancusi and the Duchamps featured prominently at the Armory Show and were given greater attention than many better-known leaders of the *avant-garde*. Davies was immediately impressed by meeting Brancusi and seeing his work. He turned to Pach and said, 'That's the kind of man I'm giving the show for.' He also bought a marble work, *The Torso*, which he later lent to the Armory Show.

Davies was equally impressed by the many talents of the Duchamp family, which consisted of the painter Jacques Villon, the sculptor Raymond Duchamp-Villon and Marcel Duchamp. The two eldest brothers, Jacques and Raymond, were prominent Cubists, but Davies thought the youngest offered the most promise. At the age of twenty-five Marcel had already acquired a reputation in the Paris art world and, on the strength of one painting, the famous *Nude Descending a Staircase*, he had succeeded in upsetting some of the most seasoned members of the *avant-garde*.[17]

Marcel Duchamp with his brothers. From left to right: Jacques Villon, Raymond Duchamp-Villon and Marcel Duchamp.

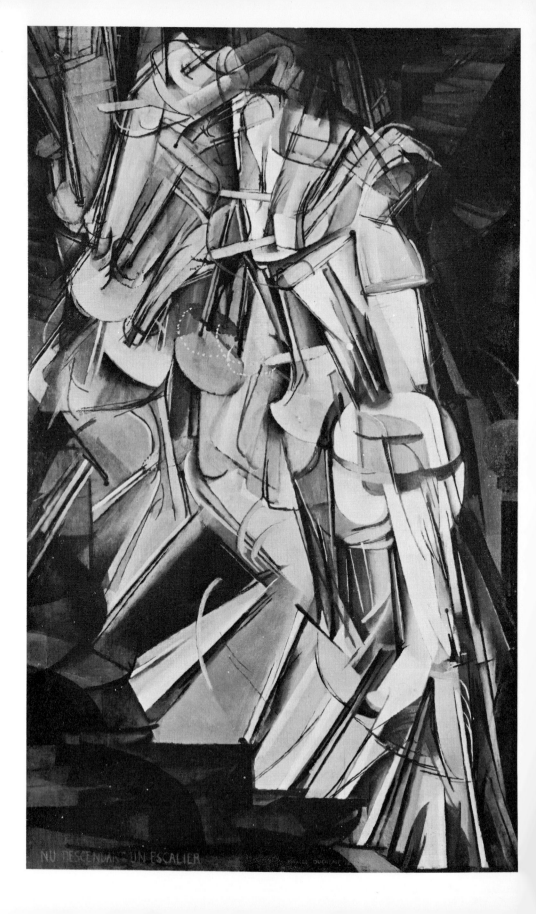

NU DESCENDANT UN ESCALIER

Marcel Duchamp, *Nude Descending a Staircase, No. 2, 1912.*

This large painting was executed at Neuilly in January 1912 and it stemmed partly from previous work – a drawing for a poem by Jules Laforgue called *Encore à cet Astre* ('Once more to this star'), which showed a nude *ascending* a staircase, and a dark sombre painting called *Sad Young Man in a Train*, which looks a bit like the multi-reflections obtained by standing between two parallel-facing mirrors – and also from external sources like the cinema and the 'chronophotographs' that appeared in the illustrated magazines and used a process pioneered by Jules Marey for showing figures in motion. By coincidence it resembled the devices used by the Futurists to convey movement, which Duchamp may have heard about but could not have seen as the first Futurist exhibition in Paris did not take place until February 1912.

Duchamp later came to explain the evolution of his *Nude*: 'In the sketch for Laforgue's poem I had the nude ascending, but then I began to think that it would help my expression to have her descending. More majestic, you know – the way it's done in the music-halls.'[18] To Katherine Dreier he explained his reasons for restricting his palette: 'A painting is, of necessity, a juxtaposition of two or more colours on a surface. I purposely restricted the Nude to wood colouring so that the question of painting *per se* might not be raised.'[19]

Superficially, in its colouring and its use of repeated pictorial elements, the *Nude* resembles a Cubist painting, but whereas the small bits and pieces in an orthodox Cubist work could theoretically be put together to form a figure, a still life or a landscape, no such reconstruction is possible in the Duchamp picture. Indeed it requires some knowledge of pictorial conventions to know what the painting represents. Is the *Nude* a man or a woman, for example? It is natural to think of it as a female, but Duchamp has indicated that the work has an auto-biographical character, and he evidently felt it necessary to give the work a descriptive title, which is incorporated in large clear letters into the surface of the painting itself. Some writers, for example Robert Lebel, speak of the *Nude* as if 'it had moved to the farthest limits of painting',[20] but others, like William Rubin, correctly in my view, have pointed out, 'The *Nude*'s place in modern painting is not far from that of Futurist painting. Its novel element – the "representation" of movement by the depiction, in one picture, of successive phases of an object in movement – was a *narrative*, not a *plastic*, innovation, and it did not open a new direction for painting.'[21]

The commotion caused by the painting is largely due to the title, which is both suggestive and joky. It was the former quality that earned the picture its notoriety in New York and the latter quality that caused the trouble in Paris. The hanging committee of the Salon des Indépendants of 1912, to which Duchamp sent the *Nude*, consisted of Albert Gleizes, Jean Metzinger, Henri Le Fauconnier, Fernand Léger and Alexandre Archipenko, all orthodox Cubists determined to make the exhibition that year a great manifestation of Cubism. It was partly to

be the culmination of many years of struggle and also a counter-demonstration to the stir caused by the Futurists in February. The atmosphere was rather like that of Russia after the success of the Revolution: the victories needed to be consolidated, the movement freed of its deviationists and potentially treacherous allies. This was no time for humour or for treachery and to the Cubists Duchamp appeared to be guilty of both crimes. They therefore asked his two brothers to use their good offices to get Duchamp to remove his painting. Dressed suitably for the occasion they called on the young Marcel. 'I said nothing to my brothers,' recalled Duchamp, 'but I went immediately to the show and took the painting home in a taxi. It was really the turning-point in my life. . . .'[22]

The rebuff does not seem to have affected Duchamp and indeed it may have been a spur to his imagination. The next few months were among the most productive of his career and on a visit to Munich he finished what is generally regarded as his best, and almost last, painting, *The Passage from the Virgin to the Bride*. On his return to Paris in September he renewed his friendship with Picabia and Apollinaire. There are the first glimmerings of Dada in their interchanges. To Davies and Kuhn, Duchamp must have seemed the epitome of the Parisian *avant-garde* spirit.

Davies was in Paris for only ten days and in that short period he had to absorb a variety of visual sensations. But despite the rush he and Kuhn had laid plans for the backbone of the foreign section in the Armory Show. Leaving Pach to tie up loose ends they went on to London, where on 16 November they went to Fry's second Post-Impressionist show. According to Kuhn: 'I could see in the glint of Davies's eye that we had nothing to fear by comparison.'[23] Following them, Brown underestimates the Grafton Gallery show. In fact it was a more concentrated and more carefully conceived exhibition than the first one and it contained a magnificent display of Matisses. The two Americans were evidently impressed by this aspect, for they instructed Pach to get more Matisses for the New York exhibition.

On 21 November they sailed for New York and soon after their arrival Kuhn sent Pach a progress report on the exhibition: 'You have no idea how eager everybody is about this thing and what a tremendous success it's going to be. Everybody is electrified when we quote the names etc. The outlook is great, and having figured up the likely income we stand to come out ahead of the game as far as money goes.'[24] Kuhn seems to feel it necessary to apologize for his request for publicity information. He explains:

John Quinn, our lawyer and biggest booster, is strong for plenty of publicity, he says the New Yorkers are worse than rubes, and must be told. All this is not to my personal taste, I'd rather stay home and work hard at my pictures shoving in some of the things I have learned, but we are all in deep water now and have got to paddle – Don't disappoint me on this – Our show must be talked about all over the U.S. before the doors open.[25]

On 17 December Davies and Kuhn met the members of the associa-
tion and told them about their European visit. Plans were drawn up
for the selection of the rest of the exhibition. Davies spread the
responsibility for the organization and promotion of the show as diplo-
matically as possible between the members. Various committees were
formed – a general executive committee under Myers, a committee on
domestic exhibits under Glackens, a committee for foreign exhibits
under MacRae, and committees to look after the catalogue, printing,
publicity and the conversion of the armoury into exhibition rooms. It
was decided to open the show on 17 February, which meant that there
was less than two months to complete the arrangements. More money
was needed and Clara Davidge set out to knock on the doors of Mrs
Whitney Straight and Mrs Payne Whitney, who donated a thousand
dollars each.

Undoubtedly the committee on domestic exhibits faced the stiffest
task. They had to cope with the susceptibilities of the American artists
and at the same time ensure that the American work fitted in with the
foreign entries. They were naturally anxious to exclude 'exhibition'
pictures and they felt it necessary to issue a statement on 4 January
pointing out that the foreign works would be characterized by 'dis-
tinct individuality of expression' and they asked American artists to
supply work with a 'personal note'.

Originally the association had planned to do away with the jury sys-
tem and to conduct the selection by invitation only. But they were soon
faced with numerous requests by uninvited artists to take part and they
were forced to relent and arrange a small jury to consider these entries.
They did well, for, out of many possibilities, they chose among others
Stuart Davis, Edward Hopper and Joseph Stella.

The domestic committee were better acquainted with the Social
Realist painters, but they seemed to have acted with commendable fair-
ness to Stieglitz and his artists. Among those to take part in the
Armory Show were John Marin, represented by his Cubist-inspired
watercolours of the new Woolworth building, Alfred Maurer, Samuel
Halpert, Abraham Walkowitz and Marsden Hartley, whose untitled
drawings seemed to one critic to have crossed the dividing line into
pure abstraction. The leaders of the association appear to have been
almost too modest in their contributions to the show. Davies was
represented by three oils and three drawings, Kuhn by two oils and
some drawings and Glackens by three oils only. But despite this there
were complaints of favouritism and unfairness. Weber, who had
studied with Matisse and who had been closely associated with Euro-
pean modernism for a number of years, could with some justice regard
himself as the leading American modernist. To be asked to send only
two paintings to the exhibition was an insult, he felt, and he declined
to show his work, though he did lend works by his friend Henri
Rousseau. Robert Henri was disgruntled, but the association managed
for a time to patch up their disagreement. Gutzon Borglum, a difficult

D. Marsden Hartley,
Still-life No. 1, 1913.

NEW YORK

1913

International Exhibition
of Modern Art

**Association of American Painters
and Sculptors, Inc.**

February Seventeenth to March Fifteenth

Catalogue 25 Cents

Cover of the Armory
Show catalogue.

character at the best of times, found himself at loggerheads with Davies over the selection of American sculpture for the exhibition. He attempted to win his way by appealing to the constitution of the association and when this had no effect he resigned, making as much fuss as possible in the newspapers. It was all good publicity.

As the opening date drew nearer there was little time for the organizers to stop and consider what they were doing. Problems had to be solved as they came up. Postcards had to be ordered, pamphlets printed, catalogues prepared, works cleared through customs, publicity maintained, invitations sent out. The armoury had to be converted, special rooms and partitions built, and decorations found. The American contributions had to arrive by 14 February, which allowed only two days in which to hang the exhibition. It is a tribute to the drive and organization of Davies and his teams that everything was ready for the press show on 16 February.

Journalists are not easily impressed. After so much advance publicity the exhibition might have come as an anticlimax. But if there were such fears they were quickly allayed by the sight of the show, which was every bit as spectacular as the organizers had promised. On view were approximately 1,300 works of art, the bulk of which (two-thirds) came from American artists. About three hundred artists were represented. The works were spread through a series of eighteen rooms. The entrance contained work by American sculptors, including Bob Chanler's decorative screens. Through the hall, in the main central section, was a survey of modern art, starting with a Goya miniature, lent by John Quinn, continuing with paintings by Ingres, Delacroix, Courbet, Corot, Daumier and Manet and extending to the work of the Impressionists, Post-Impressionists and moderns. Noticeably absent from this section is any work by Millet, arguably the best-known French artist of the nineteenth century in America. Nor were there any paintings by the Barbizon school, or 'the great cow-painters', as the editor of *Century* magazine, Frank Crowninshield, used to call them. One minor result of the Armory Show was to encourage American museums to remove their great stocks of Barbizon works to the basement.

A feature of the historical section is the high number of American lenders. The Post-Impressionists had already begun to enter American collections and the Armory Show helped to encourage the process. Among the lenders were John Quinn, who had bought a Cézanne, a Van Gogh and a Gauguin from Vollard on a brief visit to Paris the previous summer, two Boston collectors who lent Cézannes, a Chicago collector who sent Gauguins, George Of, who sent the Matisse mentioned earlier, and Katherine Dreier, who sent a small Van Gogh.

American paintings and sculpture were arranged on either side of the central section and these too were preceded by a historical survey that included works by Whistler, Twachtman, Weir, who lent generously to the exhibition and must have smoothed over his differences with the

View of the interior of the Armory Show showing the octagonal shaped 'booths'. Two Matisse portraits can just be made out in the first room on the right.

association, and Albert Ryder, one of the discoveries of the exhibition. Among notable absentees were Homer, Eakins, Chase and Sargent.

The most controversial rooms were at either end of the armoury: the Cubists to the south and the British and German artists to the north.

The show seemed 'complete' enough, to use Quinn's phrase, but few were aware of what had been left out. The exception was Christian Brinton, who was sufficiently well versed to be able to compare the show with Fry's second Post-Impressionist exhibition and the Cologne Sonderbund.[26] He felt that the Armory Show was not as representative as it might have been. He noticed the absence of the German groups and he felt that Redon's work had been over-emphasized. Charles Caffin, English by birth and a regular contributor to Stieglitz's *Camera Work*, was disappointed by the choice of paintings by the big three Post-Impressionists.[27]

Odilon Redon, *Orpheus*.

In retrospect the show can be criticized for its treatment of Cubism, for failing to give sufficient attention to Picasso and Braque and for throwing too much emphasis on the work of the Duchamp brothers. Expressionism was not properly displayed and the organizers showed an unfortunate anti-German bias. Kirchner should have been better represented and there should have been work by other members of the *Blaue Reiter* and *Die Brücke* groups. Munch appears to have been added as an after-thought and the organizers might have thought of including Ensor. The British section was badly over-balanced by Quinn's massive holding of Augustus Johns.

But these are quibbles and the journalists and critics attending the preview rightly concentrated on congratulating the association for putting on such a spectacular show. Frank Jewett Mather, the art historian, disliked much of the work on view but he felt that the presentation was 'a simple miracle of good taste and good management'. The show's chief value, he says, 'is that it demonstrates how

practical it is to organize a comprehensive art exhibition in New York. The example may be commended to the Academy. If it really wishes to assume national significance as an exhibition body, the way is pointed out.'[28] The exhibition was a tribute to American enterprise and 'go' and showed what could be done with sufficient enthusiasm. Most of the newspaper comment, from the *New York Times* down, agreed that the exhibition was an experience not to be missed. The association was congratulated for its initiative.

Despite good publicity and many favourable reviews the attendance in the first two weeks failed to come up to Kuhn's expectations, at any rate. But it was the lull before a storm. The figures mounted rapidly and as many as 10,000 people may have gone to the show on the last day in New York. By the time it closed there had been about 87,000 attendances. In Chicago a reduced version was seen by more than double the New York numbers: in three and a half weeks the number of visitors amounted to nearly 188,650. In Boston there were 12,670 visitors, bringing the combined total to nearly 300,000.

Some two weeks after the opening Kuhn knew that the show would be a popular success. In a letter of 3 March he wrote proudly, 'Every afternoon Lexington Avenue and the side streets are jammed with private automobiles, old-fashioned horse equipages, taxi cabs and what not.' With his usual self-assurance he informed his correspondent, 'All foreigners who have seen European shows concede that this is greater than any ever held anywhere on earth.'[29]

The show proved a great social attraction. Many visitors went over and over again. You never knew who you were going to see there. Enrico Caruso went one Saturday and amused the crowd with his caricatures. Lady Gregory and some of the Irish actors from the Abbey Theatre – on a second visit to America – appeared. The sixty-six-year-old Albert Ryder was seen one day walking round the exhibition on the arm of Arthur Davies. Pierpont Morgan's son came and complained that the show was a waste of money. Henry Frick toured the exhibition and was near to buying the most expensive work in it, Cézanne's *Woman with a Rosary*, which was priced at $48,000, but was persuaded by a dealer to stick to Old Masters and bought instead a flower-piece by Pach for $87.50. Mrs Astor was a regular morning visitor and so was Lillie P. Bliss. Quinn popped in when he could. He informed the Irish painter A. E. Russell: 'I enjoy a visit to the Armory with its pictures more than I would to an old cathedral. This thing is living. The cathedrals, after all, seem mostly dead or remind one of the dead.'[30] He wrote to another of his regular correspondents, Joseph Conrad, that the show was 'a genuine refreshment to me. I never got tired of going round.'

Before the exhibition Quinn's collecting energies had been mainly centred on Irish and English artists, notably John. He showed little interest in contemporary American art but Walt Kuhn became a close friend and through him Quinn took an active part in advising the

A Caruso caricature.

Caruso Becomes a Cubist, Draws Picture of Himself
FROM LA FOLLIA DI NEW YORK.

A cartoonist's view of the public's reactions to exhibition.

Opposite Maurice Prendergast, *Crepuscule*, 1912. One of seven works by this artist in the show.

association and helping out generally. Before the show opened Quinn had begun to take an interest in modern French art. His trip with John to Paris and Provence had perhaps stimulated him to start buying the Post-Impressionists. In New York Kuhn egged him on to buy and Quinn responded by spending $5,808.75 on an assorted collection including works by Duchamp-Villon, Villon, Jules Pascin, Redon André Dunoyer de Segonzac, Signac. His collecting was proceeding at an avaricious pace, and even while the Armory Show was on he had time to search for Chinese works of art and manuscripts. On 2 March he made the costliest purchase to date, two large oils by Puvis de Chavannes, for $28,000. Quinn's choice from the Armory Show shows no real insight into the development of modern art. But the sight of some of the works began to have an effect. He wrote to A. E. Russell on 2 March: 'After studying the work of the Cubists and Futurists, it makes it hard to stomach the sweetness, the prettiness and the clawing sentiment of some of the other work.'[31] His conversion to modernism had started and eventually Quinn was to form an unrivalled collection of twentieth-century masters, including some of the works from the show itself, such as Matisse's *The Blue Nude* and Brancusi's *Mlle. Pogany* Many years later he bought a study for Duchamp's *Nude Descending a Staircase*, a 'a personal souvenir of the Armory exhibition'.

Below Theodore Roosevelt.

Bottom George Luks, *Study of a Lion in the Bronx Zoo*. Roosevelt admired his drawings.

The painter John Yeats was one of Quinn's intimates to see the show, and he gave his son, W. B., his news of the goings-on:

Quinn has bought a whole heap of pictures at the International Exhibition. He is wildly happy over the exhibition. All the Americans think it overtops creation, and it is extraordinarily interesting, but I think artists who have lived and studied abroad, in France and England, are not so much astonished and impressed. Matisse to my mind is an artistic humbug, though probably an honest man. . . .[32]

Quinn was one of those in attendance when former President Theodore Roosevelt visited the exhibition. It was 4 March, the day Taft left the White House to be replaced by Woodrow Wilson. By splitting the Republican votes Roosevelt had been instrumental in Taft's downfall. According to Pach, Roosevelt was in 'his happiest mood'. On his tour round the exhibition he joked with the artists and there were frequent cries of 'bully!' as he examined some of the more unusual works. On meeting Arthur Davies he complimented the painter on the composition of one of his figure paintings. Presumably he made some crack about Cubism because Davies replied that his works were 'all built up geometrically. Just full of pentagons and triangles on the inside.' 'I dare say,' answered the Colonel, 'and I dare say the Venus of Milo has a skeleton on the inside, and that's the right place to keep it.'[33]

Roosevelt was so stimulated by his visit that he decided to write a 'layman's view' of the exhibition for *Outlook*.[34] It appeared on 9 March and judging by a letter to a friend he was sufficiently pleased by his venture into art criticism to consider reprinting it in a volume of essays. The author of *The Rough Riders* is apt to be treated as a philistine, an anti-intellectual, a proto-Hemingway. His passion for big game and the outdoor life should not obscure the fact that he was also a cultivated man, widely-read, open-minded and outward-looking.[35]

Roosevelt was clearly more at ease with the work of the American painters and sculptors which, he felt, 'is of the most interest in this collection, and a glance at this work must convince anyone of the real good that is coming out of the new movements, fantastic though many of the developments of these new movements are.'[36] His eye was caught by the work of Sloan and Luks, a picture of the *Terminal Yards* by Leon Kroll, and the sculpture of Mahonri Young. The extremist element in the exhibition was beyond him but he said that the organizers 'are quite right as to the need of showing to our people in this manner the art forces which of late have been at work in Europe, forces which cannot be ignored.' He clothes his suspicion of these forces in wisecracks. The very word 'Cubism' strikes him as a technical term used to impress the innocent; for people to call themselves Cubists is as fatuous as if they were to call themselves 'Octagonists, Parallelopipedonists, or Knights of the Isosceles Triangle, or Brothers of the Cosine'. Duchamp's *Nude* is an abstract pattern like his Navajo rug

nd he wonders why the artist should have given his picture a descrip-
ve title. He concludes that 'from the standpoint of decorative value,
f sincerity, and of artistic merit, the Navajo rug is infinitely ahead', an
nderstandable remark, coming as it did from a collector of Indian
1gs and handicrafts.

The modern element in the exhibition placed Roosevelt in an awk-
vard quandary and his reactions were those of many of his fellow
ountrymen. In principle he welcomed 'newness' and 'progress'. He
ead the catalogue and agreed: '. . . there can be no life without change,
o development without change, and that to be afraid of what is dif-
erent or unfamiliar is to be afraid of life.' But the problem posed by
1e show was how to reconcile a belief in progress with his traditional
1ste in art. At least Roosevelt tried, and his attitude, like that of many
mericans, is preferable to the complacency with which Englishmen
reeted the Post-Impressionist exhibitions in London.

Roosevelt, in common with the majority of visitors, was intrigued by
1e title of Duchamp's *Nude*. Visually it is a sombre work; the colouring
nd brushwork are restrained, the imagery almost indecipherable. It
ffers nothing of the visual shock of seeing Picasso's *Demoiselles
'Avignon* or Manet's *Déjeuner sur l'herbe* for the first time. Yet it became
1e star of the show. Long queues formed up to see it and it inspired
1ore discussion than any other work in the exhibition. The reason for
s becoming such an attraction was, says an eye-witness, Guy Pène du
3ois, 'because it was the most incomprehensible. It was the most
1comprehensible because its title was misleading. There were plenty of
qually mysterious pictures but none in which the promise of the title
/as so definitely unfulfilled.'[37]

The title is undeniably suggestive. 'If it moves, it's rude,' they used
3 say about the nude shows at the Windmill Theatre in London, and
nuch the same could be said of Duchamp's title. The humorous verse
1spired by the *Nude* echoes this line of thought. Maurice Morris in
he *Sun* concluded his poem with the lines:

> The face unguessed,
> The form repressed,
> And all the rest
> Unseen, I'm chanting
>
> Each curlicue
> And whirl of you,
> Each splotch and hue
> But leaves me panting.[38]

But in addition to the suggestiveness of the title the picture seems to
ffer a genuine puzzle. 'Where is the nude?' people used to ask, and
)ach is supposed to have replied, 'Can you see the moon in the Moon-
ight Sonata?' But this did not prevent magazines setting competitions
3 find the nude or the *American Art News* from publishing a poem

that started:

> You've tried to find her,
> And you've looked in vain
> Up the picture and down again.

and ended:

> The reason you've failed to tell you I can,
> It isn't a lady but only a man.[39]

Nor did it prevent a Chicago collector and lawyer, Arthur Jerom Eddy, from publishing in all seriousness a diagram which purporte to unravel the mystery.[40]

Day after day crowds formed before Duchamp's picture. Journalist and commentators outdid each other in efforts to describe the work 'An explosion in a shingle factory,' it was called. 'A pack of brown card in a nightmare', was another attempt, and among the wittiest, 'a stair case descending a nude'. Its fame spread throughout America and San Francisco dealer, Frederic C. Torrey, wired from Albuquerque o 1 March that he would buy the picture sight unseen. The price: $324

Soon there were other buyers for Duchamp's work. Arthur Edd was drawn to everything new. It was said that he was the first man i Chicago to ride a bicycle and among the first to drive a motorcar. I was a relatively easy matter to be the first in Chicago to own a Duchamp Like Quinn he enjoyed a good argument and like Roosevelt he believe in the strenuous life. 'Art thrives on controversy – like every huma endeavour,' he wrote in his book, *Cubists and Post-Impressionists*, pioneering work published in 1914. 'The fiercer the controversy th *surer*, the *sounder*, the *saner* the outcome.'[41] Eddy's style matches hi breathless enthusiasm. He declared, 'The world is filled with ferment ferment of new ideas, ferment of originality and individuality, of asser tion of independence. . . . New thought is everywhere.'

Unlike Roosevelt, Eddy accepted the challenge of the new art an put his wallet where his mouth was. He purchased two Duchamps *King and Queen Surrounded by Swift Nudes* for $324, and *Portrait of Che Players* for $162, Picabia's *Dances at the Spring*, another of the mor advanced pictures in the show, and works by Villon, Gleizes, Derair Vlaminck and Amadeo Sousa-Cardoza, for a total of $4,888.50. Hi motives were not entirely artistic ones. 'Because a man buys a fe Cubist pictures it must not be assumed he is a believer in Cubism,' h pointed out. 'To most men a new idea is a greater shock than a col plunge in winter. Personally, I have no more interest in Cubism tha in any other "ism", but failure to react to new impressions is a sure sig of old age. I would hate to be so old that a new picture or a new ide would frighten me.'[42]

To what extent Eddy was one of the converts made by the Armor Show it is hard to estimate, but by the time he came to write his boo he had read widely about modern art. He was evidently familiar wit developments in London and quotes Frank Rutter, and Clutton

Left Some reactions to Duchamp's and Brancusi's work.

Below One of Arthur Eddy's purchases made in New York on Sunday, 2 March 1913: Marcel Duchamp, *King and Queen Surrounded by Swift Nudes*, 1912. Bought for $324.

Francis Picabia, *Dances at the Spring*, 1912. Bought by Arthur Eddy for $400.

Brock's article on Post-Impressionism in the *Burlington Magazine* [4] mentioned in the previous chapter. He had heard of the more progressive-minded British artists and cites, among others, Fergusson, Peploe, Lewis, Grant, Bell and Fry. His French sources include Émile Bernard, André Salmon and Apollinaire. He mentions the *Blaue Reiter* and *Die Brücke* groups and quotes from Otto Fischer.

Reactions to Duchamp's *Nude*, though mainly unfavourable, were on the whole good-humoured. Brancusi also got off lightly. *Mlle Pogany* was called 'a hard-boiled egg balanced on a cube of sugar', and works like *The Kiss*, with its strong rectilinear forms, provoked numerous jokes, cartoons and comic verses. Matisse, on the other hand

rove people, especially the critics, to anger. The critic for the *New
ork Times* put it bluntly: 'We may as well say in the first place that his
ctures are ugly, that they are coarse, that they are narrow, that to us
ey are revolting in their inhumanity.'[44] When the exhibition moved
Chicago it was a Matisse, *The Blue Nude*, that the art students decided
burn in effigy before the Art Institute. Collectors stayed clear of his
ork, though Mrs Radeke, of the Rhode Island School of Design,
owed her independence by buying a drawing. Even a critic like F. J.
lather, who wrote so ably about Matisse's drawings, found himself
nable to take the oils. In his article for the *Nation* he wrote: 'Upon
ie ugliness of the surfaces I must insist at the risk of repetition. Every-
ing tells of a studied brusqueness and violence. It is an art essentially
pileptic. Sincere it may be, but its sincerity simply doesn't matter,
cept it is pitiful to find a really talented draughtsman the organiser of
teapot tempest.'[45]

At least Mather believed Matisse to be 'sincere'. Most people thought
must be mad, but Kenyon Cox felt that the artist painted 'with
ngue in cheek and an eye on his pocket'. People began to wonder
hat Matisse was like as a person and the answer was supplied by
lara MacChesney's long interview with the artist, which was pub-
hed in the *New York Times* during the course of the exhibition. She
rote:

M. Matisse himself was a great surprise, for I found not a long-haired,
ovenly dressed, eccentric man, as I had imagined, but a fresh, healthy,
bust blonde gentleman, who looked even more German than French, and
hose simple and unaffected cordiality put me directly at my ease. . . .
One's idea of the man and of his work are entirely opposed to each other:
e latter abnormal to the last degree, and the man an ordinary healthy
dividual, such as one meets by the dozen every day. On this point Matisse
owed some emotion.
'Oh, do tell the American people that I am a normal man; that I am a devoted
asband and father, that I have three fine children, that I go to the theatre,
le horseback, have a comfortable home, a fine garden that I love, flowers,
c., just like any man.'[46]

hese were the right words to relay to America, where individualism is
ten more admired in name than in fact. The interview with Matisse
as recognized as a useful weapon for the defence. It was reprinted
Eddy.
The Cubists also had a useful defensive aid in the person of Francis
cabia, Duchamp's friend, who arrived in America in time to be
terviewed by nearly all the newspapers. Although he was articulate,
was not always understood: the *Sunday World* printed one of his
atements and offered a prize for the best 150-word explanation of what
meant. For a time Picabia's name was better known than Picasso's.
The press did very well out of the exhibition. Every day there were
ories and comments. Samuel Halpert, a friend of Robert Delaunay,
tempted to have the Frenchman's work and that of Patrick Bruce

Constantin Brancusi, *The Kiss*,
1908. An obvious target for
the cartoonists.

Henri Matisse, *The Blue Nude*, 1907.
'It is not madness that stares at you
from his canvases but leering
effrontery.' (Cox).

removed from the exhibition because Delaunay's main contribution
The City of Paris, had not been hung. Max Weber's name was drawn into
the controversy. But of course the more the exhibition was written
about the more people came. The association could afford to be
generous to its critics and on 8 March they laid on a beefsteak dinner
at Healy's Restaurant, dedicated to their 'friends and enemies' of the
press. The guests included Royal Cortissoz and his friend, Bryson
Burroughs, who had bought Cézanne's *The Poorhouse on the Hill* for the
Metropolitan Museum, the first Cézanne to enter an American public
collection. It was a lively evening and it ended with Putnam Brinley
leading someone dressed up as an aged Academician in a wild turkey
trot.

There was a larger and more emotional party on the last day of the
exhibition in New York, on Saturday, 15 March. All through the day
the crowds came to take one last look at the exhibits. Jerome Myers
has left a description:

It was the wildest, maddest, most intensely excited crowd that ever broke decorum in any scene I have witnessed. The huge Armory was packed with the élite of New York – and many not so élite. The celebrities were too numerous to register. Everyone came to witness the close, and the audience created a show equally as phenomenal as the exhibition itself. Millionaires, art collectors, society people, all were packed in like sardines.[47]

When the doors closed at ten o'clock in the evening the organizers and staff stayed on to celebrate. Quinn was there and he wrote to a friend:

The artists and their friends, including about a dozen policemen and twelve or fifteen watchmen, formed a procession led by a band, with a tall artist about six feet four [Putnam Brinley again] as drum major, and I directed him, and we marched in and around the . . . rooms of the exhibition, winding our way in between statues and bronzes and figures and groups, and cheering the different artists, cheering Augustus John, cheering the French, cheering the 'Nude Coming Downstairs', cheering Odilon Redon, and so on. Everybody enjoyed himself.[48]

Dinner at Healy's, dedicated to 'our Friends and Enemies of the Press'.

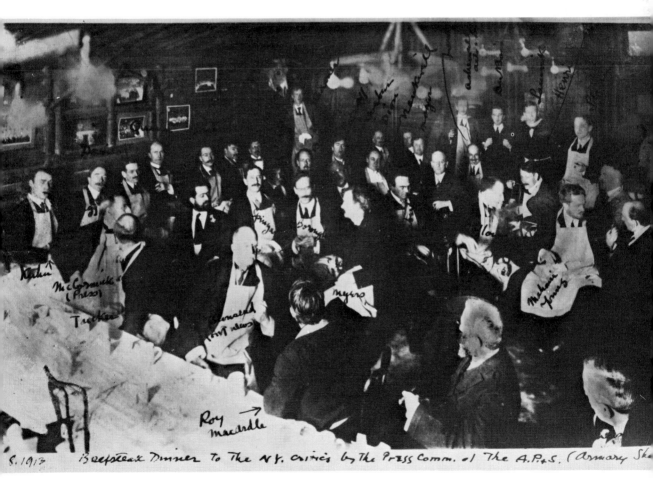

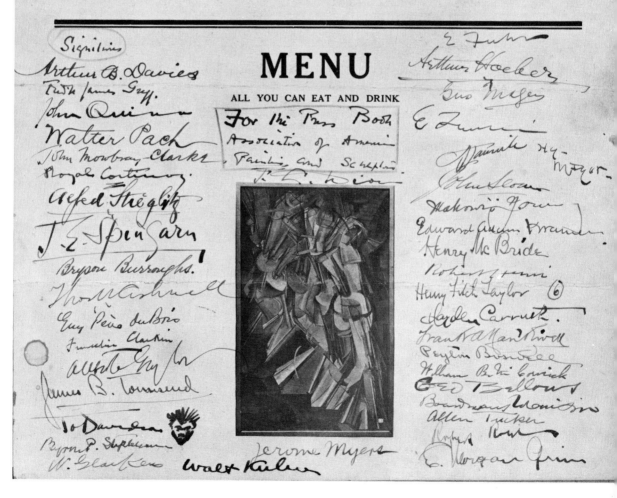

International Exhibition Modern Art
New York

To our
Friends and Enemies
of the Press

The Association of
American Painters and
Sculptors, Inc.

March 8th

BEEFSTEAK DINNER
Healy's—66th St. and Columbus Ave.

1913

MENU

ALL YOU CAN EAT AND DRINK

The menu for the celebratory dinner held at Healy's on 8 March 1913.

It is a pity not to be able to end the story of the Armory Show on that happy note. But New York was not the end of the exhibition. A selection went to the Art Institute, Chicago. There it attracted twice as many visitors as in New York, but the reception was not so good-humoured or so enthusiastic. Quinn wrote to the sculptor Jacob Epstein: 'The artists hated Chicago and thought it ignorant, bumptious, conceited, arrogant and hateful in every way.'[49] Kuhn thought the art students of Chicago 'a lot of rowdy rough-necks. . . . All the instructors at the Institute are mad through, one even went so far as to take a big class of the students into the French room and threw a virtual fit condemning Matisse.'[50]

Chicago was going through one of its periodical anti-vice campaigns. A clergyman wrote to the newspapers that he was obliged to turn back his flock of Sunday-school children when he saw that the rooms were filled with the 'degeneracies of Paris'. The president of the Law and Order League announced: 'The idea that some people can gaze at this sort of thing without its hurting them is all bosh. The exhibition ought to be suppressed.'[51] The chairman of the Senatorial Vice Commission, Senator Woodward, toured the exhibition but could find nothing harmful. According to Walter Pach, word got round the Chicago underground that the Institute was showing 'the real thing from Paris'. As a result the exhibition began to attract some unlikely visitors all dressed in suitable hoodlum attire. Naturally they were disappointed. However one of them was convinced that the real thing was there somewhere and nothing would persuade him otherwise. In desperation he was taken into a back-room where a group of works by Bouguereau and other Salon luminaries were being stored, and these finally satisfied his curiosity.

The foreign section of the show was then transferred to Boston, where it was exhibited by the Copley Society. The exhibition had little impact, and with attendances falling it was time to bring the circus to a close. It had had a good run for its money.

Now came the tiresome business of packing the exhibition up, returning the works to their owners, repairing those damaged, settling claims and preparing accounts. The aftermath was unfortunately made even more unpleasant by a dispute among the members of the association. Henri and his followers were dissatisfied with the running of the exhibition. Davies's methods seemed too autocratic. In addition they resented the financial and critical attention paid to the foreign section in the show, which they felt had stolen the limelight from their own work. Eight members resigned, led by du Bois, Henri, Bellows and Myers. This was the end of the association, though it lingered on as a name until August 1916.

But there were some consolations for all the hard work and time spent by the organizers on the exhibition. Pach felt satisfied and wrote, 'The men who gave the show felt the thrill of contributing to the life of the time.'[52] There was the reward in watching the seeds planted by the

Chicago was going through one of its periodic anti-vice campaigns. Headline from the Chicago *American*.

show bear fruit many years later, often in unlikely quarters. Among the direct effects of the Armory Show was the encouragement it gave Quinn in his successful fight to remove the tax on imported modern art. More important was the impetus it gave to collectors of modern art in America.[53]

The sales realized by the show are impressive and reveal a deeper commitment to modern art than anything shown by the Grafton Gallery exhibitions in London. Altogether 174 works were sold, 123 by foreign artists, 51 by Americans. The sales amounted to $44,148, and again the lion's share ($30,491) went to the Europeans. Prices were by no means low. The most expensive work in the exhibition was Cézanne's *Woman with a Rosary* at $48,000; but a good Van Gogh,

Paul Cézanne, *The Poorhouse on the Hill*, 1888–94. Bought by the Metropolitan Museum for $6,700, the highest price for a work sold at the Armory Show. This was the first Cézanne to enter an American museum.

Mountains at Saint-Rémy, was priced at $15,025, and a Tahitian Gauguin was marked at $8,100. Matisse's work was expensive by comparison with his contemporaries. *Red Studio* was priced at $4,050, *Luxury* and *The Young Sailor II* at $1,350 each. The highest price for a Picasso was $675 for *The Woman and the Pot of Mustard*.

The high prices for the Post-Impressionists and for some of the moderns deflected attention towards the less expensive works in the exhibition though, as has been seen, a Cézanne was sold to the Metropolitan Museum for $6,700. The most popular artist with collectors was Redon, whose lithographs could be bought for $12.50 and his oils for $1,350. The Duchamp family also did well: Marcel sold all four of his exhibits, Villon sold all nine of his paintings and Duchamp-Villon sold three of his sculptures.

Several future collectors of modern art made their first tentative purchases at the Armory Show. Quinn and Eddy have already been mentioned. But Lillie P. Bliss, whose collection was to form the nucleus of the Museum of Modern Art, New York, made a modest beginning at the Armory Show. Dr Albert C. Barnes, who started the Barnes Foundation of Philadelphia and became Matisse's foremost patron in America, visited the show and bought a Vlaminck. He said at the time that he was unimpressed by what he saw, declaring that he had better works at home, but the show helped to broaden his horizons. Two of Duchamp's closest patrons saw his work for the first time. They were Walter Arensberg and Katherine Dreier, and although their purchases were conservative – Dreier bought lithographs by Redon and Gauguin; Arensberg, three lithographs and a Villon oil – they marked the start of adventurous careers as patrons of modern art, which led in one case to the Louise and Walter Arensberg Collection, Philadelphia Museum of Art, and in the other to the Société Anonyme, Inc. and the Katherine Dreier Collection at Yale University.

Duncan Phillips was another collector to be affected by the exhibition. His first reactions were hostile, and in one article he dismissed the show as 'stupefying in its vulgarity'. Later he revised his opinions and in subsequent articles referred to the exhibition as just 'stupefying'. Indirectly the show drew his attention to Cézanne and he was launched on a pattern of collecting that is now embodied in the Phillips Memorial Gallery, Washington.[54]

In general, critical reaction to the Armory Show was disappointing. Although there were many favourable reviews and many enthusiastic defenders of the exhibition and new art, there was no critic capable of giving a comprehensive explanation of modern art and its origins. The show could have done with a Roger Fry, or even someone with Clive Bell's ability to put across an aesthetic argument in a readable and persuasive way. Davies produced a sort of historical chart to explain the development of modern art, but it was not a very profound theory. Most of the argument generated by the exhibition is sociological, political and even moral in tone. Few of the critics analysed their

Maurice Denis, a lithograph from *Amours*, published by Vollard, Paris, 1898. One of three prints bought by Lillie P. Bliss and later presented to the Museum of Modern Art, New York.

visual responses to the works. The pros tended to talk about 'life', 'progress' and 'the need for change'; the antis to mention 'anarchism', 'insanity' and 'charlatanism'. The most eloquent of the antis, the artist Kenyon Cox, wrote an attack on the exhibition that is largely a moral argument: 'Believing, as I do, that there are still commandments in art as in morals . . . I have no fear that this kind of art will prevail, or even that it can long endure.'[55] Interestingly, Cox believed that the new movements in art stemmed from where this book opened, the 1860s. He wrote:

The lack of discipline and the exaltation of the individual have been the destructive forces of modern art, and they began their work long ago. For a time the persistence of earlier ideals and the possession by the revolutionaries

of the very training which they attacked as unnecessary saved the art from entire dissolution. Now all discipline has disappeared, all training is proclaimed useless, and individualism has reached the pitch of sheer insanity or triumphant charlatanism.

The effect of the show on artists was not immediately beneficial. The elder ones like Davies, Kuhn and Ernest Lawson attempted to adapt their styles to the new forms, but their post-Armory Show work is only modern in surface detail. Although he was forty-two John Sloan was deeply affected by the exhibition and said it marked

. . the beginning of a journey into the living past. The blinders fell from my eyes and I could look at religious pictures without seeing their subjects. I was freed to enjoy the sculptures of Africa and prehistoric Mexico because visual verisimilitude was no longer important. I realised that these things were made in response to life, distorted to emphasise ideas about life, emotional qualities about life.[56]

Unfortunately the merits of Sloan's art lay in his sensitive and uncomplicated recording of life around him, and modernism proved more of a hindrance than a help in his subsequent work.

The real American modernists, men like Marin, Weber, Hartley, MacDonald-Wright and others, were already launched on their careers and the Armory Show had little effect on their work, though it helped to create a more sympathetic climate for them to exhibit in. But the full impact of the show was felt by younger artists. Stuart Davis, who was approaching twenty, later recalled:

The Armory Show was the greatest shock to me – the greatest single influence I have experienced in my work. All my immediately subsequent efforts went toward incorporating Armory Show ideas into my work. . . .
I was enormously stimulated by it although appreciation of the more abstract work came later. I responded particularly to Gauguin, Van Gogh, and Matisse, because broad generalisations of form and the non-imitative use of colour were already practises within my own experience. . . . I also sensed an objective order in these works which I felt was lacking in my own and which was present here without relation to any particular subject matter. It gave me the same kind of excitement I got from the numerical precisions of the Negro piano players in the Negro saloons and I resolved that I would quite definitely have to become a 'modern' artist.[57]

Davis had the talent and the personality to make the most of this experience. Others did not, and Pach, among the organizers, was disappointed by the effect of the show on young artists, who seemed content merely to become American Derains, Picassos and Cézannes, where once they had been American Manets and Renoirs. 'The ingredients for producing greatness are beyond the imagination,' he wrote. 'All we can do is to furnish better surroundings and tools for the great man to use when he appears.'[58] If nothing else the Armory Show did help create better surroundings for modern art in America.

6 The International Surrealist Exhibition

In January 1938 the signs of imminent catastrophe were unmistakable. Once again Europe prepared for war. In Germany, Hitler strengthened his hold over the army and began laying plans for the invasion of Austria; in Spain, the Republicans prepared to evacuate the civil population from Madrid; in Britain, Chamberlain set about implementing his policy of appeasement, which led to Anthony Eden's resignation in February; in Washington, Roosevelt vainly called for an international conference on world problems; and in France, industrial unrest led to the downfall of yet another administration.

There was no escaping from the sense of doom even in the world of art. The Fascist governments of Germany and Italy posed an obvious threat to civilization and to free artistic expression. After the Moscow show trials the Soviet government in Russia appeared equally oppressive. The 'Degenerate Art' exhibitions were widely written about and the newspapers were full of stories of new measures taken by the Nazis to implement their art programme.

On 21 January the lead story of the *Beaux-Arts*, a Parisian weekly devoted to the arts, bore the headline: 'Will Van Gogh, Matthias Grünewald and Rembrandt be expelled from German Museums?' In the same issue there was also the story of the opening of an international Surrealist exhibition at the Galerie Beaux-Arts on 17 January. The contrast between these two stories is striking. Here on the one hand is an item indicating the extent to which the Nazis were prepared to go in acting out their artistic dogmas; here on the other is an account of a wild party thrown by a group of artists and writers as entertainment for a crowd of socialites in a gallery that might well be considered the very temple of capitalism. Could anything be more irrelevant to the spirit of the times? Other newspaper reports are equally damning. The correspondent of a British newspaper cabled:

Smartly dressed women splashed with mud by a nude actress swathed in chains. . . .

A woman in a torn night-dress screaming on a luxurious bed. . . .

These were among the amazing sights at the opening here today of the International Surrealist Exhibition, one of the most fantastic collections of pictures and objects ever seen.[1]

The reporter described a pool of water fringed with pampas grass, beside a bed: 'There it was the closely packed guests witnessed an almost incredible demonstration. From the sheets leapt a beautiful actress, Hélène Vanel, with chains tied around her nude body. A moment later she was splashing frenziedly in the pool, kicking the muddy water over the exquisite dresses of the startled women.'

The International Surrealist Exhibition, Paris, 1938: The Pool; in the
background paintings by Paalen, Penrose and Masson.

It all sounds very decadent, very Gay Paree. It is tempting to conclude that a section of Parisian society was determined to go on enjoying itself, irrespective of the world situation. There is also an element of black humour about the occasion, as if the organizer, the poet André Breton, had decided to lead his subjects in one last manic dance before the coming conflagration engulfed them all.

Yet this was not the case. No one was more aware of the dangers than Breton, and no one was more active in seeking ways to oppose the menace of totalitarianism. Contemplating the European situation, he once wrote, 'Thought cannot consider the exterior world without an immediate shudder.'[2] But he was no poet in an ivory tower. He was 'committed', to use an expression that came to the fore after the war, and in 1936 he warned against inactivity: 'It is impossible to conceal the fact that this immense danger is there, lurking at our doors, that it has made its appearance within our walls, and that it would be pure byzantinism to dispute too long, as in Germany, over the barrier to set up against it, when all the while, under several aspects, it is creeping nearer and nearer to us.'[3]

But dispute they did. From 1929, the year of the second Surrealist manifesto, those in the movement and those sympathetic to it argued not only over methods but over the nature of the enemy and its whereabouts. Surrealism was conceived as a form of revolution and it was natural to think that it shared many similar goals with Communism; but in practice the two were incompatible. To start with, Breton placed the Surrealist movement 'at the service of the Revolution'[4] but neither he himself nor his followers were content to take orders from the Communist Party in Russia or its satellite in France. A series of snubs and defections led to an open breach. Breton was among the first of the French intellectuals to condemn the Moscow show trials and he called Stalin 'the great negator of the proletarian revolution'. The Communist Party became as great a danger as the Fascist regimes of Germany and Italy. Breton would not tolerate any disloyalty. The Surrealists who joined or collaborated with the Party were summarily expelled. Louis Aragon, one of the founders of the movement, was among the first to go, and even friends as close to Breton as Paul Éluard were dismissed. When Éluard published some poems in the Communist review *Commune* in 1939 Breton reacted by calling on his followers to 'sabotage in every possible way the poetry of Paul Éluard'. Fifteen years of collaboration and companionship ended overnight.

At the same time Breton sought for ways of forming a popular front between the Surrealists and other intellectuals of the Left. He admired Trotsky enormously and published the latter's work on Lenin in *La Révolution Surréaliste*. He was able to meet him in 1938 on a cultural mission to Mexico through the help of the painter Diego Rivera. One result of their talks was the manifesto 'Towards a Free Revolutionary Independent Art'. The opening words convey Breton's feelings at that time:

We can say without exaggeration that never has civilization been menaced so seriously as today. The Vandals, with instruments which were barbarous, and so comparatively ineffective, blotted out the culture of antiquity in one corner of Europe. But today we see world civilization . . . reeling under the blows of reactionary forces armed with the entire arsenal of modern technology. We are by no means thinking only of the world war that draws near. Even in times of 'peace', the position of art and science has become absolutely intolerable.[5]

The manifesto repeats Breton's demand for 'complete freedom of art' and it adds: ' We believe that the supreme task of art in our age is to take part actively and consciously in the preparation of the revolution.'

Breton produced this manifesto not long after the opening of the International Surrealist Exhibition at the Galerie Beaux-Arts in Paris. It is clear that he was the last person to organize frivolous entertainments for Parisian society, and most of the painters associated with the movement, with the exception of Salvador Dali, were of the same way of thinking. Joan Miró, for example, whose work in the thirties was often abstract but never *purely* abstract, declared in 1939:

The outside world, contemporary events, never cease to influence the painter, that goes without saying. The play of lines and colours, if it does not strip naked the creator's drama, is nothing more than bourgeois entertainment.

If we do not try to discover the religious essence, the magic sense of things, we will only add new sources of brutalization to those innumerable ones offered today.[6]

The Surrealists, however abstract their work, never recognized a divorce between art and life. Art was not a remote activity but a form of communication. The work of art, like tantrist diagrams, served as visual aid to the contemplation of a higher reality. The artist was in this sense a mediumistic being, a message-bearer from the other world.

Early in its development it became natural to regard Surrealism as a form of religion, with its own priesthood, mysteries, rituals and modes of worship. It is now almost a cliché to refer to Breton as Pope. But his magisterial bearing, his icy good manners, his intense seriousness, his intransigence and integrity gave him the moral authority for a dominating role within the movement.[7] Indeed Breton's expulsions had the force of a papal excommunication.

Continuing the metaphor, exhibitions for the Surrealists were a form of church service, combining the ritual of worship with the evangelical aims of a revival meeting. They were an occasion for celebrating past achievements and for spreading the word to the unredeemed sinners outside. The artists who took part in them rarely expected to benefit financially or critically from them. Even a well-attended and much-publicized show like the international Surrealist exhibition held in

London in 1936 produced virtually no sales. In the first decade o Surrealism, from 1925 to 1935, most of the artists and poets connectec with the movement were poor in an appropriately bohemian fashion a factor that helped create a group identity and forced them to poo their resources in order to finance their activities. In any case Breton frowned on the commercialization of art.

But if exhibitions did not serve conventional aims they were usefu in providing a way for the Surrealists to test their work in public. Al artists require some form of public reaction to their work, but the Surrealists needed it more than most. In the early days of the move ment, in the twenties, it was still possible to startle the public; and ever themselves. But by the thirties the public had become more sophisti cated and the Surrealists found themselves facing the danger of repeti tion. An element of self-consciousness entered their actions. They discovered that it is one thing to '*épater le bourgeois*' and another to seek publicity for personal gain – Dali's crime – and, by the same token it is one thing to be provocative and another to indulge in provocatior for its own sake. To outsiders the Surrealist demonstrations of the thirties took on a stagey and cliquey character. In his review of the exhibition at the Galerie Beaux-Arts, the critic of *Le Figaro*, Raymond Lécuyer, remarked: 'I feel that Surrealist exhibitions are like some amateur theatricals; those who put them on and have a part to play enjoy themselves much more than the audience.'[8]

In purely artistic terms many of the Surrealist painters found it hard to sustain the level of inventiveness achieved in the twenties. En couraged by Breton, who took a scientific interest in the process o artistic creation, the painters sought new ways of stimulating the imagination. Leonardo's advice to look at 'walls spotted with stains or with a mixture of stone' became a favourite text.[9] In the twentie Max Ernst had pioneered the technique of *frottage* – a sheet of paper i placed on an uneven patterned surface and the back is rubbed with a lead pencil – but various newcomers to the movement in the mid thirties added further techniques. Wolfgang Paalen, for example, intro duced the Surrealists to the technique of *fumage* – where the artist make use of the smoke trails deposited by a candle held under the pictur surface – and Oscar Dominguez started a craze for 'decalcomanias' the chance patterns, often of a biological-looking nature, produced b placing a clean sheet of paper on top of another sheet which is we with ink or gouache. Children's games, and pastimes like the 'decal comanias', or an elaborate version of Consequences, were taken up and practised with great seriousness by Breton and others, but, as is so often the case, the surprises yielded by a new technique soon wear of and these activities began to take on a repetitive character. Few of the pioneers of Surrealism escaped this danger. From 1935 onwards Dal began to use his signs and symbols almost like a formula; Ernst began to be trapped by his vegetable-cum-animal imagery; Yves Tanguy wa stuck with his underwater landscapes; and both Miró and Andr Masson had moments of flatness.

By 1938 the older Surrealists were beginning to drift apart. Political and personal differences made Breton's style of leadership less and less acceptable. Hans Arp, for example, who left the movement in 1928, had almost lost touch with his former colleagues. Ernst fell in love with an English Surrealist, Leonora Carrington, and began to spend most of his time in the South of France. He was at the same time disillusioned with Breton's authoritarianism. Éluard was on the point of joining the Communist Party. Dali's flirtation with Fascism – he seems to have regarded Hitler as an honorary Surrealist – and his financial avarice made him no longer welcome within the movement. After living many years in Spain Masson never fully regained Breton's confidence. Alberto Giacometti made his last object-sculpture in 1934 and from then on had little to do with Surrealism, eventually declaring his early work to be 'worthless, fit only for the junk heap'.

But these defections did not mean that Surrealism was finished. As a climate of ideas it showed remarkable powers of survival. It outlived the purges of 1928 and 1929, the disputes with the Communists in the early thirties, and as older members left new artists arrived to give fresh inspiration to the movement. In 1933, for example, the Romanian Victor Brauner was introduced to the Surrealists by his neighbour in Paris, Tanguy. In 1935 Paul Delvaux began to exhibit with the Surrealists in Belgium; Vilhelm Bjerke-Petersen and Wilhelm Freddie exhibited in Copenhagen; Toyen and Jindrich Styrsky showed their work to Breton and Éluard in Prague; in Paris Wolfgang Paalen, the Viennese-born artist, introduced the Surrealists to his technique of *fumage* and Oscar Dominguez, newly arrived from Tenerife, showed his 'decalcomanias', while a Berlin artist, Hans Bellmer, circulated photographs of his doll. In 1938, just when the cynics were about to declare Surrealism dead, two new adherents arrived: the Chilean Roberto Matta and the Cuban-born Wilfredo Lam.

During these years Breton and Éluard were constantly travelling, making visits to Brussels, London, Prague and Tenerife to mention just a few places, and as a result of their missionary activities Surrealist exhibitions and conferences began to crop up all over the world. Surrealism emerged as the first truly international movement since Romanticism. Two large international Surrealist exhibitions held in 1936 set the seal on this development.

The first opened in June at the New Burlington Galleries in London. It consisted of 390 works, by 68 artists, of whom 23 were British. Fourteen nations were represented. The French committee for the exhibition, Breton, Éluard, Georges Hugnet and Man Ray, were no doubt surprised by the degree of English interest in Surrealism, which had come about largely through the work of Roland Penrose, who had got to know many of the leading Surrealists in Paris, and the proselytizing at home by two poet-critics, David Gascoyne and Herbert Read.

According to Penrose the organizers were uncertain how to hang the

Henry Moore, *Head*, 1934. Moore was one of the leading British Surrealists in the exhibition at the New Burlington Galleries.

show, and it was E. L. T. Mesens, who had organized a large Surrealist exhibition at the Palais des Beaux-Arts in Brussels in 1934, who suggested placing works as different as possible next to each other, small next to large, abstract next to figurative, bright colours next to quiet ones, a method that contributed to the unusual appearance of the exhibition.[10]

The arrival of many of the leading Surrealists in London helped boost interest in the movement. Dali once again stole the headlines when he gave a lecture inside a diver's suit and nearly suffocated in the process. But although the exhibition generated considerable excitement and attendances were high throughout its run, the impact was not on the same level as for Roger Fry's Post-Impressionist exhibitions. The public was baffled and bemused, but not shocked.

Many of the works appeared in a much bigger exhibition in December at the Museum of Modern Art, New York. Called 'Fantastic Art, Dada and Surrealism', the show had wider aims than its London predecessor and included nearly seven hundred works by a hundred artists. It was hailed as 'the biggest Surrealist show on earth' and, like the Armory Show, it attempted to relate a new movement to its historical antecedents. Attention was drawn to the fantasy element in the work of Bosch, Baldung, Dürer and Arcimboldo; the English advocates of the Sublime, Fuseli and Blake, were represented; and the more immediate influence of Rodin and Ensor was pointed to. The graphic section was wide-ranging and included Goya's etchings, drawings by Lewis Carroll, caricatures by Daumier and Gillray, designs for elaborate and fantastic jewelry and costumes, and other curiosities. Among special sections was one devoted to twentieth-century pioneers with Surrealist affinities – Picasso, Klee, Kandinsky and Chagall; one to the work of children and the insane; one to commercial and journalistic art; and another to Surrealist objects past and present.

The main emphasis of the exhibition naturally fell on the Surrealists themselves, and they were handsomely represented. Ernst had forty-six works in the exhibition, Arp thirty, Miró fifteen, Dali thirteen and Magritte seven. The most successful exhibit was Meret Oppenheim's *Fur-lined Tea-cup, Saucer and Spoon*, which achieved a similar notoriety to Duchamp's *Nude Descending a Staircase*.

With this exhibition Surrealism became recognized as a potent worldwide force, with a respectable art-historical background. Surprisingly, similar recognition had not been extended to Surrealism in its birthplace and headquarters, Paris. There had been group exhibitions and special shows but nothing on the scale of those held in Brussels, London and New York.

The opportunity to rectify this omission came as a result of an invitation from the Galerie Beaux-Arts. The gallery was part of the large art-dealing empire presided over by Georges Wildenstein, who, besides owning one of the largest establishments in the ultra-fashionable

The main room in the exhibition with Duchamp's coal-sacks hanging from the ceiling. The brazier signified friendship. On the right paintings by Tanguy.

rue du Faubourg Saint-Honoré, also owned the highest-ranking of the French art magazines, the *Gazette des Beaux-Arts*. Wildenstein himself had little interest in Surrealism but his gallery had arranged a series of retrospective surveys of modern movements, including Impressionism, Fauvism and Cubism, and Surrealism was next in line. To his credit he gave the Surrealists almost a free hand and the exhibition that emerged was less a historical survey of the movement – though this element was included – than a demonstration of Surrealist beliefs and practices.

Looking back some ten years later André Breton recalled how the show developed: 'The organizers had in fact made an effort to create an atmosphere that did away as far as possible with that of an "art" gallery. I stress that they were not consciously obeying any other imperative: if we look back on it today, the over-all effect of their efforts has nevertheless transcended the goal they had set themselves.'[11]

The exhibition was meant to assault all the senses. Its effect was to be made not just through the visitor's visual sense, but through his sense of balance, his hearing and his sense of smell. Any means for shaking his preconception of an art exhibition was to be included. Thus while most galleries are bright and well-lit, this one was purposely made dark and subterranean. Man Ray, who was put in charge of the lighting because of his experience as a photographer, came up with the idea of supplying pocket torches to the visitors at the opening so that they could illuminate the works for themselves, a system that had to be abandoned when the painters complained that nobody could see their work, and when the supply of torches began to run out.

All ideas were welcomed. In his account of the exhibition Man Ray noted:

> The poet Peret, who had lived in South America, installed a coffee-roasting machine, whose fumes assailed the nostrils of the visitors. There were recordings of hysterical laughter by inmates of an insane asylum, coming out of a hidden phonograph, which cut short any desire on the part of the visitors to laugh and joke. There were other extravagances introduced by the painters to bewilder them, and destroy the clean, clinical atmosphere generally seen in most exhibitions.[12]

Other ideas for the exhibition were supplied by Marcel Duchamp, who in the catalogue bears the title '*Générateur-Arbitre*'. Duchamp was never a Surrealist but his attitude to life and his artistic iconoclasm were admired by the Surrealists, and Breton, who wrote a moving tribute to the *Large Glass*, referred to him as 'the most intelligent, and (for many) the most troublesome man of the first part of the 20th century'.[13] Duchamp took over the task of arranging the main central gallery. He transformed it into a fantastic grotto but instead of stalactites hanging from the ceiling he placed sacks of coal – 1,200 of them, according to Breton. The floor was made uneven and strewn with dead leaves and twigs, and on a raised section Duchamp placed a lighted iron

brazier, like the ones used by road-menders, which were often placed on the terraces of Paris cafés in the winter. According to Marcel Jean the brazier recalled the days when the Surrealists used to huddle together round the fire at the Café de la Place Blanche and symbolized friendship and togetherness.[14]

A more obvious symbol was the four beds placed in the corners of the main gallery. The beds were luxurious and capacious, covered in satin counterpanes. In photographs they look well-made and tidy, but according to eye-witnesses they soon became disordered and one critic noted that the sheets were 'dirty and crumpled'. Next to one of the beds was the pool in which Hélène Vanel sprayed the crowd, and before it a tailor's dummy painted by Marcel Jean to look like a map of the world.

Dali made an equally spectacular work out of the lobby to the exhibition, though his creation was not an environment like Duchamp's but a tableau. It consisted of an old broken-down taxi, covered with ivy and other plants. Inside there was an ingenious system of pipes and ducts so that from the roof of the cab there fell a steady downpour. In the front the head of a begoggled chauffeur appeared through the jaws of a shark, as if he were wearing a visor. In the back a tousled blonde, clad in a scanty cretonne dress, reclined against the cushions with a sewing-machine beside her and numerous rotting vegetables. A note of horror was provided by the live Burgundy snails that clung to her face and hair. Lécuyer of *Le Figaro* spotted a reproduction of Millet's *Angelus* pinned to her dress, no doubt recalling Dali's versions of this work, in which he found many unexpected sexual symbols. The presence of the sewing-machine may have been a reference to the much-admired definition of beauty by the Comte de Lautréamont (a pseudonym for Isidore Ducasse): 'As beautiful as the chance encounter on a dissecting table of a sewing-machine and an umbrella.'

Dali's *Rainy Taxi* is one of his most spectacular creations and shows his talent at its best. It was liked even by critics who were hostile to

Salvador Dali, *Rainy Taxi*. It made a spectacular opening to the exhibition.

the exhibition as a whole. The correspondent of *The Times* called it a
'triumph'. For the visitors it acted as a suitable prelude to the sights
that awaited them inside. From the lobby they proceeded to a corridor
lined with mannequins, another of the unexpected experiences pro-
vided by the exhibition. The catalogue lists sixteen mannequins, but
there may have been more; each was the work of one artist and gives
an idea of his obsessions and interests. It was generally agreed that the
most successful one was dressed by André Masson. He had placed the
head in straw birdcage and left the door open. Round her face was a
black velvet band and where her mouth should have been was a pansy.
The rest of her body was unadorned except for an elaborate G-string
decorated with seven glass eyes and with two peacock feathers sprout-
ing out of the top. Flowers appear to have been placed under each arm.

The other mannequins were equally exotic. Max Ernst's was
dressed in black and appeared to be trampling on the prostrate figure of
a man. Dali's wore an elaborate Benin-like choker and mask and her
body was covered with small metal spoons. Léo Malet's had a goldfish
bowl filled with water and fish for a stomach. Maurice Henry sur-
rounded the head of his mannequin in a cloud of wool. Wolfgang
Paalen produced a Gothic nightmare by dressing his in moss and
hundreds of small button mushrooms, capped with a head-dress of
bat's wings. The hair of Man Ray's model was pinned with clay pipes
from which emerged smoke in the shape of glass bubbles; from her
eyes drooped four large glass tears. Marcel Duchamp's mannequin
simply wore heaving walking-shoes and a man's jacket, with a red
light-bulb in the top pocket.

The mannequins were an extension of the Surrealists' preoccupation
with objects, and with the 'marvellous' and unexpected. By taking
ordinary objects out of their usual context, as Duchamp had done with
his 'ready-mades', or by juxtaposing them in unusual combinations,
the Surrealists found a potent source for stimulating a sense of strange-
ness and sinister ambiguity. Among the most gifted in this technique

Above André Masson, Mannequin.
On the left, photographs of
Belmer's doll.

Left A view of the installation
showing the revolving door.

Above Kurt Seligmann,
Ultra-Furniture.
Right The street with the
mannequins. Paalen's gothic
nightmare, made of mushrooms
and grass, is in the centre.

was Oscar Dominguez, who carried it into the direction of furniture
his wheelbarrow padded and lined with satin made an admirable arm-
chair and was much admired by his fellow Surrealists. Dali and Miró
also proved adept at making strange objects. But the artist who trans-
formed the cult into art was Giacometti, whose object-sculptures of the
early thirties are among the outstanding achievements of Surrealism in
that decade.

The exhibition at the Galerie Beaux-Arts naturally included a wide
selection of Surrealist objects and furniture. Dominguez showed one of
his most haunting creations, called *Never* – an old gramophone painted
white with two legs protruding from the horn and a hand replacing the
armature and playing needle. Meret Oppenheim's cup, saucer and
spoon were included; and among other objects were a padded foot-
stool supported by four silk-stockinged legs in high-heeled shoes, the
work of Kurt Seligmann; a cabinet, also with mannequin legs, decor-

The main room with object by Oscar Dominguez entitled *Never* On the left, painting by Dali; on the right, painting by Tanguy.

ated with seaweed and topped with hands and stuffed birds in a glass case; Wolfgang Paalen's lightning-conductor-cum-gallows; Dali's aphrodisiac telephone; a poem-object from Breton; and objects by Miró, Tanguy and others. The correspondent for *The Times* drew attention to three creations:

An open umbrella, beautifully made from sponges. Presumably the bearer is less concerned to shelter himself from the rain than to ensure a steady wetting, neither too great during heavy showers nor too small during the intervals.
An 'Aesthetic coat-rack', with the inestimable advantage of being so large that it is visible even when the garments are hung on it.
A large daffodil-like contraption of white linen suspended from the ceiling, the bell-shaped nectary being duplicated by an enormous pair of frilly drawers, which must surely have belonged once to a female circus giant of Victorian days.[15]

Overleaf Salvador Dali, *The Birth of Liquid Desires*, 1932.

With so many unusual and eye-catching objects and environments to compete with, the paintings and sculpture were in danger of being overlooked. Yet the catalogue reveals that the exhibition contained a first-class collection of Surrealist works. One or two of the paintings might now be called masterpieces and the general balance of the selection, the weight given to each of the exhibitors, is one that might be followed today. Much of the credit for the selection must go to the two poets, Breton and Éluard, listed in the catalogue as the principal organizers. Breton, in particular, had a marvellous eye for pictures and for all his intransigence and authoritarianism retained an open-mindedness to new work and an unerring ability to recognize quality. His success in this direction was perhaps due to the fact that he was never really an art critic. His writings on art are interesting for the light they throw on his enthusiasms but in their obscurity of language they offer little help to the uninitiated.

Breton was among the first of the Surrealists to respond to Giorgio de Chirico's metaphysical paintings, and, despite de Chirico's fall from grace and his disavowal of all his early work, eight of his paintings, ranging from 1913 to 1917, were included. The majority came from the personal collections of the Surrealists themselves. Éluard lent his *Portrait of the Artist*, Breton that haunting essay into childhood fears *The Child's Brain*, and Roland Penrose *Melancholy of an Afternoon*, *The Purity of a Dream*, and *The Jewish Angel*.

The elder statesmen of Surrealism – Ernst, Miró, Magritte, Masson and Tanguy – were well represented, with works drawn from all stages of their careers. Ernst, for example, had fourteen paintings, spanning the years 1922 to 1937, including the strange animal-vegetable imagery of works like *The Meeting of Friends* and *Zoomorphic Couple*, the lush, threatening vegetation of *The Joy of Life*, the weird animal contraptions called *Garden Aeroplane-traps*, and examples of his collages and sculptures. Miró was represented by twelve paintings, early landscapes of 1918 and 1922, the *Dialogue of Insects*, one of the first masterpieces of Surrealism, a Dutch interior, one of four paintings based on Dutch genre paintings, which Miró had reinterpreted following a visit to Holland in 1928, and a more abstract work called simply *Painting*, dated 1933. Masson was represented by eight paintings, ranging in style from the early Cubist-influenced works of 1924 to the 'automatic' abstract paintings of the late twenties and a recent work dated 1937. Tanguy had nine paintings, including *The Love of Proteus*, dated 1931, which belonged to Breton. Magritte, whose work was so different in character from that of these four artists, was also represented by nine canvases, including *Signs of Evening*, which belonged to the writer and early champion of the Surrealists in Belgium, Claude Spaak, the *Countryside on Fire*, which belonged to Dali's wife, Gala, and *The Therapeutist*.

The Dalis in the exhibition were of a high quality and included two

Giorgio de Chirico, *The Child's Brain*, 1914. It was lent to the exhibition by Breton.

of his best early paintings, *The Great Masturbator*, a true compendium of Dalian obsessions, and *The Birth of Liquid Desires*, and a more obvious, though striking, work of 1937, *Sleep*. Other converts of the 1930s to be shown were Victor Brauner (three paintings), Matta (four works), Wolfgang Paalen (nine), and Kurt Seligmann (twelve). In Giacometti's case the catalogue lists only one entry, 'sculptures', but Roland Penrose recalls seeing *The Invisible Object* at the exhibition.

On the whole the exhibition was limited to present and past Surrealists but one or two sympathetic outsiders were included, and one or two former members like Arp. Duchamp showed a ready-made of 1914, a corrected ready-made called *The Pharmacy*, a preliminary study for the bottom half of the *Large Glass* entitled *Nine Malic Moulds*, and one of his rotary machines with the disc bearing the tongue-twisting title: *Rrose Sélavy et moi nous esquivons les ecchymoses des Esquimaux aux maux exquis*. Picasso, courted by Breton but never a Surrealist, was represented by two paintings, both entitled *Figure*.

The door the wind

the bird the valise

René Magritte, *Key of Dreams*, 1930.

The international character of Surrealism was confirmed by the presence of a number of artists from outside France. Numerically the strongest team was the British, which included Eileen Agar, Edward Burra, Leonora Carrington, Norman Dawson, S. W. Hayter, Humphrey Jennings, Henry Moore, Paul Nash – six paintings and two collages – and Roland Penrose. The Danish Surrealists were represented by Freddie and Bjerke-Petersen; the Czechs by Styrsky and Toyen; the Germans by Bellmer. Man Ray excepted, the American Surrealists do not seem to have established a close enough link with the leadership to be included in the exhibition and there were only the collages of Joseph Cornell to indicate the extent of American interest

Edward Burra, *The Hostesses*, 1932.
One of a strong British contingent.

n the movement. But artists from further afield were drawn into the
how, for example Matta, from Chile, and Okamoto, from Japan.
Nearer at hand were the Belgian Surrealists, who in addition to Mag-
itte were represented by Mesens, Raoul Ubac and Delvaux.

However, national and individual characteristics were forgotten
when the show was hung. The organizers produced a proper *mélange*
of styles, personalities and materials. In one corner, for example, works
y Paalen, Penrose and Masson hung next to each other; in another
culpture, objects and paintings were all in close proximity. One novel
evice in the hanging was the use of revolving doors for the collages,
rawings and prints.

DICTIONNAIRE ABRÉGÉ
DU
SURRÉALISME

Cover of the *Dictionnaire Abrégé
du Surréalisme*, designed by Tanguy.

With the selection of the exhibition finished all that remained to b
arranged was the catalogue and the invitations to the opening. Th
catalogue was an elaborate production. The first part consisted of
simple list of participants and their works; the second part contained a
illustrated dictionary of Surrealism, profusely decorated with Surreali
ornaments and motifs – Dali's soft watch, for example.[16] The names
the leading Surrealists were accompanied by special description
Miró was called 'the sardine-tree', Magritte 'the cuckoo's egg', Ern
'the Bird Superior' and Dali 'the prince of Catalan intelligence, colo
sally rich'. The rest of the dictionary contained a miscellaneous sele
tion of words, names and processes. To mention just a few:

APHRODISIAC TELEPHONE. 'Telephonic apparatuses will be replaced b
lobsters, whose advanced state will be rendered visible by phosphoresce
plaques, veritable *flytrap truffle-grounds*.' (SD) [Salvador Dali]

BREAST. 'The Breast is the chest elevated to the state of mystery – the che
moralized.' (Novalis)

CHIRICO. (Giorgio de) born in 1888, in Greece, of Italian parents. Pr
Surrealist painter. 'The most amazing painter of this time.' (Apollinair
1914) 'If this man had some courage he would have tired long ago of th
game of making fun of his lost genius.' (AB) [André Breton] ... The pictori
work of Chirico claimed by Surrealism came to a halt in 1918. Since then o
owes him for nothing but the publication of an admirable prose wor
Hebdomeros (1929).

COLLAGE. 'If it is plumes that make plumage, it is not the glue that makes
glueing.' (ME) [Max Ernst] 'It is something like the alchemy of the visu
image. The miracle of total transfiguration of beings and objects with
without modification of their physical or anatomical appearance.' (M

SURREALISM. 'Everything leads us to believe that there exists a certain poi
of mind at which life and death, real and imaginary, past and future, co
municable and incommunicable, high and low, cease to be perceived in co
tradition. One would search surrealist activity in vain for another moti
than the hope of determining this point.' (AB)[17]

The invitation cards also bore a characteristic Surrealist stamp. Th
card asked guests to wear evening dress and to assemble by ten o'cloc
on 17 January, when André Breton would declare the exhibition ope
The card promised a series of entertainments, including dances b
Hélène Vanel. In the centre of the invitation there was a photograp
of a monster, 'the authentic descendant of Frankenstein, the automa
"Enigmarelle", built in 1900 by the American engineer, Irelan
which would make an appearance at twelve-thirty.

All was now set for the opening. And what an opening. Even Pari
ians hardened to spectacular first-nights and grand *vernissages* had
admit that there had been nothing like it. Long before the appointe

our a crowd formed in the street outside the gallery. The crowd
tracted a larger crowd, as passers-by tried to see what was happening.
oon there was the danger of a riot and the police had to be called in to
tablish order. Even so it was 1 am before the Austrian ambassador
ould reach the sanctuary of his residence. A taxi-driver bringing one
f the English Surrealists to the exhibition thought the whole thing
as one of the many anti-government demonstrations taking place at
hat time. A journalist told André Breton that he had never seen so
aany fashionable people trampled upon since the fire at the Bazar de
Charité.

Inside the gallery there was just as big a crush. Everyone was there,
ith one noticeable exception, Marcel Duchamp. Marcel Jean came
cross him a few hours before the opening: 'It was then that I saw
)uchamp standing at the entrance of the still deserted hall, casting a
nal eye over his creation. We exchanged a few words and he soon
ent. He did not appear at the official opening; afterwards, it was learnt
aat on leaving the gallery he had taken the train for England.'[18]

One can understand Duchamp's feelings. The opening attracted
hat the newspapers called a *'tout-Paris'* crowd, made up of Czechs,
ermans, Japanese, Englishmen and even a few Parisians. The critic
)r the *Nouvelle Revue Française* thought very little of those present,
.king note of 'the professional and traditional snobs, and professors
f philosophy out on the spree, patrons of divine right in disgrace,
vil servants in need of reform, critics on the rebound, nature lovers,
ue reactionaries, and false revolutionaries, and all those who find
aemselves alarmed by the reality of 1938'.[19]

The *Beaux-Arts* carried a lively description of the evening:

A gramophone played a recording of hysterical cries over and over again.
ut its howls were unable to create the hoped-for sense of anguish. There
ere too many people in black ties, too many evening dresses for Surrealism
 escape a whiff of worldliness. There were also too many ladies whose im-
aculate beauty was frankly opposed to Surrealist concepts.
We waited impatiently for the entertainments promised in the programme:
e appearance of object-beings, the crimson clover. . . .
The biggest success was the performance of the *'acte manqué'* by the nude
ancer Hélène Vanel, on one of the beds of rose-coloured satin.
There was a crush to see her; by using my elbows I managed to get a
impse of eiderdown feathers fluttering under a sky of flying-bats; a pillow
:w up into the air; I heard cries of hysteria, but to my great disappointment
could see nothing . . . but a rumpled bed, with no one left on it. And yet it
as very good. Our secretary assured us of this, having that afternoon
tended, on the quiet, a rehearsal of the *acte manqué*, which took place before
e greedy eyes of the film cameras.
. . . That party, which will long be remembered by those who were present,
as full of miracles. No one fainted . . . and of the hundred pocket-torches
nt at the entrance, they did manage to recover ten, including two from
side a taxi.[20]

he evening proved a natural target for the gossip-columnists. Just

how vogueish Surrealism had become before the war is shown by on
irritating report that appeared in a British newspaper under the headin
'Boys and Girls' Dept':

> La! La! but the Surrealist Boys and Girls seem to be having a splendi
> romp at their Exhibition in Paris.
> Actually the whole thing strikes us as simply divinely sort of . . . well, yo
> know . . . that is, if you've got a *Thing* about it. . . .
> And one really *must* have a Thing about it – one means to say, unless on
> wants to be crushingly unsmart, don't you think? . . . or don't you?[21]

However much Breton might loathe it, however much his fellow
Surrealists might profess a desire to revolutionize the world, Surrealisn
had attracted, on both sides of the Channel, a smart social following
The same people who bandied Freud's name about when psychiatr
first became a fashionable topic of conversation, those smart people i
the novels of Huxley and Evelyn Waugh, also took up Surrealism.

The symbols in Dali's paintings or the enigmatic objects in Magritte
appealed to the many amateur interpreters of dreams who began t
blossom in the thirties. It has to be admitted that many Surrealis
paintings, particularly the more figurative ones, enjoyed then as the
do now much the same popularity as the problem pictures of th
nineteenth century. On a personal level the Surrealists seemed to b
'interesting' people, the sort who could be relied on to add an excitin
and original touch to a party. In France and in England the aristocrac
are permitted a degree of eccentricity not tolerated among the rest c
society, a factor that enabled some of the Surrealists to be acceptabl
in the fashionable salons that had survived the First World War. Fore
most among the patrons of Surrealism was the Vicomte Charles d
Noailles, who owned a fine collection of Old Masters and was a kee
collector of modern art. He bought one of Dali's best paintings, *Th
Lugubrious Game*, and is said to have hung it between a Cranach and
Watteau. The Noailles enjoyed giving parties and often assembled
wide cross-section of Parisian society at their *château* in the South c
France. Man Ray found himself invited there to film the party in a soi
of Surrealist charade. Charles de Noailles became Dali's leading patro
and financed Dali and Buñuel to make *L'Age d'Or*, a film that subse
quently earned the Vicomte a formal excommunication.

Another patron of the Surrealists was Comte Étienne de Beaumon
who enjoyed throwing elaborate costume balls. He introduced Ma
Ray to the Comtesse Greffulhe, the aristocratic beauty who had dazzle
Proust as a young man and who in her old age showed a remarkabl
interest in photography; Man Ray refers to her in his memoirs as '
sweet, well-meaning lady'.[22]

Of all the Surrealists Dali, of course, was the most enamoured c
society. When he first arrived in Paris he pretended to think very littl
of it and maintained that he used it merely as a mirror to reflect his ow
glory. But he soon became a regular party-goer and numbered amon

his friends the Prince and Princesse de Faucigny-Lucinge and the Comtesse Marie-Blanche de Polignac. His social-climbing began to take on an obsessive quality and his dreams were disturbed, he tells us, by 'a troubling image, post-card style, of a naked woman loaded with jewels, wearing a sumptuous hat, prostrating herself at my dirty feet'.[23]

Such delusions naturally became a source of embarrassment to his fellow-Surrealists, who were for the most part, unlike him, good solid left-wingers. As a result Dali saw less and less of his colleagues from 1936 onwards. But however much they might wish to conceal the collaboration between the Surrealists and society they could not deny it altogether. Besides, the collaboration was not entirely without intellectual respectability. Had not Baudelaire held up the dandy as a model for true artists to follow? But unfortunately for the Surrealists this defence was overlooked by their critics on the Left. The audience attracted to the opening of the exhibition and on subsequent days became a weapon with which to attack the movement and its leaders. Typical of these attacks is the article by A.M. Petitjean in the *Nouvelle Revue Française*: 'Nothing is more irritating than such manifestations. Not only because they attract the most odious, the most irresponsible and the most down-graded of publics – the trendies, who correspond on the social ladder to the *Lumpenproletariat*, but because it forces every one to speak in low voices, as in a hospital, there being no greater constraint, no greater form of censorship, than trying to be up-to-date....'[24] Petitjean said that he did not believe too much in the complicity of writers, particularly the Surrealists, and he added that he was particularly loath to see anything despicable in poets of the calibre of 'the adorable Éluard' and Breton, 'one of our greatest writers'.

Jacques Lassaigne in the *Revue Hebdomadaire* felt that Surrealists lacked their original revolutionary spirit. Time was against them. He wrote:

> I realize that revolutions never remain important once they've got past the stage when they were conceived; that ideas that have triumphed do not continue to ferment. It isn't the sudden and unexpected vogue that Surrealism is enjoying today that makes it seem to us to have no range, but rather we judge its lack of fermentation by the extent of its success and the ease with which it wins support.[25]

Lassaigne argues that the Surrealists were unable to match the genuine horror and visionary imagination of a Bosch or Goya, and besides there was something self-contradictory in their arguments. He concludes:

> For the future of Surrealism one would like the movement ... to disappear one day by means of some magic spell. Thus in René Clair's old film *Entr'acte*, which I tend to think of as one of the masterpieces of Surrealism, men get out of breath running after death and no sooner have they caught up with it than the magician makes them disappear with a wave of his wand. Then he himself has no option but to make himself disappear.

Some of the French critics seem to have regarded Surrealism as not only in decline but a sign of the decadence of non-French art. Albert Flament, for example, was relieved to note that the exhibition was an 'international' one, and contained very few French names.[26] Raymond Lécuyer, writing in *Le Figaro*, observed that the origin of Surrealism was to be found in Shakespeare, in Nordic literature, in Flemish and Spanish painting, in the work of Bosch, Breughel and Goya, and also in the laboratories of German and Russian Romanticism. He concluded his attack by saying: 'This type of Romanticism can scarcely be called French. A way of thinking is needed that the people of our race can never properly acquire. Hence the pseudo-Surrealism, made to order, according to recipes and formulae, that is being offered to us at the moment. . . . One of the exhibitors jokingly speaks in the name of the "ministry of the national imagination". National? Oh no, my friend, hardly.'[27]

Some of the reviewers were critical of the setting and felt that the paintings had been done a disservice. Lécuyer, for example, thought that it was all too obtrusive and too obviously provocative. Lécuyer, in *Le Figaro*, felt that painting was reduced to the vague role of an accessory: 'In this bric-à-brac,' he questioned, 'in this lumber-room, how can one have the time or the wish to look for individual talent? Behind the farce of a perpetual student literature disappears; behind the joke of a young art student painting no longer distinguishes itself.'[28]

Paul Fraysse, writing in *Le Figaro Littéraire* a week later, thought: 'The over-all mood of this exhibition in fact tends towards a different feeling, rather difficult to analyse because of the black humour that lurks in every corner and shatters in a menacing fashion the predominating atmosphere. The latter, however, arises from an affectionate melancholy.'[29] Fraysse was writing in support of the Surrealists and he put forward a plea for open-mindedness:

Some of the pairs of eyes who look at it are well and truly blindfold. There have always been secret societies bound together by intelligence. Because they do not yield up their secrets easily they have always been mocked in the most infantile way. To enter such societies you have to abandon your comfortable traditional ideas, to refuse any form of refuge, to be able, since you are not yourself an inventor, to recognize the infuriating brilliance of the inventions that have emerged. And this ability presupposes knowledge that has been acquired with the greatest difficulty and that is never accepted, and it sometimes presupposes dangerous victories over oneself.

The foreign correspondents of the English-language newspapers recognized a good story in the exhibition. The *New York Times*'s man in Paris sent back a report that bore the headline: 'PARIS JOKE – Art World Ponders Surrealist Show'; having described one or two of the more extraordinary objects in the exhibition, he concluded: 'What with numerous clothes models with their heads in bird cages, there seems very little art, no poetry and a great deal of argument in this exhibition.'[30]

The report from the correspondent of *The Times* in London was more jocular. He appears to have enjoyed his time at the show and he was prepared to admit that, 'on the two dimensional plane there are some pictures of ability, many of which convey a nightmare atmosphere with considerable conviction,'[31] and he singled out Dali for praise because he seemed capable of 'first-class work in a less esoteric form'. But on the whole he felt that the pictures failed, because, as he pointed out 'it is difficult to take seriously a picture whose principal elements are a gigantic soda-water siphon in a rock-studded desert, with a neatly fried egg in one corner and a 10-franc piece supported by a solitary peanut in the other.'

Breton found it equally difficult to take seriously the criticism levelled against the exhibition in the French press. In his essay 'Devant le rideau' he quoted the titles of some of the articles: 'The Surrealist fair', 'The school of practical jokers', '*A charge d'atelier*', 'The elderly *enfants terribles*', 'Where Dada becomes gaga', 'The *cochons compliqués*'; and several with a necrological bias: 'Surrealism dead, exhibition follows', 'The Surrealist funeral', 'Surrealism not yet dead', 'The death-throes of Surrealism', 'The bankruptcy of Surrealism'. These clichés, as Breton acidly noted, 'seem for the past twenty years to have given the most wretched of columnists the joy of discovery'.[32]

In general, the criticism stimulated by the exhibition is disappointing. Some of the leading French papers and art magazines seem to have chosen the safe course of ignoring it. I could find no article on the exhibition in a serious newspaper like *Le Temps*, nor in a more popular paper like *L'Intransigeant*; and although the exhibition was a godsend to any picture-editor, illustrated magazines like *L'Illustration* and *Le Monde Illustré* also appear to have passed it by. The criticism that did appear was confined mostly to the satirical magazines and arts magazines like *Marianne, Gringoire, Candide, Le Temps Présent, Je suis partout*. It is tempting to conclude that the exhibition at the Beaux-Arts marked not the death of Surrealism but the slowly dying craft of art criticism and public interest in art. The Impressionists, the Fauves and the Cubists were better served by their critics, even if they had to accept a good deal of fierce opposition in the process. It is also tempting to conclude that the exhibition marks the last occasion when Paris could be said to be the capital of the world of art. Surrealism was not dying, but Europe was, and with it ended the role of Paris as a centre of civilization. The Surrealists who had gathered there were soon forced to find shelter elsewhere, some in London, some in Spain and some in the unoccupied zone of France round Marseilles. One by one they arrived in America and their contacts with American artists helped to establish the atmosphere that turned New York from being an artistic outpost on the receiving end of ideas from Europe into the great art centre that it is today.

André Breton. He dismissed the criticism as clichés.

7 Entartete Kunst

The most popular of all the exhibitions covered by this book, at least
in terms of attendance, was the Exhibition of Degenerate Art that
opened in Munich on 19 July 1937. In just over four months it attracted
two million visitors. Admittedly it lasted longer than most exhibitions
but in the first week of being open to the public it attracted 187,160, the
average attendance was around 25,000 a day, and on one occasion
15 August, the numbers rose to 42,000. Considering that the exhibi
tion was housed in cramped rooms up a flight of narrow wooden stairs
and considering that the exhibits were arranged as unattractively as
possible, its popularity is all the more remarkable.

In a sense it was another Salon des Refusés and exerted a similar
popular appeal. The two exhibitions have many points in common
Both were started by a dictator; both consisted of works that were
considered unacceptable by the regime and its artistic advisers; both
offered, at any rate in principle, an opportunity for the public to judge
for themselves whether their artistic leaders were right or wrong
both were accompanied by an official exhibition that aimed to set
certain standards; and both in the end proved to be the opposite of the
organizers' original intentions. The official exhibitions are now seen to
have contained works of little worth, while the exhibitions of the
refusés showed work that is among the most highly regarded work in
their respective periods. The main difference between the two events
is that the Salon des Refusés marked a beginning, while the Exhibition
of Degenerate Art marked an end.

It is tempting to think that the Munich exhibition could have hap
pened only in Germany, or in some totalitarian state. That is probably
true, but what makes it interesting for outsiders is that the Germans
or rather the Nazis, put into practice ideas that were widely held in the
liberal democracies of the West. France, Britain and America con
tained people who disliked modern art, and disliked it as vehemently
as their counterparts in Germany. The Nazis were not the only ones
to believe that modern artists were playing the fool, were incompetent
and were misleading the public. All over the world people have re
garded modern art as a kind of international conspiracy, a plot hatched
by a small number of dealers, critics and artists. The charge is still made
today.

These accusations were made not just by philistines, those who have
no feeling for art in any form. On the contrary, the fiercest attacks have
come from art historians, critics and artists. A painter like Professor
Adolf Ziegler, who was largely responsible for selecting the Exhibi
tion of Degenerate Art, is by no means unique to Nazi Germany
There are Zieglers all over the world. Several presidents of the Royal

Academy in recent years, notably Sir Alfred Munnings, have expressed views very similar to Ziegler's.

The Exhibition of Degenerate Art is a reminder of the pent-up forces directed against modern art. It deserves to be better known outside Germany. Only a small amount of the basic material has been translated and the main account in English is *Art under a Dictatorship* by Hellmut Lehmann-Haupt, published in 1954, which suffers from being written too near to the events it describes. Since then there has been a brilliant book by Barbara Lane, *Architecture and Politics in Germany, 1918–1945*, which touches only briefly on the Nazis' policies on fine art. In writing this chapter I have relied on John Willett's *Expressionism*, Joseph Wulf (ed.), *Die Bildenden Künste im Dritten Reich*, Franz Roh's *'Entartete' Kunst, Kunstbarbarei im Dritten Reich* and the catalogue to an exhibition held in the Haus der Kunst, Munich, in 1962 and entitled *Entartete Kunst, Bildersturm vor 25 Jahren*.

Ernst Ludwig Kirchner, *The Masters of Die Brücke*, 1925. From left to right: Otto Mueller, Kirchner, Erich Heckel, Karl Schmidt-Rottluff.

Before the First World War Germany could be proud of the open-mindedness and adventurousness of a few of her artists, critics, and collectors. Museum curators like Hugo von Tschudi, Ernst Osthaus and Count Harry Kessler, critics like Julius Meier-Graefe, dealers like Paul Cassirer and artists like Max Liebermann were true inter-nationalists, as much at home in Paris and London as in Berlin. They were among the first to appreciate the French Post-Impressionists and they were active in conveying their enthusiasm to their fellow country-men. In 1897 the Berlin National Gallery became the first museum any-where to buy a Cézanne, and the Folkwang Museum, founded by Ost-haus, showed an equally advanced policy in its purchases of Van Goghs and Gauguins. British critics and collectors could only stop and stare at this display of modernity. Their tastes remained provincial and lagged several years behind the more progressive-minded Germans.

Some critics, like D. S. MacColl (see page 151), maintained that the German hunger for modern French art sprang from artistic starvation at home. But this was far from the case. Between 1905 and the out-break of war there was an outburst of artistic activity, which affected not only the visual arts but poetry, drama and music as well. The upsurge was felt throughout Germany. In Dresden *Die Brücke* was born, in Munich the *Neue Künstlervereinigung–München* and the *Blaue Reiter*, and in Berlin the *Neue Sezession*. Interestingly the poet Gottfried Benn, like Virginia Woolf, pinpointed the moment of change on the year 1910: 'It was indeed the year when all the timbers started creaking,' he wrote.[1]

The war put a stop to many of these developments and radically altered the direction of those that continued. The Expressionist movement in painting and sculpture took on a new meaning. Among its leading practitioners to be killed were Franz Marc and August Macke. E. L. Kirchner suffered from a series of nervous breakdowns and by the time of his discharge and retreat to a Davos saniatorium in May 1917 he was almost a total wreck. Oskar Kokoschka was badly wounded. Max Beckmann was discharged from the army in 1915 after a serious illness. George Grosz came to hate the war and the military way of life with uncontrollable bitterness and his drawings of 1916 show how near he was to collapse. Only a few artists managed to go on working. Erich Heckel painted his famous *Ostend Madonna* on tent canvas during Christmas 1915, while serving with a medical unit in Flanders.

The war tended to turn German artists (to some extent like the English poets) towards pacifism. In the November Revolution that overthrew the Hohenzollerns they naturally supported the revolu-tionaries who were at the same time ending the war. Two interlocking groups of artists and intellectuals were formed: the *Novembergruppe* started by Max Pechstein, one of the most prominent of the *Brücke* artists, and Cäsar Klein, which called on all artists, whether they were Expressionists, Cubists or Futurists, to work for 'unity and close

co-operation' and 'the closest mingling of art and people', and which attracted, among others, Otto Mueller, Heinrich Campendonk, Hans Purrmann and the sculptor Rudolf Belling;[2] and the *Arbeitsrat für Kunst*, or Workers' Council for Art, launched by the pioneer architects Walter Gropius and Bruno Taut. Between them the two associations joined together almost all the progressive spirits in Germany in a programme of lectures, exhibitions and other activities that were largely socialist in flavour, idealistic and visionary. Typical of these activities was Bruno Taut's proposal for an 'alpine architecture', published in 1919, calling for crystalline, faceted forms, sparkling and flashing in the pure air.[3]

In 1919, after the constitution of the Weimar Republic had been ratified by the Treaty of Vienna, the progressives began to benefit from the support of the new, mainly socialist, administrators. Gropius was put in charge of the former grand ducal schools for art and applied arts at Weimar, which he renamed the Bauhaus. Taut was given the chance to supervise the rebuilding programme at Magdeburg. Professorships in the art schools were awarded to Kokoschka in Dresden, Carl Hofer in Berlin, Müller in Breslau. Max Liebermann became president of the Prussian Academy of Art and among the new members were Ernst Barlach, Christian Rohlfs and Pechstein. Dr Erwin Redslob was appointed State Minister for Arts and he set about redesigning German flags, currency and insignia, employing, among others, Karl Schmidt-Rottluff. The new Weimar National Assembly used Cäsar Klein to design posters. The National Gallery of Berlin was empowered to buy modern works of art and a new section was formed at the Kronprinzenpalais. Among its first purchases were Marc's *The Tower of Blue Horses*, one of the most popular of all Expressionist paintings, Kokoschka's portrait of his Dresden colleagues, *The Friends*, Kirchner's portrait of his former colleagues, *The Masters of Die Brücke*, and Heckel's *Ostend Madonna*. New progressive policies were ushered in at many provincial museums and galleries and among the notable new appointments was that of Gustav Hartlaub at Mannheim.

In a sense the war, or more properly the loss of the war, had benefited the progressives. There was now a market for their work that had hardly existed before; there were directors and publishers keen to spread their work to a wider audience; there were commissions; and there were jobs. The Expressionist painters had done particularly well. Their work had increased tenfold in value, managing to keep up with the rapid inflation that affected the mark until around 1924.

It is perhaps only to have been expected that their work lost a sense of urgency, and few of the Expressionists attained the standards reached before and during the war. Kirchner, for example, never regained the brilliance of his Berlin period. A new feeling seemed to enter the arts in Germany. It was identified by Gustav Hartlaub and called *die neue Sachlichkeit*, a phrase that has been variously translated as 'new objectivity', 'new matter-of-factness' and 'new practicality'.

'Cynicism and resignation are the negative side of the *neue Sachlichkeit*; the positive side expresses itself in enthusiasm for the immediate reality as a result of the desire to take things entirely objectively on a material basis without immediately investing them with ideal implications.'[3] So wrote Hartlaub[4] and he illustrated what he meant in an exhibition at Mannheim in 1925. Among those to feature in it were George Grosz, Otto Dix, Max Beckmann and Carl Hofer. Grosz and Dix were realists who conveyed strong political convictions through their choice of subject-matter and angle of vision. Grosz was a remorseless exposer of class hypocrisy. Dix concentrated more on individual weaknesses. Beckman's work, which is less descriptively literal than the others', also conveys strong social feelings, but the imagery is more universal, less tied to specific German events, more enigmatic and of greater artistic consequence.

Hartlaub believed that the clearest expression of *neue Sachlichkeit* was in architecture, particularly in the work of the Bauhaus architects and designers. There the arrival of Laszlo Moholy-Nagy had brought a new emphasis on functionalism, on mechanical and technical efficiency. Oskar Schlemmer's murals for the Bauhaus, done in 1923, offered a foretaste of the new mood. In the theatre Erwin Piscator brought greater simplicity to stage design. By the end of the 1920s the cynical yet socially aware work of Bertolt Brecht and Kurt Weill began to be noted.

The new mood was resented. The functionalism of the Bauhaus was attacked as materialistic, bereft of spirituality and national identity. The realism of Grosz and Dix was disliked because they painted ig-noble models – a line of argument that goes back to the criticism of Millet and Courbet. Both attacks, it is worth pointing out, have an element of truth in them. The Bauhaus style is impersonal, functional and it did become international. The realists *did* paint what they saw without concern for aesthetic considerations. Their portraits are indeed merciless. Compare Grosz's portrait of the writer Max Hermann-Neisse with that of an Expressionist, Ludwig Meidner's picture of 1913: the latter, which is a frontal view, minimizes the physical pecu-liarities of the sitter, and could almost be called a happy picture, while the former, a side view, reveals the writer to all his physical dis-advantage.

Among the critics of these new tendencies was an architect, Paul Schultze-Naumburg, who began his attack on the Bauhaus in *Das ABC des Bauens* (*ABC of Building*), published in 1926, and moved to the broader field of art and culture in an influential work, *Kunst und Rasse* (*Art and Race*), published in 1928.

Before the war Schultze-Naumburg had established a reputation as one of Germany's leading architects, specializing in country residences, employing clean lines, bare surfaces and a simplified historical style. He was also a prolific writer on design and architectural questions. Although considered a modernist, he nevertheless remained a believer in traditional ways of building, in craft techniques and finish. After

Max Ernst, *Men Will Know Nothing about it*, 1923.

Pages from Schultze-Naumburg's
Art and Race.

the war there were no longer the opportunities to build the type of building he had specialized in and his concept of building was hardly suitable for the mass-housing projects that were needed. Schultze-Naumburg found himself on the side-lines of architectural activity.

Art and Race is an expression of his resentment of the changes he had witnessed. It was not a piece of Nazi propaganda, because at that time Schultze-Naumburg was known to none of the Nazi leaders. The argument of the book is fairly simple: all paintings are a form of self-portrait; they reveal the man and his racial background. By taking the distorted aspect of the human figure as revealed in a lumpy sculpture, a Dix-like portrait of a prostitute and a painting of two girls and placing them alongside photographs of individuals suffering from genetic deformities it was a simple matter to say that the artists who produced distorted work were suffering from mental and physical deformities themselves. He refers to them as 'the uncreative men, formless and colourless, the half and quarter men, unbeautiful men who desire no beauty, who set their stamp upon our time'.[5] He believed that in the nineteenth century the inferior part of the German nation had multiplied and that the leaders, the cream of the population, had been killed off by the First World War. The nation was now biologically inferior to what it had been and this fact was reflected in the new cheap, materialistic building and the distorted work of the Expressionists and their followers.

Schultze-Naumburg's arguments were not original. Similar views had been expressed by Dr Hans Günther.[6] The theme of cultural decline, whether linked or not with genetic decline, was a popular one with German intellectuals – witness the success of Oswald Spengler's *Decline of the West.* The racial, or to be more specific, the German element in German art was a favourite theme. German artists and writers, to a greater extent than their colleagues in Paris, or for that matter London, seem unduly concerned with their Germanness.

Wagner is an obvious example, but art historians like Arthur Moeller van den Bruck were just as preoccupied. Kirchner, it should be said, set out to revive 'German' art when he began his artistic career in the early 1900s. He and his followers studied the work of Lucas Cranach, Hans-Sebald Beham and Grünewald, not because they were interested in medieval art but because these artists revealed peculiarly 'German' qualities in their work. Similarly, Nolde was proud of the 'Nordic' element in his work, and it was an enormous shock to have this side questioned by the Nazis.

The nationalism shown by German artists before the war was revived in the twenties and was not an exclusive concern of the National Socialists. It was a phenomenon that could be seen in politics, art, music and the cinema. War novels were another example.

The writings of a young agricultural expert, Richard Walter Darré, a friend of Schultze-Naumburg, illustrate another strand in the racial argument. Darré is best known for his doctrine of 'blood and soil', the title of his second book, published in 1930, *Neuadel aus Blut und Boden* (*The New Aristocracy of Blood and Soil*). In it he extols the peasant way of life as superior to the nomadic life of the big cities. Indirectly it is an attack on city art and culture, on the Bauhaus style. Again Darré did not introduce a new element. In 1926 Emil Hogg had demanded: 'Let us be rid of skyscrapers and asphalt and return to green German soil.'[7] But Darré, a latecomer to Nazi politics, rose quickly within the ranks to become Minister of Food and Agriculture from 1933 to 1942 and one of the most influential Nazi propagandists.

His views were to some extent shared by another influential Nazi writer, Alfred Rosenberg, author of *Der Mythos des 20 Jahrhunderts* (*The Myth of the Twentieth Century*), who incorporated them into his campaigns against modern art. Around 1928 Rosenberg founded the *Kampfbund für Deutsche Kultur*, the 'Militant League for German Culture', which was given national status on 26 February 1929. The *Kampfbund* enlisted prominent conservative intellectuals, not just those concerned with art and architecture but sociologists, writers and playwrights, in a general moral and cultural watch-dog campaign. Among those to join was Schultze-Naumburg, who presented a series of lectures entitled *Kampf um die Kunst* (*The Struggle for Art*), which put forward a theme that became a central feature in the Nazi attitude to art: 'For, just as in German politics, a battle over life and death rages in German art today. Alongside the struggle for power, the struggle for art must be fought through with the same earnestness and the same decision, if we do not want to sacrifice the German soul.'[8] The words find an echo in Hitler's maxim, that hung over the entrance to his Haus der Kunst, 'Art is a mission demanding fanaticism'.

In 1930, when Wilhelm Frick won two ministries in the local elections in Thüringia, Schultze-Naumburg enjoyed a brief moment of power as head of the former Bauhaus. Among his first acts was to have the murals by Schlemmer painted over and works by Ernst Barlach,

Kandinsky, Klee and Schmidt-Rottluff removed from public view. When the Nazis came to power in 1933 Schultze-Naumburg did not receive the rewards he might have expected. Hitler told Albert Speer that there was nothing distinctive about his work, 'nothing that sets it off from former times'.[9] However, he did keep a copy of his *Die Kunst der Deutschen* in his personal library.[10]

Schultze-Naumburg's brief period of influence offered a foretaste of what was to come. After the elections of 1933 Hitler and the Nazis were in a position to implement their cultural policies on a national scale. They began by removing the modernists from their teaching and museum posts. Beckmann lost his job at Frankfurt; others to go were Willi Baumeister, Hofer, Oskar Moll and Campendonk. The Bauhaus was finally closed on 10 August 1933. Hartlaub was dismissed and some of his purchases for the Kunsthalle in Mannheim, including Chagall's *Rabbi*, were paraded round the town in an open cart. Kaesbach, who had been responsible for the purchases of the Expressionists at the Berlin National Gallery, and who had subsequently moved to Düsseldorf, was also sacked. Among the new museum directors was the SS officer Count Baudissin, who was given the Folkwang Museum. He was the author of the immortal words: 'The most perfect shape, the sublimest image that has been recently created in Germany has not come out of any artist's studio. It is the steel helmet.'[11] Not all the new appointments were as frightening. Eberhard Hanfstaengl, a cousin of one of Hitler's old Munich friends, 'Putzi' Hanfstaengl, was made director of the National Gallery in Berlin, where he fought a valiant rearguard action to protect the gallery's prestige and possessions.

At the same time a power battle developed between Rosenberg and Goebbels over who should control the arts. Rosenberg hoped that his *Kampfbund* would be transformed from a party agency into a state one. Goebbels felt that it would interfere with the work of his Ministry of Propaganda. It was partly a personal matter and partly a battle of ideas. Rosenberg wished to implement his conservative, traditionalist views; Goebbels wished to convey an image of newness and youth. The testing point came with an exhibition organized by Otto Schreiber called 'German Art', which included work by Barlach, Nolde, Schmidt-Rottluff and other Expressionists, and which opened in July 1933. Schreiber started the argument by publishing an inflammatory letter that denounced 'the erection of historicism into a dogma' (i.e. Rosenberg's 'myth') and called for 'a revolutionary view of art'. It ended, 'Long live the complete National Socialist revolution'.[12]

Rosenberg felt bound to reply and he endeavoured to argue his case through newspaper articles and a rally of the *Kampfbund* on 15 July. The dispute threatened to get out of hand and various attempts were made to put a stop to it. Rosenberg, however, was no match for Goebbels in political in-fighting and by the end of the summer Goebbels emerged the winner, with his ministry given control over a new state institution, the *Reichskulturkammer*, the State Chamber for Arts

Max Beckmann, *Carnival in Paris*, 1930. It was removed from National Gallery, Berlin. This deeply ambiguous work conveys a mood which is both light-hearted and menacing.

and Culture, which was established on 15 November 1933.

The Chamber consisted of a number of sub-chambers with control over film production, literature, theatre, music, radio, newspapers and art. These were in turn divided into smaller units. The art chamber, for example, had sections for dealers, art publishers, interior decorators, graphic artists and so on. The Chamber was based in Berlin but there were over thirty provincial offices. Through it Goebbels could control every aspect of the arts. Not surprisingly, membership increased rapidly as there was no other way for an artist to gain a living. By 1936 the Chamber consisted of forty-two thousand members, including over fourteen thousand painters and sculptors and fifteen thousand architects.

The fact that Goebbels was in control rather than Rosenberg gave some German modernists scope for optimism. Goebbels's opening address to the Chamber seemed progressive in spirit. He declared: 'German art needs fresh blood. We live in a young era. Its supporters are young, and their ideas are young. They have nothing more in common with the past, which we have left behind us. The artist who seeks to give expression to this age must also be young. He must create new forms.'[13]

Goebbels, however, was an opportunist in everything. Consistency was never one of his virtues and his tolerance to new forms proved short-lived. Speer redecorated his offices and borrowed some Nolde watercolours to hang in them. Goebbels made no objection but when Hitler saw them and expressed his displeasure Goebbels summoned Speer to come to him immediately. 'The pictures must go at once; they're simply impossible!' said Goebbels. Speer comments: 'There was something fantastic about the absolute authority Hitler could assert over his closest associates of many years, even in matters of taste. Goebbels had simply grovelled before Hitler. We were all in the same boat. I too, though altogether at home in modern art, tacitly accepted Hitler's pronouncements.'[14]

It took time for the modernists to realize how weak an ally they had in Goebbels. Even Gropius felt it was worth appealing for the new architecture. In June 1934 he wrote: 'Shall this strong new architectural movement which began in Germany be lost to Germany? Must we be forced to stop our work, when the entire world has begun to accept our initiative and to carry further our inspiration?'[15]

Gottfried Benn put in an appeal for Expressionism. He had been one of the outstanding pre-war Expressionist poets, a man of wide interests, a doctor, an expert on venereal diseases and a student of theology. In 1934 he published *Kunst und Macht* (*Power and Culture*), which argued that 'everything that has been interesting, even meaningful in European art for the past twenty years has been genetically related to Expressionism', that the Expressionists of his generation had experienced 'an evolution towards a new order and new historical meaning' – in other words National Socialism.[16]

As Bernard Myers has pointed out,[17] the Nazis and the Expressionists had originally had many aims in common. During their days in the wilderness both movements had believed in the dream of a Third Reich – for the Expressionists the goal was a mystical and spiritual one; for the Nazis it was a political reality though tinged with mystical implications. Both were disillusioned with the Weimar Republic; both employed language that was ecstatic and emotional; both advocated a return to the emotional purity that the Expressionists saw in the work of the primitives and the Nazis identified with 'folkdom'.

There was, therefore, good reason for some of the Expressionists to believe that the new regime would uphold their claims to represent the true 'German' art. Some, like Nolde, were among the first to join the Nazi Party. Others, like Benn, believed that the National Socialists would rejuvenate a jaded Europe. For a time the Party toyed with them but eventually rejected them. Why? Partly because Hitler disliked their work, partly because the Expressionists were identified with the pacifist and socialist movements that ended the war, partly because they were associated with the patronage of the Weimar politicians, and partly because Hitler wanted to create a heroic and monumental style of his own.

A new, tougher line began to emerge towards the end of 1936, when in quick succession El Lissitzky's abstract room in Hanover was destroyed, artists like Dix and Schmidt-Rottluff were forbidden to exhibit and the leading Expressionists were attacked and harassed. On 30 October the modern wing of the National Gallery in Berlin was closed. On 1 December Adolf Ziegler was made head of the Chamber of Fine Arts.

Ziegler was a Munich painter who specialized in a form of revived neo-classicism. His nudes combine marble-like qualities with eroticism: he was sometimes referred to as the 'master of the pubic hair'. Hitler admired his work and one of his most ambitious compositions, *The Four Elements*, hung in a place of honour above the mantelpiece in the Führer's house in Munich. Hitler also commissioned him to do a posthumous portrait of his niece, Geli Raubal. He could rely on Ziegler to carry through his artistic programme.

A few days before his appointment Goebbels issued a decree banning art criticism. His order went:

Because this year has not brought an improvement in art criticism, I forbid once and for all the continuance of art criticism in its past form, effective as of today. From now on, the reporting of art will take the place of an art criticism which has set itself up as a judge of art. . . . The reporting of art should not be concerned with values, but should confine itself to description. Such reporting should give the public a chance to make its own judgements. . . .[18]

Among other measures introduced at the same time was an order that required critics to be over thirty.

These measures were greeted with some derision by the foreign press.

Adolf Ziegler, *The Judgement of Paris*. It was admired by Hitler.

Today it seems incredible that someone can simply forbid the publication of value judgements. But even at the time the order caused some confusion. Captain Weiss, head of the Press Chamber, called a press conference on 16 March 1937 to explain:

> The art of observation does not differ from the former art criticism, in Heaven's name. Though the idea that everything is to be accepted as good or exemplary [is equally wrong]. No. Indeed. The newspapers make a catastrophic mistake when they believe they can fulfil the requirements of the prohibition of criticism by praising everything. The mistake must instantly be corrected. However, the old idea that there is good art or bad art must be removed.[19]

Weiss went on to give new directives: 'If a work of art and its presentation contain a National Socialist idea we favour it. If the opposite is the case we have not only the right but the duty to be against it. Art criticism is not primarily an aesthetic question but a political one. . . .'

The fact that the Propaganda Ministry had told critics to give up the distinction of good and bad art did not mean that the ministry itself could not pronounce on artistic matters. During the next few weeks Goebbels decided that the ministry not only could but should give a clear demonstration of the good and bad elements in German art, and what could be better than an exhibition of 'degenerate' art to coincide

236

with the opening of the Haus der Deutschen Kunst in Munich in July.

The idea had been tried before. There had been an exhibition called 'Kulturbolschewismus' at Mannheim, an 'Artistic Chamber of Horrors' at Nuremberg, a display entitled 'Art that did not come from the heart' at Chemnitz, and an exhibition called 'Reflections of Decadence in Art' at Dresden. The advisability of repeating these shows became the subject of a fierce argument within Goebbels's ministry, the Arts Chamber and other related Nazi ministries. An idea of the debate can be gained from a report sent by W. Willrich to Darré. Willrich was the author of *Säuberung des Kunsttempels* (*The Cleansing of the Temple of Art*), which was published in 1937. So far as I am aware the report has not been published in English and since it gives a vivid picture of Nazi procedures, and of the mentality of the leading bureaucrats, it is worth quoting at length:

In the second week of April 1937 Dr Richter from the Propaganda Workshop telephoned and asked if I could put together a display of decadent art for the exhibition 'Give Me Four Years' Time', the official exhibition at the Haus der Kunst promised by Hitler in 1933. The Propaganda Minister, Dr Goebbels, wanted to show very explicitly how great the disparity is, like black and white, between 'the art of yesterday' and 'the art of today'. I was happily surprised by this invitation and said, 'Yes, that's really something. But the Chamber should be doing it.' To this Dr Richter answered: 'We did in fact go straight to the Chamber, and the Chamber of Fine Arts said they could not do it and had no material for it. When we asked them to recommend an expert they named you and Walter Hansen. So I am asking you to please get in touch with Mr Walter Hansen and to do it with him.' I answered: 'Except for the collection that Mayor Zorner [Mayor of Dresden] has sent round Germany, it will be hard to get anything, because the men who are at the moment the directors of our museums sympathize for the most part with the artists whom we must show to be degenerate. These people who used to buy these Bolshevist hack works . . . will naturally get a frightful shock when the works they have been secreting away are now exposed to the public, because indirectly they will be exposed with them. We can also expect some crossfire from them . . . and at the least we will meet passive resistance.' Then Dr Richter said to me, 'There will be absolutely no question of that. We can put a lot of pressure behind it from the ministry.' I replied: 'If that is the case and the minister seriously wants to pillory the leaders of the rabble that is opposed to the artistic policies of National Socialism, then I shall not evade it, although I know I shall personally be making deadly enemies of these people. I shall naturally accept complete responsibility for the choice of material. . . . Can you in the meantime get the necessary authorizations?' It took four or five days before I got an authorization, signed by Dr Karstensen (II 2060/16.4.37) and a further authorization from the Gestapo (II P 3–6/H–) into my hands. . . .[20]

Hansen and Willrich then set off on their searches. In Berlin the director of the National Gallery, Dr Hanfstaengl, played hide-and-seek with them, using every bureaucratic trick to delay them. But they seem to have collected sufficient material to satisfy them. Willrich continues his report:

As I was putting my display together, it was suddenly revealed to me that the President of the Chamber of Fine Arts, Ziegler, and his colleague Hoffman had announced that it was undesirable to reopen the argument about degenerate art. But I received my commission from the Propaganda Ministry and not from the Chamber of Fine Arts. . . . Then along came Councillor Haegert [head of Abteilung II (Propaganda Department) of the Ministry of Propaganda and Education for the Masses] and announced that certain artists – Schmidt-Rottluff, Nolde, Pechstein and Ludwig Gies – were not allowed to be shown. . . . I asked Councillor Haegert for the reasons for this decision and he replied: 'These people are now in the Chamber of Arts and Culture.' To his astonishment I revealed to him that Schwitters . . . was also in the Chamber of Arts and Culture today, and, furthermore, that with the exception of several emigrants, foreigners and a few Jews, all the cultural Bolshevists that I had got together here were already members of the Chamber, even the most grotesque, Dix, for example. So if you turned down all the painters in the Chamber you might as well shut up shop, as far as art was concerned. Councillor Haegert said he could not decide as he was no art expert. . . . Then there was an argument between various officials about what to do. It was finally decided to wait and hear what the minister himself had to say about it. . . . Then Herr Richter – at Haegert's order – quite suddenly decided to alter the whole thing. In my opinion this alteration contradicted what the minister wanted, as it was first explained to me when I accepted the task, and as it has been expounded in numerous oral and written pronouncements against Bolshevism and lapses of *Weltanschauung*, for which there is no excuse. . . . I announced that from now on I could accept no responsibility for what was going on and had to withdraw my material. . . .

The gentlemen named above . . . are acting counter to the expressed will of the Führer. . . . Since I cannot stand for this and know from previous experience what a dubious game is played with the authority of their minister by certain people of intermediate rank, I consider it absolutely necessary to submit this affair to a judicial inquiry.

On 30 June the interdepartmental rows were silenced. Ziegler, as head of the Chamber of Fine Arts, was authorized by Hitler and Goebbels jointly to 'select works of decadent art in the sphere of painting and sculpture since 1910 from those owned by German state, provincial and municipal authorities . . .'.[21] In a series of lightning raids Ziegler and four colleagues visited museums to remove works for an exhibition of degenerate art. Some museum directors did their best to delay the operation. Hanfstaengl refused to meet Ziegler's deputation, which arrived at the National Gallery in Berlin on 5 July. Others complied but were bewildered by the criteria for the confiscations. A letter from E. Buchner, director of the Bavarian State Collections, conveys the sense of confusion felt even by leading Party members:

On Wednesday, 25 August, at 9 o'clock, a Commission from the State Chamber of Fine Arts appeared in the director's office of the Alte Pinakothek and presented a photocopy of a letter signed by the Führer and the Chancellor authorizing the President of the Chamber, Ziegler, to carry out a purge of German art belonging to the state. . . .

The gentlemen were given an opportunity to view all the works of art con-

tained in the collection and its depositories. Since the word of a German civil servant and National Socialist was obviously not thought to be sufficient, I had to sign a written undertaking that to the best of my knowledge and conscience I had shown all the works that were in my charge in the collection and depositories.

I made every effort to understand just what the criteria were for the confiscation of paintings which covered greatly varying styles, but I was unable to come to any satisfactory conclusion. There were many young Munich painters of good reputation on the proscribed list, e.g. Achmann, Geigenberg, Gött, Grassmann, Lichtenberger, Schwalbach, but also older ones like the excellent colourist Max Feldbauer and the brilliant improvisator, Franz Naager. Fritz Hülsmann's *Bathing Figure on the Shore*, personally acquired and presented to the museum by the State Minister, as well as a harmless sketch of a mountain landscape by Otto Ditscher . . . are on the list. My objection that my *gauleiter* had personally purchased the painting from Hülsmann was waved aside with the brusque remark that that was of no significance. . . .

The confiscated pictures are to be sent to Berlin, but as yet we have not had any definite written instructions. I request herewith an instruction as to whether the works are to be sent to Berlin. These works of art, especially the four important works by Corinth and the two Munchs, represent a considerable market value. I should like to suggest that before they are despatched they should be insured by our assurance firm (Allianz) at the expense of the Chamber of Arts and Culture.

Most of the selections were made by Director Stahl, of Nuremberg, who a year ago certainly made a fool of himself when he deliberately exchanged a genuine de Hooch from the Nuremberg collection for a forged Spitzweg from abroad. . . . Now Herr Stahl of all people turns out to be the spokesman for this commission whose purpose is to defame as degenerate a series of works of art showing outstanding and highly original talent.[22]

Despite numerous obstacles Professor Ziegler and his team managed in just over a fortnight to assemble over seven hundred works. That alone was something.

On 18 July, a Sunday, the Führer opened the Haus der Deutschen Kunst in Munich. The project had engrossed him for over four years. He had worked closely with the architect Paul Troost, supervising every stage of the building. When Troost died he continued to work with Troost's widow and former partners. In many ways the building was as much Hitler's responsibility as anyone else's; the newspaper reports certainly gave that impression.[23]

Hitler's architectural ambitions stemmed from his early hopes of becoming an artist. His rejection by the Academy of Fine Arts in Vienna remained one of his most bitter memories. In *Mein Kampf* he wrote:

Indeed I was so sure of my success that the news of my rejection took me completely by surprise, like a bolt from the blue. It was true, all the same. When I called on the director and asked to know on what grounds I had been denied admission to the general school of painting at the Academy, he assured me that the drawings I had submitted showed clearly that I was not equipped to become a painter, but that my talents evidently lay in the field of architecture. . . .[24]

The Haus der Deutschen Kunst, Munich. The architect was Professor Paul Troost but Hitler supervised every stage of the building.

Hitler's biographers have tended to take opposite views on his gifts, depending on whether they are for him or agin him. Konrad Heiden says: 'He was not able to draw a human form or even a head from nature. But sometimes, instead of the flower girls or angels, there was a view of Vienna with stiff, angular lines – and these he could make, though not directly from nature but painfully and fussily copying from other pictures. His products are precise stereotypes, rather geometric in effect. . . .'[25] Heinrich Hoffmann, his court photographer, goes so far as to say: 'He had a discerning and highly appreciative eye for quality and was himself a watercolour artist of very considerable merit.'[26]

However, Hitler was neither as good nor as bad as that. He was an efficient watercolourist. A few surviving doodles show that he was quite capable of drawing the human head and figure, using, surprisingly, an expressionistic technique. Could he have qualified as an architect? Albert Speer says that he was remarkably quick in his assessment of architectural drawings and had no difficulty in visualizing them in three dimensions. There is no denying his passion for architecture. He would ignore important government business for the pleasure of studying an architectural drawing and he displayed an almost childlike enjoyment in the model buildings Speer and others produced for him. But his taste was confused. He admired Troost's style, with its simplified lines and clean limestone surfaces – he used to say that Troost had opened his eyes – and he also admired Speer's 'classical' style. But he retained a taste for the architecture of his youth – the world of 1890 to 1910 – which Speer calls 'decadent Baroque'. He enjoyed a certain amount of ornateness and one of his favourite buildings was the Paris Opera House by Charles Garnier. He used to say: 'The stairwell is the most beautiful in the world. When the ladies stroll down in their costly gowns and uniformed men form lanes – Herr Speer, we must build something like that too!'[27]

Hitler had a pronounced sweet tooth, and this is undoubtedly a characteristic of his taste in paintings. He liked the work of Eduard Grützner, painter of tipsy monks, jolly peasants and naughty servant girls. 'Grützner is greatly underrated,' he would say to Hoffmann, who shared his tastes. 'Believe me, this Grützner will some day be worth as much as Rembrandt.'[28] Another favourite was Carl Spitzweg, a Bavarian genre painter, fond of touching scenes drawn from the life around him. One of Hitler's proudest purchases was Spitzweg's *Thought is Free of Tax*, a scene at a custom's post, which much to his embarrassment proved to be a forgery.

Hitler's taste also extended to the erotic. His appreciation of Ziegler's nudes has already been mentioned, but further proof of his propensities was given in 1938 when he came out in support of an obviously erotic work by P. M. Padua, *Leda and the Swan*. It showed the swan mounted between the girl's thighs, its neck and head thrust towards the sky, and not surprisingly the work offended several

P. M. Padua, *Leda and the Swan*, 1938. Hitler gave it his approval.

240

women's organizations within the Party. Putzi Hanfstaengl once caught Hitler gazing at a picture of the same subject by Correggio. Hanfstaengl goes so far as to say that Hitler was himself capable of producing erotic, if not pornographic, drawings, using his niece as a model.[29] If he is right, this reveals Hitler as a repressed Expressionist himself.

For someone interested in art Hitler showed remarkable gaps in his knowledge, which he does not appear to have made any effort to fill. Hanfstaengl gives a hilarious account of a visit with him to the Berlin National Gallery. Hitler declared his admiration for the heroic qualities of Michelangelo and was determined to find examples of his work to prove his point. But, relates Hanfstaengl:

> The Berlin museum had no original of this master, only a marble statue of the young John the Baptist which is ascribed to him, probably erroneously. Hitler came to a halt in front of this lightly poised, almost feminine figure and proclaimed . . .: 'Michelangelo – that is the most monumental, the most eternal figure in the history of human art,' all the time looking around somewhat desperately for better examples of his work. . . .[30]

Hitler then went off on a rapid search with Hanfstaengl doing his best to keep up with him:

> We quick-marched again and were just passing through the Italian Baroque room on the way to the exit when Hitler came to a sudden halt in front of Caravaggio's *Matthew the Apostle*, a somewhat florid and not particularly successful composition. I was thunderstruck, especially as it was the first Christian subject at which Hitler had cast a glance. Then I understood. With his hunger for Michelangelo still unsatisfied, Hitler had misread the plaque. The name of the artist started with Michelangelo all right, but he had overlooked the other two words, which read Amerighi – Caravaggio. 'There you are, Fritzl,' said Hitler triumphantly. 'There was no end to his genius. There is no time now but we shall have to come back and look at it again.'

Hitler's lack of knowledge made him rely on the advice of art experts, whom he would treat with exaggerated respect alternating with paranoiac suspicion. Through his advisers he spent, during the war years, something like £23,500,000 on works of art, mainly for a museum he intended to build in Linz. It was, says Janet Flanner, 'the greatest individual outlay for beauty ever recorded, especially for a man who knew and cared nothing about it'.[31]

His choice of art advisers was capricious and almost as suspect as his choice of paintings. Dr Hermann Voss, a former director of the Dresden Gemäldegalerie, proved himself to be notoriously inept at his job. Heinrich Hoffmann, whom he made principal selector for the exhibition of German art at the Haus der Deutschen Kunst, was only marginally better informed about art than he was.

Hoffmann was given the job almost by accident. Originally there was a jury of twelve art teachers and painters. With over eight thousand works to choose from the jury were naturally keen to save the best

places for their own work. Hitler became suspicious and after an inspection of the work they had selected he threatened to cancel the whole exhibition. Troost's widow fainted and the situation was saved only by the intervention of Hoffmann. The photographer knew his master's tastes and whittled the numbers down to some 1,700 works. Unwisely he included a few moderns and when Hitler saw them he was far from pleased: '"Take the whole damned lot away," he rasped and stumped angrily out of the room,' recalled Hoffmann.[32]

The final selection barely filled the new gallery. The catalogue mentions only 884 works, and an English critic commented on 'the striking spaciousness in the arrangements of the exhibits'.[33] Unintentionally the bare interior implied that German art had not flourished under the Nazis to quite the degree they had hoped. Hitler tacitly admitted that the work was fairly commonplace and that the artists of genius were yet to come. The selection does, however, show the type of art that the Nazis wished to encourage. The main emphasis of the exhibition fell on the larger-than-life heroic sculpture of Arno Breker and Josef Thorak. Georg Kolbe and Fritz Klimsch were also featured. The sculpture of Breker and Thorak, which is chunky, masculine and large-

Thorak's sculpture was a prominent feature in most exhibitions in the Haus der Deutschen Kunst.

cale, was much in demand as decoration for the new Party buildings designed by Speer and others. Kolbe's art is more sensitive, though it was acceptable to the Nazis because of its association with sport and athletics. The paintings in the exhibition tended to fall into well-defined categories – portraits, landscapes, nudes and genre. In the 1937 exhibition there were portraits of Hitler, Troost and Hesse. The nudes included Ziegler's *Four Elements* and Klein's *The Awakening Ideal*, a picture of a well-developed young man gazing sternly into the distance. The genre section favoured scenes of peasant life: there was a picture of three muscular women in traditional-type dress resting on their toes, a picture by Thomas Baumgartner of a peasant family gathered round a bare wooden table while one of them slices up a loaf of bread, and there was a market scene set in Munich in the nineteenth century. A number of the genre paintings were devoted to recent events. Hermann Hoyer's *In the Beginning was the Word* showed Hitler addressing one of his first Munich meetings, and Elk Eber's *Call to Arms, 23 February, 1933* showed two Nazi fighters tightening their belts (literally) and fastening their collars, both looking suitably grim-faced and resolute.

Richard Klein, *The Awakening Ideal*, 1937. One of the successes of the official exhibition.

All was now ready for the opening ceremonies. A stranger might have thought he had strayed on some ancient religious rite. He would have noticed the procession of gigantic Teuton gods and emblems and he would have been aware of an awesome silence falling on the crowd as high above them, standing before his temple, the Führer began his oration: 'When, four years ago, the solemn ceremony of laying the cornerstone for this building took place, we were all conscious of the fact that not only the stone for a new building must be laid but the foundation for a new and true German art. At stake was our chance to provoke a turning-point in the development of the total German output. . . .' An hour or so later, the voice a few decibels louder, the speaker concludes: 'And when once again in the realm of art the holy conscientiousness will have regained its full rights, then, I have no doubt, the almighty will elevate a few from the multitude of decent creators of art into the starry skies of the immortal, divinely inspired artists of the great past. . . .'[34]

In between the stranger would have heard arguments going back to Plato's Republic, combined with a lecture on art history and a denunciation of fashion and obscurity in modern art. It is a fascinating speech, partly because it expresses, in emotional and vituperative language, what many people secretly think. 'The first thing we should try to realize,' commented the English critic Herbert Read, 'is the significance of the event. The supreme head of one of the great nations makes a speech which must have taken an hour-and-a-half to deliver entirely concerned with the nature and functions of art. We in this country, who suffer from the complete indifference of the State to all such questions, may well feel this is already something.'[35]

A large part of the speech was directed at critics like Read and art criticism in general. Like Goebbels, Hitler seems to have found the high-flown language of art critics particularly irritating. He believed that the critics used expressions to bewilder the public, who were often ashamed of their ignorance and frightened to answer back. Because critics are so caught up with trends and new movements they are continually in need of new terms to describe what they see:

Art and art activities are lumped together with the handiwork of our modern tailor's shops and fashion industries [argues Hitler]. Every year something new. One day Impressionism, then Futurism, Cubism, maybe even Dadaism. A further result is that even for the most insane and inane monstrosities thousands of catchwords to label them will have to be found. If it weren't so sad in one sense, it would be almost a lot of fun to list all the slogans and clichés with which the so-called 'art initiates' have described and explained their wretched products in recent years.

Later in his speech Hitler lists some of the expressions that have particularly annoyed him. They are: 'inner experience', 'strong state of mind', 'forceful will', 'emotions pregnant with the future', 'heroic attitude', 'meaningful empathy', 'original primitivism'. He is particu-

Opposite Elk Eber, *The Call to Arms*, 1937.

244

larly distrustful of 'ists' and 'isms', and some of his remarks bring to mind Theodore Roosevelt's jibes at 'Octagonists, Parallelopiped-onists', and 'Knights of the Isosceles Triangle' (see page 184). But he comes to a conclusion that the American would never have accepted: 'I will confess now that I have come to the final unalterable decision to clean house, just as I have done in the domain of political confusion, and from now on rid German art life of its phrase-mongering.' Hearing these words Goebbels felt justified in continuing his ban on criticism and repeated many of Hitler's accusations in his address to the Chamber of Arts and Culture on 26 November 1937.

Turning to the artists supported by the critics, Hitler introduced a favourite rhetorical device: 'there are only two possibilities . . .'. The argument takes on a sinister ring:

No, here there are only two possibilities: either these so-called artists really see things this way and therefore believe in what they depict; then we would have to examine their distorted eyesight to see if it is the product of a mechanical failure or of inheritance. If the first is the case, these unfortunates can only be pitied; in the second case, they would be the object of great interest to the Ministry of Interior of the Reich which would then have to take up the question of whether further inheritance of such gruesome mal-functioning of the eyes cannot be checked. If, on the other hand, they them-selves do not believe in the reality of such impressions but try to harass the nation with this humbug for other reasons, then such an attempt falls within the jurisdiction of the penal law.

(To put it more briefly: 'We have ways of dealing with such people.')

The more positive parts of the speech are concerned with art as an expression of national ambitions and, more specifically, with what is German in German art. He attacks art historians who regard art as a series of international periods or styles: 'According to this theory . . . Greek art was not formed by the Greeks, but by a certain period which formed it as their expression. The same, naturally, was true of Roman art, which for the same reasons coincided only by accident with the rise of the Roman Empire. . . .' In Hitler's view this obsession with periods undermines the lasting, eternal element in art:

Art is not founded on time, but only on peoples. It is therefore imperative for the artist to erect a monument, not so much to a period, but to his people. For time is changeable, years come and go. Anything born of and thriving on a certain epoch alone would perish with it. . . .

But we National Socialists know only one mortality, and that is the mor-tality of the people itself. . . . As long as a people exists, however, it is the fixed pole in the flight of fleeting appearances. It is the being and lasting per-manence. And indeed, for this reason, art as an expression of the essence of this being, is an eternal monument – in itself the being and permanence. . . .

Hitler comes to two interrelated conclusions: 'To be German is to be clear,' he maintains, and adds: 'To be German is to be logical and also, above all, true.' When art is clear it can be understood by the people. 'From now on the people will once again be called upon to be the judges of their own art.'

Stripped of their emotional language Hitler's observations are reasonable enough. There is a case for saying that art historians have paid too much attention to style and that national qualities have been underestimated; there is a case for expressing concern over the fashionableness of modern art; there is a case for disliking art which is élitist and unrelated to life; and there is every reason to attack critics for using meaningless and obscure words. Where Hitler goes wrong is in turning his observations into rigid laws. His argument against periods forces him to ignore the fact the Gothic style was European, that artists like Dürer, Rubens and El Greco were internationalists, that at times Englishmen have painted like Frenchmen, that Frenchmen have painted like the Japanese, and that Germans have imitated the art of South Sea Islanders. The Exhibition of Degenerate Art was one of the results of Hitler's rigidity.

The exhibition opened on the following day, 19 July, in the annexes of the Municipal Archaeological Institute, which normally housed the Institute's collection of plaster-casts. The rooms were long and alley-like. Paul Rave has described the impression they made on the visitor:

Once you had mounted the narrow wooden stairs you were immediately confronted with an enormous crucifix, Gies's *Memento Mori*, from Lübeck Cathedral, accompanied by some horrifying Noldes. The room was labelled 'Sponsored by the Centre for the Insolent Mockery of Religious Experience'. The next room, a long narrow corridor, used pictures and captions of the most awful bullying kind, all in the cause of anti-Semitism.[36]

Karl Schmidt-Rottluff, *Village by the Sea*, 1913. Schmidt-Rottluff was one of the artists to suffer the most from the purges of the German museums.

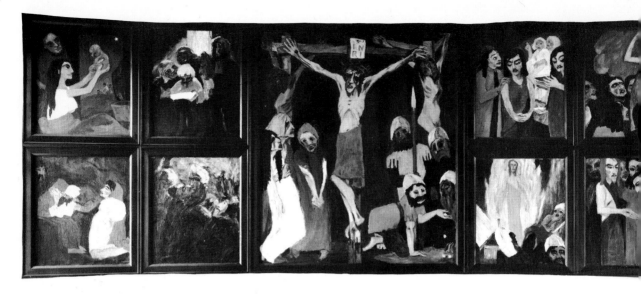

Despite the cramped space Ziegler and his staff managed to cram in over seven hundred works. Numerically the Expressionists dominated the show. There were at least twenty-five paintings by Kirchner, Nolde and Schmidt-Rottluff, thirteen by Mueller, nine by Kokoschka, seven by Heckel and six by Marc. The *neue Sachlichkeit* artists were there in strength. Rave lists ten paintings by Beckmann, ten by Dix and five by Grosz. The Bauhaus artists were represented by isolated examples. Feininger had seven paintings, Kandinsky three, Klee six paintings and nine watercolours, Moholy-Nagy one watercolour and Schlemmer five works. Examples by the Dadaists were a little thin, perhaps because few of their works had entered the museums. Nevertheless there were two works by Schwitters taken from Dresden. Two works by Max Ernst represented the Surrealists' contribution to the exhibition.

Some distinguished German artists of an older generation were included: Liebermann because he was Jewish, Corinth because he had suffered a stroke, which the organizers maintained had affected his art. The sculptures in the show were mainly the religious works of Barlach and Gies, but there was an abstract sculpture, *Triad*, by Rudolf Belling, which seemed to cause a surprising amount of fuss.

A few works by non-Germans were included in the exhibition as examples of decadence bought by misguided museum directors, the chief works being Gauguin's *Riders on the Sand*, which was later acquired by Göring, Picasso's portrait of the Soler family, a Mondrian *Composition* and Chagall's *Rabbi*.

Altogether the show included 113 artists, though the final figure may have been higher. It would be impractical to list all the artists but among those represented were Archipenko, Baumeister, Campendonk, Cas-Nay, Pechstein, Purrmann, Rohlfs. In fact the exhibition gave a representative picture of German Expressionism. Not to have been

Top Emil Nolde, *The Life of Christ*, 1911–12. This great religious cycle was removed from the Folkwang Museum, Essen.

Above Rudolf Belling, *Triad*, 1919. Belling was a founder member of the Novembergruppe, a movement bitterly resented by the Nazis.

included would have been just as insulting.

Although the choice of works was intended to show the artists in as poor a light as possible the organizers did pick several masterpieces. Among the outstanding works were Marc's *The Tower of Blue Horses*, several brilliant pre-war Kirchners, Nolde's great religious cycle from the Folkwang Museum, Essen, the portrait of Hermann-Neisse by Grosz, Corinth's *Ecce Homo*, a striking self-portrait by Beckmann, some of Lyonel Feininger's finest work done at Halle and Wilhelm Lehmbruck's sculpture *Woman Kneeling*, which was shown at the Armory Show.

What were the criteria for selecting such a varied display? The catalogue, or guide to the exhibition, divides the work into nine categories. The first section contained work in which form and colour had been wilfully distorted. Then there was a room devoted to religious paintings and carvings. The comments in the guide went: 'In the Jewish press these horrors were once called "Revelations of German Religio-

Above Ernst Barlach, *Doubting Thomas*, 1926. The squat peasant figures were not sufficiently Nordic or enobling.

Left Lovis Corinth, *Ecce Homo*, 1925. One of Corinth's last works attacked by Professor Ziegler because it was painted after the artist's second stroke.

„Kunstkommunist werden heißt zwei Phasen durchlaufen:
1. Platz in der kommunistischen Partei nehmen und die Pflichten der Solidarität im Kampf übernehmen;
2. Die revolutionäre Umstellung der Produktion vornehmen."

Der Jude Wieland Herzfelde in „Der Gegner" 1920/21.

sity''. At the sight of these revelations, however, those who react normally will tend to think of witches, and regard it, irrespective of their own creed, as a shameless mockery of all religious belief.'[37] Attention was drawn to the fact that the artists in this section had avoided subjects from the Jewish Old Testament legends. The third section was devoted to graphics that seemed to preach political anarchy and to encourage 'the class war'. The following section dealt with work that undermined the people's 'deep-rooted respect for military virtue, courage, bravery, and willingness to serve'.[38] Dix obviously fell into this category. The fifth section provided an insight into the 'moral side of degenerate art'. 'Obviously the whole of life is one large brothel . . . and humanity is made up only of whores and pimps,' proclaimed the catalogue.[39] Section six dealt with art that made the Negro and the South Sea Islander a 'racial ideal'. Section seven compared the work of the 'degenerates' with that of 'idiots and cretins'. Section eight was given over to work by Jewish artists. Section nine, the largest room in the show, was entitled 'Utter Madness' and contained a cross-section of 'isms', from Constructivism to Surrealism.

In hanging the exhibition the organizers used every technique to make the work seem crude, insignificant and incoherent. Works were hung close to each other, paintings were taken out of their frames and crude slogans in large black letters were written on the walls round them. Some of the slogans merely gave the artist's name, the museum where the work came from and the price paid (expressed in inflated currency). Others were more specific. Kirchner's *Peasants at Midday* bore the slogan 'German peasants as seen by the yids'. Mueller's *Gypsy Girl, Sitting* was captioned 'Jewish longing for desert origins finds its expression'. (The reason for this attack was that Mueller's mother was said to have been a gypsy.) A work by Dix was labelled 'Military Sabotage'.

Opposite A page from the handbook to the exhibition showing works by Grosz and Chagall's *The Rabbi*.

Right The interior of the exhibition of Degenerate Art. The installation was the ultimate Dada demonstration against art.

Interior of the exhibition.
Belling's *Triad* is in the centre.

The slogans flowed in and out of the paintings and sculpture, occasionally breaking out into a forest of exclamation marks, dots and dashes. This was noticeable round the Dada section, where two pages from Dada magazines were pinned to the wall. Ironically, the organizers had followed Dada methods. In many ways the exhibition was the greatest Dada exhibition of all; its slogans mocked the commercialization of art and the whole event was an anti-art demonstration.

To help visitors round the exhibition the organizers provided a guide rather than a catalogue. On the left-hand side there were pieces of propaganda explaining the purpose of the exhibition, interlaced with quotes from Hitler's speeches. On the right-hand side were reproductions of the most offensive works, accompanied by captions, and the odd extract from writings by 'degenerate' artists. The cover bore a photograph of a stone head by Otto Freundlich. Among the incriminating quotes provided by the guide was one from *Der Gegner*, dated 1920: 'We prefer to exist in squalor than to go under in cleanliness.'[40] The physical appearance of the 'degenerate' artists was drawn attention to, with reproductions of a self-portrait by Wilhelm Morgner, Dix's portrait of the painter Franz Radziwill, and Kirchner's portrait of Schlemmer.

On 19 July Professor Ziegler opened the exhibition with a speech. He began: 'You see around you the products of madness, of impudence, of ineptitude and decadence. This show produces in us feelings of shock and repugnance.'[41] Ziegler's main target is the museum directors, whom he accuses of deliberately buying work by unhealthy and insane artists and of ignoring the work of decent artists in disregard of the people's real wishes. He points out that the directors even refused works by Corinth in his early days, but after his second stroke they began buying his paintings in earnest. He concludes: 'It is a sin and a shame that institutes are filled with this stuff while honest and upright artists are ignored.' Ziegler then threw the matter open to the public: 'May the German people decide. We need not fear their verdict.'

The verdict of the party officials gathered before him, however, was by no means unanimous. Hoffmann says that even the most conservative members of the party felt that Ziegler and his team had gone too far. On his tour of inspection Hitler expressed surprise at some of the choices, and later Hoffmann was able to get some of the works removed, including Corinth's *Walchensee*.[42]

There was also some embarrassment over the inclusion of Marc. He had been a volunteer in a Bavarian regiment and had been killed in action at Verdun. Several members of his former regiment and some friends of the sculptor Professor Arnold Waldschmidt questioned the advisability of condemning an artist who had died for Germany in battle.[43]

Nolde protested at being included. As a long-standing member of the Nazi Party he felt that he had been slighted and he wrote to Goebbels requesting the return of his work. His letter continued: 'I also request, most honoured Herr Minister, that the defamation raised against me cease. ... When National Socialism also labelled me and my art "degenerate" and "decadent", I felt this to be a profound misunderstanding because it is just not so. My art is German, strong, austere and sincere.'[44]

Willrich indirectly replied in his book: 'Really there is just no visible reason why Nolde of all people should again be regarded as the indispensable leader of the German national style. Neither Goltz nor Nierendorf nor any other dealers sailing under the Red Flag would have taken Nolde's pictures in the first place if they had exuded even a breath of a healthy German spirit.'[45]

These disputes remained largely in the background. The German newspapers were almost unanimous in their praise for Goebbels, Ziegler and Willrich. Some were quite emotional. An Essen newspaper pointed to 'pictures that steep the experience of war and the soldier at the front in the sewers of Jewish derision and vileness, so that one is tempted to tear down every single one of them and hang the criminals who committed such follies on the nails instead.'[46]

Other reports are unintentionally comic:

Emil Nolde. Protested in vain.

Otto Dix, *Portrait of the Painter, Franz Radziwill*, 1928.

Ludwig Gies, *Memento Mori*.

In the fresh green atmosphere of the Hofgarten a white banner is spread out between wall and tree like the goal at a cross-country run. From there it is only a few steps to the steep staircase on top of which, like a monkey in a tree, a wild phantom is crouching [Gies's Crucifix]. . . . People wonder what would happen if this phantom were suddenly to jump down on them. There wouldn't be any alternative: just get your knives out! But probably he would jump down to escape as far as he could from human beings into the deepest, deepest forest, there to do what every fibre of his martyred, abused wooden body cries out for, putrefy! putrefy! putrefy![47]

Schultze-Naumburg's view that painting is a form of self-portraiture is echoed in the *National-Zeitung* of Essen: 'The conception of these decadent artists seems to be at their most typical in the pictures that are either self-portraits or portraits of their friends. In these works they have reproduced the men of today in such a distorted way that one would think that the present was ruled by cripples and idiots.'[48] Several papers express relief: 'Expert or not – everyone who has even a spark of interest, not to mention love, for the fine arts in all their forms will have heard . . . the speeches from Munich . . . with a sincere "Thank God".'[49]

Even an English critic writing in a scholarly journal, *German Life and Letters*, felt that there was something to say for the exhibition: 'On the whole Dr. Goebbels must be congratulated on a timely exposure of many art tendencies which are pure nonsense. Skilfully selected and arranged, satirically interlarded with large-print quotations from the critics who praised them, the Degenerates cut a sorry and even a comic figure.'[50] But in mitigation it should be said that the author, J.B.C. Grundy, went on to point out the merits of Nolde, Schmidt-Rottluff and Corinth and added: 'One leaves with the impression that it is all a little too glib and easy; that, in the modern German idiom, it is all not quite "fair".'

Of course Goebbels had no intention of being 'fair'. But one or two of the German newspapers gave a positive interpretation of the exhibition: One correspondent wrote: 'Today art, which was once chained and yoked to the intellectuals and alienated elements, has been given its freedom back again. "To be clear is true!" These words of the Führer encompass a programme for art in which the German artist will conquer the field of art once again, as he did in the golden age.'[51] Several newspapers refer to a golden age but it is by no means clear which period of German art they mean. Dr Karl Korn in the Berlin *Tageblatt* mentions Grünewald, but this master was not at all in keeping with Hitler's taste for the heroic and the sweet.[52]

After Hitler's visit it was possible for the public to go and judge the exhibition for themselves. On 20 July 31,700 people went. On 6 August the *New York Times* reported that the Party was rather embarrassed by the high attendance, which was almost three times as many as those who had been to see the official show. The report stated: 'Many visitors

. . . have been foreign tourists, especially American and British, but included also are many German art students to whom this exhibit is presumably their last opportunity to study modern art. . . .'⁵³ Among the foreign visitors was Cyril Connolly, who has written: 'I still re- member being fascinated by this, my first introduction to the work of these German artists and by my increasing guilt . . . when we paused longer and longer in front of some twenty-five Kirchners and Noldes, the Kokoschkas, Chagalls, Marcs and Barlachs, all with contemptuous captions. . . .'⁵⁴

Visitors like Connolly were not welcome: the guards kept a look-out for spectators who did not appear to be shocked by the exhibits or did not laugh sufficiently loudly.

As the exhibition proceeded Ziegler and his team continued their purge of German museums. An estimated 5,000 paintings and sculpture were confiscated and 12,000 graphics. An idea of the losses can be gained from the list provided by Roh and Willett. The museum to suffer the most was the Folkwang Museum (1,273 works), followed by the Kunsthalle, Hamburg (1,252 works), the Berlin National Gallery (1,152 works) and the museums of Düsseldorf, Dresden and Chemnitz. The artists most affected were mainly Expressionists, partly because so many of their graphics were in museum collections, the chief ones being Nolde (over 1,000 works), Heckel (729), Kirchner (639), and Schmidt- Rottluff (608).⁵⁵

These removals were accompanied by measures designed to bring the museum directors under stricter control. The more recalcitrant, men like Hanfstaengl, were removed. Others were ordered by Dr Berhard Rust, the Minister of Education, to undergo a 'school course' and attend a camp where military discipline prevailed. There they were to be instructed by approved Nazi experts on how to distinguish good German art from bad.⁵⁶

The Prussian Academy of Arts was also reformed. Barlach received a letter from the President, Georg Schumann, on 8 July which went: The reorganization of the Academy . . . is now extended to include a new composition of members. The information in my possession gives me to understand that it is not to be expected that you will continue as a member in the future. I would like to suggest in your own interests that you make public your resignation from the Academy as quickly as possible.'⁵⁷ Barlach's reply has been lost but he evidently protested at the way the resignations were to be described in the press. On 4 August he received a reply:

. . I can inform you that the Minister has taken note of your protest without being able to convince himself that it is justified. The text of the so-called newspaper article is – as the Minister emphasizes – phrased in such a way as to avoid any denigration of the resigning members of the Academy, and to make their voluntary resignation appear as loyal contributions to the new cultural ambitions of the Third Reich.⁵⁸

Even the eighty-nine-year-old Rohlfs was asked to resign. With great dignity he replied:

I have gone my own way as an artist for seventy years, and I have worked without asking how much applause or how much displeasure I would reap. Agreement or rejection, honour or dishonour, make my work neither better nor worse. If you do not like my work you are free to strike me from the list of members of the Academy. I, however, shall do nothing that could be interpreted as a confession of my own unworthiness.[59]

To use Hitler's phrase: there were now only two possibilities – artists could either leave the country, which was tantamount to confessing their lack of loyalty and their lack of Germanness, or they could stay behind and be denied all opportunity for showing or selling their work, and in some cases be forbidden to work at all.

The non-Germans at the Bauhaus had long since departed. Klee, who had Swiss nationality, left when the Nazis first came to power, writing in 1933: 'I would rather accept hardship than present the tragicomic figure of a man scurrying about in order to curry favour with

Paul Klee, *The Golden Fish*, 1925. Removed from the Berlin National Gallery.

hose in power.'[60] Feininger, who had an American passport, remained
or a while, though he was aware of the dangers. In 1935 he wrote to
is wife: 'About my work I shall say nothing except that I am working.
think it is better to keep quiet. I shall only say I hope . . . in a hopeless
period in the history of civilization, in a country where every decent
cultural force is being systematically persecuted.'[61] On 11 July 1937
Feininger left for the United States, saying, 'I feel 25 years younger now
hat I'm going to a country where imagination in art and abstraction
re not considered the absolute crimes they are here.'[62]

A day after the opening of the Exhibition of Degenerate Art Max
Beckmann left Germany for Amsterdam. His diaries for the next few
years have been destroyed but a feeling of his mood is captured in a
surviving fragment: 'I begin this new notebook in a condition of com-
plete uncertainty about my own existence and the state of the planet.
Wherever one looks: chaos and disorder.'[63]

It required even more courage to stay in Germany. Otto Dix was
one who did and from 1933 he led a precarious, almost underground
existence. He told his biographer: 'I painted landscapes by the dozen
during the Nazi period. There wasn't anything else. So I went out and
drew trees, groups of trees and that sort of thing. I was exiled into
landscapes. Landscapes. . . . They don't really interest me very much.
People, people, much more.'[64] In 1939 he was arrested following an
assassination attempt on Hitler's life in Munich, but he was released
after a week.

Schlemmer stayed. In his diaries for 1937 he noted: 'A Summer! A
house! Munich and the "Degenerates". A studio, big and beautiful –
o no sense of purpose now.'[65] In a letter to Heinz Braune, Director
f the Württemberg State Gallery, Stuttgart, dated 7 December 1937,
Schlemmer does not seem to have understood why he should have
been labelled a 'degenerate':

Now I hear from Berlin, however, that I am also to be included in the great
anti-Bolshevist exhibition – 'Bolshevism Unmasked'. . . . It is one of my best
pictures from 1924, *The Passer-by*, which I still believe in. – What purpose it
serves in this exhibition I simply cannot understand. . . .

As I have said, the situation really does seem now to be getting dangerous,
and I have no idea what will happen. . . . Is one going to be forced abroad?[66]

The threat of exile seems to have troubled Barlach as much as any
of the humiliations he experienced in the last years of his life. He wrote
o a friend: 'At a discussion about one thing and another one of the
Reich officials answered the question, "What should Barlach do then?"
with, "He can go abroad". It was his good fortune not to have said
hat in my presence.'[67] The incident upset him considerably and in his
letters he refers to it over and over again. To Friedrich Düsel, for
example, he wrote: 'The man does not know me. I shall never go.'[68]
His reasons for staying are given in a letter to Heinz Priebatsch:
'People say you can flee, but it is horrible to think that as a stranger

Max Beckmann, *Self-portrait*, 1925.
Over five hundred of his works
were confiscated. In his diary he
noted: 'I just don't fit into the new
world of the barracks.'

abroad one would be a stranger to oneself. One would simply go under in a state of homelessness.'[69]

Barlach, the most accomplished writer among the Expressionist artists, has left a moving record of the artist's plight under the Nazis. At the beginning of 1937 he realized that his position was hopeless. In a New Year letter to his brother he wrote:

> Hating gets boring. Bitterness is just being petty, fighting is impossible as the conditions for honourable equal combat are lacking. Even patrons and sponsors, who are usually so full of encouragement, are giving up hope. Hope? Hope for what, I ask them and myself. For a change in attitude by those on high? They used to tell me that it was possible, but they speak about it no more. What could I do anyway? I'm not going to change. I've already rejected a stealthy feeler, expressed in a squalid and humiliating manner, that I should make 'contact' with them. Strangely, I'm lulled into a kind of youthfulness. . . .'[70]

Ernst Barlach. 'I can see the moment coming when I shall drown.'

A few months later the tone of the letter was even more uncertain. '"They know not what they do?" Oh, no. They must know, and they can never be forgiven. That I am being dispensed with is understandable, but they really think no differently from what they say. I really am vermin in their eyes. . . .'[71] And to R. Piper he wrote: 'This brave new world does not suit us. My little boat is sinking and sinking faster and faster. I can see the moment coming when I shall drown. . . .'[72]

On 9 February 1938 Barlach wrote to his brother: '. . . Meanwhile they have decided to remove my work from the war memorial in Hamburg. When that's done all my larger works will have been disposed of or obliterated. . . . I'm not complaining, and I'm not in the least repentant or reformed.'[73]

On 24 October Barlach died. There is a drawing by Käthe Kollwitz of infinite sadness showing the sculptor on his death bed, his head turned away from the light, his body dissolving into nothingness.

Barlach's death was not the end of the Nazi purge of modern art. There were further insults, further humiliations to go through. Artists were forbidden to paint (Nolde and Schmidt-Rottluff), brushes were felt to see if they had been used, materials were supplied only to approved artists and those out of favour were forced underground. Karl Hofer recalled the formation of 'speakeasies' for the display of prohibited art.

The end of the Exhibition of Degenerate Art was an auction of some of the works organized by the Galerie Fischer in Lucerne on 30 June 1939. At one time Goebbels had planned to burn all the confiscated work but Hoffmann persuaded Hitler to sell it for foreign currency instead. A commission was set up to investigate the possibilities. The London dealers Colnaghi's did their best to act as agents for the sale. In a strongly worded letter they pointed out that they were the only large English firm that had neither shown nor recommended its clients to buy the work of the Degenerates from any country.[74] They also added that the possible use of two Jewish firms in Paris, Wildenstein

et Cie and Seligmann et Cie was hardly in keeping with the right spirit.

Colnaghi's letter may have had some influence but the job of disposing the works went to a Swiss firm, the Galerie Fischer, instead. One hundred and twenty-five of the best paintings and sculptures were put on display in the Guildhall in Zurich and later in the Grand Hotel National in Lucerne. Dealers and museum directors from all over the world came to the auction. There were some rich pickings. A Van Gogh self-portrait was sold for £8,750; a Gauguin Tahitian landscape for £2,500; a Picasso painting of two harlequins for £4,000 and his portrait of the Soler family for £1,800. Works which failed to find buyers were either sold off privately or included in a general bonfire of a thousand oil paintings and innumerable graphics organised by the Berlin Fire Brigade. Thirty years of enlightened collecting by the leading German museum directors and advisors disappeared in smoke.

CHAPTER 1

1 Joseph C. Sloane, *French Painting between the Past and the Present* (Princeton 1951).

2 The idea of an *avant-garde* can be traced to the writings of Claude Henri de Saint-Simon (1760–1825), the French Utopian Socialist. For an account of its development see Donald D. Egbert, 'The Idea of "Avant-Garde" in Art and Politics', *American Historical Review* (December 1967).

3 Letter to Joseph Huot (4 June 1861), included in Paul Cézanne, *Letters*, ed. John Rewald, trans. Marguerite Kay (London 1941).

4 John Rewald, *The Ordeal of Paul Cézanne*, trans. Margaret Liebman (London 1950).

5 Quoted in Amaury-Duval, *L'Atelier d'Ingres*, ed. E. Fauré, and in Rewald, *History of Impressionism* (New York 1949).

6 From an unfinished manuscript, 'Un Programme de Critique', quoted in Louis Gonse, *Eugène Fromentin: Painter and Writer*, trans. Mary Caroline Robbins; reprinted in *Realism and Tradition in Art, 1848–1900*, ed. Linda Nochlin (New York 1966).

7 For a list of jury members, prizewinners and winners of the Prix de Rome in Manet's time see George Heard Hamilton, *Manet and his Critics* (New Haven 1954).

8 Ernest Chesneau, in *Le Constitutionnel* (28 April 1863).

9 For a full discussion of the critics and their views see Sloane, *French Painting*.

10 Edmond and Jules de Goncourt, *Journal*, 4 vols (Monaco 1956); entry for 15 February 1864.

11 Goncourt, *Journal*; entry for 11 December 1866.

12 Letter to Alfred Sensier of 30 May 1863, quoted in Julia Cartwright, *Jean-François Millet, his life and letters* (London 1896; New York 1902).

13 Antonin Proust, *Édouard Manet; souvenirs* (Paris 1913); first published as a series of articles in the *Revue Blanche* (February–April 1897).

14 Émile Zola, *Mes Haines* (Paris 1879), trans. in Hamilton, *Manet*.

15 See *Cahiers d'Art* (1932).

16 For a defence of Manet's compositional innovations see Alan Bowness, 'A Note on Manet's Compositional Difficulties', *Burlington Magazine* (June 1961).

17 Linda Nochlin believes that the *Déjeuner* was a deliberate *blague*. See 'The Invention of the Avant-Garde: France, 1830–80', in *Avant-Garde Art*, ed. Thomas B. Hess and John Ashbery (New York 1970).

18 The authenticity of the oil sketch, now in the Courtauld Institute, was at one time questioned. It is now accepted. It almost certainly preceded the larger *Déjeuner*, rather than following it as was at one time argued.

19 For a full discussion of Couture's methods see Albert Boime, *The Academy and French Painting in the Nineteenth Century* (London and New York 1971).

20 Proust, *Édouard Manet*.

21 J. E. Blanche, *Manet*, trans. F. C. de Sumichrast (London 1925).

22 Chesneau, in *L'Artiste* (1 April 1863).

23 Paul Mantz, 'Exposition du Boulevard des Italiens', *Gazette des Beaux-Arts* (1 April 1863).

24 Paul de Saint-Victor, in *La Presse* (27 April 1863).

25 Jules Castagnary, 'Le Salon des Refusés', *L'Artiste* (1 August 1863); reprinted in *Salons (1857–1870)* (Paris 1892), 1. Castagnary also wrote for the Brussels newspaper *Le Nord* (seven articles), for *Le Courrier du Dimanche* (nine articles) and *L'Artiste* (three articles).

26 For an account of the steps leading

up to the *Salon des Refusés* see Adolphe Tabarant, *La Vie artistique au temps de Baudelaire* (Paris 1944). Tabarant based his account on the memoirs of Philippe de Chennevières. Ernest Chesneau in *L'Artiste* gives the date of his visit as 22 April.
'Le Salon des Refusés de 1863', *Gazette des Beaux-Arts,* LXVI (1965).
Le Moniteur universel (24 and 28 April 1863).
Castagnary, in *L'Artiste* (1 August 1863).
Chesneau, in *L'Artiste* (1 May 1863).
Philip Gilbert Hamerton, 'The Salon of 1863', *Fine Arts Quarterly Review* (October 1863).
Whistler to Fantin, spring 1863, quoted in L. Bénédite, 'Whistler', *Gazette des Beaux-Arts* (June 1905), and also in Rewald, *History*.
Hamerton, in *Fine Arts Quarterly Review*.
Théophile Gautier, in *Le Moniteur Universel* (23 May 1863).
Quoted in Robert Baldick, *Dinner at Magny's* (London 1971).
Chesneau, in *Le Constitutionnel* (5 May 1863).
Saint-Victor, in *La Presse* (27 April 1863).
Paul Mantz, in *Gazette des Beaux-Arts* (June 1863).
Saint-Victor, in *La Presse* (10 May 1863).
Hamerton, in *Fine Arts Quarterly Review*.
Hector de Callias, in *L'Artiste* (15 May 1863).
Castagnary, *Salons*.
Saint-Victor, in *La Presse* (28 June 1863).
Letter to Sensier of 30 May 1863, quoted in Cartwright, *Millet*.
Saint-Victor, in *La Presse* (28 June 1863).
Hamerton, in *Fine Arts Quarterly Review*.
Quatremère de Quincy had proposed a special Prix de Rome for landscape.
For a full discussion of academic thinking on landscape see Boime, *Academy*.
Thoré's criticism of the Salon of 1863 appeared in *L'Indépendance Belge* and was later reprinted in

Salons de W. Bürger, 1861 à 1868 (Paris 1870).
50 See E. Fromentin, *The Old Masters of Belgium and Holland*, trans. Mary Robbins (Boston 1882).
51 Thoré, *Salons*.
52 The full catalogue is reprinted in the *Gazette des Beaux-Arts*, LXVI (1965). Tabarant seems to have been unaware of the supplement. He mentions 380 painters, 52 sculptors, 14 engravers, 3 architects.
53 *Gazette des Beaux-Arts*, LXVI (1965).
54 Hamerton, in *Fine Arts Quarterly Review*.
55 Another possibility is no. 112, *Horses in a Pasture, an Autumn Scene*, by Charles Delton.
56 *La Presse* (17 May 1863). The writer is said to have been Arsène Houssaye, founder of *L'Artiste*, and at that time one of those opposed to the *Salon des Refusés*. However, he is not mentioned in the most recent publication on Whistler: *From Realism to Symbolism: Whistler and his World*, exhibition catalogue (New York 1971), henceforth referred to as *Whistler*.
57 See Rewald, *Ordeal*.
58 *L'Oeuvre* remains one of the least well known of Zola's novels in English. I have therefore quoted from it at some length. This translation is by Thomas Walton, (London and New York 1950).
59 Hamerton, in *Fine Arts Quarterly Review*.
60 Louis Étienne, *Le Jury et les exposants* (Paris 1863).
61 Hamerton, in *Fine Arts Quarterly Review*.
62 Thoré, *Salons*.
63 Castagnary, *Salons*.
64 Zacharie Astruc, *Le Salon* (Paris 1863).
65 *Gazette de France* (1863), quoted in Tabarant, *La Vie*.
66 Quoted in E.R. and J. Pennell, *The Life of James McNeill Whistler*, 2 vols (London and Philadelphia 1908).
67 The *Athenaeum* mentioned the picture on 28 June, 5 July and 19 July 1862.
68 *Athenaeum* (5 July 1862). For a full account of the origins of this picture see *Whistler*.

69 Castagnary, *Salons*.
70 Mantz, in *Gazette des Beaux-Arts*.
71 Victorine Hefting, *Jongkind, d'après sa Correspondance* (Utrecht 1969).
72 Leroy, in *Charivari* (20 May 1863).
73 Castagnary, *Salons*.
74 Quoted by Rewald, *The Ordeal*.
75 Castagnary, *Salons*.
76 Maxime Du Camp, *Le Salon de 1863, La Revue des Deux Mondes*, 15 June 1863.
77 Édouard Lockroy, 'L'Exposition des Refus´s,' *Le Courrier Artistique*, 16 May 1863.
78 Thoré, *Salons*. In this and the following passages I have used the translation provided in Nochlin, *Realism and Tradition*.

CHAPTER 2

1 Théodore Duret, *Manet and the French Impressionists*, trans. J.E. Crawford Flitch (London and Philadelphia 1910).
2 Ambroise Vollard, *Renoir, an intimate record*, trans. Harold L. Van Doren and Randolph T. Weaver (New York 1925).
3 Degas told Vollard that he returned Manet's plums after he had discovered the damage done to his portrait of Manet and his wife.
4 Paul Alexis, in *Le Cri du Peuple* (8 January 1885).
5 Thiébault-Sisson, 'Claude Monet, An Interview', *Le Temps* (27 November 1900).
6 John Rewald, *The History of Impressionism* (New York 1949).
7 M. Easton, *Artists and Writers in Paris: The Bohemian Idea, 1803–1867* (London 1964).
8 M. Elder, *Chez Claude Monet à Giverny* (Paris 1924).
9 Duret, *Manet*.
10 Elder, *Chez Claude Monet*.
11 Vollard, *Renoir*.
12 Édouard Manet, 'Reasons for a Private Exhibition', statement issued to accompany his one-man show (24 May 1867). Zacharie Astruc is thought to have been part author of the statement, but Hamilton, *Manet and his critics*, believes that Zola helped him to formulate it.
13 Manet, 'Reasons'.

14 Gaston Poulain, *Bazille et Ses Amis* (Paris 1932), trans. Linda Nochlin and reprinted in Nochlin, *Realism and Tradition*.

15 Poulain, *Bazille*.

16 M. Scolari and A. Barr, 'Cézanne in the letters of Marion to Morstatt', *Magazine of Art* (1938); this letter is dated April 1868.

17 Manet to his wife (23 November 1870), published in E. Moreau-Nélaton, *Manet raconté par lui-même* (Paris 1926).

18 The subject was a view of Louveciennes.

19 Pissarro to Duret (2 February 1873), quoted in A. Tabarant, *Pissarro* (Paris 1924), and in Lionello Venturi, *Les Archives de L'Impressionnisme* (Paris and New York 1939).

20 Venturi, *Les Archives*.

21 Armand Silvestre, introduction to *Galerie Durand-Ruel, receuil d'estampes*, 1 (Paris 1873), quoted in Rewald, *History*. The catalogue was never put on the market.

22 Duret to Pissarro (6 December 1873), quoted in Venturi, *Les Archives*, and in Venturi and L. R. Pissarro, *Camille Pissarro, Son Art, Son Oeuvre* (Paris 1939).

23 Venturi and Pissarro, *Camille Pissarro*.

24 Louis Vauxcelles, 'Un Après-Midi chez Claude Monet', *L'Art et les Artistes* (December 1905).

25 Vauxcelles, in *L'Art et les Artistes*.

26 See Venturi, *Les Archives*.

27 E. Degas, *Letters*, ed. Marcel Guérin, trans. Marguerite Kay (Oxford 1947). Letter headed 'Friday, 1874'.

28 Berthe Morisot, *The Correspondence of Berthe Morisot with her Family and her Friends*, ed. Denis Rouart, trans. Betty W. Hubbard (London 1957).

29 Georges Rivière, *Renoir et ses amis* (Paris 1921).

30 Degas, *Letters*. Letter headed 'Tuesday, 1874'.

31 Degas, *Letters*. See also Silvestre, *Galerie*.

32 J. de Nittis, *Notes et Souvenirs* (Paris 1895).

33 Castagnary, 'Exposition du Boulevard des Capucines', *Le Siècle* (29 April 1874).

34 Philippe Burty, 'Chronique du Jour', *La République Française* (16 April 1874); quoted in Venturi, *Les Archives*.

35 Ernest Lacan, in *Le Moniteur de la photographie* (1 December 1876). See *Nadar*, catalogue of exhibition at the Bibliothèque Nationale (Paris 1965).

36 Nadar, *La Grande Revue* (6 May 1866).

37 Vollard, *Renoir*.

38 Durand-Ruel's memoirs are published in Venturi, *Les Archives*.

39 Venturi, *Les Archives*.

40 *La Patrie* (21 April 1874); quoted in Jean Renoir, *Renoir, My Father*, trans. R. and D. Weaver (London 1962).

41 Morisot, *Correspondence*.

42 Leroy, 'L'exposition des Impressionistes', *Charivari* (25 April 1874).

43 Émile Cardon, 'Avant le Salon', *La Presse* (29 April 1874). Dr Blanche ran a famous lunatic asylum.

44 Joanna Richardson, *The Bohemians* (London 1969).

45 See Vollard's amusing account of his portrait in Vollard, *Recollections of a Picture Dealer*, trans. V. M. Macdonald (London 1936).

46 Roger Fry, *Cézanne: A Study of his Development* (London 1927).

47 J. Lindsay, *Cézanne, His Life and Art* (Bath 1969).

48 'Marc de Montifaud', 'Exposition du Boulevard des Capucines', *L'Artiste* (1 May 1874).

49 Jean Prouvaire, 'L'Exposition du Boulevard des Capucines', *Le Rappel* (20 April 1874).

50 Castagnary, in *Le Siècle*.

51 Renoir, *Renoir*.

52 Leroy, in *Charivari*.

53 Castagnary, in *Le Siècle*.

54 Castagnary, in *Le Siècle*.

55 Cardon, in *La Presse*.

56 See Venturi, *Les Archives*.

57 'Montifaud', in *L'Artiste*.

58 Philippe Burty, 'Expositions de la Société Anonyme des Artistes', unsigned article in *La République Française* (25 April 1874); see Venturi, *Les Archives*.

59 Venturi and Pissarro, *Camille Pissarro*.

CHAPTER 3

1 Jourdain's account of the founding of the Salon d'Automne can be found in F. Jourdain, *Le Salon d'Automne* (Paris 1928). Other accounts are in Pierre Cabanne, *Homage au Salon d'Automne*, catalogue of an exhibition at Wildenstein's, London (1964), and in *Histoire de l'art contemporain*, ed. René Huygué (Paris 1935).

2 Guillaume Apollinaire, 'Le Salon d'Automne, 1907, Je dis tout' (26 October 1907), reprinted in Apollinaire, *Oeuvres Complètes*, ed. Michel Décandin (Paris 1965).

3 Vollard, *Recollections*.

4 Proust to Marie Nordlinger (24 June 1905).

5 Maurice Denis, *L'Ermitage* (15 November 1905); reprinted in Denis, *Théories, 1890–1910* (Paris 1920).

6 Denis, *Théories*.

7 The critic Mellerio, quoted in Rewald, *The Ordeal*.

8 See Rewald, *The Ordeal*.

9 *Red Vineyards at Arles*, sold to Anna Boch at the exhibition of *Les Vingt* in Brussels in 1890.

10 See the new edition of J.B. de la Faille, *The Works of Vincent Van Gogh* (London and New York 1970).

11 Maurice de Vlaminck, *Portraits avant décès* (Paris 1943).

12 Vlaminck, *Dangerous Corner*, trans. Michael Ross (London 1961).

13 Georges Duthuit, *The Fauvist Painters*, trans. Ralph Manheim (New York 1950).

14 Duthuit, *Fauvist Painters*.

15 Duthuit, *Fauvist Painters*.

16 Gertrude Stein, 'The Making of Americans', *Transatlantic Review* (April–December 1924). See Leon Katz, 'Matisse, Picasso and Gertrude Stein', in *Four Americans in Paris*, catalogue of exhibition at the Museum of Modern Art, New York (1970).

17 Letter to Raymond Escholier (10 November 1936). Included in Alfred H. Barr, Jr, *Matisse: His Art and His Public* (New York 1951), from which the information in the above paragraph is derived, and without which this chapter could not have been written.

18 See Duthuit, *Fauvist Painters*, and Barr, *Matisse*.

19 Marielle Berr de Turique, *Raoul Dufy* (Paris 1930).

Duthuit, *Fauvist Painters*.

Leo Stein, *Appreciation: painting, poetry and prose* (New York 1947).

André Derain, *Lettres à Vlaminck* (Paris 1955).

Derain, *Lettres*.

Derain, *Lettres*.

Henri Matisse, 'Notes d'un peintre', *La Grande Revue* (25 December 1908); trans. by Barr in *Matisse*.

Vollard, *Recollections*.

Marcel Proust, *Remembrance of Things Past*, trans. C. K. Scott-Moncrieff, VI (London 1929).

Élie Faure, introduction to the catalogue of the Salon d'Automne (1905).

The others were Lucien Abrams, Eduard Bryan, William Horton, Anna Hudson, George Oakley, Ethel Sands, Theodore Scott-Dabo.

There is some doubt whether Vauxcelles made this remark at the Salon d'Automne of 1905 or at the Salon des Indépendants in 1906. For further information see Vauxcelles's account of the Fauves in the *Gazette des Beaux-Arts* (December 1934) and also Barr, *Matisse*.

The confusion was a real one. See C. Lewis Hind, 'The New Impressionism', *English Review* (December 1910).

Quoted in P. Courthion, *Georges Rouault* (London 1962).

Vauxcelles in *Gil Blas* (17 October 1905).

See Henri Certigny, *La Vente sur le Douanier Rousseau* (Paris 1961).

'Paris exhibitions', unsigned article in *The Times* (19 October 1905).

Arsène Alexandre, 'Le Salon d'Automne', *Le Figaro* (17 October 1905).

R. de Bettex, 'Le Salon d'Automne', *La République Française* (17 October 1905).

Félix d'Anner, 'Le Salon d'Automne', *L'Intransigeant* (17 October 1905).

Alexandre, in *Le Figaro*.

Émile Cordonnier, 'Le Salon d'Automne', *La Grande Revue* (15 November 1905).

Cordonnier, in *La Grande Revue*.

Thiébault-Sisson, in *Le Temps* (17 October 1905).

43 Vollard, *Recollections*.

44 D'Anner, in *L'Intransigeant*.

45 André Gide, 'Promenade au Salon d'Automne', *Gazette des Beaux-Arts* (December 1905).

46 Denis, in *L'Ermitage*.

47 See *Four Americans in Paris*.

48 Leo Stein, *Journey into the Self*, ed. Edmund Fuller (New York 1950).

49 Gertrude Stein, *The Autobiography of Alice B. Toklas* (New York and London 1933).

50 L. Stein, *Journey*.

51 For a full discussion on this purchase see Barr, *Matisse*, and *Four Americans in Paris*. A slightly different assessment is expressed in Clive Bell, *Old Friends* (London 1956), who maintains, 'Neither Gertrude or Leo had a genuine feeling for visual art. . . . Pictures were pegs on which to hang hypotheses.'

52 Quoted in Barr, *Matisse*.

CHAPTER 4

1 Robert Ross, *Morning Post* (7 November 1910).

2 Desmond MacCarthy, 'The Art-Quake of 1910', *Listener* (1 February 1945).

3 Oliver Brown, *Exhibition: Memoirs* (London 1968).

4 W. S. Blunt, *My Diaries*, II (1900–14) (London 1921).

5 For an account of the Chantrey Bequest inquiry see Samuel Hynes, *The Edwardian Turn of Mind* (Princeton and London 1968).

6 For a defence of the Academy see G. D. Leslie, *The Inner Life of the Royal Academy* (London 1914).

7 Gerald Reitlinger, *The Economics of Taste* (London 1961).

8 A. Thornton, *The Diary of an Art Student of the Nineties* (London 1938).

9 See an excellent reissue with a biographical study by Denys Sutton, text revised and annotated by Theodore Crombie (London 1962).

10 Frank Rutter, *Art in My Time* (London 1933).

11 Rutter, *Art*.

12 Bell, *Old Friends*.

13 Douglas Cooper, *The Courtauld Collection*, a catalogue and introduction (London 1954).

14 Rutter, *Art*.

15 Quentin Bell, *Victorian Artists* (London 1967), ch. 3.

16 Brown, *Exhibition*.

17 See his account of the Manchester exhibition of nineteenth-century British artists in 1887, which Fry went to see from Cambridge, in Virginia Woolf, *Roger Fry* (London 1940). 'I was delighted with Leighton's Daphnephoria,' he says.

18 Roger Fry, *Vision and Design* (London 1920).

19 Woolf, *Roger Fry*.

20 The argument of *An Essay in Aesthetics*, reprinted in *Vision and Design*, reads like a scientific paper.

21 William Rothenstein, *Men and Memories, 1900–1922* (London 1932).

22 Woolf, *Roger Fry*.

23 Fry, *Vision*.

24 Letter to the *Burlington Magazine* (March 1908).

25 For a fresh account of Fry's artistic development see Denys Sutton's introduction to the forthcoming publication of Fry's letters. See also Benedict Nicolson, 'Post Impressionism and Roger Fry', *Burlington Magazine* (January 1951).

26 Woolf, *Roger Fry*.

27 Woolf, 'Mr. Bennett and Mrs. Brown', lecture given on 18 May 1924.

28 MacCarthy, in *Listener*.

29 Cooper, *Courtauld Collection*.

30 MacCarthy, in *Listener*.

31 MacCarthy, in *Listener*.

32 Fry, letter to his friend G. L. Dickinson (15 October 1910), to be included in the forthcoming edition of Fry's letters, ed. Denys Sutton.

33 Ottoline Morrell, *Ottoline, the Early Memoirs of Lady Ottoline Morrell*, ed. Robert Gathorne Hardy (London 1964).

34 Letter to G. L. Dickinson.

35 Woolf, *Roger Fry*.

36 MacCarthy, in *Listener*.

37 Claude Phillips, *Daily Telegraph* (11 November 1910).

38 MacCarthy, in *Listener*.

39 Fry, *Vision*.

40 Benedict Nicolson, in *Burlington Magazine*. This is an important and scholarly appreciation of Fry's influence.

41 For a list of Van Gogh exhibitions see J. B. de la Faille, *The Works of*

Vincent van Gogh, revised ed. (London and New York 1970).

42 MacCarthy, in *Listener*.

43 *The Times* (7 November 1910).

44 Ross, in *Morning Post*.

45 John Cooke's letter to *Saturday Review* (24 December 1910).

46 Phillips, in *Daily Telegraph*.

47 Rutter, *Sunday Times* (15 November 1910).

48 It was written by MacCarthy from notes supplied by Fry.

49 Fry, *Nation* (19 November 1910).

50 Robert Morley, *Nation* (3 December 1910).

51 Ross, in *Morning Post*.

52 C. Lewis Hind, 'The New Impressionism', *English Review* (December 1910). Parts of the *English Review* are reprinted in Hind, *The Post Impressionists* (London 1911).

53 Fry, in *Nation*.

54 Michael Sadler, *Nation* (3 December 1910). Letter dated 30 November 1910. Sadler was in a few months to become a passionate collector of Post Impressionists. See Sadler, *Michael Ernest Sadler* (London 1949).

55 Laurence Binyon, *Saturday Review* (12 November 1910).

56 The quotation comes from the introduction to the catalogue of the exhibition.

57 Ross, in *Morning Post*.

58 Sadler, in *Nation*.

59 Arnold Bennett, *Nation* (7 December 1910).

60 A. Clutton-Brock, 'The Post-Impressionists', *Burlington Magazine* (January 1911).

61 Blunt, *My Diaries*.

62 Morley, in *Nation*.

63 Ross, in *Morning Post*.

64 Unsigned article in *Tatler* (23 November 1910).

65 D.S. MacColl, *Confessions of a Keeper* (London 1931).

66 Phillips, in *Daily Telegraph*.

67 Fry, *Nation* (3 December 1910).

68 Morrell, *Ottoline*.

69 Blunt, *My Diaries*.

70 Mary Lowndes, *The Englishwoman* (January 1911).

71 Fry, *Nation* (3 December 1910).

72 Fry, 'Acquisition by the National Gallery at Helsingfors', *Burlington Magazine* (February 1911).

73 MacColl, *Confessions*.

74 MacColl, *Life, Work and Setting of Philip Wilson Steer* (London 1945).

75 MacColl, *Confessions* (note added 1931).

76 Largely because there was no native *avant-garde* tradition.

77 Phillips, in *Daily Telegraph*.

78 Binyon, *Saturday Review* (26 November 1910).

79 Sadler, in *Nation*.

80 P.G. Konody, *Observer* (13 November 1910).

81 MacColl, *Confessions*.

82 Arnold Bennett, 'Books and Persons', *New Age* (December 1910); Bennett signed the article 'Jacob Tonson'.

83 Fry, *Nation* (3 December 1910).

84 John Sargent, *Nation* (1 January 1911).

85 In Charles Merrill Mount, *John Singer Sargent: a biography* (London 1957). For a convincing refutation of Mount's charges see Quentin Bell, 'John Sargent and Roger Fry', *Burlington Magazine* (November 1957).

86 See MacColl, *Steer*.

87 Joseph Hone, *The Life of Henry Tonks* (London 1934).

88 Letter to E. Fry (24 November 1910).

89 Letter to A.M. Daniel (13 August 1917), quoted in Hone, *Tonks*.

90 MacColl, *Steer*.

91 I am indebted to Benedict Nicolson for this information.

92 Rothenstein, *Men*.

93 Quoted in Rothenstein, *Men*.

94 Augustus John to John Quinn (12 January 1911). I am indebted to Michael Holroyd for unearthing this letter.

95 C. Bell, *Old Friends*.

96 C. Bell, *Old Friends*.

97 Richard Sickert, *A Free House: The Writings of Walter Richard Sickert*, ed. Osbert Sitwell (London 1947).

98 Sickert, *Free House*.

99 Fry, *Cézanne* (London 1927).

100 Sickert, 'Mesopotamia-Cézanne', *New Age* (March 1914); reprinted in *Free House*.

101 See Reitlinger, *Economics*.

102 Sickert, in *New Age*.

103 Rothenstein, *Men*.

104 Letter to Dorothy Brett (1921), quoted in Antony Alpers,

Katherine Mansfield (London 1954).

105 Christopher Nassall, *Edward Marsh, Patron of the Arts: a biography* (London 1959).

106 Michael Holroyd, *Lytton Strachey* (London 1967–8).

107 Hynes, *Turn of Mind*.

108 Fry, *Vision*.

109 Fry, *Last Lectures* (Cambridge 1939), with an introduction by Kenneth Clark.

110 Cooper, *Courtauld Collection*.

111 C. Bell, 'How England met Modern Art', *Art News* (October 1950).

112 Binyon, in *Saturday Review* (26 November 1910).

113 C.J. Holmes, *Notes on the Post-Impressionist Painters* (London 1910); Rutter, *Revolution in Art* (London 1911); Hind, *Post-Impressionists*.

115 Hind, *Post-Impressionists*.

CHAPTER 5

1 For an account of this exhibition see Hans Huth, 'Impressionism comes to America', *Gazette des Beaux-Arts* (April 1946).

2 Quoted in Milton W. Brown, *The Story of the Armory Show* (Greenwich, Connecticut 1963).

3 Brown, *Story*.

4 For a general discussion of the literary and political background to American Art see Oliver W. Larkin, *Art and Life in America* (New York 1956). For the literary background to the period leading up to the Armory Show see Van Wyck Brooks, *The Confident Years, 1885–1915* (London 1952).

5 Lloyd Goodrich, *Thomas Eakins, His Life and Work* (New York 1933).

6 Guy Pène du Bois, *Artists Say the Silliest Things* (New York 1940).

7 Brooks, *John Sloan, A Painter's Life* (New York and London 1955).

8 Veblen's most influential work was *The Theory of the Leisure Class* (New York 1899).

9 Somerset Maugham, *Of Human Bondage* (London 1915). The same display of wealth and naïveté was a characteristic of the American invasion of Paris after the First World War. See V.S. Pritchett, *Midnight Oil* (London 1971).

10 See Barr, *Matisse*.

For an account of American collecting of Impressionists see Huth, in *Gazette des Beaux-Arts*. For collectors see Aline B. Saarmen, *The Proud Possessors* (New York 1958; London 1959).
Brown, *Story*.
Du Bois, *Artists*.
Walter Pach, *Queer Thing, Painting; Forty Years in the World of Art* (New York and London 1938).
Walt Kuhn, *The Story of the Armory Show* (New York 1938).
Internationale Kunstausstellung des Sonderbundes Westdeutscher Kunstfreunde und Künstler, exhibition held in Cologne (25 May–30 September 1912).
For a sympathetic account of Duchamp's development see Robert Lebel, *Marcel Duchamp* (Paris and New York 1959).
Calvin Tomkins, *The Bride and the Bachelors* (New York and London 1965).
Collection of the Société Anonyme, Museum of Modern Art, 1920; catalogue of the Katherine Dreier collection, prepared by Yale University Art Gallery (1950).
Lebel, *Duchamp*.
William Rubin, *Dada and Surrealist Art* (New York and London 1969).
Tomkins, *Bride*.
Kuhn, *Story*.
Letter from Kuhn to Walter Pach (12 December 1912). Quoted in John W. McCoubrey, *American Art 1700–1960, Sources and Documents in the History of Art* (New York 1965).
McCoubrey, *American Art*.
Christian Brinton, 'Fashions in Art – Modern Art', *International Studio* (March, April 1913).
Caffin also wrote for the *American*.
Frank J. Mather, 'Art Old and New', *Nation* (March 1913).
Letter to Rudolph Dirks, quoted in Brown, *Story*.
This and the following quotation are to be found in B.L. Reid, *The Man from New York, John Quinn and His Friends* (New York 1968).
Reid, *Man*.
Letter to W.B. Yeats (16 March), published in *J.B. Yeats, Letters to his son, W.B. Yeats and Others, 1869–1922*, ed. (with a memoir)

33 Pach, *Queer Thing*.
34 Theodore Roosevelt, 'A Layman's View of an Art Exhibition', *Outlook* (29 March 1913); an extract appears in McCoubrey, *American Art*.
35 For a defence of Roosevelt's article see Joseph Masheck, 'Teddy's Taste: Theodore Roosevelt and the Armory Show', *Art Forum* (November 1970).
36 Roosevelt, in *Outlook*.
37 Du Bois, *Artists*.
38 Maurice Morris, *Sun* (23 February 1913). A better poem, but echoing the same line of thought, is to be found in X.J. Kennedy, *Nude Descending a Staircase* (New York 1961).
39 Quoted in Brown, *Story*.
40 See Brown, *Story*.
41 Arthur Jerome Eddy, *Cubists and Post-Impressionism* (Chicago 1914).
42 Eddy, *Cubists*.
43 A. Clutton-Brock, 'The Post-Impressionists', *Burlington Magazine* (January 1911).
44 *New York Times* (23 February 1913).
45 Mather, in *Nation*.
46 Clara MacChesney, *New York Times* (9 March 1913).
47 Jerome Myers, *Artist in Manhattan* (New York 1930).
48 Reid, *Man*.
49 Reid, *Man*.
50 Letter to Arthur Davies, quoted in Brown, *Story*.
51 Pach, *Queer Thing*.
52 Pach, *Queer Thing*.
53 For an account of the effect of the Armory Show on collectors see Brown, *American Painting from the Armory Show to the Depression* (Princeton 1955).
54 See Duncan Phillips, 'Revolutions and Reactions in Painting', *International Studio* (December 1913). Parts of this article appear in a revised form in Duncan Phillips, *The Enchantment of Art* (Washington 1927). For a fascinating analysis of Phillips's conversion, see Brown, *American Painting*.
55 Kenyon Cox, 'The Modern Spirit in Art, Some Reflections inspired by the Recent International Exhibition', *Harper's Weekly* (15 March 1913).

Joseph Hone (London 1944).

56 Brooks, *Sloan*.
57 Excerpt from the autobiographical monograph, *Stuart Davis* (New York 1945), Herschel B. Chipp (ed.), reprinted in *Theories of Modern Art, A Source Book of Artistic Concepts by Artists and Critics* (Los Angeles and London 1970).
58 Pach, *Queer Thing*.

CHAPTER 6
1 Newspaper cutting from Sir Roland Penrose.
2 André Breton, *What is Surrealism?*, trans. David Gascoyne (London 1930).
3 Breton, *What is Surrealism?*
4 The title of one of the first Surrealist magazines.
5 Manifesto called 'Towards a Free Revolutionary Art, 1938', translated by Dwight MacDonald for the New York journal *Partisan Review* (1938). Reprinted in Herschel B. Chipp (ed.), *Theories of Modern Art* (California 1970). For tactical reasons the manifesto was signed by Breton and Diego Rivera but, according to Breton, Leon Trotsky rather than Rivera was the co-author of the document.
6 *Cahiers d'Art* (1939), taken down by George Duthuit and reprinted in Lucy R. Lippard (ed.), *Surrealists on Art* (New York 1970).
7 For an assessment of Breton's role in the Surrealist movement see Claude Mauriac, *André Breton* (Paris 1949). For a new study see Anna Balakian, *André Breton, Magus of Surrealism* (New York 1971).
8 Raymond Lécuyer, 'Une Charge d'Atelier', *Le Figaro Littéraire* (22 January 1938).
9 This passage is quoted by Max Ernst in *Beyond Painting*, trans. Dorothea Tanning (New York 1948).
10 I am grateful for Sir Roland Penrose's help on this section.
11 André Breton, 'Devant le rideau', essay in *La Clé des Champs* (Paris 1953).
12 Man Ray, *Self Portrait* (London and Boston 1963).
13 Breton, Éluard and others, *Dictionnaire abrégé du Surréalisme* (Paris 1938).

14 See Marcel Jean, *The History of Surrealist Painting*, trans. Simon Watson Taylor (London 1960), an invaluable source book, packed with information by someone close to the movement.

15 'Surrealist Art', *The Times* (21 January 1938).

16 Breton, Éluard and others, *Dictionnaire abrégé*.

17 Lippard, *Surrealists*.

18 Jean, *History*.

19 A. M. Petitjean, *La Nouvelle Revue Française* (March 1938).

20 Article signed 'Le grincheux jovial', *Beaux-Arts* (21 January 1938).

21 'Boys' and Girls' Dept', *Daily Mail* (20 January 1938).

22 Ray, *Self-Portrait*.

23 Quoted in Fleur Cowles, *The Case of Salvador Dali* (London and New York 1959). See also Dali's autobiographies, especially *The Secret Life of Salvador Dali* (London 1948).

24 Petitjean, in *La Nouvelle Revue Française*.

25 Jacques Lassaigne, in *La Revue Hebdomadaire* (26 February 1938).

26 Albert Flament, in *La Revue de Paris* (1 February 1938).

27 Lécuyer, in *Le Figaro*.

28 Lécuyer, in *Le Figaro*.

29 Jean Fraysse, 'Un Art d'insolite grandeur', *Le Figaro Littéraire* (29 January 1938).

30 'Paris Joke', *New York Times* (6 March 1938).

31 *The Times* (21 January 1938).

32 Breton, *La Clé*.

CHAPTER 7

1 Quoted in John Willett, *Expressionism* (London 1970).

2 Circular letter (December 1918), signed M. Pechstein, C. Klein, G. Tappert, Richter-Berlin, M. Melzer, B. Krauskopf, R. Bauer, R. Belling, H. Steiner, W. Schmid.

3 Bruno Taut, *Alpine Architektur* (Hagen 1919).

4 G. Hartlaub, in *Arts* (January 1931); see Bernard S. Myers, *Expressionism, a generation in Revolt* (London 1963).

5 Paul Schultze-Naumburg, *Kunst und Rasse* (Munich 1928).

6 Hans F.K. Günther, *Rasse und Stil* (Munich 1926).

7 Emil Hogg: speech to the National Congress of German Architects and Engineers (Autumn 1926), quoted in Barbara Miller Lane, *Architecture and Politics in Germany, 1918–1945* (Cambridge, Mass. 1968).

8 Schultze-Naumburg, *Kampf um die Kunst* (Munich 1932), quoted in Lane, *Architecture*.

9 Albert Speer, *Inside the Third Reich*, trans. Richard and Clara Winston (London 1970).

10 Hitler's library is in the Rare Books Division, the Library of Congress, Washington. For a list of Hitler's art books see Hellmut Lehmann-Haupt, *Art under a Dictatorship* (New York 1954).

11 Quoted in Paul Ortwin Rave, *Kunst und Diktatur im Dritten Reich* (Hamburg 1948).

12 Otto-Andreas Schreiber, in *Deutsche Allgemeine Zeitung* (12 July 1933). Quoted in Lane, *Architecture*.

13 Josef Goebbels, address to the Reichskulturkammer (1933), reported in the *Völkische Beobachter* (16 November 1933).

14 Speer, *Third Reich*.

15 Gropius to Hönig, President of the Reichskammer der Bildenden Künste (27 March 1934), quoted in Lane, *Architecture*.

16 Gottfried Benn, 'Bekenntnis zum Expressionismus', *Deutsche Zukunft* (November 1933); republished in *Kunst und Macht* (Stuttgart 1934). An extract has been translated and published by Victor H. Miesel in *Voices of German Expressionism* (New Jersey 1970).

17 Myers, *Expressionism*.

18 *Der Deutsche Schriftsteller*, Jahrg. I, Heft 12 (27 November 1936). Translated in George L. Mosse (ed.), *Nazi Culture* (London and New York 1966).

19 'Reich play Critics may now criticize', *New York Times* (16 March 1937).

20 W. Willrich to Richard Darré, 30 April 1937. Reprinted in Joseph Wulf ed., *Die bildenden Künste im Dritten Reich, eine Dokumentation* (Gütersloh 1963).

21 Order dated 30 June 1937.

22 Letter headed Munich, 1 September 1937, addressed to Staatsministerium für Unterricht und Kultus, München, reprinted in Franz Roh, *'Entartete' Kunst, Kunstbarbarei im Dritten Reich* (Hanover 1962).

23 See Lane, *Architecture*.

24 Adolf Hitler, *Mein Kampf* (Munich 1933). See also Franz Jetzinger, *Hitler's Youth*, trans. Lawrence Wilson (London 1958) and William A. Jenks, *Vienna and the Young Hitler* (New York 1960).

25 Konrad Heiden, *Der Fuehrer, Hitler's rise to power*, trans. Ralph Manheim (London 1944).

26 Heinrich Hoffmann, *Hitler was my friend*, trans. R. H. Stevens (London 1955). See also Otto Dietrich, *The Hitler I Knew*, trans. Richard and Clara Winston (London 1957).

27 Speer, *Third Reich*.

28 Hoffmann, *Hitler*.

29 The accusation is in the chapter on Geli Raubal in Ernst (Putzi) Hanfstaengl, *Hitler, the Missing Years* (London 1957).

30 Hanfstaengl, *Hitler*.

31 Janet Flanner, *Men and Monuments* (London 1957).

32 Hoffmann, *Hitler*.

33 J. B. C. Grundy, *Art Tendencies in the Third Reich, German Life and Letters*, II (Oxford 1937–8).

34 The following quotations are from the translation by Ilse Falk in Herschel B. Chipp (ed.), *Theories of Modern Art* (Berkeley, Los Angeles and London 1970). A verbatim report appeared in *Freude und Arbeit* (1937), with an English translation.

35 Herbert Read, 'Hitler on Art', *Listener* (22 September 1937).

36 Rave, *Kunst und Diktatur*.

37 *Führer dund die Ausstellung Entartete Kunst* (Munich 1937); guide to the exhibition. The catalogue is reproduced.

37 *Führer die Ausstellung Entartete*

38 *Entartete Kunst*, guide.

39 *Entartete Kunst*, guide.

40 *Entartete Kunst*, guide.

41 Wulf, *Die bildenden Künste*.

42 Hoffmann, *Hitler*.

43 See K. Lankheit, *Franz Marc* (Stuttgart 1961).

44 Emil Nolde to Dr Josef Goebbels (2 July 1938), from *Seebüll bei Neukirchen*; reprinted in Diether Schmidt (ed.), *In Letzter Stunde,*

1933–1945 (Dresden 1964); translation appears in Miesel, *Voices*.

Wolfgang Willrich, *Säuberung des Kunsttempels* (Munich 1937).

'Afterkunst der Systemzeit', *Der Rühr-Arbeiter* (20 July 1937).

'Die Gespenstergalerie', *Münchener Neueste Nachrichten* (20 August 1937).

'Eine entsetzenerregende Schau', *National-Zeitung* (20 July 1937).

'Kunst ohne Mode', *Hamburger Nachrichten* (20 July 1937).

J.B.C. Grundy, *Art Tendencies in the Third Reich, German Life and Letters*, II (Oxford 1937–8).

Dr Wilhelm Spael, 'Das Haus der deutschen Kunst', *Kölnische Volkszeitung* (22 July 1937).

Dr Karl Korn, 'Kunstgegendeutsche Art', *Berliner Tageblatt* (21 July 1937).

'"Degenerate" Art Popular in Reich', *New York Times* (6 August 1937).

Cyril Connolly, 'Shivering the Timbers', review of Willett, *Expressionism*, *Sunday Times* (4 April 1971).

These figures come from Willett, *Expressionism*.

'Goering Launches the Nazi Art Purge', *New York Times* (4 August 1937).

Dr Georg Schumann to Ernst Barlach (8 July 1937), quoted in Barlach, *Brief an Hans Barlach*, in *Die Briefe, 1925–1938*, II (Munich 1969).

Letter dated 4 August 1937, in Barlach, *Briefe*, II.

Quote in *Entartete Kunst*, catalogue to the exhibition at Haus der Kunst. Documentation by Jurgen Claus.

Paul Klee to his wife, 6 April 1933.

Quoted in *Entartete Kunst*, catalogue.

See *Entartete Kunst*, catalogue.

See *Entartete Kunst*, catalogue.

Peter Selz, *Max Beckmann* (New York 1964).

Fritz Lottler, *Otto Dix, Leben und Werk* (Vienna and Munich 1967).

Oskar Schlemmer, *Briefe und Tagebücher*, ed. Tut Schlemmer (Munich 1958).

Schlemmer, *Briefe*.

Barlach to Heinz Priebatsch (23 October 1937), in Barlach, *Briefe*.

68 Barlach to Friedrich Düsel (5 December 1937), in Barlach, *Briefe*.

69 Barlach to Heinz Priebatsch (23 October 1937), in Barlach, *Briefe*.

70 Barlach to Hans Barlach (5 July 1937), in Barlach, *Briefe*.

71 Barlach to Heinz Priebatsch (20 April 1937), in Barlach, *Briefe*.

72 Barlach to R. Piper; see *Entartete Kunst*, guide.

73 Barlach to Hans Barlach (9 February 1938), in Barlach, *Briefe*.

74 Letter from P.D. Colnaghi (19 October 1938), addressed to the 'Ubernahme des Gesamtkomplexes "Entartete Kunst"'. See *Entartete Kunst*, catalogue.

The author and publishers would like to thank Angela MacDonald and Mathilde Rieussec for the picture research and the collections, museums and agencies listed below for their help in obtaining photographs and permission to reproduce them; in particular Mrs Walter A. Haas for lending the transparency of Matisse's *Woman in a Hat* (p. 87); Alex Reid and Lefevre Ltd for Burra's *The Hostesses* (p. 217); Henry Moore for the photograph of a head (p. 203) and Anthony d'Offay for the permission to reproduce a page from Claud Lovat-Fraser's *Journal* (p. 159).

Addison Gallery of American Art, Phillips Academy, Andover (Mass.) 184B

Archives of American Art, Smithsonian Institute 162, 165, 170T, 170B, 173, 178, 179, 181, 187T, 191, 192, 193

Archives Photographiques 26, 50

Art Institute, Chicago (Ill.) 172

Ateneumin Taidemuseo, Helsinki 136

Baltimore Museum of Art, Baltimore (Ma.), (Cone Collection) 190

Bes-Nolde Stiftung, Seebull Remmer, Flensburg 248T

Bibliothèque Nationale 10, 15, 16L, 23, 31T, 31B, 35B, 38, 41, 42, 45

Bildarchiv Foto Marburg 249R

Bilderdierst Süddeutscher Verlag 236, 243, 245

Bulloz 20, 30, 31C, 52, 56B, 57, 58–9, 63, 66, 68, 75, 107, 108T, 111, 116

Cleveland Museum of Art, Cleveland (Ohio) 180

Columbus Gallery of Fine Arts, Columbus (Ohio) (Ferdinand Howald Collection) 177

A. C. Cooper 104–5, 106, 121, 133, 140, 141, 145, 149, 153, 218, 230

Deutsche Fotothek, Dresden 248B, 253T, 257, 258

Gemente Musea, Amsterdam 139

André Held 65

Peggy Guggenheim Foundation, Venice 210–11, 215

Images et Textes (D. Bellon), Paris 199, 204, 206, 207T, 207B, 208L, 208R, 209

Jasper Johns Collection 216

Kunsthalle, Hamburg 256

Landebildstelle Rheinland, Düsseldorf 253B

London Express News and Features Service 251, 252

Marlborough Fine Art Ltd 110

Mansell Collection 130, 152

Metropolitan Museum of Art, New York, (Mrs H. O. Havemeyer Bequest) 47, 48, (Wolfe Fund) 194

Morton D. May Collection 247

Museu de Arte, São Paulo 138T

Museum of Art, San Francisco (Calif.), (Levy Bequest) 150

Museum of Fine Arts, Boston (Mass.) 79T, 147

Museum of Modern Art, New York, (Lillie P. Bliss Collection) 196, (Mrs Simon Guggenheim Fund) 214

F. and P. Nathan, Zurich 76

National Gallery of Art, Washington, D.C. 36

Nationalmuseum, Stockholm 213

Öffentliche Kunstsammlung, Basle 249L

Phaidon Press 17T, 17B, 71, 128T, 128B

Philadelphia Museum of Art, Philadelphia (Pa.), (Louise and Walter Arsensberg Collection) 174, 187B, 188, 189

Photographie Giraudon 32, 94T, 94B, 103

Presse-Hoffman, Berlin 239

Radio Times Hulton Picture Library 16A, 56R, 125, 155, 184T

Rheinisches Bildarchiv, Cologne 60

Rizzoli Archives, Milan 96

H. Roger-Viollet 13, 25, 39, 40, 81, 92–3

Rowholt Verlag, Hamburg 250

Sam Salz, New York 87

Service de Documentation Photographique 161

Sirot Collection 19, 44, 72, 73, 74, 84, 91

Staatliche Museen, Berlin 27

Städelsches Kunstintitut, Frankfurt 77

Stedelijk Museum, Amsterdam 138B

Tate Gallery 97, 229

Dietrich Hans Teuffen 242

Wallraf-Richartz Museum, Cologne 225

J. H. Whitney Collection 79B, 98, 99